WOMEN IN VICTORIAN SOCIETY

WOMEN IN VICTORIAN SOCIETY

ANNE LOUISE BOOTH

AMBERLEY

For Sophia Katie, my constant writing companion

First published 2024

Amberley Publishing
The Hill, Stroud
Gloucestershire, GL5 4EP

www.amberley-books.com

Copyright © Anne Louise Booth, 2024

The right of Anne Louise Booth to be identified
as the Author of this work has been asserted
in accordance with the Copyright, Designs and
Patents Act 1988.

ISBN 978 1 3981 0540 9 (hardback)
ISBN 978 1 3981 0541 6 (ebook)

British Library Cataloguing in Publication Data.
A catalogue record for this book is available
from the British Library.

1 2 3 4 5 6 7 8 9 10

Typesetting by SJmagic DESIGN SERVICES, India.
Printed in the UK.

CONTENTS

Introduction

SUFFRAGETTE CITIES

June 2018: UK temperatures reached near-record levels for the time of year ensuring a holiday mood for the purple, white and green 'moving artwork' *Processions*, created to celebrate the centenary of the Representation of the People Act 1918, following which the first women in the UK were allowed to vote at last. After decades of campaigning and living with the prevailing ideology throughout the Victorian age that they were the inferior sex, they had secured a victory that led to universal franchise for women within ten years.

On a summer's day a hundred years later, women of all ages, from all spheres of society, appeared live on the BBC wearing their suffragette colours as part of a living, travelling suffragette flag. Their spirited, expressive and confident simultaneous celebration of a century of emancipation in the 'Suffragette Cities' of Belfast, Cardiff, Edinburgh and London was streamed across the globe via social media.

YouGov research in February 2018 revealed that over one in three British people said that the suffragettes' campaign for votes for women made them especially proud to be British.[1] Annie Kenney had written in the Suffragette Fellowship newsletter *Calling All Women*: 'May the younger generation find ... the inspiration and will to dedicate their lives anew to high and noble deeds.'

A century after the first women were given the vote, young women are still inspired and still willing. Twelve-year-old Rosie said she attended *Processions* in London with her mother to 'say thank you to the suffragettes for what they did for us'. Art student Sophie Ellis produced an artwork as a memorial to suffragette Emily

Davison who was force-fed forty-nine times during the suffragette hunger strike: 'I have produced forty-nine concrete teacups in the suffragette colours to commemorate [Emily's] death. The concept of a concrete teacup echoes how a woman's status was depicted through the quality of their tea set. The fragility of a porcelain teacup references the fragile frame of the women who empowered the hunger strike, yet pursued the cause with such strong ambition and passion. I have juxtaposed this by using a material that is not traditionally related to the stereotypical feminine qualities, revealing supremacy and bravery.'[2]

And alongside their campaign to secure the vote, both suffragettes and suffragists[3] responded holistically to the Victorian culture of domesticity and its subordination of women, flinging open the door to almost its fullest extent seventeen years after the death of the queen who gave her name to the era. The word 'suffragette' was not coined until after the end of the Victorian era, and became loaded with meaning; it was patronising, diminutive, used only to characterise women and screeching, violent and militant ones at that. The suffix '-ette' in itself meant mini, smaller, somehow less than the whole. Victorian women campaigners for the vote would not have self-identified as suffragettes.

Economic and social pressure meant that marriage remained the objective of most Victorian women of all classes. GRO statistics show that 85 per cent of Victorian women were married by the age of fifty. Marriage was simply a necessity for survival. But once married, society expected women to be the submissive partner. Custom and common law supported the age-old notion that men would command and women would obey; this was of course reflected in marriage vows. Personal ambition was a virtue in a man but a vice in a woman, therefore women should aspire to support and minister. Sweetness, subservience and modesty were the admired feminine qualities. The masculine ideal was self-control, the famous stiff upper lip of Empire and mastery over others. Gender-based roles were so polarised that the result was a world ruled solely by male discretion, which rarely took into consideration the woman's viewpoint.

Emily Tennyson was well read in literature and politics, wrote poetry herself, dabbled in writing fiction and set her husband's poetry to music. Although she believed women should not concern themselves with public affairs, except in private and at home, she

did write twice to Prime Minister William Ewart Gladstone with intelligent suggestions on such subjects as tax reform and the need for old-age pensions. But Emily is remembered merely for being the helpmate to her famous husband Alfred, presenting him in the best possible light as he expected and demanded, and for being a 'living stream of love whose fount is never dry'.[4]

Victorian mathematician and historian Thomas Carlyle once told his wife Jane that she must regard him as the master of the house: 'The man should bear rule in the house and not the woman.' Never mind that Jane was described as 'one of the rare Victorian wives who are of literary interest in their own right ... to be remembered as one of the great letter writers – in some respects her husband's superior – of the nineteenth century is glory beyond the dreams of avarice'.[5] Jane herself felt that 'these arrogant men may please themselves in their ideas of our inferiority to their hearts' content; they cannot hinder us in being what we will and can be'.[6]

The suffragettes did more than procure the vote for women. They were freedom fighters. They battled the growing subjugation of women such as Jane, Emily and thousands more like them throughout the Victorian era. These women understood absolutely the necessity for their emancipation in many different areas of life. By the end of Victoria's reign, gender inequality remained a fact of British life, symbolised most markedly by women's exclusion from the parliamentary franchise. Now, many women who had previously been stuck at home, keeping the perfect Victorian household and overseeing the bringing up of children all whilst being expected to be silent and well behaved, were stepping out of their boxes and realising they wanted more. They wanted a voice. But did all of them?

In fact, many women campaigned against enfranchisement, deeming it unfeminine and a betrayal of their intrinsic nature. Most surprisingly, the prolific and popular Victorian author Marie Corelli produced anti-suffrage literature including a pamphlet entitled *Woman, or Suffragette?*[7] suggesting it was not possible to be both.

Corelli's views may be seen as complex, contradictory and paradoxical. Her fictional heroines are independent women with successful artistic careers, and Corelli articulates to her readers that the lives of these women are preferable – and more to be admired – than those of the typical Victorian woman as wife and mother, with

limited or no opportunity of exercising her intellectual capabilities. Yet in her pamphlet, she makes her personal feelings clear:

> To my mind, the very desire for a vote on the part of a woman is an open confession of weakness, – a proof that she has lost ground, and is not sure of herself. For if she is [a] real Woman, – if she has the natural heritage of her sex, which is the mystic power to persuade, enthral and subjugate man, she has no need to come down from her throne and mingle in any of his political frays, inasmuch as she is already the very head and front of Government. Let those who will, laugh at, or sneer down the statement, the fact remains that a man is seldom anything more than a woman's representative. No man, in either business or pleasure, can ever quite shake off the influence of the woman with whom he is most privately and intimately connected. Good or bad, she colours his life.
>
> The clever woman sits at home, and like a meadow spider spreads a pretty web of rose and gold, spangled with diamond dew. Flies – or men – tumble in by scores, and she holds them all prisoners at her pleasure with a silken strand as fine as a hair. Nature gave her at her birth the "right" to do this, and if she does it well, she will always have her web full. But her weaving must not be to hold the flies, i.e., to influence men, solely for her own amusement and satisfaction; she must learn to take a wider outlook and use her limitless powers for the benefit and betterment of the world.
>
> I love my own sex, and I heartily sympathise with every step that women take towards culture, freedom, advancement, and the moral and intellectual mastery of themselves. I would fain serve them in all that may be for their peace and perfect happiness, but I honestly feel that such peace and happiness are not to be gained by violent or unnatural methods. The object of woman's existence is not to war with man, or allow man to war with her, but simply to conquer him and hold him in subservience without so much as a threat or a blow. Clever women always do this; clever women have always done it. It is only stupid women who cannot command men.

Corelli, though, did not marry or have a relationship with a man so was never subjugated in quite the same way as her married

counterparts. Moreover, she appears to be representing women not as equals but as mistresses of manipulation.

Gladstone wrote during his final term as Prime Minister in 1892 that 'there is on the part of large numbers of women who have considered the matter for themselves, the most positive objection and strong disapprobation. Is it not clear to every unbiased mind that before forcing on them what they conceive to be a fundamental change in their whole social function, that is to say in their Providential calling, at least it should be ascertained that the womanly mind of the country is ... set upon securing it?'[8]

But why would any woman wish to oppose such a step towards equality? Part of the answer can be found in Mary Augusta Ward's 1889 *An Appeal Against Female Suffrage:*

> ... we believe that the emancipating process has now reached the limits fixed by the physical constitution of women, and by the fundamental difference which must always exist between their main occupations and those of men ... we maintain that the necessary and normal experience of women does not and can never provide them with such materials for sound judgement as are open to men ... We are convinced that the pursuit of mere outward equality with men is for women not only vain but demoralizing. It leads to a total misconception of women's true dignity and special mission. It tends to personal struggle and rivalry, where the only effort of both the great divisions of the human family should be to contribute the characteristic labour and the best gifts of each to the common stock.[9]

The reasons for these views are multifarious. Used to being in the home and family, which consumed all their attention and energy and sheltered them to a degree, it could have been felt that women had no interest or knowledge of world or imperial politics so they could therefore not be trusted to vote intelligently. Besides, involvement in politics and world matters would distract their attention from their real calling – the domestic sphere. The more involvement they had in party politics, the greater damage would be done to the institution of marriage and family. Heaven forbid, they may even make up their own minds and start to disagree with their husbands – where would that lead?

There was also the imperial question. It is true that British authority in India was personified by an empress, but the imperialist view was still geared against women having any decision-making powers over who was voted into office. Another consideration was that women were less 'evolved' in their thinking skills, so their vote could be manipulated by men – politicians and their husbands. And the simplest reason of all is that some women were not interested in politics at all, relishing and thriving in the supporting homemaker role.

But from the middle of Victoria's reign, educated women began to steadily unlock the doors to certain professional occupations. It was ironic that a society that insisted on intelligent women being kept in the house was also responsible for the powerful Victorian 'gospel of work' that detested idleness. As a result of this gradual and determined challenge, by the end of the Victorian age the UK had 212 female physicians, 140 dentists, six architects and three vets. The arts boasted 14,000 female professional painters and over 43,000 musicians.

These were the grandmothers and great-grandmothers of today's women. Nowadays, it is impossible for their female descendants to imagine a world without women's suffrage and it seems safe to say that the original suffragists would have been appreciative of the centenary procession.

But what of today? If the suffragists could see us now, I wonder what they would think? Women's rising political profile, increased economic opportunities and equality are to be celebrated but barriers still remain: the continued varying levels of harassment at the hands of men, leading to the #MeToo movement; the objectification of female bodies; and the patriarchal power that still dominates in politics and many workplaces. Women have come a long way since achieving suffrage but there is still more work to be done. The suffragist spirit not only grew out of the discontent of many Victorian women but inspired campaigns for progress against racism, homophobia, bullying and sexist attitudes. A hundred years since British women first stood for Parliament, still less than a third of Westminster MPs are women. With the hindsight of a hundred years, today's women's movement can be seen to have its beginnings in the Victorian era.

The original suffragists provide the motivation behind present-day women's human rights defenders who, like the original women, work to empower and create a fairer world for all.

I

THE CULTURE OF DOMESTICITY

The culture of domesticity is the cornerstone of Victorian women's lives and its philosophy is inextricably linked to the ideology of 'separate spheres' enshrined in the predominant set of beliefs relating to nineteenth-century gender roles. Whereas the male domain was business, politics and industry, women were expected to focus on cultivating and maintaining a supportive, warm and virtuous home environment. Whilst the husband was the head of the household, the wife was at its centre.

Despite the philosophy of private and public spheres, the changes in society brought about by the end of the Industrial Revolution and the emergence of different professional occupations could quite conceivably have influenced a Victorian woman to feel her social role to be somewhat unclear and ambiguous. Women were generally thought to be inferior to men, but the Industrial Revolution cemented the power of the middle class and as these men took up their places in professions and business, their women were expected to support them. Female responsibility for education, childrearing, domesticity and morality came into being as never before.

These values were reinforced in many of the popular writings of the time: household management books, magazines and sermons. *The Englishwoman's Domestic Magazine*, *Lady's Treasury* and *The English Woman's Journal* contained articles on fashion, society, menus, running a home and pastimes such as needlework and embroidery along with short stories.

However, this philosophy could only ever be an ideal as it was impossible to represent the whole of society. Although the vast majority of women married, not all of them did. Widows and single women were outside the realms of patronage and often had no choice but to work. The middle and upper classes created and reinforced the perceived ideal, yet middle- and upper-class married women did undertake philanthropic and women's movement activities. Women were even in charge of businesses. But law and custom still enforced female dependency. And many women did choose to live their lives according to these ideals. So, who was the ideal woman, according to the Culture of Domesticity? Queen Victoria was promoted as a True Woman and a role model for women everywhere. Reverend John Rusk wrote that

> ... the world esteems lofty womanhood more than regal power, and personal virtue more than political influence. And no Queen in modern or in ancient days better deserved such a tribute. In her influence upon manners and morals she held world-wide sway over the hearts of men and women. Her purity and integrity of character commended her to her subjects and they acknowledged the force of these traits and manifested their appreciation by such an outpouring of sympathy as no other English sovereign ever received. In devotion to her domestic duties, in the bringing up of her family, in the enforcement of morality without prudery, in devotion to religion without bigotry, in personal courtesy to every-one, in simplicity of tastes, habits and dress, in all gentle dignity and sweet graciousness, the influence of her character was greater than the influence of her position. She set an example to all women of exalted, useful, Christian womanhood which is a grander record than that of queenly power or royal state.[10]

While this extract formed part of a retrospective on the life of Queen Victoria following her death, Victoria gave us her self-view in October 1844: 'They say no sovereign was more loved than I am (I am bold enough to say), and that, from our happy domestic home – which gives such good example.'[11]

And the Americans held her up as an example too, as this article in the *Christian Parlor* magazine from the same year shows:

The example of the Queen is a beautiful and forcible recommendation of the superior character of domestic enjoyment to any other of a temporal nature. With the whole range of worldly pleasures before her, she enters the little circle of home, and finds her happiness there. Her children and her husband are worth more to her than crown and kingdom and regal pomp.[12]

Although votes for women were finally realised in the twentieth century, it was during the reign of Victoria that the women's movement had its active beginnings and slow and steady progress, albeit without any patronage from the queen herself. Famously, Victoria wrote in 1870: 'Let women be what God intended, a helpmate for man, but with totally different duties and vocations.'[13]

Victoria was the most visible female political figure in the land but instead of endorsing the progress of women's equality she consistently and publicly reinforced the ideal of the Victorian woman's place in the home as celebrated by Coventry Patmore in the 1854 poem *The Angel in the House* and Henry Rowley Bishop's 'Home! Sweet Home!'. Natalie MacKnight has this to say:

Second only to the Virgin Mother in her influence on Victorian expectations of motherhood was Queen Victoria. As a mother of nine, and as the sovereign of England, she became an emblem of the ideal mother – fertile; patient; long-suffering in her labours; devoted to her husband, children, and country; and very traditional in her public attitudes about the role of men and women.[14]

Predominant Value Systems and Ideals of Womanhood

An upper-class woman's purpose in life – to marry, have children and raise them in an appropriate and respectful manner – was expected to be aspired to and to form the source of total fulfilment for women. After all, Victoria idolised her husband and was devoted to her family, providing the perfect role model. Even in widowhood, she was visibly modest, remaining loyal to Albert's memory. Social scientist Herbert Spencer thus radically changed his earlier sympathetic stance on feminism and argued the highest calling for a woman in society was as a wife and mother. Authors of the day called those who embodied this value system of piety, purity, domesticity and submissiveness 'True Women'.

The Reverend Charles Kingsley gave a series of what he called 'Lectures to Ladies' in 1855; in 'Women's Work in a Country Parish', he expounds the idea that women should focus on their own family before all else. He displays the prevalent attitude towards domesticity and family: 'I will suppose, then, that you are fulfilling home duties in self-restraint, and love, and in the fear of God.'

As well as managing large households, wives in country houses were expected to play the role of 'Lady Bountiful' in the wider community, rather like Lady Lufton in Anthony Trollope's *Framley Parsonage*, who 'desired ... that all the old women should have warm flannel petticoats, that the working men should be saved from rheumatism by healthy food and dry houses'.[15] Even Tennyson's 1847 poem *The Princess* expounds the values of the time:

Man for the field and she for the hearth:
Man for the sword and for the needle she:
Man with the head and woman with the heart:
Man to command and woman to obey:
All else confusion.[16]

The Victorian home was meant to offer a refuge for the husband from the world of business and politics and the city with all its evils – vice, drink, crime. He could close the door on all that noise, all that reality, and be secure.

Additionally, owning a house in a respectable area indicated that a man had worked hard and provided for his family. This was reflected in Victorian art where the majority of paintings showed the Victorian family 'as it should be'. As for the home – the father paid for it, the children played in it, and the wife and mother, the Angel in the House, held it all together.

Many aspects of paintings in the later nineteenth century differed from earlier British artwork as they commented on Victorian life and society. Artists liked to dispense moral medicine with stark warnings of what could happen when things went wrong, such as inappropriate relationships. Victorian artists showed courtship as a risky business. Temptations of the flesh were everywhere and betrayal, why, that could be just behind the garden fence! Many artists' works carried a clear moral message: the sooner couples married, settled and had a family, the better.

Abraham Solomon repainted his work *First Class – The Meeting: And at First Meeting Loved* following unfavourable reviews. A young

woman had been depicted as holding a conversation with a man on a train in a much too familiar fashion whilst her father, her 'authority figure', was sleeping in the corner. The painting was criticised by both *Punch* and the *Art Journal* for being suggestive and inappropriate. To make it morally acceptable, the second version positioned the girl in the far corner as an onlooker whilst the young man carries on an animated conversation with her father.

Osborne House, Victoria and Albert's Isle of Wight home, was held up as the royal model for the perfect family house. Away from the noise and bustle of the city, Victoria could retreat from politics and her role as queen for a while. Franz Winterhalter's 1846 painting *The Royal Family* was painted at Osborne. The older girls, Vicky and Alice, are shown gazing at new baby Helena as if they were preparing for the day they would be wives and mothers themselves. Victoria and Albert were united in their wish to create a family that would serve as a role model for the nation. Over a period of seventeen years, Victoria was almost constantly pregnant and many portraits of her show her as a dutiful wife and mother.

Kim Reynolds wrote that 'the central concerns of aristocratic life' remained 'the enhancement of family prestige, influence, and economic strength; the maintenance of a hierarchical, paternalist society; the exercise of patronage; and the government of the country'.[17] Female dependence was therefore often considered to be social progress. Women were expected to uphold the values of stability, morality, and democracy by making the home a refuge where her husband could escape from the highly competitive, unstable, immoral world of business and industry and where children could be raised to carry on the moral values of the era. But there was a shadow side to this patriarchal society and a gap between the ideals and the actual behaviour.

The newly fashionable area of Kensington was where Edward Linley Sambourne and his wife Marian settled – a proper, upper-middle-class couple. No. 18 Stafford Terrace looked like the perfect respectable 1870s household. Linley was a cartoonist for *Punch* magazine; Marian was the ideal full-time housewife and mother, putting her heart and soul into the house and ordering the household from the morning room whilst writing letters, doing the accounts and planning the menus, probably with reference to Mrs Beeton's *Book of Household Management*. Pictures hanging on the walls showed how to run the perfect house. The man was the head of the family and the moral guardian of the

home. The woman was the provider of love, comfort and a figure of purity and goodness. Marian Sambourne embodied the Angel in the House, but her husband was definitely lower than the angels. He was a talented cartoonist, but was not so competent at drawing the human form, and so he took up photography and used photographs as a guide to drawing people. The perfect excuse, then, for this moral guardian of the home to use his bathroom as a darkroom, smuggle in female models when his wife was out and take nude photographs of them. Keeping up appearances was what it was all about, but the darker side was kept hidden and painted like one of the works of art commissioned to show that the family was part of the Victorian ideal.

In his painting *Many Happy Returns of the Day*, William Powell Frith presented himself as a perfect patriarch and his family as the true picture of Victorian virtue and happiness. Pictures such as this proclaimed that life was wonderful in the Victorian home. Critics applauded its moral tone which was replicated up and down the land, reminding families of what to aspire to. But every picture tells a story, and this one told a pack of lies. Whilst William lived in the agreeable middle-class enclave of Bayswater, along with his wife Isabelle and their twelve children, he was also leading a double life in Paddington with Mary Alford and their seven children. He got away with this for many years until one day Isabelle saw him posting a letter in London when he was ostensibly in Brighton. What a contrast to the moral message proclaimed through his paintings!

Even Isabella Beeton fell victim to syphilis, and Thomas Hardy had plenty to say about the Victorian double standards that were the probable cause. It is likely that she contracted the disease on honeymoon; Samuel Beeton was a regular user of prostitutes and sexually transmitted diseases were often covered up with other explanations. Isabella had many of the symptoms, including suffering several miscarriages. Hardy's poem 'The Ruined Maid' is a satirical attack on society's hypocritical view that women who lost their virginity before marriage were 'ruined' or 'damaged goods' and gave women no choice and men free rein.

Queen Victoria and Prince Albert were extolled as representing the perfect family that everyone should aspire to, yet the law ignored prostitution, which was excused by medical experts who provided scientific opinions to demonstrate that whereas men had strong sexual drives 'normal women' did not.[18]

The image of the fallen woman, the fallen angel, showed the woman as the victim of an unjust system that saw a man go unpunished while she would have been cast out of society for behaving in the same manner as Samuel Beeton and William Frith. Augustus Leopold Egg's painting *Past and Present* depicts the unfaithful wife not only prostrate with grief in the present, but the family home collapsed like a deck of cards and the children of the marriage doomed to destitution and tragic futures as penniless spinsters because their mother's disgrace marked them as unsuitable marriage material. Yet Edward Sambourne got away with his actions. The 'Home Sweet Home' shown in paintings could indeed be hell on earth. So, women were expected to look up to and obey their husbands, many of whom were living double lives with impunity, tolerated by society.

Paintings showed women bound by law and convention, religious teachings and the clothes she wore. The delicate, feminine, perfect Victorian woman was restricted by excruciating corsets and crinolines underneath her dresses – giving rise to the tight-laced versus loose woman image which the Dress Reform Movement of the later part of the century intended to change. *The Rational Dress Society Gazette* wrote in 1888 that 'succeeding generations [will] look back with contempt and wonder at the ignorance and obstinacy of their ancestors'.

Women began to fight against divorce laws that saw them lose their house, children and money, and took Caroline Norton's early campaigning work over child custody and the conditions of divorce further. They challenged conventions that kept them in the house and the prejudice that education was only for men. Universities became open to women and with the admission of a few middle-class women the door that had been locking them in the house began to open a crack. Victoria wrote in her diary: 'All marriage is such a lottery – the happiness is always an exchange – though it may be a very happy one – still the poor woman is bodily and morally the husband's slave. That always sticks in my throat. When I think of a merry, happy, free young girl and look at the ailing, aching state a young wife generally is doomed to – which you can't deny is the penalty of marriage.'[19]

The husband wasn't always the faithful provider, and the wife was not always the contented homemaker. The only law Victoria seemed to support in this matter was the Married Women's Property Act, which saw that women did not lose the right to their own property when they got married. In other words they could divorce without

fear of poverty, even though divorce was very rare even in the late nineteenth century. Society condemned women if they cheated on their husbands but turned a blind eye if their husbands did the same.

The Influence of Queen Victoria

Dualism was present in a number of ways in the Victorian era, including within the role of Victoria herself. As a head of state, a married woman and a mother, she would have to navigate situations that called for political leadership while embodying the characteristics of the ideal Victorian woman at the same time. In doing so, she influenced contemporary women. Victoria appeared on the 1851 census as the wife of the head of the household and gave her occupation as 'Queen', indicating her conformity to the accepted views towards women whilst asserting her queenly role and responsibility to her nation.

In trying to reconcile her dual roles, Victoria asked in 1856 why 'the wife of a King has the highest rank and dignity in the realm after her husband assigned to her by law [whilst] the husband of a Queen regnant is entirely ignored by the law ... This is the more extraordinary, as a husband has in this country such particular rights and such great power over his wife, and as the Queen is married just as any other woman is, and swears to obey her lord and master ... this is a strange anomaly.'[20]

Millicent Garrett Fawcett, president of the National Union of Women's Suffrage Societies, observed that it was exactly the possession of feminine characteristics that enabled Victoria to combine the role of a mother and a ruler to such great effect, proving at the highest level that a career was not incompatible with motherhood and furthermore had no negative impact on femininity.

Indeed, this view had been articulated at the start of Victoria's reign when Sarah Stickney Ellis, an author who commented on the role of women in society, wrote in 1839 of 'those noble-minded women who *are* able to carry forward, with exemplary patience and perseverance, the public offices of benevolence, without sacrificing their home duties, and who thus prove to the world, that the perfection of female character is a combination of private and public virtue'.[21]

How far-reaching this influence really was is examined in the months leading up to Victoria's Diamond Jubilee, when columnist Lily Bell wrote:

We are entering upon the sixtieth year of our Queen Victoria's reign, and all sorts of projects are on foot for its fit and proper celebration. Curiously enough, none of these schemes which are at present being aired in our public newspapers, seem to take into consideration the fact that our Queen is a woman ... one would naturally think that the most appropriate form which could be given to what is, virtually, national testimony to the fitness of ... one woman to occupy the position she has held over us for so many years, would be a public recognition of the fitness of her sex to share in the government of the country.[22]

The frustration was evident that, after sixty years of being ruled by a female, the vote was still denied to contemporary women.

It seems clear then that without being a feminist herself, Victoria did have a substantial impact on the views and writings of many prevalent feminists and authors through the way she lived her life and, through their writings, on the contemporary woman in society.

Exploring the Four Ideals

Charlotte Brontë observed that men were meant to 'do', and women were supposed to 'be',[23] reflecting the androcentric values that were publicly presented. The dualistic vision of the idealised Victorian woman embodied four main virtues: piety, purity, submissiveness and domesticity. Possession of all of these meant she was equipped to support her husband, raise excellent children, and protect the morals of nineteenth-century Britain. As such, this True Woman was presented as an example that both women and men could and should admire and respect, and Queen Victoria was portrayed as the epitome of the True Woman. Yet, as we shall see, even Victoria thought pregnancy and childbirth was the 'shadow side' of marriage and recorded her views of small babies: 'Abstractedly, I have no tender for them till they have become a little human; an ugly baby is a very nasty object – and the prettiest is frightful when undressed.'[24] Several pregnancies meant that Albert had to take over more of her responsibilities. The 'perfect True Woman' Victoria was in reality somewhat vexed at having to relinquish control.

Piety was thought of as the greatest virtue a woman could possess; if she had this, all else would fall into place. Participation in church work was thought to develop all the other qualities that a True Woman

was expected to personify, and moreover would not interfere with her true calling, unlike intellectual pursuits which were a distraction and a 'menace'.

If a woman did not preserve her purity until her wedding night, she was thought of as immodest, damaged goods, unnatural and unfeminine. Her virtue was priceless, the greatest gift she could give to her husband, following which she ceded complete control to him including her legal existence. The perceived high value of virtue and the consequences of its loss were used to keep women under control and avoid them making any changes; such things as the Dress Reform Movement, for example, were proclaimed as inappropriate as it would be an attack on a woman's virtue. Victorian marriage was 'the fountainhead from which must flow the future population' and the template for 'the moral nature of the people of the future':[25]

> Like the useful bee, [marriage] builds a house and gathers sweetness from every flower, and labours and unites into societies and republics, and sends out colonies, and obeys kings, and keeps order, and exercises many virtues, and promotes the interests of mankind.[26]

But that, of course, depended on female submission, virtue and piety. Celibacy was only expected outside marriage, because marriage perpetuated the human race, the British Empire as it was, and the social order. The family embellished the status of men, and was supported by the submission of their wives.

Submission was considered to be the most feminine quality a woman could hold, which the truly pious woman was expected to embody as ordained by God in his creation of Adam before Eve. Any attempt to subvert this was thought contrary to the order of God's universe. The teachings of the apostle Paul were used to exert pressure under the guise of maintaining the virtue of piety, with the claim that Paul – despite being a lifelong bachelor – knew what was best for women. Feminine emotions were meant to be kept under control and women were meant to be kept safely in the domestic sphere lest they fall prey to the evils and iniquities of the public sphere. This division between the spheres was meant to reflect nature, where women were supposedly more nurturing but less forceful and intelligent than men.

Victorian women were conditioned to believe that marriage improved their character and social standing, and motherhood even more so; led to understand that if they chose to create their reality from sources other than male authority figures, the church or domestic women's magazines they would bear responsibility for damage to the fabric of society by their collective disobedience. It can be argued that this paradigm was not only bitterly ironic but contradictory to progress, impeding the intellectual and moral development of society. How could the difference between men and women or a woman's abilities and attributes be fairly evaluated if she was unable to demonstrate her capabilities? Only by a change in laws and attitudes would women be free to compete on a level playing field, allowing the differences between men and women to naturally become apparent.

And what about those women who rejected the social expectations of the Victorian era and challenged these gender norms? Those who did not want to be a mere ornament in society? A piece in *The Times* in 1868 captured perfectly the challenges faced by these women:

No woman has yet pretended to be on a level with men in physical strength. The fact is that physical strength has a good deal to do with politics in innumerable ways, and, for that reason alone, women are not capable of holding their own in the rough contests of the world. If they attempted to do it, they would sacrifice that delicacy, that gentleness, that submission that are now their most potent charms. They have at present the privileges and the protection of the weak. Let them undertake to defend themselves, and they must be content with the bare rights they can enforce. Instead of gaining any additional rights, they would risk some of the rights they possess; and they would inevitably lose the peculiar influence which is now derived from their very subordination.[27]

As we shall see, the transformation of Britain into a leading industrial nation irrevocably influenced the Victorian perception of the ideal woman and at the same time presaged change from within as women began to disagree with their apportioned role.

EXPECTATIONS AND LIMITATIONS

Setting the Scene

Teach young women from their childhood upwards that marriage is their single career, and it is inevitable that they should look upon every hour which is not spent in promoting this sublime end and aim as so much subtracted from life. Penetrated with unwholesome excitement in one part of their existence, they are penetrated with killing ennui in the next. If mothers would only add to their account of marriage as the end of a woman's existence – which may be right or it may not – a definition of marriage as an association with a reasonable and reflective being, they would speedily effect a revolution in the present miserable system.

As it is, the universe to her is only a collection of rich bachelors in search of wives, and of odious rivals who are contending with her for one or more of these two wary prizes. She thinks of nothing except her private affairs. She is indifferent to politics, to literature – in a word, to anything that requires thought. She reads novels of a kind, because novels are all about love, and love had once something to do with marriage, her own peculiar and absorbing business. Beyond this her mind does not stir.

Saturday Review, 1867

According to this editorial, it seemed that whilst Victorian men were expected to live a public life in their clubs and meetings in the public

sphere, women were meant to be focused on finding a husband, whereupon they would be completely domesticated and obedient in their private sphere. And women were not allowed to vote – with the exception of limited participation in local municipal council elections, which was eventually afforded to female ratepayers by the 1869 Municipal Franchise Act. Championed by Jacob Bright, the Manchester Liberal MP, this landmark reform to thirty-four-year-old legislation was remarkable in that it included the clause:

> ... wherever words occur which import the masculine gender the same shall be held to include females for all purposes connected with and having reference to the right to vote in the election of councillors, auditors, and assessors.[28]

Fine words indeed, and a significant step forward. Bright was adamant that he viewed this clause as 'a restoration of long-established rights', seeing it less as an advance than a return to the norm which prevailed just five years before Victoria came to the throne. For, before the Representation of the People Act 1832 – also known as the Reform Act – women were indeed able to vote in elections. Up to that time there were occasional, although rare, instances of women voting if they qualified through their property holding. Single property-holding women would nonetheless have their property transferred to their husband under the rule of coverture if they married, meaning the only female householders in their own right would be spinsters or widows. Even they now found this right taken away.

The Industrial Revolution had brought about the rise of the industrial middle classes and with it a desire and pressure for change, but the political system still reflected the social structure of the times. It is noteworthy that the demand for reform was supported by both the middle and working classes as epitomised by Thomas Attwood's Birmingham Political Union. At their first meeting on 25 January 1830 he stated that the House of Commons

> ... in its present state, is evidently too far removed in habits, wealth and station, from the wants and interests of the lower and middle classes of the people ... The great agricultural interests of all kinds are well represented there. The landed interest, the church, the law, the monied interest – all these have engrossed, as

it were, the House of Commons into their own hands ... But the interests of industry and of trade have scarcely any representatives at all! These, the most vital interests of the nation, the sources of all of its strength, are comparatively unrepresented.[29]

These Birmingham Political Union activists played a key role in the electoral reform movement with a series of pressure group meetings. Even though the 1831 bill was thrown out several times, eventually Whig leaders came to realise that limited reform was necessary. The economic power of the middle class was on the rise, so what reason was there to continue to refuse them a concurrent share in political power? Actually none, so long as they were male.

Harriet, Duchess of Sutherland was undecided as to whether she supported the bill. Whilst she sympathised with the Whig notion of reform in principle, she thought it unsafe to give 'the people' any more of a voice than they already had. 'I admire the plan more than I can express, but I fear the results and certainly do not think these are times in which the voice of the people ought to be more heard.'[30]

Yet she did go to watch the debates in the House of Lords, retiring with other ladies to drink tea. Like most women of her status, Harriet identified with her class, rather than her gender. If she had reservations about extending the franchise to the upper middle class, she would have been even less ready to support its extension to women. In this respect, she conformed to the nineteenth-century prejudice that held politics to be a male domain.

The first ever petition from a woman, Mary Smith, was presented to the House of Commons in August 1832. The petition for the right of women to the vote was presented on her behalf by Henry Hunt MP:

Mr Hunt said, he had a petition to present which might be a subject of mirth to some hon. Gentlemen, but which was one deserving of consideration. It came from a lady of rank and fortune – Mary Smith, of Stanmore, in the county of York. The petitioner stated that she paid taxes, and therefore did not see why she should not have a share in the election of a Representative; she also stated that women were liable to all the punishments of the law, not excepting death, and ought to have a voice in the making of them; but so far from this, even upon their trials, both judges and jurors were all of the opposite sex. She could see no good reason for the exclusion

of women from social rights, while the highest office of the State, that of the Crown, was open to the inheritance of females, and, as we understood, the petition expressed her indignation against those vile wretches who would not marry, and yet would exclude females from a share in legislation. The prayer of the petition was, that every unmarried female, possessing the necessary pecuniary qualification, should be entitled to vote for Members of Parliament.[31]

After brief consideration, however, it was dismissed by Sir Frederick Trench: 'It would be rather awkward if a jury half males and half females were locked up together for a night ... this might lead to rather queer predicaments.'[32]

Although when it became law on 7 June 1832, the Reform Act extended the breadth and scope of franchise holders, it clearly failed as a force for true democracy in government – although it could be thought of as the start of the democratic process. Around one million people were now eligible to vote, but they had to be male. The 1832 Act resulted in the formal exclusion of women from voting in parliamentary elections, as a voter was now defined by the Act as a man. Voting rights, whilst still based on property ownership, were restricted to 'male persons'; Trevelyan wrote that '[the] "sovereignty of the people" had been established in fact, if not in law'.[33]

Furthermore, one of the main aims of the Reform Act had been to achieve democracy by putting an end to corruption in rotten boroughs and addressing the imbalance of the franchise as it applied to the aristocracy and the middle class; only those who owned property worth £10 or over were able to vote, which generally excluded the working class.

But from the 1850s the shift began, with women organising regional chapters of national groups to lobby for the female franchise. Barbara Leigh Smith Bodichon, Jessie Boucherett and Helen Taylor of the Women's Suffrage Petition Committee had their 1866 petition, boasting more than 1,500 signatures, presented to the House of Commons by Liberal MP John Stuart Mill. Their demands included that all householders be afforded the franchise 'without distinction of sex'.

The 1867 parliamentary debate attempted to change the word 'man' in the Second Reform Bill to 'person' but was unsuccessful; nevertheless it did not stop petitioning and private members' bills on female suffrage being presented to the Commons almost annually up to the end of the Victorian era and beyond.

But the vote was only part of the picture. Evidence shows that women did participate in local elections; whilst female ratepayers were entitled to do so, there were others who did so by subterfuge and ingenuity. Josephine Butler's seventeen-year campaign to repeal the Contagious Diseases Act, reform divorce and child custody laws, and change the property holding rights of married women all achieved some measures of success.

In March 1865 Charlotte Manning had formed the women's discussion and debating group the Kensington Society with ten other educated middle-class women. Only two of them were married. In 1867, 300 women members of the Kensington Society presented a petition requesting that married women's property laws be reformed. The society disbanded in late 1867, mainly due to differences in party allegiances, but they succeeded in persuading Jacob Bright to introduce the Married Women's Property Bill to Parliament.

Meanwhile, in 1867 the franchise was made available to male householders – not necessarily owners – who met certain financial requirements. This Second Reform Act effectively extended the vote to male members of the skilled working classes and resulted in around 30 per cent of men being enfranchised. But still no women. Should there be? Perhaps the answer lies in new research by Carry van Lieshout of the Cambridge Group for the History of Population and Social Structure. The British Business Census of Entrepreneurs, created at the University of Cambridge as part of the project Drivers of Entrepreneurship under Professor Robert Bennett, reveals a remarkable statistic: women owned between 27 and 30 per cent of all British businesses between 1851 and 1911.

While many Victorian manufacturing businesses run by women were related to the textile industry, there were also many women running more traditionally male-oriented businesses, such as Eliza Tinsley. In 1871 she was the owner of Eliza Tinsley & Co., a nail and chain manufacturing firm in Dudley, Staffordshire, employing 4,000 people and which is still a successful business today.

Similarly, back in 1849 the owner of William Whiteley's scissor manufacturers in Sheffield died and his widow, Elizabeth, took over the running of the firm. She was a highly enterprising character and set about turning Whiteley's into a force to be reckoned with. She travelled around Ireland and built a good market for scissors there. She smoked a clay pipe, wore clogs and ran Whiteley's successfully

for twenty years, including overseeing scissor-making for the Great Exhibition of 1851, which was organised by Prince Albert to bring together all products from Britain and the Empire. Clear evidence therefore exists to show that businesswomen were present in most towns and cities in the nineteenth century and moreover were active as investors and business owners.

This challenges the traditional view of the Victorian entrepreneur as male, and shows that after they got married, women were more likely than men to set up their own business. In Victorian Britain, clothing manufacturing and personal services were the sectors with more female proprietors. While generally similar proportions of economically active single men and women ran their own businesses, after marriage, women were more likely than men to be business proprietors. Additionally, trade directories and advertisements show that women operated outside the strictly 'feminine' trades of sewing, cooking and domesticity, giving rise to a need to view urban society in the nineteenth century more broadly and inclusively:

> Business? Really the word makes me conscious I am indeed no longer a girl but quite a woman, and something more ... I hold a man's position: it is enough to inspire me with a touch of manhood.[34]

Of note is that between 3 and 5 per cent of all mid-century female business owners were grocers. Furthermore, van Lieshout's research shows that not only were female grocery proprietors much more likely to be married but that their husbands were often farmers or were in other occupations related to food production or distribution. Research by Jennifer Aston[35] shows that we can confidently theorise that approximately 6 per cent of business owners at the turn of the century were female and that the majority of women, at least in Birmingham and Leeds, entered the business world after the death of a husband or father; therefore by accident of circumstance rather than choice.

Before the Married Women's Property Act women had been subject to coverture, which meant that married women had no independent legal status and therefore could neither sue nor be sued. Female traders possibly used this as a loophole to their advantage, ostensibly trading separately from their husband yet relying on his involvement to secure credit and then pleading coverture when their business

suffered financial difficulties. This was a useful strategy to give them greater protection under the law than would be available to a single woman or a male business owner.

A few upper-class women benefited from changing economic dynamics by assuming responsibilities previously held solely by men. But the very fact there was scant opportunity for married women to work in the professions was a driver for female entrepreneurship; nonetheless, when it came to the political issues that affected their business these company owners were paradoxically prevented from expressing their views or contributing to decisions, just as they were for matters concerning the society and community in which they operated. But there are always exceptions.

A box of old solicitors' papers found in Lichfield Record Office in 2013 held a surprise. A set of twelve handwritten sheets, dating from 19 May 1843, listed voters for a parish election. The Assistant Overseer of the Poor had set out six columns with names of voters, their addresses, the annual rental value of their property if it was let out and how they voted on the question of who should be the new assistant overseer. In all, 371 people voted for the Tory and Liberal candidates; of this number, thirty were women.

The 1835 Municipal Corporation Act had defined a voter as a male person but locally the system was chaotic and women in theory had the right to vote. Before the Lichfield discovery there had been a lack of evidence for them doing so, but now we have proof of elections where unmarried women did manage to cast a vote. We see that they voted in workhouse guardian and town commission elections, giving a useful corrective to the assumption that women could never cast a ballot. Clearly, there were a few areas where women could sneak in.

Although the Lichfield election was not parliamentary, the voters had real power in terms of how their decision affected life on the doorstep. Local officers had incredible power of discretion on such concerns as who qualified for and received poor relief. All these issues were mediated and decided by overseers, so in casting their vote these women were actually bestowing authority on very powerful local officials.

Women lost their right to hold property when they married, but the 1841 Lichfield census reveals that several of the women who voted in 1843 were married (although some may have been widowed by the time of the election). One was listed as a pauper, aged seventy-five, yet she still voted in the parish election. Caroline Edge, washerwoman and

widow, aged thirty-five with six children, and Sarah Payne, servant, aged thirty-five, both voted even though it would not have been expected that a servant had this right. Elizabeth Smith, aged sixty-five, described as a pauper, also voted. This is the first direct evidence of women going to the polls, but finding paupers and a servant on the register is completely unexpected and defies the official narrative about female voting rights. Lichfield relied heavily on outdoor relief, which should have effectively barred these women from voting. As there was no secret ballot, it was possible that someone else paid their rates and they were instructed how to vote.

The fact women could and did exercise their vote at a parish level in the 1840s was unfamiliar to suffragists at the time. If further examples emerged – as technically, single rate-paying women could vote – this could have transformed the debate on Victorian female citizenship. The suffragists would have been absolutely delighted to have breached that 1832/5 hurdle and strengthened their argument; in the 1880s and 1890s, women organising suffrage societies used historical figures such as Hilda of Whitby to prove that women had enjoyed electoral rights in the past and that these had been gradually withdrawn.

In Manchester, Mrs Lily Maxwell ran a chandler's shop and therefore had to pay her rates to the local council. All male ratepayers' names appeared on the Chorlton registered list of voters and, through a clerical error, so did Lily's. The overseers – presumably men – who compiled the lists apparently had not realised that 'Lily Maxwell' was a woman. The shop and house which she rented at 25 Ludlow Street were of sufficient value to qualify their occupier under the pre-1867 borough franchise (the £10 household franchise). Although the Second Reform Act had received the royal assent on 15 August 1867, it specified that any by-elections held before 1 January 1869 would take place under the old conditions. And the very fact of Lily's inclusion on the electoral roll, mistake or not, entitled her to vote.

Lily took advantage of all of this to vote in the local parliamentary by-election in November 1867 and was 'escorted to the polling booth by a bodyguard of Liberal supporters, to protect her from loutish behaviour by opponents of women's voting rights. Her actions caused uproar at the time … Discounting fears for her safety she declared her preference [for Jacob Bright] at the polling booth and the crowd broke into ringing cheers.'[36] Although Lily's vote had to be accepted

because of the fact she appeared on the electoral roll, it was later ruled as illegal. Nevertheless, she had become the first woman in the UK to cast her vote. *The Yorkshire Post* reported that 'a woman actually voted!' The newspaper also implied that the polling clerk should have ignored Lily Maxwell's claim when she turned up to vote, 'as he would have ignored that of a child ten years old'; a stark observation of the predominant views on women at the time. The following year, Lady Scarisbrick, along with twenty-seven female tenant farmers in South West Lancashire, also appeared on the register and they went to the polling booth *en masse* to cast their votes for Gladstone in 1868.

Among Lily Maxwell's bodyguard had been one Lydia Becker. An interesting character who held ambitions for more than just the vote, Becker had a much wider goal of complete gender equality. *The Englishwoman's Review* offered that 'it is sometimes said that women, especially those of the working class, have no political opinion at all. Yet this woman, who by chance was furnished with a vote, professed strong opinions and was delighted to have a chance of expressing them.'[37] Becker later presented an application to Richard Pankhurst and Sir John Coleridge from more than 5,000 female heads of households who thought that qualified women should appear on the electoral register. The claim that the 1867 Act enfranchised women was heard at the Court of Common Pleas in late 1868, but it was thrown out on the grounds that Parliament's clear intention was to debar women from the parliamentary vote. Women's suffrage was now illegal.

But even after the 1869 Municipal Franchise Act, married women were excluded from voting whether or not they were ratepayers. Lord Cairns highlighted, probably by accident rather than design, the difference between single and married women even in the context of this reform. A single woman could own and deal with her property in any way to suit herself. It was therefore unreasonable to prevent her having 'a voice in saying how it should be lighted and watched, and generally in controlling the municipal expenditure to which [her] property contributed'.[38] Thus a single woman or a widow could exercise her right to vote; as a widow Eliza Tinsley would be enfranchised, but our married female grocers would be forbidden to vote in their own local elections.

At the end of 1871, two married women from Sunderland disagreed with this decision with such zeal that they were willing to break the law. They turned out to vote in an election, but a legal decision the

next year sustained the principle of coverture. A married woman could own a business but she would still be a *femme covert* and disqualified from the franchise because of that status. The 1872 court case found that 'a married woman is not a person in the eye of the law. She is not *sui juris*'[39] – meaning she was under the control of another, in the same way as a child or a mentally incapable person may be. So long as she was a partner in a marriage contract she lacked any separate legal existence. Furthermore, if that marriage broke down, she would lose access to all the social networks, resources, labour and capital which may have helped her set up her business in the first place.

The thoughts of George Nathaniel Curzon, future Viceroy of India, were typical. He believed that the purpose of a woman was merely to be an ornamental accessory to her husband, not an individual in her own right. As a student at Oxford in the early 1880s he filled the office of president of the Oxford Union Society, in which capacity he gave a speech aimed at keeping undergraduates from the two new women's colleges out of the Union library. Curzon failed in this endeavour: the proposal to allow women Union library membership was carried by 254 votes to 238.

In Manchester, Matthew Curtis was elected as mayor in November 1886 and his wife, Charlotte, became lady mayoress. As such she was part of the reception committee which greeted the Prince and Princess of Wales on their visit to Manchester for Victoria's Golden Jubilee. Charlotte Curtis organised and managed several such events but notwithstanding her role, she still found her life and opportunities restricted by law and convention.

Two years before George Curzon married in 1895, he wrote to his fiancée, Mary Leiter, telling her that the House of Commons terrace pavilion was so crowded with females that it resembled the Royal Enclosure at Ascot and expressed his intransigent indignation at the fact. 'Give me a girl that knows her place and does not yearn for trousers,' he wrote. 'Give me, in fact, Mary.'[40] Mary had no choice but to know, and accept, her place irrespective of the vast wealth she brought to the union, which Curzon initially wished to appropriate to save his estate.

Not all women, however, wanted to vote. Annie Booler, born in Sheffield in 1866 and who would become the mother of Malcolm Muggeridge, was implacably opposed to female suffrage. She didn't want the vote herself 'at any price', considering that voting was akin

to smoking or bicycling in bloomers and 'demeaned her sex'.[41] Even Beatrice Webb, keen as she was to see change in social structures to the benefit of women during the 1890s, was no supporter of female suffrage. It could be argued she did not experience the same kind of subordination, married as she was to Sidney Webb, which allowed her to 'never suffer[ed] the disabilities assumed to arise from [her] sex'.[42] Marriage afforded her this political and social visibility, which she would not have enjoyed had she continued her earlier relationship with Joseph Chamberlain, opposed as he was to the women's movement. Sidney Webb treated her as an equal, and this gave her the freedom of choice.

The Victorian age was coming to a conclusion. Although some progress had been made through legislation, it seemed that little had changed with regard to how women were thought about. They were still generally looked upon as inferior and were expected to not only know their place in society but accept it unquestioningly.

This was the context for the married woman's role throughout Victorian society – whether she belonged to the upper, middle or working class – as 'by the common law, a married woman's status was so entirely merged in that of her husband that she was incapable of exercising almost all public functions'.[43] Through the veil of coverture, married women faced problems of continued subordination that their single counterparts did not experience to the same extent.

Separate Spheres: Work and Politics

The philosophy of separate spheres assumes that the inherently discrete natures of men and women can be distilled into a dualistic framework explained by biology. It was further supposed that, along with being unsuited to the public sphere, women simply did not want to be involved in it, and that whereas men were deserving of a space in the public sphere women must be protected from it. The Victorian marriage ceremony upheld this notion by barring married women from owning property of their own or existing as separate legal subjects. This relied upon the association of men and women with a highly specific separate set of characteristics.

The Laws Respecting Women, published in 1777, said that '[by] marriage the very being or legal existence of a woman is suspended, or at least it is incorporated or consolidated into that of the husband; under whose wing, protection and cover she performs everything;

and she is therefore called in our law a *femme covert*.[44] Within this framework, the respective roles of men and women became more clearly demarcated than ever before. Although a gender distinction between men and women had pre-existed the Victorian middle class, now biological and psychological hypotheses led to the Angel in the House concept, which was used as shorthand to defend this distinction.

The separate spheres approach pitted the two sexes against each other as opposites. Men were supposedly self-sufficient, out there in the world of industry, whilst women were dependent and loving but always passive, never passionate. In the Victorian ideal, men and women were part of a complementary relationship in which they benefitted from each other's strengths. However, being the ultimate Victorian woman demanded an ignorance of male-oriented topics. Some feminist historians, notably Carroll Smith-Rosenberg,[45] thought that domesticity was not necessarily confining and the female's role emphasised companionship, common interests and 'love and friendship' within and across families. However, it can be argued that, far from achieving harmony, this rigid definition of 'spheres' only served to make true comradeship difficult to achieve; and though collective action between women was realised, it would be oppositional.

Catherine Hall[46] discussed the influence of the evangelical movement as emphasising the singular and separate role of women as the 'carriers of social and religious virtue'. Charles Kingsley[47] exalted the role of marriage and motherhood to the extent that women were 'most divine because they were most human'. This almost likened their role within the family to that of a clergyman and his flock.

Of course, this was only attainable if women were protected from the 'competitive public world of men and the market'.[48] Thomas Gisborne, a Church of England clergyman and a moralist, had published *An Enquiry into the Duties of the Female Sex* in 1797 to instruct 'women placed in the higher or in the middle classes of society'.

Events, activities and places viewed as part of this public world were off limits to women, whilst maintaining the home and raising children to embrace middle-class values was emphasised. By the middle of the nineteenth century, women were openly criticised if they dared to walk unaccompanied or ride a horse in public. Of course, this restricted their ability to engage with the world at large and bolstered the view that work was an inappropriate activity for a married woman, as it would cast doubt on her femininity and

embarrass her husband and other male relatives. Female dependency was part of English law and excused under the premise that this was woman's true nature. A married woman had no control over her body, property or even her children. The husband's control was practically absolute. The philosophy of women having such an influence at home was used as an argument to continue to withhold votes for women.

As a result of these traditional expectations, women encountered very few educational opportunities and were excluded from the public sphere of nineteenth-century society when not accompanied by their husband or father. Even the contemporary fashions – stays, crinolines and bombazine – positioned women as decorations, enforcing and advertising their economic pointlessness. This ideology encouraged the economic dependence of women on male relatives. It seems reasonable to assume that although there were women who remained within their apportioned domestic sphere, a fair proportion did this out of necessity rather than personal choice. The ideological construction of the separate spheres also meant that whatever women did in the home went unrecognised. In the 1881 census, women at home were classified as 'unoccupied' and consequently wouldn't appear in occupational tables.

Of course, if women were dependants in the home, this would mean that men were the breadwinners and the earners of wages, making a profit and a difference out there in the world of commerce and industry. They would expect to return to a domestic haven where they could recharge their batteries, attended to by the Angel in the House.

In Charles Petrie's article 'Victorian Women Expected to Be Idle and Ignorant', he writes, 'From infancy all girls who were born above the level of poverty had the dream of a successful marriage before their eyes, for by that alone was it possible for a woman to rise in the world.'[49] Because women were not afforded the opportunity to work or take part in the world of men, they spent their formative years in preparation for marriage. They expected men to take care of them and provide for them since they were unable to provide for themselves.

Whilst a proper education was considered critical to the future of any upper-class girl, they would rarely be educated outside the house. As her only aspiration should be marriage, education was focused on making her attractive to a potential husband, with accomplishments that emphasised cultural distinction. Caroline Bingley tells us as much in *Pride and Prejudice*:

A woman must have a thorough knowledge of music, singing, drawing, dancing, and the modern languages; ... and besides all this, she must possess a certain something in her air and manner of walking, the tone of her voice, her address and expressions ...[50]

An upper-class gentleman sought a wife who would be a social asset, able to follow conversation whilst not posing an intellectual threat to him, understanding what was being said around her without offering ready opinions or advice. Women were not expected to engage in sexual activity except to provide children and to please their husbands – a case for likening Victorian marriage to legal prostitution. Change did come, but it came slowly, because lawmakers were diffident about intervening in the notion of 'wifely obedience'.

'Is a woman really meant to have no duty, no work to do in the world and depend entirely on her husband?' Thierna Saxelhurst wonders in *Martyrs to Circumstance*.[51] 'Is her husband to possess every virtue and talent in order that her faculties may lie dormant?'

On the face of it then, upper- and middle-class women appeared privileged. But a look under the wedding veil would probably reveal that many women married merely to be provided for as they had no viable alternative.

Differences in Limitations of Single and Married Women

In 1889, *Tit-Bits* magazine offered prizes to single female readers who sent in the best answers to the question 'Why Am I A Spinster?' A Miss Sparrow of Paddington said that she didn't 'care to enlarge my menagerie of pets, and I find the animal man less docile than a dog, less affectionate than a cat and less amusing than a monkey', whilst Sarah Kennerly of Ashton-on-Ribble found it 'more delightful to tread on the verge of freedom and captivity than to allow the snarer to cast around me the matrimonial lasso'. This is unsurprising. The act of marriage was life-changing for the Victorian woman in myriad ways, acutely more so than for a man. The decision to marry was perhaps the most profound choice she would ever make as the 'right' decision made the difference between social prestige or failure.

For a woman who remained single, either through personal choice or lack of opportunity, spinsterhood set her apart from her sex and labelled her a loser in society. A woman immediately augmented her social standing upon marriage; pressure and persuasion exerted on her

to marry was immense, arising from family, the church and society in general, which valued a woman by her marital status. Indeed, there were women who weighed their own self-esteem by their married (or unmarried) state. The paradox of conformity was the deleterious effect on her life and liberties. She would lose political and financial freedom along with rights over her own property, should she possess any. Her social life would be subsumed within that of her husband and his circle. And for a woman of a lower social standing, her reward for complying with society's expectations was constant housework, multiple pregnancies and years of childrearing.

Perhaps the only thing worse than merely being unmarried was being an unmarried mother. Single mothers and their children were deemed an affront to morality and such children were thought to inherit their parents' lack of moral character. Moreover it was thought they might even contaminate the minds and morals of legitimate children. Family and friends rarely offered support, as to associate with the mother of an illegitimate child brought disgrace to them, too. A young woman who became pregnant while still living with her parents was often forced to leave home and move to an area where nobody knew her. She was disdained by family, friends and employer if she was working, and following the birth, many women farmed their child out in order to earn a living from the few employment opportunities that were available.

The mid-nineteenth century saw a real entrenchment of biological determinism, an ideology which drew a sharp dividing line between domestic women and public men. Society expected a woman's world to be at home, since for the vast part of the Victorian era she was excluded entirely from public life: barred from entering university, from following a profession and from voting in any parliamentary election. If she was compelled to work because of adverse family circumstances, this would invariably be in a low-status role with poor pay and often wretched conditions. And, naturally, the man was the *pater familias*, the head of the household.

Whilst a single woman was heavily criticised for not upholding her duty to marry and produce a family, she of course had an advantage over her married sisters in that she was free of coverture, which effectively submerged the identity of a married woman within that of her husband and took away ownership of any property she may hold and indeed her very identity as a citizen. Once she married, in the eyes

of the law, she no longer existed in her own right. Unmarried women had greater rights, for example over their own property. And although the 1869 Municipal Franchise Act qualified female ratepayers to vote for local municipal councils as well as to elect and stand as Guardians of the Poor, the 1872 *Regina* v. *Harrald* court case restricted this right to unmarried women and widows, leaving married businesswomen with no say over the local councils to whom they paid rates.

Meanwhile, society frowned upon the Victorian female singleton. Women who stayed single for whatever reason were not only pitied, they were perceived as not having fulfilled their natural destiny or indeed their responsibility to society. But then again there were so many legal and societal limitations placed upon married women that one may question why any single woman owning property or possessions of any significance would voluntarily give them up. Although a few women did remain single and live by their own means, for many others, particularly middle- and upper-class women, marriage was a necessity. Prohibited from earning a living of their own, they could very rarely avoid dependency.

Around the time that Victoria acceded the throne, Harriet Martineau became an expert on issues normally the province of men, among them law, education and economics. Queen Victoria read her publications and invited her to her 1838 coronation. Martineau was described as a born lecturer and politician, 'less distinctively affected by her sex than perhaps any other, male or female, of her generation'.[52] She was a prolific writer, social theorist and campaigner for education even though she was criticised for writing on 'unfeminine' issues. She wrote in her autobiography that when her fiancé died, notwithstanding her grief, she was grateful that she did not have to marry. Her writing provided her with a career and her independence.

In the middle of the nineteenth century, over a third of women over the age of twenty in England and Wales were unmarried. This included 1,563,000 single women and 223,000 widows aged between twenty and fifty; the average age of first marriage for women in 1851 was 24.6 years, with the groom being two to five years older; this reinforced the 'natural hierarchy' between men and women as it was preferable for a groom to be established and able to provide for a wife and family.[53] Of the 5,210,000 adult males aged between twenty and fifty, 1,551,000 were single and 109,000 widowers. In addition, the census data shows 4,000 unmarried adult males aged under

twenty alongside 26,000 females. Although not all of these would immediately marry, it suggests they would be outnumbered by single women throughout the 1860s and 1870s.[54]

This data indicates a clear surplus of single women.[55] There were three main reasons why women outnumbered men. The mortality rate for boys was already far higher than for girls, added to which a large number of males served in the armed forces abroad; many did not return. Men were also far more likely to emigrate than women. By the next census in 1861 there were 10,380,285 women living in England and Wales but only 9,825,246 men.

Although Victorian society's overarching view was that getting married and having children was the main aspiration for all girls, a young woman was supposed to be subtle about her intentions when finding a husband. It simply was not the 'done thing' for a Victorian female to show any form of attraction towards a man; this was considered 'forward' behaviour and deemed highly inappropriate. Moreover, the purpose of marriage for a woman was purely to become a mother, not to participate in an emotionally satisfying romantic relationship. Besides, women were held to be passive, possessing different natural characteristics to men, so any pursuit would be the natural preserve of the male.

But there was a hypocrisy surrounding the image of the ideal Victorian family unit. Queen Victoria thought that 'feminists ought to get a good whipping. Were women to "unsex" themselves by claiming equality with men, they would become the most hateful, heathen and disgusting of beings and would surely perish without male protection'. In airing these views she gave powerful men carte blanche to halt the progression and development of women as individuals. Anna Clark points out that marital violence in the Victorian era 'potentially undermined the legitimacy of the patriarchal sexual contract, in which men's dominance was justified by their protection of their wives'.[56] Married women who were unhappy and wished to separate from their husbands would have been unable to, simply because the resources needed for survival were unavailable to them. Divorce was a disgrace; divorcees were afforded the status of an outcast by society; women were torn apart by divorce lawyers. Being all too aware of this, some husbands used the ideal as a form of coercive control.

To be single, wrote Louisa Garrett Anderson,[57] was thought shameful. A woman was an 'old maid' at the age of thirty. Should her

parents die, often the best a single middle-class woman could hope for would be to keep house for a brother or another relative. The next best thing would be to throw herself on their charity. Otherwise she would have to earn a living and maintain herself. Here, more employment opportunities were perhaps available to working-class women, but alongside these went more opportunities for exploitation and meagre earnings. Working-class women would start work around the age of ten in factory work, agricultural labour or domestic service. On marriage, they would often continue to work in these roles if their husbands didn't earn enough to support them, only taking breaks to produce children. A woman was prevented from entering government or the professions, and working as a governess was often a middle-class woman's only option. Here, too, the pay was poor and the conditions often matched it. The fictional Agnes Grey remarks:

> While receiving my instructions they would lounge upon the sofa, lie on the rug, stretch, yawn, talk to each other, or look out of the window; whereas, I could not so much as stir the fire, or pick up the handkerchief I had dropped without being rebuked for inattention by one of my pupils, or told that mamma would not like me to be so careless.[58]

Furious about the lack of opportunities and enforced idleness that was the plight of upper-class Victorian women, Florence Nightingale authored a ferocious essay, 'Cassandra', in 1852. Though she printed it privately eight years later, it would not be published until 1928. 'Cassandra' is probably the catalyst for the resolve and fortitude that drove Nightingale's career. Her ambition and determination inspired countless women to enter the nursing profession. As she asserts in 'Cassandra':

> Women are never supposed to have any occupation of sufficient importance not to be interrupted, except 'suckling their fools'; and women themselves have accepted this, have written books to support it, and have trained themselves so as to consider whatever they do as not of such value to the world as others, but that they can throw it up at the first 'claim of social life'. They have accustomed themselves to consider intellectual occupation as a merely selfish amusement, which it is their 'duty' to give up for every trifler more selfish than themselves.

Women never have an half-hour in all their lives (except before and after anybody is up in the house) that they can call their own, without fear of offending or of hurting someone. Why do people sit up late, or, more rarely, get up so early? Not because the day is not long enough, but because they have 'no time in the day to themselves'.

The family? It is too narrow a field for the development of an immortal spirit, be that spirit male or female. The family uses people, not for what they are, not for what they are intended to be, but for what it wants for – its own uses. It thinks of them not as what God has made them, but as the something which it has arranged that they shall be. This system dooms some minds to incurable infancy, others to silent misery.

Nightingale holds herself as an equal to men and is disappointed with how quickly women submit to the opposite sex. She argues that it is the lack of direction that leads to physical and emotional weakness, not that women are born this way: 'What these suffer – even physically – from the want of such work no one can tell. The accumulation of nervous energy, which has had nothing to do during the day, makes them feel every night, when they go to bed, as if they were going mad; and they are obliged to lie long in bed in the morning to let it evaporate and keep it down.'

Nightingale maintains that society thwarts a woman's goal to create a productive life, even if she dared to do so: 'Society triumphs over many. They wish to regenerate the world with their institutions, with their moral philosophy, with their love. Then they sink to living from breakfast till dinner, from dinner till tea, with a little worsted work, and to looking forward to nothing but bed.'

The novelist and suffragist Mona Caird also developed themes in her books suggesting that a woman was likely to find a career more satisfying than marriage. She wrote a series of essays that were published in several magazines, including *The Westminster Review* and *The Fortnightly Review*. Her 1888 essay[59] discussed marriage as a form of legalised abuse towards women. *The Daily Telegraph* subsequently published a series of articles asking, 'Is Marriage a Failure?' Caird's view was that 'to place the sexes in the relationship of possessor and possessed, patron and dependent, is almost equivalent to saying in so many words, to the male half of humanity: "Here is

your legitimate prey, pursue it."' She felt that marriage itself precluded supportive relationships and fostered female oppression.

When Clementina Black's mother died from injuries sustained lifting and caring for her disabled husband, Clementina, aged twenty-two, was left to look after her father, the house and her seven siblings whilst holding down a teaching job. As the eldest daughter, this was expected of her. Clementina Black disagreed with some of Mona Caird's assertions and wrote a pamphlet outlining her own views:

> Marriage, like all other human institutions, is not permanent and alterable in form, but necessarily changes shape with the changes of social development. The forms of marriage are transitional, like the societies in which they exist. Each age keeps getting ahead of the law, yet there are always some laggards of whom the law for the time being is ahead.
>
> The main tendency of our own age is towards greater freedom and equality, and the law is slowly modifying to match ... At present the strict letter of the law denies to a married woman the freedom of action which more and more women are coming to regard not only as their just but also as their dearest treasure; and this naturally causes a certain unwillingness on the part of the thoughtful women to marry ... That law and custom should alike enlarge so as to suit the growing ideal is evidently desirable ... we can all of us influence custom a little, since custom, after all, is only made up of many individual examples ... Easier divorce may be necessary, but the opportunity of making wiser and happier marriages is more necessary still.[60]

Black did observe that Caird's view on women not having money of their own was a fair one and that this also applied to single women living with fathers or brothers. The woman would have to ask the male relative, or husband, for money. A married woman 'is likely to be in a worse position for earning a regular livelihood outside her home; she sacrifices to wifehood and motherhood a portion of her chance of earning an income for herself'. Black felt married women should be remunerated for housekeeping and domestic duties and that this remuneration should belong to the woman by rights.

Suffragist and writer Elizabeth Wolstenholme was passionate about excellence of education for women. She established a boarding school

in Manchester in 1853, founded the Manchester Schoolmistresses Association in 1865 and the North of England Council for the Higher Education of Women in 1867 to train women as schoolteachers. Elizabeth and her life partner Ben Elmy did not believe in marriage, although she was careful to criticise the socio-cultural systems rather than men themselves for the oppression of women.

After acting as a bridesmaid as a teenager, Elizabeth decided that the 'immoral vow to love, honour and obey bound women for the rest of their lives in sex slavery',[61] and resolved that she would never get married. Elizabeth and Ben suffered condemnation and verbal attacks from society and suffragist colleagues who accused them of bringing the movement into disrepute. However, when Elizabeth became pregnant, they eventually did get married in a register office after prolonged and intense pressure from various sources. This pressure and criticism continued after their marriage to the point where Elizabeth was effectively bullied by her suffragist contemporaries. Her work in strengthening the rights of married women was seen as less important than securing the vote for single women and widows, and she faced difficulty in continuing to work with suffragist organisations.

Although a man could not dispose of it without her consent, his wife's personal property, such as money from earnings or investments, and personal belongings such as jewellery, passed absolutely into his control upon marriage. She could not part with any of it without his consent. Although the Married Women's Property Act of 1870 allowed women to keep earnings or property they acquired once married, it would be another twelve years until the 1882 Act stated that they were allowed to retain what they owned at the time of marriage. As Sir William Holdsworth puts it, 'Marriage is a gift of the wife's chattels to her husband.'[62] Somehow, though, it is difficult to imagine the enlightened Ben Elmy, even once married, holding Elizabeth to the letter of the law by appropriating her property.

Rejecting a proposal to extend the vote to women in 1892, Home Secretary Herbert Asquith justified his position to Parliament by arguing that '[women's] natural sphere is not the turmoil and dust of politics but the circle of social and domestic life'. His stance is not surprising; this is a man who had commented on his wife, Helen, in a letter to artists' muse Frances Horner thus: 'Her mind was clear and strong, but it was not cut in facets and did not flash lights, and no one would call her clever or intellectual. What gave her rare quality

was her character, which everyone who knew her agrees was the most selfless and unworldly that they have ever encountered. She was warm, impulsive, naturally quick-tempered, and generous almost to a fault.'[63]

Legal Attitudes to Sexuality, Marriage and Divorce

By the early twentieth century, the very word 'Victorian' had become synonymous with prudery, sexual repression and social convention. Women were encouraged to think of themselves as relative to men, dependent upon them. This clear distinction – separate spheres – also extended to the personal realm. Within marriage the man was accepted to be the sexually active partner and the woman the passive recipient. Leading gynaecologist William Acton supposed that, 'happily for society', the majority of women 'are not very much troubled with sexual feeling of any kind'.[64] Here, one has to commiserate with his wife. Acton's view of female desire as an 'aberration' was seized upon as credible scientific endorsement of Victorian ideological presumptions about sexuality, personified by Coventry Patmore's *Angel in the House*.

Ostensibly, society believed in sexual restraint and strict moral values. Above all, sexuality was a private concern, not to be discussed or demonstrated in public; what in the 1970s Michel Foucault termed the 'repressive hypothesis'. Of course, as Foucault points out, in the nineteenth century sex absolutely had to be talked about for functional purposes in a wide range of contexts including the law, medicine and religion. But Victorians were warned about overindulgence. Another obstetrician, Haydn Brown, stipulates in a self-help book written for single women in 1899 that 'the intercourse between the sexes in married life is best, most propitious, most complete, and most promising for the future of the race, being as it is, exclusive and regulated by the bonds of religion and custom; not promiscuous and deviating, not varied and risky, not wayward and wanton, but right and orderly. Sexual indulgences are, under marriage association, kept down to a reasonable and harmless minimum.'[65]

The book *Sex Tips for Husbands and Wives*,[66] written in 1894 by vicar's wife Ruth Smythers, set out some guiding principles to help married couples manage their sex lives. Smythers advised that 'while sex is at best revolting and at worst rather painful, it has to be endured', and wives should 'give little, give seldom and above all give grudgingly. Otherwise what could have been a proper marriage could become an orgy of sexual lust.'

Whilst it is true that the Victorian individual's personal life, and particularly that of a woman, was governed to a great extent by complex and rigid rules of behaviour, was the picture really as simplistic as it at first seems? Were there contradictions or complexities surrounding Victorian attitudes to marriage and sexuality that would affect the place of women in their culture, meaning that not all of them were as passive or subordinate as conventional images of the era would suggest?

Although Claire Tomalin has argued that '[Caroline Norton] was so disappointed and disgusted with her experience of sex within marriage as to lack any wish at all to embark on extra-marital ventures of that kind',[67] surprisingly it is Queen Victoria who provides the most marked contradiction, reflecting in her journal on the merits of her husband: 'Albert really is quite charming, and so excessively handsome, such beautiful blue eyes, an exquisite nose, and such a pretty mouth with delicate moustachios and slight but very slight whiskers; a beautiful figure, broad in the shoulders and a fine waist.'[68] Her attraction to Albert is palpable. In fact, Victoria embraced the physical expression of her sexuality with delight as she documented her wedding night:

> I NEVER, NEVER spent such an evening! MY DEAREST, DEAR Albert ... his excessive love and affection gave me feelings of heavenly love and happiness I never could have hoped to have felt before. He clasped me in his arms, and we kissed each other again and again! His beauty, his sweetness and gentleness,— really how can I ever be thankful enough to have such a Husband! Oh! This was the happiest day of my life![69]

Given the predominant opinions on sexuality, Victoria's passionate nature and evident physical desire for her husband is not only astonishing but, for the times, counter-cultural.

Robert Lawson Tait, a Scottish obstetrician, held a more balanced view, writing in 1877: 'The majority of women enter the married state with but a very hazy notion of what its functions are ... there is a false modesty on these subjects ingrained in our English life which has to be paid for in much suffering amongst women.'[70]

And no wonder. Sex education for women, such as it was, concerned preparation for marriage and was bound up with morality

messages. 'Instruction and Advice for the Young Bride', an American article published in the *Madison Institute Newsletter* for autumn 1894, promotes the belief that women have no interest in sex even after they are married. Ruth Smythers writes that 'by their tenth anniversary many wives have managed to complete their childbearing and have achieved the ultimate goal of terminating all sexual contacts with the husband'. But such publications were primarily designed to promote self-restraint to young women. In doing so, they make clear that the Victorian perception of women's sexuality was an ideology seeking to be established rather than a true reflection of the prevalent views or indeed practices of the majority of women.

Although no parallel British survey has been discovered, Dr Clelia Mosher, a professor at Stanford University, conducted a survey[71] of middle-class women in 1892 which was accidentally stumbled upon in Stanford's archives eighty years later, finally made public in 1974. Many of the surveyed women were unquestionably forthright in their responses. One, born in 1844, called sex 'a normal desire' and observed that 'a rational use of it tends to keep people healthier'. Another, born in 1862, thought that 'the highest devotion is based upon it, a very beautiful thing, and I am glad nature gave it to us'.

But more than half of the women questioned reported that they knew nothing about sex until they were married. Those who did have some knowledge before marriage found their information through books, conversations with older women, and natural observations like 'watching farm animals'. Mosher's work is an important historic resource which refutes the stereotype that Victorian women knew little about sex and desired it even less.

Smythers, meanwhile, appeared to find passion between a husband and wife repulsive, instructing a woman to 'turn her head slightly so that the kiss falls harmlessly on her cheek instead' if her husband tried to kiss her on the mouth, and to 'never allow her husband to see her unclothed body'.

The Emma Thompson-directed 2014 film *Effie Gray*, a dramatisation of the real-life marriage between Effie and the art critic John Ruskin, shows Dakota Fanning's Effie stripping in front of Greg Wise's Ruskin on their 1848 wedding night only for him to decline to consummate the marriage and to continue to do so for the next six years. It is difficult to understand why Ruskin would not want to have a sexual relationship with Effie when she became his wife. After all, he had known her and

been very fond of her since adolescence. Some illumination may be provided by a letter she wrote to her father, George Gray:

> [John] alleged various reasons, hatred of children, religious motives, a desire to preserve my beauty, and finally this last year he told me his true reason ... that he had imagined women were quite different to what he saw I was, and that the reason he did not make me his wife was because he was disgusted with my person the first evening 10th April.

In a statement to his lawyer Ruskin admitted, 'It may be thought strange that I could abstain from a woman who to most people was so attractive. But though her face was beautiful, her person was not formed to excite passion. On the contrary, there were certain circumstances in her person which completely checked it.'

We get a glimpse of Ruskin's perfect woman in his Manchester lectures on the subject of separate spheres and their absolute requirement for an ordered society. His paper 'Of Queen's Gardens'[72] can be taken to hint at his fear of gender subversion, which leads one to hypothesise that here is the reason for his wedding night debacle. He suggests that a woman should be responsible for 'sweet ordering' in the home, creating a Utopian paradise unsullied by the unpalatable reality of the 'outer world'. By staying true to her feminine nature, she will carry out her 'queenly and feminine duty' as the moral guardian of the home. Ruskin provides a clear distinction of gender roles by his separate spheres ideology, and subsequently establishes an unfeminine category of the 'masculine' woman who acts in opposition to the ideal. His wife had taken the initiative in the most daring way possible, and with this context his reaction is unsurprising. As a close friend and contemporary of Coventry Patmore, it is safe to assume that Ruskin's idea of a woman was one who apparently retained her chastity even as a wife and mother, and in this Effie failed to make the grade. His ideal 'enduringly, uncorruptibly good' woman would remain exactly that, as he never married or was known to maintain a successful adult relationship.

Women, and mothers in particular, were idealised in Victorian literature and poetry. Fidelity within marriage was the supreme virtue, and sexual irregularity the worst of sins. Adultery, especially in the case of a wife, and no matter what the extenuating circumstances,

was spoken of with horror. A 'feeble and erring woman' became, in fact, a social outcast.[73] Undoubtedly there would be men for whom the concept of even a married woman feeling romantic desire did not fit with their unblemished image of the Victorian woman; if she did, there was only one judgement to be made upon her character.

These attitudes, whilst not being in and of themselves points of law, were certainly encompassed within the law and helped shape it. Victorian civil law both embodied and justified middle- and upper-class views about the superiority of men, the weakness of women and the expectations of the behaviour of both. The effect of English law at the time was to make a woman, in a sense, her husband's property immediately they were married as the common law doctrine of coverture forced a married woman's legal identity to be subsumed within that of her husband. The irony of this situation was that the ruler of England, a woman herself, would become the only woman in the land who did not face gender-based legal obstructions.

But in high aristocratic circles, sexual licence did seem to be condoned or even considered as the norm. Country house parties provided ample opportunity for flirtation and extramarital encounters. Elinor Glyn considered it 'quite normal in Society circles for a married woman to have a succession of illicit love affairs during the intervals of which, if not simultaneously, intimate relations with her husband were resumed'.[74] But they should be conducted so as not to invite gossip: 'Our rule was No Scandal! Whenever there was a threat of impending trouble, pressure would be brought to bear, sometimes from the highest quarters, and almost always successfully. We realised that publicity would cause chattering tongues, and as we had no intention of changing our mode of living, we saw to it that five out of every six scandals never reached the outside world.' But Daisy, Countess of Warwick didn't always follow this advice herself, as her lover's pregnant wife learned of their affair upon opening a letter addressed to him from Daisy questioning his commitment after discovering his wife's pregnancy. When the contents of the letter became embarrassingly public knowledge, Daisy appealed to the Prince of Wales – which resulted in her becoming, in turn, his mistress.

Victoria's son Bertie had several affairs with married women including Lillie Langtry and Alice Keppel, who revelled in the celebrity they gained as a result. 'Society accepted the presence of Mrs Langtry at any occasion attended by the Prince of Wales.'[75] But when

things went wrong, society ladies could still find themselves socially ostracised. Lillie Langtry had a concurrent affair with the Earl of Shrewsbury, but when the press implied that Bertie would be called upon in her divorce case, the relationship was quickly curtailed.

It should be borne in mind that although coverture has been cited as a clear example of male privilege, the original intention of this law was to impose responsibilities upon men and to penalise them should they fail to fulfil these obligations. At a time when a large proportion of paid work sufficient to maintain a family was gruelling manual labour which women physically could not do without great difficulty, it is easy to see why society made men answerable in this way. It could perhaps be argued that coverture does not personify male privilege but rather male obligation. In this way, coverture was bound up in a social system that held men accountable for providing resources in support of their wives, family, lifestyle and public image.

Whilst a married woman was effectively legally non-existent under the law of coverture, a key aspect of this law was the principle of 'necessaries' whereby a married man had an obligation to provide for his wife financially, which may have been the true basis for many Victorian marriages. Under this system, a married woman could enter into a contract or purchase goods on credit without the knowledge of the husband if these items were deemed to fall under the auspices of 'necessaries', whilst he would still be ultimately responsible for the debt. Of course, wives were in charge of maintaining the household, so it would be expected that these would be reasonable purchases, but what actually constituted necessaries? This depended on the household, class and status. So a wealthy Victorian wife would consider servants, carriages and horses, expensive outfits and accessories as essential items for a woman in her position; indeed, such trappings would be expected. We can therefore see that the aspect of necessaries effectively gave women great powers of consumption with no legal individual responsibility for the consequences. Additionally, this principle still applied when women separated from their husbands. There are several examples[76] of estranged wives deliberately getting into large amounts of debt simply in order to pressure their husbands into accepting favourable divorce terms; some even had their husbands imprisoned until they agreed to the demands.

However, there can be no doubt that the law of coverture fostered subordination of women to men within the marital relationship and

continued to disadvantage and oppress Victorian women, operating as a patriarchal control mechanism. Caroline Norton has often been suggested as not only the first Victorian feminist, but an accidental feminist at that. Before her marriage, Caroline Sheridan did in fact subscribe to the belief that men were superior. Intriguingly enough, that view may have helped her influence the male lawmakers whose support she needed to make changes over the next twenty years.

Married in 1827 to George Norton, a Tory MP for Guildford ten years her senior, Caroline was the main breadwinner in her marriage. The relationship was precarious, volatile and unstable, with George frequently exhibiting jealous outbursts and physically attacking Caroline with the full knowledge of her family, who were powerless to intervene:

We had been married about two months, when, one evening, after we had all withdrawn to our apartments, we were discussing some opinion Mr Norton had expressed; I said, that 'I thought I had never heard so silly or ridiculous a conclusion.' This remark was punished by a sudden and violent kick; the blow reached my side; it caused great pain for several days, and being afraid to remain with him, I sat up the whole night in another apartment.

Four or five months afterwards, when we were settled in London, we had returned home from a ball; I had then no personal dispute with Mr Norton, but he indulged in bitter and coarse remarks respecting a young relative of mine, who, though married, continued to dance – a practice, Mr Norton said, no husband ought to permit. I defended the lady spoken of when he suddenly sprang from the bed, seized me by the nape of the neck, and dashed me down on the floor. The sound of my fall woke my sister and brother-in-law, who slept in a room below, and they ran up to the door. Mr Norton locked it, and stood over me, declaring no one should enter. I could not speak – I only moaned. My brother-in-law burst the door open and carried me downstairs. I had a swelling on my head for many days afterwards ...[77]

George also scalded Caroline with a kettle and dragged her downstairs whilst she was pregnant with her youngest son. She learned to live with this and made the best of the situation, knowing that, socially, a separated wife 'may as well be dead', becoming a victim of society's

double standards. Granddaughter of the playwright Richard Brinsley Sheridan and a successful editor and writer in her own right, she earned her own money along with admiration from many society men for her personality and achievements. Such achievements would be a plus for a man, but for a woman it was deemed clear evidence of her licentiousness. Caroline was attractive, witty, intelligent, successful and outgoing, therefore it also followed that she must be decadent.

By 1836 Norton had barred Caroline from the house, packed their three children off to his cousin and refused her access to them. These actions were the result of Caroline's refusal to allow George to use her marriage trust as security to raise money. But George had a further trick up his sleeve. He sued the Prime Minister, Lord Melbourne, for 'criminal conversation' – in other words, adultery – and demanded £10,000 in damages for alienating his wife's affections, notwithstanding the fact Norton had initially encouraged and used his wife's friendship with Melbourne for his own advancement. The relationship, whilst close and affectionate, was most likely platonic, a fact Melbourne attested to on his deathbed. Claire Tomalin has commented: 'Lord Melbourne was nearly thirty years her senior; his wife (Caroline Lamb) had lately died; and he was a man peculiarly susceptible to the delights of a quasi-paternal relationship. Caroline Norton offered him beauty, charm, a sharp interest in everything that interested him and something like an eighteenth-century sense of fun; more, she idealised him for his urbanity, his power, wealth and well-preserved good looks.'[78]

The evidence George Norton presented in court was so ridiculous that the jury found in Melbourne's favour without even having to call any witnesses. Nevertheless, he was still able to get his hands on Caroline's income as an author as well as her personal inheritance and to continue to deny her access to her boys, as was his legal right. Everything Caroline earned, owned or had been bequeathed was, in law, her husband's property. She had earned more in a month than many men did in a year and was entitled to keep none of it.

Although she was exonerated, Caroline's reputation was ruined. Labelled a 'scandalous woman', she was unable to obtain credit, 'scrambling about for sixpences' and struggling to find 'either a chandler or grocer who would trust me', and had 'borrowed off Charlie'.[79] But in trying to negotiate a successful outcome to this situation for herself and her boys – at this point she was certain she

wanted justice rather than equal rights for women – Caroline gained a new and wider sense of purpose. She fought to change the law. She assiduously researched case law and uncovered other instances of women being denied access to their children on separation, proving through her legal work that the supposedly feebler female brain was nothing of the kind.

She lobbied friends and acquaintances in Parliament to support her aim and wrote two pamphlets about it to educate the public on the predicament of mothers in unhappy marriages, hoping to persuade MPs to support her cause. 'It is a strange and crying shame,' she wrote, 'that the only despotic right an Englishman possesses is to wrong the mother of his children.' In her somewhat awkwardly titled pamphlet *The Separation of Mother and Child by the Laws of Custody of Infants Considered* – political pamphlets were a powerful persuasive instrument at the time – Caroline systematically took apart the law.

Caroline's intended outcome was for all children under the age of seven to remain in the custody of their mother and for the courts, not the father, to decide where older children should live. She set out all those points of law that appeared unjust, including the principle of natural justice which deemed the children the property of the father, whose rights were absolute and paramount. This, she shrewdly argued, was in direct contradiction of the prevailing Victorian view that motherhood was a woman's highest calling. The pamphlet was published in early 1837 and made Caroline the first Victorian women's rights campaigner; moreover she was the first woman in history to challenge this law. However, she also wrote to *The Times* to press the point that 'the natural position of women is inferiority to men ... I never pretended to the wild and ridiculous doctrine of inequality.'[80]

A serendipitous opening arose when Caroline was introduced to Thomas Talfourd, the Reading MP who was already preparing to introduce a bill to reform infant custody. Talfourd had felt a moral disconnect with the law he had been forced to uphold when representing husbands like George Norton in the past and saw an opportunity to change it. The aims of the Custody of Infants Bill he presented to Parliament were to allow mothers against whom adultery had not been proved to have custody of children under seven, with rights of access to older children. Although the bill was passed by ninety-one to seventeen votes in the House of Commons in May 1838, the House of Lords subsequently rejected it by a mere two

votes. Talfourd's impassioned response was that the House of Lords was acting in a manner 'contrary to justice, revolting to humanity, and destructive of those maternal and filial affections which are among the best and surest cements of society', and he further accused them of enabling 'a profligate, tyrannical, or irritated husband to deny [his wife], at his sole and uncontrolled caprice, all access to her children'.[81]

Caroline channelled her frustration at the result into positive action with a second pamphlet, *A Plain Letter to the Lord Chancellor on the Infant Custody Bill*, sending a copy to each member of Parliament; the bill was again presented by Thomas Talfourd in 1839. This time it was opposed by malicious accusations that Talfourd and Caroline 'were lovers and that he had only become involved with the issue because of their sexual intimacy'. Caroline was pilloried in *The British and Foreign Quarterly Review*[82] as a 'she beast' and 'she devil', and the publication also 'coupled [her] name with Mr Talfourd in a most impertinent way'. She could not even sue for libel as she was a married woman: 'I have learned the law respecting married women piecemeal, by suffering every one of its defects of protection.'[83] It is impossible to imagine this kind of treatment being meted out to a man.

Finally, after a frequently interrupted journey through both houses of Parliament, the Infant Custody Act was passed in August 1839, making Caroline – who always denied being a feminist – responsible for what Diane Atkinson calls 'the first piece of feminist legislation in Britain'.[84] The Act gave custody of children under seven to the mother (provided she had not been proven in court to have committed adultery) and established the right of the non-custodial parent to access to the child. It was the first piece of legislation to undermine the patriarchal structures of English law and the first small step on a remarkable campaign that would transform marriage – and society – forever.

Caroline's campaign had brought the issue into the public domain and worn away opposition to the bill. She managed to expose the mean-minded nature of the opposition, revealed by their spiteful slurs on her character. But the price of leading the way in legislation was social opprobrium. Tennyson refused to sit beside Caroline at a dinner party. Melbourne had already withdrawn from her, fearing further contact would compromise her and cause scandal for himself. We must remember that Caroline had indeed sinned – against convention.

But there were still allies. Mary Shelley was one. Harriet, Duchess of Sutherland arranged to take Caroline driving around London, which

was a very visible means of support aimed at easing her path back into polite society. Rather than acting from any feminist tendencies, Harriet's backing was more to right a grievous wrong by encouraging her friend, raising her morale in a situation that she could not bear to witness. But even when a Deed of Separation was eventually agreed upon in 1848, Caroline remained George Norton's property. She was still unable to divorce him and still had no legal rights.

Caroline Norton now focused even more intently on her writing career. Her novels were extremely popular and highly regarded; being loosely autobiographical, they could not be taken as an advertisement for happy marriage, but she had now made the establishment sit up and take notice.

By 1850, Parliament began to consider reforming existing divorce laws and established the Royal Commission on Divorce, chaired by Lord Chief Justice Campbell; this also included the intention to establish a secular court to hear all divorce cases. The subsequent divorce reform bill was presented by Lord Chancellor Cranworth to the House of Lords in 1854. Although he drew up new legislation, he did voice opposition to changing the law to allow a wife to be able to sue for divorce on the grounds of her husband's adultery; hardly equality of access for all, though others argued that the current divorce laws perpetuated 'the trite, but not altogether unjust observation, that men made the laws and women were the victims'.[85]

Meanwhile Caroline Norton, far from remaining on the sidelines, produced *English Laws for Women in the Nineteenth Century* calling for the inclusion of a clause in the legislation to ensure that wives would retain their own property upon marriage. According to E. S. Turner, 'the Common Law of England, in the early part of the nineteenth century, granted a wife fewer rights than had been accorded to her under the later Roman law, and hardly more than had been conceded to an African slave before emancipation ... the husband ... owned her body, her property, her savings, her personal jewels and her income, whether they lived together or separately'. Astonishingly, a husband was allowed to 'legally support his mistress on the earnings of his wife'.[86]

A decade later Caroline would be criticised as 'a sort of professional injured person'.[87] Now, however, she found her arguments supported by Barbara Bodichon in her own forty-page pamphlet *A Brief Summary in Plain Language of the Most Important Laws Concerning*

Women, which pointed out: 'A man and wife are one person in law; the wife loses all her rights as a single woman, and her existence is entirely absorbed in that of her husband. He is civilly responsible for her acts; she lives under his protection or cover, and her condition is called coverture. A woman's body belongs to her husband; she is in his custody, and he can enforce his right by a writ of *habeas corpus*.'[88]

The pamphlet became a popular focus of public discussion and empowered women to completely understand, possibly for the first time, the coverture laws and their consequent legal position if they married, emphasising their inability to own property in their own right, to vote or join the professions. Barbara had already turned down a proposal of marriage because she refused to lose her legal rights as a single woman.

Caroline 'consulted whether a divorce "by reason of cruelty" might not be pleaded for me; and I laid before my lawyers the many instances of violence, injustice, and ill-usage, of which the trial was but the crowning example. I was then told that no divorce I could obtain would break my marriage; that I could not plead cruelty which I had forgiven; that by returning to Mr Norton I had condoned all I complained of. I learnt, too, the law as to my children – that the right was with the father; that neither my innocence nor his guilt could alter it; that not even his giving them into the hands of a mistress, would give me any claim to their custody. The eldest was but six years old, the second four, the youngest two and a half, when we were parted. I wrote, therefore, and petitioned the father and husband in whose power I was, for leave to see them – for leave to keep them, till they were a little older. Mr Norton's answer was, that I should not have them; that if I wanted to see them, I might have an interview with them at the chambers of his attorney.'[89]

In 1855 came her impassioned petition to Queen Victoria,[90] which protested the 'grotesque anomaly which ordains that women shall be non-existent in a country governed by a female sovereign': 'If her husband take proceedings for a divorce, she is not, in the first instance, allowed to defend herself. She has no means of proving the falsehood of his allegations ... If an English wife be guilty of infidelity, her husband can divorce her so as to marry again; but she cannot divorce the husband, however profligate he may be. No law court can divorce in England. A special Act of Parliament annulling the marriage, is passed for each case. The House of Lords grants this almost as a matter

of course to the husband, but not to the wife. In only four instances (two of which were cases of incest), has the wife obtained a divorce to marry again.' Victoria passed her own judgement on 'this mad and wicked folly of women's rights' by declaring that 'God created men and women differently – let them remain each in their own position'.[91]

But Caroline was no longer alone in fighting for fairness. Barbara Bodichon's pamphlet had raised the profile of public debate on married women's property laws, leading to discussion in Parliament in 1856. Her Married Women's Property Committee prepared a petition demanding equal legal rights with men. With overwhelming support and over 26,000 signatures from both women and men, it was presented to Parliament. Now, here was an issue 'almost entirely new to public consideration, and, as was natural, the feeling both in support of and in opposition to change was very strong. It would disrupt society, people said; it would destroy the home, and turn women into loathsome, self-assertive creatures no one could live with.'[92] The Married Women's Property Bill of 1857 ensued. Proposing as it did property rights for all married women, it threatened to subvert the existing social order – the ideology of separate spheres – and as a result failed to get past the first reading.

But what the campaign did do was gather first-hand evidence supporting the debate that coverture laws were overwhelmingly disadvantageous to women. Husbands were legally entitled to squander their wives' property or earnings, and even justify or excuse the physical and sexual abuse of wives under cover of the law. It is now widely agreed that this first campaign was of vital importance in raising consciousness about a woman's legal position (or lack thereof) and creating an evidence-led case for substantial reform of the law.

Meanwhile the 1854 Divorce Bill finally received royal assent on 28 August 1857. The protracted delay turned out to be providential as it now allowed for abolition of coverture to be introduced into the debate, which had not been included in the original bill. The Matrimonial Causes Act was finally passed and became law in January 1858.

It contained sixty-eight clauses, four of which were based on Caroline Norton's pamphlets. Separated and divorced women were given control over their own properties and earnings – although married women were excluded – and provision was made for maintenance payments to former wives.[93] The divorce process was simplified and

streamlined and the action of 'criminal conversation' was abolished. Individual Acts of Parliament were no longer required. But although a man could divorce an adulterous wife, women who wanted to divorce their husbands needed also to prove an additional aggravating factor such as bigamy, rape or desertion. So, the Matrimonial Causes Act remained discriminatory on the basis of gender. The Married Women's Property Committee would continue to fight for reforms and the Infant Custody Act had given them legal rights and visibility. The absurdity of women being expected to be dependent but with the potential to be punished for this dependence was laid bare. Furthermore, this continuing inequality overlooked the hypocrisy that men were entitled to sexual freedom and women were not.

The High Court in London was the only place to get a divorce, and proceedings were held in open court, allowing society to be scandalised by the personal details revealed during the process. In June 1858, Isabella Robinson was among the first women subjected to the new law. According to her private diary, her industrialist husband, Henry, was an 'uncongenial partner' and a 'mean and grasping' philanderer. As well as her feelings about Henry, Isabella recorded those about a certain Dr Edward Lane: 'I find it impossible to love where I ought, or to keep from loving where I ought not', leading to a later evening 'full of passionate excitement, long and clinging kisses, and nervous sensations'.[94] Henry found the diary, read her private thoughts and used it to demand a divorce.

Never mind that Henry had several mistresses and two illegitimate children with one of them; he invoked his rights to divorce Isabella for adultery under the double-standard divorce law. For her, the criteria were different. Furthermore, she was a married woman, so the diary didn't belong to her, nor did the thoughts she had written inside, which Henry used as the basis of his divorce case. 'The copyrights of my works are his,' as Caroline Norton had said of George, 'my very soul and brains are not my own.' Henry Robinson may not have wished to profit financially from Isabella's writings, but he did want to use them to humiliate and shame her. Infidelity was not only a crime, it was simply the worst indiscretion a Victorian society woman could commit, and it was even more unbelievable that she would want to write about it. Isabella Robinson was not allowed to appear in court and her only voice was her diary. Edward Lane categorically denied any romantic involvement with Isabella

and her diary entries were discredited as the disturbed fantasies of a sex-obsessed madwoman. Isabella's lawyer argued that the diary was a symptom of disease and her writings were evidence of erotomania. As a result of her supposed insanity, the court found the diary entries to be a fiction, ruled that no adultery had been committed and refused Henry his divorce.

Of course, the diary entries may simply have been Isabella's way of escaping from her miserable marriage, or mere wishful thinking, but equally as shocking as the diary itself is the way it exposed the deeply unjust treatment of women in Victorian society; this case had strongly highlighted the contradictions of the divorce reforms. Although Henry's adultery was an open secret, his behaviour was irrelevant in this context. By remaining married, Isabella retained her allowance from Henry along with access to her children, but in 1864, when she was caught with her children's French tutor on several occasions, Henry Robinson was finally able to divorce her. That same year, Helen Codrington's seemingly lascivious character was disparaged in court in an 'extraordinary divorce case'[95] when her Admiral of the Fleet husband, Harry, charged her 'with having committed adultery with David Anderson and divers other persons'.[96]

After the Act of 1857 the number of divorces rose from three to 300 a year, and despite legal and financial limitations, women were the petitioners in almost half of the divorces and almost all the judicial separations. Financial provision, however, was far less favourable. The vast majority of wives were awarded no property or further financial support – a factor which led to many wives abandoning their applications after issuing petitions. But wives were now also allowed to make counter-charges. Helen took advantage of this change to accuse Harry of cruelty, neglect and attempting to rape her friend Emily Faithfull. Emily refused to substantiate this allegation and Admiral Codrington was awarded his divorce, but Helen's life was destroyed. Furthermore, how valid was his evidence?

And the result of the whole is that, upon an accumulation of inadequate and doubtful, though very damaging, pieces of evidence, Admiral Codrington, who is rather the reverse of a model husband, is divorced from a wife whose affection he never had the good luck or good feeling to conciliate or retain. It is not to be denied that, taken together, the pieces of evidence against

Mrs Codrington are not only inconsistent with themselves, or with guilt, but present a definite picture of a wilful, passionate, ill-trained, and guilty woman. All we say is that, taken separately, the proofs are legally weak.[97]

The attitude towards women remained that if they had committed adultery, they were unfit mothers. As well as losing the trial and incurring heavy legal costs, Helen lost her two children along with her reputation. Harry Codrington promptly remarried, and his second wife took possession of Helen's children who were never allowed to contact their mother or even mention her name again.

Harriet, Lady Mordaunt suffered a similar fate. After a string of extramarital affairs that began within months of her marriage, she became pregnant and confessed all to her husband: 'Charlie, I have deceived you; the child is not yours.'[98] A writ for divorce came to court and the Prince of Wales found himself in the witness box giving evidence. Harriet suffered a nervous breakdown and it was a further five years before a divorce was granted, on grounds that Harriet was insane and her confession invalid. The 1871 and 1881 census reveals Harriet living in an asylum and her daughter, Violet, being brought up by her parents with no contact between them.

In 1869, John Stuart Mill argued in favour of legal and social equality between men and women. He wrote that 'the legal subordination of one sex to the other' is 'wrong in itself, and now one of the chief hindrances to human improvement':

The wife is the actual bondservant of her husband: no less so, as legal obligation goes, than slaves commonly so called ... she can acquire no property, but for the husband: the instant it becomes hers, even if by inheritance, it becomes *ipso facto* his ... This is her legal state. And from this state she has no means to withdraw herself. If she leaves her husband she can take nothing with her, neither her children nor anything which is rightfully her own. If he chooses he can compel her to return by law, or by physical force; or he may content himself with seizing for his own use anything which she may earn or which may be given to her by her relations. It is only separation by a decree of a court of justice which entitles her to live apart without being forced back into the custody of an exasperated jailer.[99]

There was still some way to go. Infant Custody Acts of 1873 and 1886 built upon Caroline Norton's successes and embraced greater equality, with the welfare of the child and both the conduct and wishes of each parent now being taken into account.

The Married Women's Property Act 1870 had removed the disadvantages around property and earnings and put an end to coverture. A married woman was now allowed to hold her own property and also retain her income independently of her husband. Married women were also allowed to inherit property in their own names and the financial maintenance of any children became the responsibility of both parents. The Act was amended in 1882, allowing women further property rights and most significantly this established the 'separate legal personhood' of women. With women now equal and responsible individuals in the eyes of the law, most arguments against full female suffrage could be dispelled. At last most of the legal disadvantages women suffered as a result of coverture law were removed. But male authority within marriage still prevailed. In 1891 a Mrs Jackson left her husband for another man. Mr Jackson kidnapped her as she was leaving church and dragged her home. Mrs Jackson took her husband to court but only won her case on appeal. If a husband ever had the legal right to beat his wife, said Lord Halsbury, that entitlement was now obsolete.[100]

But still no grounds for divorce other than adultery were recognised. Women remained second-class citizens and, in this respect, would stay that way throughout Victoria's rule.

Attitudes to Work and Education – Subversion of the Proper Social Order?

Although Britain was arguably the world's most industrialised nation by the Victorian age, its approach to education lagged behind: 'Education in general and primary education in particular were probably as finely and self-consciously differentiated by social class [in nineteenth-century Britain] as they have been at any other time and place ... this statement is especially true of the education of the working classes.'[101]

The debate about equal education for boys and girls had started by 1694 when Newcastle-born philosopher Mary Astell, well known for her theories on the education of women, wrote, 'If all Men are born

free, how is it that all Women are born Slaves?'[102] Astell claimed that women should receive an education equal to men and furthermore should be able to opt not to marry if they wished.

Harriet Martineau, the daughter of a textile manufacturer from Norwich, was born in 1802. Her parents maintained progressive views on the education of girls and when she was eleven, Harriet and her sister Rachel were sent to a school also attended by boys. At fourteen, Harriet went to a boarding school run by her aunt near Bristol. By the time she was fifteen Harriet left school, her education considered finished. Any time spent reading or writing was considered wasteful. Though Harriet and Rachel received a similar education to their brothers, only the boys were expected to use their education to benefit their careers. This did not impress Harriet, who wrote 'On Female Education', a critical account of her own educational experience, and published it anonymously in the Unitarian publication *Monthly Repository*.[103]

In this piece she pointed out that women rarely had any opportunity to demonstrate how intellectually similar they were to men, for while boys were preparing for a career, 'the girl is probably confined to low pursuits, her aspirings after knowledge are subdued, she is taught to believe that solid information is unbecoming her sex; almost her whole time is expended on low accomplishments, and thus, before she is sensible of her powers, they are checked in their growth and chained down to mean objects, to rise no more; and when the natural consequences of this mode of treatment are seen, all mankind agree that the abilities of women are far inferior to those of men'. Harriet Martineau argued that the work of several notable female authors had proved that women were equally able to comprehend 'the noblest subjects that can exercise the human mind'. It would be another forty years before this fact was formally recognised.

As the Victorian era dawned, nothing much had been done about improving the quality of female education. The purpose of learning for girls was to make them better wives and mothers, not to help transform them except in terms of social skills and manners to make them decorative, modest, marriageable beings. Lessons often included music, Latin, Greek and classes in social graces and etiquette. Only the very privileged few were taught to a high level in subjects such as mathematics, and this was usually alongside their brothers. In *Household Education*, Harriet Martineau argued:

I mention girls, as well as boys, confident that every person able to see the right, and courageous enough to utter it, will sanction what I say. I must declare that on no subject is more nonsense talked, (as it seems to me) than on that of female education, when restriction is advocated. In works otherwise really good, we find it taken for granted that girls are not to learn the dead languages and mathematics, because they are not to exercise professions where these attainments are wanted; and a little further on we find it said that the chief reason for boys and young men studying these things is to improve the quality of their minds...

If it is said that the female brain is incapable of studies of an abstract nature – that is not true: for there are many instances of women who have been good mathematicians, and good classical scholars. The plea is indeed nonsense on the face of it; for the brain which will learn French will learn Greek; the brain which enjoys arithmetic is capable of mathematics. If it is said that women are light-minded and superficial, the obvious answer is that their minds should be the more carefully sobered by grave studies, and the acquisition of exact knowledge. If it is said that their vocation in life does not require these kinds of knowledge – that is giving up the main plea for the pursuit of them by boys; – that it improves the quality of their minds. If it is said that such studies unfit women for their proper occupations – that again is untrue.

Men do not attend the less to their professional business, their counting-house or their shop, for having their minds enlarged and enriched, and their faculties strengthened by sound and various knowledge; nor do women on that account neglect the work-basket, the market, the dairy and the kitchen.[104]

Women's education always conformed to class expectations. Working-class girls, if they were educated at all, were taught the very basics of reading, writing, arithmetic and domestic skills such as needlework. They were taught in elementary schools, often dame schools – small schools run by working-class women in their own homes – or Sunday schools run by the church or charities. Women were not encouraged to harbour academic aspirations in case it undermined their attachment to the home; furthermore, it was believed that academic study was

against women's nature and that too much knowledge could affect their fertility. Church leaders were often hostile to women's higher education because they said it ran contrary to the teachings of the Bible. With no formal state education system, early Victorian education reflected the country's class structure.

In 1835, the Supervisory Committee of the Privy Council on Education reported that dame schools were 'in the most deplorable condition ... regular instruction among their scholars is absolutely impossible'.[105] As dames were by and large 'elderly and impoverished widows [stirring] the soup with one hand and [holding] a penny cane in the other',[106] such dame schools provided only the most basic learning opportunities. Shoemaker's daughter Mary Smith's[107] Oxfordshire dame school experience was typical of the early Victorian period. Mary spent most of her time knitting and sewing and 'learned nothing or next to nothing' from the 'old dame' who she described as 'a very antique specimen of humanity'.

Mary was later sent to a small private school by her father. She enjoyed learning scripture, history and English literature but still, 'a girl's education at that time consisted principally of needlework of various descriptions, thus I did an endless quantity of embroidery – children's caps, aprons, and many other things'. Needlework was emphasised as a necessary skill for girls as preparation for marriage and domestic work but it also provided vocational training for textile work. Her father took a great deal of interest in Mary's education and her abilities, and ensured that she learned mathematics. However, most of her schoolmates' parents were 'prouder of their daughters' pieces of needlework than of their scholarship' and the rest of Mary's family thought her aptitude for mathematics unnatural for a girl. As there was no state-funded education at this time, children only attended school when their families could afford it and therefore Mary had to leave school at the age of ten when the family's financial situation precluded this. Very often, girls like Mary would be sent out to work to contribute towards the family purse, although some parents withdrew their daughters from school for the simple reason that they didn't consider a formal education necessary for a girl.

In 1839 the Committee of Council of Education inspected schools. It is interesting to read a report of one of these inspectors: 'In the girls' schools that I visited, half of the time was devoted to needlework, a

portion of the proceeds of this sale was commonly used to purchase small articles of clothing for the children.'[108]

Mary Ann Hearn[109] briefly attended a dame school in Farningham, Kent in the early 1840s followed by a short period at a Nonconformist school. Joseph and Rebecca Hearn were typical of early Victorian working-class parents who regarded formal education as a distraction from their daughters' more important domestic duties. Restricting his daughter's access to books, Joseph remarked that 'he did not think such knowledge would ever be of much use to [her]' whilst Rebecca believed that a girl's education should largely consist of 'the exercise of household arts'. The concept of individual self-improvement was a key focus through all classes of society, but not, perhaps, when it clashed with the widespread understanding of a female's true role in life.

The education of daughters was regarded as an unnecessary expense, as nothing much was expected of girls, and moreover was rarely even a possibility for poor families. Many middle-class girls would be taught at home by their mother or possibly either sent to a small boarding school or educated by a governess, who may not have been that well educated herself. If home-schooled, girls would not receive such a different education from their brothers as the curriculum would depend on the ability of their mother and the family finances. However, if it was possible to afford to hire tutors, girls would cover 'ladylike' topics whilst boys would focus more on science and mathematics. The engagement of a governess was often seen as an indication of affluence.

Some families did encourage their daughters to have a meaningful education, as was the case with Millicent Fawcett and her sister Elizabeth Garrett Anderson. The Garrett sisters illustrate the change in middle-class girls' education during the nineteenth century which allowed girls to embark on a formal academic education reflecting that provided to boys, eventually leading to higher education and previously unattainable careers.

Early Victorian middle-class girls seldom studied academic subjects. They learned 'the three Rs' but these were a small part of the curriculum with most of the time being given over to what were termed 'accomplishments': languages, drawing and music, often referred to as an 'ornamental education'.[110] Ultimately, these girls were expected to become philanthropists, wives and mothers, running their homes according to what they had been taught.

Millicent and Elizabeth's education began at home in Suffolk where they were taught firstly by their mother and later by a governess – whom they heartily disliked – before being sent as teenagers to the Boarding School for Ladies in Blackheath.[111] Of course, mothers were not qualified teachers and most were not formally educated; as the daughter of a publican, Louisa Garrett did not receive a formal education herself and her education centred on basic reading, writing and arithmetic: 'A governess at home, for a short period, was the usual fate of girls ... their brothers might go to public schools ... but home was considered the right place for their sisters.' Writer and activist Frances Power Cobbe 'was supplied only with simple ... lessons by my gentle mother'[112] in reading and writing. Governesses would also often be expected to teach girls deportment, correct posture and how to behave like a proper young lady.

In the first half of the nineteenth century opinions on the content of a young society lady's education still emphasised the superficial. Of course they must learn to read and write, but the emphasis was firmly on French, drawing, dancing, music, and fancy needlework. 'To get ready for the marriage market a girl was trained like a race-horse. Her education consisted of showy accomplishments designed to ensnare young men. The three Rs of this deadly equipment were music, drawing and French administered by a governess at home, or, for girls below the aristocratic and the higher professional ranks, by mistresses in an inferior boarding school.'[113]

Mrs General in Charles Dickens's *Little Dorrit* believed that educating the surface was the acme of perfection. Young ladies should never be so unladylike as to have great purposes or great ideas; and a truly refined mind will seem to be ignorant of the existence of anything that is not perfectly proper, placid and pleasant. Therefore, any education a young lady received was not for her own benefit and personal growth but for the benefit of her husband and family as well as the wider community through charity and public benevolence. These ideas would be inculcated in girls from their early childhood, with the traditional female role of wife, mother and philanthropist also being reinforced through the church. With marriage the only career open to society girls, it is not surprising to find their education of such a nature as to cultivate their 'charms' rather than their minds.

Sophia Felicité (Sophy) Curzon, of the Kedleston Curzons, was born in 1835. A marked dissimilarity can be seen between the

educational experiences of the two Curzon girls and their brothers. Whilst George and Alfred attended Rugby public school and the University of Oxford, Sophy and her sister Mary were taught at home by a governess. The boys would have been brought up to believe they had a place in society as shapers whilst the girls were to be nurturers, and they would be expected to accept that their brothers' education was to take precedence over theirs. This sheltered upbringing may have implanted the sense of inferiority in Victorian girls at an early age, effectively training them for total dependence on their future husbands and their 'superior' wisdom and education.

Whilst middle-class mothers were generally responsible for their children's education in the early Victorian era, the vast majority of upper-class Victorian girls were educated at home by governesses. By the middle of the century there were around 21,000 women carrying out this role and many of them formed affectionate relationships with their pupils. However, many of them were not formally trained themselves as no establishments then existed for that purpose. Charlotte and Anne Brontë each took up a position as a governess and their experiences found their way into their respective works *Jane Eyre* and *Agnes Grey*. Jane Eyre advertises her services as the ability to 'teach the usual branches of a good English education, together with French, Drawing and Music' and then as an aside offers that 'in those days, dear reader, this now narrow catalogue of accomplishments would have been held tolerably comprehensive'.[114]

Educational reform had begun to gain momentum in the 1840s. Most children, whether boys or girls, were first taught at home by either their mothers or by hired governesses, and these women had very often not received any formal education.

Frances Power Cobbe was sent to a Young Ladies' Academy in Brighton in 1838: 'The din of our large double schoolroom was something frightful. Four pianos might be heard going at once in rooms above and around us while at numerous tables scattered around the rooms there were girls reading aloud to governesses and reciting letters in English, French, German and Italian. This hideous clatter continued the entire day.'[115] The inspiration for Charlotte Brontë's Lowood Hall in *Jane Eyre* was the School for Clergyman's Daughters at Cowan Bridge in Yorkshire, which the Brontë sisters attended, and it is hard to imagine that incidents involving Helen

Burns and the other girls in the novel were not based at least loosely on reality:

> ... the teacher instantly and sharply inflicted on her neck a dozen strokes with the bunch of twigs. Not a tear rose to Burns' eye; and, while I paused from my sewing, because my fingers quivered at this spectacle with a sentiment of unavailing and impotent anger, not a feature of her pensive face altered its ordinary expression. Next morning, Miss Scatcherd wrote in conspicuous characters on a piece of pasteboard the word 'Slattern', and bound it like a phylactery round Helen's large, mild, intelligent, and benign-looking forehead. She wore it till evening, patient, unresentful, regarding it as a deserved punishment.[116]

Helen Burns was based on Charlotte's eldest sister, Maria, who, like Helen, died of consumption. 'I need hardly say, that Helen Burns is as exact a transcript of Maria Brontë as Charlotte's wonderful power of reproducing character could give.'[117] In fact, Charlotte said that she would not have described Lowood as she did if she had thought the place would have been so immediately identified with Cowan Bridge.[118]

But separate spheres ideology still influenced education. Teaching girls would give them ideas about what may be available to them; it could even encourage them to think that they could train to work for a living and not only forego their 'natural' place – in the home – but equip them to fight for additional rights.

Once campaigners began to argue that a female should have the same education as a male, the genie was out of the bottle. How could the law fail to recognise the equality of individuals who had received a similar education? In 1837 Victoria had become the first female ruler in 123 years. She was the only female to escape the legal impediments that saw all other women controlled by their fathers and then handed over to their husbands.

There was a marked difference in the educational experience of Victorian girls of the working class, the middle class and the upper class. As British Victorian society was stratified by social class as well as gender, women and girls were often treated as a class apart even where they shared the same social class as males; within all classes, women's inferior and subordinate status to men was taken as read and was reflected in nineteenth-century education policy where children

of different classes as well as different genders experienced different forms of schooling and education. It was thought that boys needed a higher level of education to prepare them for paid employment in the public world, whilst it was considered wasteful to spend time educating girls in the same way as they were destined for domesticity.

Therefore, working- and middle-class girls would receive only as much education as was considered necessary for them to sufficiently carry out their roles in society. Victorian schools aimed to impart basic knowledge and religious instruction and also to teach certain habits and manners considered appropriate for the 'lower orders', so girls would be trained to be good servants, wives and mothers. Boys and girls would have separate entrances, classes and seating arrangements. The curriculum also differed; while girls and boys were generally offered the same morning curriculum, comprising reading, writing and religious instructions, boys did arithmetic in the afternoon while girls did knitting and needlework.[119]

Early Victorian girls' boarding schools did not promote many alternatives to marriage, either, and this approach was bolstered by popular attitudes. In George Eliot's *The Mill on the Floss* (1860), Maggie Tulliver is smart and intelligent and wants the same education as her brother, only to be told by the teacher that girls 'can pick up a little of everything, I dare say ... they've a great deal of superficial cleverness: but they couldn't go far into anything. They're quick and shallow.'[120]

But by the 1860s, a Schools Inquiry Commission was set up and chaired by Henry Labouchere, 1st Baron Taunton, after whom it is often referred to as the Taunton Commission. The commission found no difference between the mental capacity of boys and girls and was greatly concerned about the lack of provision of education for girls; in the whole of England in the mid-1860s there were only thirteen girls' secondary schools, and in these the curriculum was very narrow.

The commissioners were not impressed by what they found: 'It cannot be denied that the picture brought before us of the state of Middle Class Female Education is, on the whole, unfavourable. Want of thoroughness and foundation; want of system; slovenliness and showy superficiality; inattention to rudiments; undue time given to accomplishments, and those not taught intelligently or in any scientific manner; want of organisation – these may sufficiently indicate the character of the complaints we have received, in their most general aspect.'[121] Here was the start of education for girls becoming more

widespread and the gaps between boys' and girls' curriculums being narrowed.

The girls' department of Hillsborough School in Sheffield and its head, Miss M. Taylor, were more forward thinking than most. In order to brighten up the school, Taylor decided that pictures should be bought for each of the classrooms, the money being provided from the proceeds of a concert, and to motivate attendance a silk banner was hung in the room used by the class with the highest attendance. The curriculum here was, for its time, innovative, covering various science topics: 'Adhesive Substance, Iron, Steel, Copper, Lead; Seeds and Germination; Water, Steam; Rain, Mist, Dew, Snow, Hail; Paraffin, Oil, Coal, Carbonic Acid, Gas; Ventilation; How Heat affects Substances; Thermometer; Parts of a Plant; Human Body'.[122]

However, concerns about infant mortality led to working-class mothers being blamed for their lack of knowledge about childrearing. Subsequently, working-class girls at Hillsborough were trained in housecraft skills through the introduction of other subjects such as domestic economy, cookery, laundry work and childcare, drawing praise from the inspectorate: 'This ably conducted school is taught with intelligence, skill and marked success. Domestic Economy taken for the first time is exceedingly well-mastered.'[123]

Before the establishment of girls' secondary schools, middle-class girls normally received a different education to working-class girls. At the same time, the falling birth rate in the 1870s was perceived to be the fault of upper- and middle-class women; some Victorian doctors strangely asserted that study and education had a damaging effect on a woman's reproductive abilities, and many families refused to allow their daughters to pursue higher education even when Cambridge admitted women from 1869 and Oxford from the 1870s, fearing it would lead to rebellion and a lack of matches.

Emily Davies, a suffragist and campaigner for women's and girls' education, highlights this inequality:

Parents are ready to make sacrifices to secure a tolerably good and complete education for their sons; they do not consider it necessary to do the same for their daughters. Or perhaps it would be putting it more fairly to say, that a very brief and attenuated course of instruction, beginning late and ending early, is believed to constitute a good and complete education for a woman.[124]

Allowing women to further their education would lead to opportunities for freedom, the appetite for additional rights and the consequent damage to the construct of separate spheres and ultimately to a revolution in how men and women related to each other. University education was, it was reasoned, completely unnecessary for women. Their place was in the home, so why would they wish to train for any sort of profession that they would be unsuited for, being as they were inferior to men both physically and intellectually? In any case, it was widely assumed that women were not capable of sustained study and any attempts towards this should be better spent on preparation for marriage and motherhood. Imitating boys and men by studying the same subjects was considered undermining towards the gender division of labour. The prevalent upper-class view towards women's education was encapsulated by Noah Webster who approved of girls' education so long as 'it rendered the ladies correct in their manner, respectable in their families and agreeable in society, [but] that education is always wrong which raises a woman above the duties of her station'.[125]

For upper- and middle-class boys, secondary education was focused on training them to be active in the public sphere whilst their female counterparts were presented with an appropriately feminine curriculum typically covering foreign languages, sewing and painting. Incorporating the Victorian ideal of girlhood and womanhood, this paradigm almost took on a life of its own independent of any one individual experience, emphasising the model of masculine superiority and feminine subservience, reinforcing the division of the moral, intellectual and emotional universe into those separate spheres,[126] thus creating the 'emergent, provincial, middle class culture'[127] and view about family roles, which applied to the upper class as well.

The cult of domesticity split home and the outer world into the private and public spheres. Men would dominate the public sphere of enterprise and competition whilst women were to be the providers of love, emotion and home comforts once they returned home. The Victorian woman was expected to be devoid of any ambition outside the house. Upper- and middle-class girls were drenched in the concept of domesticity to perpetuate notions about family love and the purity of womanhood once they married. Therefore the teaching of 'accomplishments' was particularly important as they were skills useful in the marriage market.

A further aspect of Victorian upper- and middle-class values was the 'pursuit of gentility'. Characterised by material wealth and the outward display of particular personal and cultural attributes, this became a social status symbol of the ruling classes. The public perception of the 'head of the household' provided the measure of the family's social status whilst the measure of gentility rested on the social and cultural activities of the female of the species.

The path to womanhood for early and mid-Victorian daughters was an expectation to stay at home with their parents until they married, and to learn to participate in social and charitable activities along with their mothers, such as Sunday school teaching or provision of charity to the poor. In this way they would become aware of the formalities of society and at home contribute to the household through skills like needlework, music and painting. This widespread ideology was not feasible in all families, particularly in the lower middle class. They were expected to get married, and if they didn't their options were limited, certainly in the early Victorian era. A girl whose family could not support her financially would have to support herself or become dependent on another relative, neither of which were particularly enticing options. Living with relatives frequently meant becoming an unpaid servant and employment opportunities were so limited as to be almost non-existent.

Schooled in romance and steeped in a sense of their limited destiny, some girls would latch onto any potential prospect. 'Any person who will snatch her out of the dullness of her life and give her … something to do' was an acceptable recipient for the attentions of an idle young woman.[128] 'I understand that girls often make a false marriage and plight their faith to an unreal shadow who they suppose inhabits a certain body,' wrote Harriet Beecher Stowe to George Eliot.[129] But some Victorian girls, when they reached the end of their education felt they wanted more than marriage, a bigger purpose. George Sand felt 'a great yearning for love and a void in my heart' when her education came to an end.[130]

The Curzon girls were taught, probably from the age of about five, by Sophia Locking, who had grown up in York. She was the eighteen-year-old daughter of George Locking, secretary of the Hull and Selby Railway Company. Whilst governesses would be regarded as socially superior to the servants owing to their upbringing and post, they were not necessarily viewed as equal to the family members. However,

at Sophy Curzon's 1854 wedding, Sophia Locking was the only household employee to be invited.[131]

John Gibson Lockhart wrote in *Quarterly Review* that the governess 'is our equal in birth, manner, and education, but our inferior in worldly wealth'.[132] But where were they to obtain this education? The establishment of Queen's College (1848) by the Governesses' Benevolent Society and Bedford College (1849) in London kickstarted the advancement towards equality of middle-class girls' education. The original aim of Queen's College was to prepare girls and young women to become governesses and acquire formal qualifications; admittance to middle-class girls aged twelve and above swiftly followed. The significance of this form of female education was endorsed by both the inaugural support of male academics at King's College and by a royal charter from Queen Victoria in 1853.

The first prospectus of the ladies' college in Bedford Square, founded by Elisabeth Jesser Reid, begins by stating:

It is now a year since Queen's College, in Harley Street, was founded for the Education of Young Ladies. The success of this Institution proves that its founders rightly estimated the demand for a better and more extended system of female education than any which has previously been accessible.[133]

The first women's higher education facility in England, Bedford College influenced the development of the women's higher education movement and contributed in important ways to the foundation of other women's colleges later in the century. As a result, education later became one of the main areas for campaigning for women not only to become qualified for the professions, but to learn for learning's sake.

When completing her census form in 1911, Marie Blanche Thornton wrote across the bottom of it: 'I protest against the right of the Government to demand the above information from me, as a woman householder, when it withholds from me, as such, the parliamentary vote.'[134] Marie had joined Bedford College in 1898 and in later years, she gave her address as the University Women's Club.

Frances Buss, daughter of an artist who questioned why women were 'so little thought of', wanting 'girls educated to match their brothers',[135] attended evening classes at Queen's College, passing examinations in geography, French and German whilst teaching

during the day. Frances found the experience inspirational: 'Queen's College opened new life to me, I mean intellectually. To come into contact with the minds of such men was indeed delightful, and was a new experience to me and to most women who were fortunate enough to become students.'[136]

In 1850, the North London Collegiate School for Ladies admitted its first pupils. Frances Buss was headteacher, and by 1871 she had also founded the Camden School for Girls for families with more modest incomes. Across the two schools, places were provided for 700 girls.

A school that was partly a 'young ladies' academy' aimed at preparing girls for their future place in society but also partly reforming – several of her girls later attended university – was Laleham, run by Hannah Pipe. She had opened her first school in Manchester in 1848 and transferred this to London eight years later, successfully running the school until 1890.[137] Hannah Lynch, however, was sent to a convent school in Birmingham in the 1850s and asked in her 1899 autobiography, 'Do the ladies of Lysterby continue to train atrociously and mismanage children, to starve and thwart them, as they did in those far-off days?'[138]

Cheltenham Ladies' College opened in 1853 to offer 'a sound academic education for girls',[139] and whilst also embracing the feminine ideal, progressive changes to the curriculum were made with the appointment of Dorothea Beale as principal. Though parents argued that it was not necessary for girls to study maths and sciences, the college nevertheless became one of the first girls' schools to teach science subjects and these became a publicity feature of the school prospectus. In 1858, Beale established a scholarship for students from her previous school, Casterton School in Yorkshire, to attend Cheltenham. The reputation of the college ensured that local families eventually wanted their daughters to be educated to as high a standard as their brothers. However, as she advised the Taunton Commission in 1866, the school only accepted the daughters of independent gentlemen or professional men, to the exclusion of working-class girls who may have been intellectual equals. Realising there was no formal teacher education programme in existence, Beale eventually set up a teacher training college at Cheltenham, St Hilda's College, with girls who completed the training then going on to become teachers there.

Work still needed to be done across the board. The Newcastle Report of 1861 into education in England had found that 'much,

therefore, still remains to be done to bring up the state of elementary education in England and Wales to the degree of usefulness which we all regard as attainable and desirable.'

In 1863 Cambridge local examinations were opened to girls of Cheltenham Ladies' College for the first time, following campaigning by Emily Davies with the involvement of external examiners. Such were the high marks, particularly from North London Collegiate School, that in time girls were encouraged to sit the Oxford Senior and the Cambridge Higher Local public examinations. The numbers of girls sitting these examinations rose over the next fifteen years, with marks proving superior to those of boys.[140]

The Schools Inquiry Commission in 1864 found that 'the wealthiest class very generally do not send their daughters to school; even in the middle class many more girls are wholly kept and educated at home than boys'.[141] This report, finally published in 1868, held up the domesticity-focused nature of girls' secondary education. Dorothea Beale had given evidence to the commission and wrote the preface to the 1869 Reports on the Education of Girls with Extracts from the Evidence, which criticised the average standard of teaching in girls' secondary schools as inadequate and questioned the equality of teaching of girls compared with boys. This drove forward the establishment of over 160 girls' schools in the next fifteen years. However, whilst the Commission found that girls were well able to compete with boys with regard to academic standards, the curriculum was still required to be differentiated by their roles, focusing on domesticity and feminine pursuits for girls.

Although there is a robust argument that the Taunton Commission was a key step forward in the improvement of female education, this didn't gain momentum until after considerable lobbying. Matthew Arnold, poet and Inspector of Schools, indicates as much: 'I can hardly think that the new Commission, with all it will have on its hands will be willing to undertake the enquiry into girls' schools as well as that into boys.'[142]

Many girls with radical family backgrounds, or who were more forward-thinking themselves in terms of female education, went on to become key players in the women's movement and it is clear that their education was a crucial component in this. Without intervention from women's rights activists, girls' education would likely have continued to be neglected. Elizabeth Elmy and Emily Davies had been

campaigning for girls to be given the same access to education as boys; Elmy set up the Manchester Schoolmistresses' Association in 1865 and in 1866 she became the first woman to appear at a parliamentary select committee when she gave evidence to the Taunton Commission.

Emily Davies counted Elizabeth Garrett Anderson and Barbara Bodichon among her contemporaries in the women's movement and became an active campaigner to improve women's education. Fired by the refusal of London University to allow Garrett to sit for the matriculation examination in 1862, the next stage of Davies' campaign was to establish a university college for women. Having always held reservations about the separate nature of examinations for women and 'Ladies' Lectures', she was insistent that the same level of education should be provided for women as for men and hoped to take advantage of the University of London's plans for a new charter to ask for inclusion of women's degree-level education. Davies set about organising a committee. She faced numerous obstacles along the way, including male educators insisting women were unsuited for higher education and would have a negative influence on male colleagues, but stuck to her principles, insisting that 'special' examinations for women equalled lower standards. Her belief was backed up by the plight of Annie Rogers. The top scorer in the University of Oxford's local delegacy examinations was typically granted a scholarship to the university, but in 1873 the offer to study at Worcester College was withdrawn when it was discovered that the candidate in question was a girl. Annie Rogers' offer was instead given to a boy whose grades were several places lower.

As Muriel Bradbrook wrote: 'Miss Davies had to be a perfectionist, because the prejudice and assumption of the inherent inferiority of women's intellectual capacity must be exposed in an unambiguous fashion. Admission to degrees, good or bad, was the intellectual equivalent of the Vote. Justice must be done and must be seen to be done.'[143] Barbara Bodichon was the first to donate funds to the founding of the college and the Endowed Schools Act of 1869 proved instrumental to their aims, acknowledging for the first time that girls had the right to a 'liberal education'. And so, on 16 October 1869, the College for Women opened at Hitchin in Hertfordshire with five students and changed the face of women's education. It would become incorporated into the University of Cambridge as Girton College four years later. Students became known as 'Girton Girls' and inspired a New Woman poem by Andrew Lang:

She has just 'put her gown on' at Girton,
She is learned in Latin and Greek,
But lawn tennis she plays with a skirt on
That the prudish remark with a shriek.[144]

'In a way, the opening of Girton changed everything,' says Professor Susan Smith, current Mistress of Girton. 'It opened a doorway and was part of an unstoppable movement across the UK whereby women were seeking to improve their participation in wider society.'

Work was progressing at lower levels of education to develop the future pipeline of girls to higher education. The Newcastle Report and the Taunton Commission led on to the Elementary Education Act of 1870 which, whilst indicating that the government at last seemed to accept accountability for the education of children aged between five and thirteen, was still only the beginning. One of the key factors was the creation of school boards which it was planned would work to bring democracy to the education process and make schools answerable for the quality of education they delivered.

Though the structure was now in place to manage elementary education, the education gap between social classes was widening, and secondary education was still largely outside the remit of working-class girls. Grants were made available to deliver compulsory domestic education for girls within the elementary school curriculum.[145] It could be argued here that instead of providing an education to girls to enable them to become independent or break out of their social confines, the intention was to impress upon them their future role as an economically dependent wife and mother, prepare them to raise a family which would form part of the future workforce and of course provide a traditional haven at home for the male breadwinner.

On the other hand, eligible women were allowed to vote for the school boards and could also serve on those boards, which gave them an opportunity to prove their capability in public administration and provided a platform for campaigning to improve education for girls. The first four females elected to local school boards in 1870 were Lydia Becker, Emily Davies, Elizabeth Garrett and Flora Stevenson. Disappointingly, though, women were often allotted to suitably 'female' committees such as the 'needlework sub-committee'.

In 1871 two governess- and boarding school-educated sisters, Maria Grey and Emily Shirreff, formed the National Union for

Improvement of the Education of Women of All Classes (later to become the Women's Education Union). They aimed to improve educational standards for women and raise the profile of female teachers, providing bursaries to support female student teachers. Mary Gurney, however, was described as the union's most influential member and, along with fellow council member Henrietta, Lady Stanley, she attended a public meeting in Sheffield Cutlers' Hall to promote the idea of a girls' school in Sheffield. The Girls' Public Day School Trust was established in 1872 and financed schools through the sale of shares in the company. In 1878, Sheffield High School for Girls was opened to its first thirty-nine pupils.

The Education Act of 1870 was followed six years later by Lord Sandon's Elementary Education Act, which put the responsibility on parents to ensure that their children, regardless of gender, received education in reading, writing and arithmetic. In the absence of school boards, school attendance committees were formed to manage attendance but the girls' curriculum was still domestically focused. It was only those schools run and managed by female educators that provided a more equitable curriculum on the same level as that taught to boys. It would be up to female educationalists to ensure that girls were taught to be more than a wife and mother. But even after the opening of girls' schools, women's colleges, the 1870 and 1876 Acts and the admittance of women into universities, it was still widely argued that education for women would damage the ideal Victorian family life.

Mary Gurney published an article in *The Englishwoman's Review* in 1878, 'The Establishment of Girls' Public Middle class Schools', as well as writing a book entitled *Are We to Have Education for Our Middle Class Girls? Or, The History of Camden Collegiate Schools*. She argued that the ruling classes had always had the privilege of education; the needs of the working classes were being addressed by Sunday schools and churches, particularly the Nonconformist faiths. Additionally, the gaps between boys' and girls' curricula were actually widened through social stratification; middle-class girls received exposure to more complex subjects than working-class girls did, even though they were still expected to aspire to domesticity and perhaps the supervision of domestic staff.

Eventually, Victorian educational theory became stratified into two levels: broad education and specific vocational education. The latter became problematic as women who wished to enter professions

such as medicine, law and architecture met with men's condemnation and outright ostracism. Therefore, when Elizabeth Garrett Anderson became the first woman to qualify as a GP, she and her colleague Sophia Jex-Blake encountered inflexible barriers to progressing in their chosen profession that took years to dissolve. 'She was capable, persistent and politically shrewd. She found a way round obstacles instead of charging at them,' writes her biographer Jo Manton.[146]

One line of thought was that having women in historically androcentric professions would lower the value of said professions. Men refused to see a woman doctor. Women refused to break with the norm, or more correctly their husbands refused to allow them to.

But by the time the 1890s arrived, elementary education had been effectively formalised for two decades and women had been accepted into universities, undertaking programmes of study, but they were not allowed to graduate. Not yet. And even though there was still some way to go, teacher training colleges were proving a success. As for Girton College, Agnata Frances Ramsay was the only student to place in the first division of the first class for the Classical Tripos in 1887, and received a signed photograph from Queen Victoria in recognition. Women were sustaining their positions on school boards, with 128 female members in England and Wales in the three years between 1892 and 1895,[147] and taking roles in government offices as factory and health inspectors as well as nurses and teachers, all of which helped promote the feminist agenda.

Although women joined the workforce at the London County Council offices in 1898 following a recommendation by the Clerk of the Council, they were not treated equally:

On entering the Service the [male] Junior Clerks receive a commencing salary of £80 a year and naturally look forward to rise in course of time to the higher classes and to perform the more important work devolving upon officials in those classes. The necessary copying or typewriting work has, however, to be done and, as above pointed out, forms a portion of duties of clerks who have been for some years in the service and who are in receipt of salaries of £100 a year or more. A copying department composed of Lady Clerks would gradually relieve some, at any rate, of the departments of the ordinary copying and typewriting, and would result in a considerable saving

in as much as the pay of Lady copyists would, if the scale in government offices is adopted be from 16/- to 25/- a week, with a somewhat higher salary for a superintendent.[148]

In fact, before a year had passed, another recommendation was made to the council that women would have to resign their posts when they married.

Women such as Frances Buss and Dorothea Beale were innovators in that they refused to bow to many types of resistance from society and authority, and were sufficiently knowledgeable and confident enough to press forward with what they knew: that girls were just as logical, competent and deserving of being educated as boys. They refused to give up when obstacles emerged, with Buss stating, 'If there were a hedge in front, and we could not get through it, we must get under it, or over it, or round it. We must get somehow to the other side.'[149] Dorothea Beale also founded St Hilda's College, Oxford, in 1893, the last of the women's colleges established in Oxford to give women the right to continue their education and which would remain solely open to women for over a century. These women proved the 'science' arguments wrong, and not only opened up educational and employment opportunities to women but paved the way for advances in equality over the next 100 years.

Victorian Working Women

An understanding of the female workforce in the Victorian era can only be achieved against a background of cultural representations of women at the time, ideals of womanhood, apprehension about 'surplus' – i.e. unmarriageable – women and the work roles available to them. Debates raged: what would be the effect on society if middle-class women were to be educated, trained and employed? Furthermore, what kind of work they could actually do? Was it suitable, were they capable, and what would be the effect on men and their working roles once women were allowed into the public sphere in this way? The greater number of women than men in the population caused concern: 'The lack of husbands presented special difficulties for woman of the middle classes, women who were not raised to work, who had neither the education nor training for work, and whose family fortunes were not extensive enough to provide life-long support for unemployed spinsters.'[150] Additionally

the Victorian tradition of female dependency, a middle-class ideal, was at odds with reality for working-class women.

The majority of the London working classes experienced poor living conditions and below-subsistence income in the last half of the nineteenth century. Being a dependent wife and mother, supporting the husband in business and running the home was beyond the realms of possibility for many women, with whom the Angel in the House image probably never even registered. A study carried out by statistician Arthur Lyon Bowley[151] built on earlier work by Charles Booth and Seebohm Rowntree and looked at income in working-class households in twelve different British towns. This study concluded that only around 5 per cent of families were able to subsist on the husband's wages. Whilst many of those families would have children of working age to supplement the family income, many wives would have to work as well.[152]

Then again, many unmarried women would be required to support themselves, and to do this they needed a job. Practical thinking, and action, was needed. No longer was it acceptable to ponder what damage would be done if women entered the world of work; they had already begun to enter educational establishments. The educational reforms that accompanied these developments had already initiated debates that would fragment the spheres, throw down the gauntlet to entrenched ideas and question the correlation of dependency and femininity. There was still much dissension from those who felt that a woman's place was in the home and that educational and work opportunities would destabilise this arrangement. At the other end of the spectrum was the freedom-fighting New Woman. Somewhere in the middle, it was possible to make limited progress by arguing that an education would benefit women by developing their character, morals and thinking skills, but only insofar as this would be beneficial in their 'natural' capacity as a good wife and mother.

Sadly, women who chose to work were thought of as damaged goods; something had gone wrong in their lives to force them out into the world of work, went the general consensus. Of course, the fear was also that once they got a taste of life outside the house and a modicum of independence – dependent on the working role they undertook – the thought of marriage would be less appealing, particularly for reasons of necessity. This would threaten the Victorian ideal; never mind that during the Industrial Revolution around 75 per cent of

working-class women had worked in industries such as the cloth trade and that this was not unusual.

To demonstrate real progress, it was necessary for education to lead to personal independence, more opportunities outside the home and a transformation of beliefs about what it meant to be not only a wife and mother but, moreover, simply a woman in the Victorian era.

Occupations became segregated into those that were proper and suitable and those that were more dubious. Nursing and teaching, for example, fell into the former category as these jobs were a natural extension of the domestic role, requiring a woman to use her instinctive capacity for caring and nurturing as well as knowledge and training. Such roles would not deviate too much from a woman's expected societal position and were often presented in the popular press and women's magazines as philanthropic endeavours rather than the skilled professions they were.

Nursing was already made acceptable through the examples of Florence Nightingale and the nurse – and later novice nun – Sister Dora. These women were professionalising the actions of caring and nurturing, remaining true to their female 'calling'. In their roles, however, women would have to navigate difficulties with male doctors and deal with antagonism and prejudice, not least the fear that men were becoming marginalised in the profession.

So what was the catalyst for an acceptance that middle-class women were entitled to work and could be good at it whilst contributing to their families in a different way, as well as to society and the economy? Employment represented independence, self-respect and political involvement for the middle-class woman, where working-class women would work for survival reasons in the first instance before other considerations. It can therefore be seen that class was a factor in the development of women's work.

Though one size did not fit all – such an approach would deny human differences between women – many middle-class women were frustrated at the enforced indolence that characterised their lives, and many of those who sought an education wanted to do something with their learning. They wanted to be educated for employment. There was also a growth in commercial education following which many women went into office work, resulting in most of the first wave of female clerks coming from the middle classes. Many new opportunities for literate, educated middle- and upper-class women in clerical and

office work emerged towards the end of the nineteenth century – these were informally known as 'white blouse' occupations.[153] In fact, the census data between 1851 and 1911 shows a mammoth eighty-three-fold increase in female clerical jobs, twelve times greater than the concurrent increase in male office-based roles. Regardless of Sarah Ellis Stickney's views that a middle-class woman who chose to work 'ceased to be a lady', this was often not enough.

The Langham Place Group, organised by Barbara Bodichon and Bessie Raynes Parkes, was probably the forerunner in the activities to increase employment opportunities for women. Both women had already produced numerous articles on these topics: Parkes wrote *Remarks on the Education of Girls* in 1856 and Bodichon authored *Women and Work*, published in 1857, setting out a vision for women's education and employment.

The Society for Promoting the Employment of Women was formed in 1859, focusing on female employability and finding them suitable and appropriate jobs. But the initial focus here was on single women, galvanised by research by Harriet Martineau and the findings of the 1851 census on 'surplus women', which gave way to the 'Woman Question'. Their objective was explained as the promotion of 'the employment of women in occupations suitable for their sex, by collecting and diffusing useful information on the subject, by establishing an office which shall be a centre for inquiry by practically ascertaining the capacity of women for some of the occupations hitherto closed to them, and by encouraging their better and more complete education'.

They also focused on training young girls for new occupations rather than improving conditions, pay and opportunities in existing ones. Further articles emphasised that commercial training was the way forward in order to break down barriers to employment for women as outlined in Jessie Boucherett's later work *On the Obstacles to the Employment of Women*: 'The Committee will open classes for the instruction of women in bookkeeping and other branches of business; and it is hoped that the pupils may be able to compete for certificates at the yearly examinations of the Society of Arts.'[154]

Shop work and bookkeeping were highlighted as suitable areas of female employment, being both respectable and meeting a real requirement in society. The *English Woman's Journal*, edited by Bessie Rayner Parkes, and which appeared in 1858, was the first of many

such feminist periodicals which were to raise the public consciousness on these issues with articles on educated women's capabilities, the feasibility of their professional lives and the market for their labour. Challenges to the law of coverture and male dominance were also offered. Whilst women would be able to take advantage of training and classes organised by the society, they would still face fierce competition from men for some roles, particularly in clerical and bookkeeping jobs. Therefore, the society aimed to increase the number of available jobs for women through market research and business development. They may have had limited success in increasing the actual number, but they raised awareness of the possibilities and changed attitudes. The cultural acceptance of middle-class working women was highlighted through these publications, which gave rise to a redefinition of what it meant to be a woman at this time and what she could do.

Further publications aimed at raising awareness swiftly followed, featuring several articles on employability, job advertisements and job searching advice. *The Year-Book of Women's Work* – launched by Louisa Hubbard in 1875 – catered for the New Woman in search of a job with new job advertisements featured in each edition as well as guides to suitable job roles. This was then followed in 1880 by *Work and Leisure*, published monthly, and *Young Women*.

By the close of Victoria's reign the annual report of the society stated: 'The influence of the Society has extended more widely perhaps than its actual work ... it is quite impossible to say how far public opinion has been influenced by its persevering efforts and by the precedents it has established, nor yet how far the success of one well-trained woman recommended by the Society has opened the way for others.'[155]

The rise in office work opportunities is often attributed to the continual advancement of technology throughout the late Victorian period which included the typewriter, gramophone and both long-distance and subterranean telegraph cables. Pitman shorthand was first used in 1837 but gained momentum throughout 'the most prolific [century] ever known in shorthand invention'.[156] Bram Stoker's *Dracula* is packed with examples. The character Mina has 'been working very hard lately, because I want to keep up with Jonathan's studies, and I have been practising shorthand very assiduously ... if I can stenograph well enough I can take down what he wants to say

in this way and write it out for him on the typewriter, at which also I am practising very hard … I shall try to do what I see lady journalists do, interviewing and writing descriptions and trying to remember conversations. I am told that, with a little practice, one can remember all that goes on or that one hears said during a day.' Mina also uses a portable typewriter: 'I feel so grateful to the man who invented the "Traveller's typewriter" … I should have felt quite astray doing the work if I had to write with a pen.'[157]

However, clerical work, much of it confidential and high-status, had been carried out by men for centuries. It was almost seen as an artisanal role. 'Allowing' women to take on this work was interpreted as deskilling the role and condoning low pay. Assumptions were also made that women took jobs only until they were married, that training them to allow them to climb the career ladder was pointless as their ultimate goal was still marriage and family. Economic factors were also used as an excuse to pay women less, along with the status quo argument – it had always been this way; men deserved to be paid more than women as they were the more intelligent, superior beings. The onset of mechanisation in offices roughly coincided with the entry of women into the office, and has perhaps unfairly contributed to the negative press received by female office workers. Office work became more procedural and less creative and 'crafted'. Women were not only taking the 'jobs for the boys', they were devaluing them too as they were the ones who would be using the typewriters and adding machines that would replace older skills and also introduce new ones that many men would have found unacceptable.[158] The perceived threat to men from female office workers was alarming to the contemporary conformist opinion, leading to scathing attacks on feminism in the press.

Then again, office organisation and filing had been typically irregularly managed in nineteenth-century offices, with the overuse of loose-leaf bundles of papers, bulky ledgers and lack of clear storage and retrieval systems, leading to loss of documentation and key data and consequent staff time wasted in retrieving information. Lack of systems and handover procedures led to chaotic working practices. The introduction of mechanisation and systemisation, folders, filing cabinets and female workers transformed the office environment. The new technology, such as adding machines, freed up clerks to focus on more intricate and demanding work as they took care of the routine and mechanical work, whereas a typewriter opened up the way for

a new skill to be learned and the advent of the shorthand typist, for example, rather than deskilling the male clerical worker:

> Typewriting and shorthand writing are sister arts and time-savers; the copying press and other mechanical contrivances for multiplying copies of documents are of no less importance. None of these arts and contrivances have, until now, been brought to public notice, and advocated and encouraged through the channel of a bitter press.[159]

However, there was a further argument, or perhaps more accurately a fear: that a woman typist, secretary or clerk would simply become more independent at the expense of marriage, sacrifice her womanliness and, most inappropriately, brush shoulders with men in the office. Femininity and professionalism were presented as polar opposites, and difficult to reconcile, if not unattainable. Gender boundaries would be broken along with the taboo of women working outside the house. This seems unfair; the growth and development of commercial education as exemplified by the Langham Place Group had successfully prepared women for office jobs and as many of the students came from the middle classes, they made up the majority of female office workers. An important consequence of women joining the workforce parallel with office mechanisation was that typing became almost exclusively associated with women. Female clerks, though, and particularly young single women, were considered a 'secondary' labour force; the marriage bar forced them to resign their posts when they married, although it was possible for those who stayed single to rise through the ranks to supervisory positions, and the selection of office staff from among middle-class women gave a credibility and respectability to office work.

An area of contention, unsurprisingly, was wages. There was a perception that women would lower the going rate of pay for clerical work in general. Male office staff used the derogatory term 'pin money clerks' towards women but in reality most female office workers were single and lived at home with their families and did not spend their salary on entertainment and fashion. Usually, all income went into the family purse and single women living alone were in the minority. But male clerks had to accept their presence, and this was perhaps alleviated by their employment in secondary positions thought more

suited to them because of their feminine characteristics – leaving the more intellectual roles for the men. Additionally, the marriage bar ensured that those women who intended to become wives and mothers accepted the transience and limitations attached to their roles. Teaching, local government and banking all applied this rule. As the Civil Service clarified: 'Continuous and effective service is the first condition of permanent employment under the State, and a woman, as wife and mother, cannot be expected to work for the State continuously and effectively, and her service must therefore cease on marriage.'

Although male clerks initially feared for their jobs, by 1874 it appeared that female clerks 'would not in any way prevent a fair development of male clerks. There had been an unusually large number of male clerks appointed last year, and the lady clerks were doing a class of work that they could not get satisfactorily done by the male clerks.'[160]

From the 1880s offices grew in line with the economy, with the logical result that more data and information needed to be processed with speed and accuracy. Additionally, more large-scale organisations grew, particularly following mergers in the 1890s which also led to competition. In 1894, the Treasury offered 16/- per week as starting pay for women typists so as not 'to tempt applicants' but remarked that this moderate pay was reasonable because although women 'have proved themselves an efficient and economical form of labour ... copying with the aid of a machine ... is not difficult'. By the end of the Victorian era, shorthand typists were employed in most offices. The Registrar General's office replaced young male copyists with female shorthand typists who were cheaper to employ.

The mechanisation of the office facilitated efficiency. It seems logical to conclude that older procedures were superseded by modern methods which required new skills and workers to carry them out. It was also thought that women were more adroit at using a typewriter. The working environment for most clerical staff was revolutionised and effectively set the scene for the modern office.

Another area of work in which middle-class women were able to prove themselves was retail. In its 1851 census, England recorded for the first time the marital status of its citizens. The result produced statistical 'proof' that women not only outnumbered men by 500,000, but that 2 million of them were unmarried, meaning that some would not find a husband and so would have to support themselves

financially. By the turn of the century, there were 250,000 British women working in shops. Shop work had been feminised; most of these workers were single women who started work on leaving school and left their job upon marriage. From about 1850, advertisements began to appear in newspapers for jobs for 'respectable female shop assistants' or 'saleswomen'.[161] Most of these female shop assistants came from the working classes and preferred this type of work to factory work or domestic service, although there were also middle-class girls seeking independence who took on these roles.

But though retailers were able to take advantage of the economic boom in the mid-nineteenth century to expand, they also saw an opportunity in employing women and girls. Many working-class girls took jobs in small family shops such as drapers, greengrocers and haberdasheries. They were often thought of as less ambitious and so shopkeepers could get away with paying them lower wages than men and boys. There were even employers who declared that paying women more would be an insult to propriety.

However, female shop assistants would appeal to female customers and the wives of wealthy men whose spending power they were keen to attract. The Industrial Revolution and free trade had increased spending power amongst the newly affluent middle classes who in turn ploughed money back into burgeoning department stores, which provided a place for women to socialise and meet when their public life was limited. It was socially acceptable for women to shop, and they were therefore able to spend time outside the house by themselves, or at least unchaperoned. Department stores seized upon the opportunity to employ refined young middle-class women to serve more affluent customers. 'Why should bearded men be employed to sell ribbon, lace, gloves, neckerchiefs, and the dozen other trifles to be found in a silkmercer's or haberdasher's shop?' asked one of the publications of the Society for Promoting the Employment of Women.

Although more and more job were becoming available to women, the ideology of separate spheres was still used to pressure them into the usual domestic roles. The male workforce was one source of opposition; if a mere woman could do what men had done for years, what did it say about their superiority? Competition in the workforce began, and a woman often had to work twice as hard as a man to prove herself.

But the working-class woman found herself at the bottom of the ladder. They were working for subsistence in domestic servant roles or

factory work rather than for job satisfaction, respectability, gentility and independence. It is fair to say that progress was hampered by the divisive way of thinking of women as separately stratified by class. But, by the end of the Victorian era, the solution to the 'Woman Question' was obvious: educate them for employability.

Definition of Women by Contemporary Fashion

'Dress, then, is something more than necessity of climate, something better than condition of comfort, something higher than elegance of civilization. Dress is the index of conscience, the evidence of our emotional nature. It reveals, more clearly than speech expresses, the inner life of heart and soul in a people, and also the tendencies of individual character.' So wrote Sarah Hale, American author, poet and editor of *Godey's Lady's Book* in 1866.[162]

Lady Elizabeth Eastlake, writing in the *Quarterly Review* in 1847, said that 'dress becomes a sort of symbolic language – a kind of personal glossary – a species of body phrenology, the study of which it would be madness to neglect'. Victorians believed that dress provided clues to an individual's character and could even transform the personality; hence dressing in a restrained way would mould a woman into the demure Angel in the House and ensure compliance with the ideal.

From 1837 to 1901, though the basic structure of women's dresses was always, essentially, a bodice and skirt with variations on the theme, the high-waisted, floaty Regency look progressed through numerous variants to finally become a long-waisted dress with a straight A-line skirt. By the turn of the century women were more actively involved in daily life. Now less confined, restricted and constrained, their outfits evolved accordingly. The Victorian era saw massive social, technological and industrial changes and these were reflected in the century's changing female fashions. It is fair to say that the sociocultural context both shaped sartorial trends and in turn was shaped by them.

In the Victorian age, fashion talked. A person could instantly be placed into a social category by the garments they wore. These became an outward reminder of their roles in society, their responsibilities and, for women, their constraints. Whilst a man mainly wore dark colours as applicable to his serious role in the world of business and commerce, a woman was seen as inconsequential by comparison.

Hence her ribbons and bows, froths of lace and light-coloured silks. Clothing historians often refer to Victorian women's fashion as 'hyper-feminine'. Women were supposed to be cloaked in quiet propriety. In order to be respectable, middle-class women were expected to dress according to social morals and etiquette. A woman who showed her bosom, legs or back was considered immoral, so to be respectable and also fit with the zeitgeist a woman needed to be decorative yet demure. Movement was inhibited by the volume and weight of women's garments, underlining their inactivity and submission. Delicacy was implied by the small-waisted dresses they wore, and the corsets and crinolines suggested bondage in an analogous sense. One may therefore assume that wearing such garments helped to construct and create female behaviour, keeping them in place both literally and figuratively. Fashion, for a proper Victorian lady, meant layer upon layer of items of clothing which had both the physical and psychological effect of making a woman stand, move and act like the accepted idea of a lady – her mindset as controlled as her body.

Queen Victoria significantly influenced not only how women perceived themselves but how men in turn perceived them through attitudes and fashions; a woman's place was in the home either as wife and mother, or, if single, as a dutiful daughter. It is unclear, however, whether Sarah Hale intended to embrace the female population as a whole in her statement. It is true that Victorian women's fashion whatever their social standing was intended to promote and support the ideals of womanhood, and that women's outfits played a major part in upholding male power in a patriarchal society. Thorstein Veblen, writing in *The Theory of the Leisure Class*, described contemporary Victorian fashion as a contest. The wealthy would engage in a game of one-upmanship by displaying their affluence in the most expensive clothes, worn only once or very occasionally twice; in the case of women, these were impractical garments which signalled that they did not work, and even more importantly did not need to do so.[163]

Victorian fashion was an expression of position in society, hence working-class women and their mainly utilitarian outfits. But the ability to follow Victorian society's style trends was rarely possible for working-class women and was unattainable for the poor 'sartorial underclass'.[164] Working women had to be practical before being fashionable. Even at a lower economic level there was still a form of

idealised working-class femininity at play; poorer women would wear aprons over their petticoats not just to keep clean but to maintain the life of the fabric. Further up the social scale, an upper-class lady would attend more public events than a middle-class woman and therefore needed a bigger wardrobe; she was seldom seen in the same outfit twice. A working-class woman would therefore not seek to copy the fashions worn by the elite; where she did have a choice in what she wore, she would be more likely to model herself on a woman she respected in her own peer group rather than Queen Victoria or a member of the aristocracy.

Nevertheless, many working-class and poorer families would still mark Sunday by wearing their 'Sunday best', often for church. This presented a demarcation from and a proclamation of their industriousness and economy throughout the week, an assertion of working-class respectability. Working-class women were often limited in their choices of dress but they would often sew Sunday outfits for themselves and their children. One woman in York told of her mother being 'very handy with the needle and ... she always had a different outfit for a Sunday'.[165] Her grandmother had a plain bonnet for weekdays and one with 'bunches of violets all over the top' specifically for Sunday best. Society was indeed sharply stratified in the Victorian era, but at all levels what you wore indicated your social status – and, it was inferred, your character.

Only eighteen when she ascended the throne, Victoria initially preferred a typically romantic Regency style and so it would take a while for her to become a major fashion influence and for her style to be admired and copied. Many women still favoured the light, simpler styles of the early nineteenth century, worn by the likes of Jane Austen and her literary creations. But fashion reflects society, and Victoria's attitude to a woman's role was revealed by her wardrobe throughout the century. In the early 1830s, well-heeled women would have obtained their fashion inspiration from Paris fashion plates, favouring dresses with tightly laced corsets and bell-shaped skirts puffed out by layers and layers of stiff petticoats, often made of horsehair. The horsehair crinoline petticoat made its appearance in 1839, and although the name described the fabric it was soon being used to define any kind of supportive petticoat or dress lining. Quilted underskirts stuffed with down and feathers were also used to achieve the preferred skirt width.

A fashion plate's purpose was to keep women up to date with chic Paris society, giving them ideas to pass on to their dressmakers.[166] These plates carried images expressing contemporary cultural and social values through fashion, hairstyles and accessories and were an exciting means of advertising. Fashion changed rapidly even then, and keeping abreast of this whilst maintaining identity by way of gender, social status and class was a full-time occupation for some women; fashion plates enabled them to succeed. Young women would look at fashion plates and imagine themselves attending balls, parties and other social occasions dressed in the outfits they saw.

On Victoria's accession the fashion press anticipated that she would become a female style icon. Photographs of her before widowhood show her wearing simple, demure, elegant and well-tailored outfits, and even as queen her dress sense was influenced by male opinion. As Prime Minister, Lord Melbourne advised her on sartorial as well as political matters, with diary entries revealing an insecurity about her image and choices of apparel. When she married, Victoria would consult Albert for style advice. 'I never chose a bonnet without him,' read one of her diary entries. In fact, Empresses Eugénie of France and Elizabeth of Austria were earlier style influences and more serious fashion leaders than Victoria, who was at first criticised by French society for her dress sense – or lack of it, as it was occasionally put by a cruel press.

The Industrial Revolution had an enormous impact not only on technological advancements but also on social and moral structures, with the result that the Victorian era saw dramatic changes in the evolution of industry and society. The population of cities grew exponentially with new economic opportunities leading to the emergence of a large and influential middle class – a social group of investors, industrialists and merchants who were visible consumers of fashion.

For the upper and middle classes, the female body was dressed to emphasise a woman's separateness from the world of commerce – and her respectability. Dress etiquette became a complicated code of behaviour with nuances related to a woman's social position, marital status and age being satisfied before consideration of the occasion she would actually be dressing for. Marriage being the primary career aim for a Victorian woman, a married woman would dress to demonstrate her husband's affluence and success whilst maintaining social decorum. But a single woman had no 'career' to showcase;

Isabella Beeton for one advocated that young unmarried women should dress modestly and simply in order to attract the most suitable husband for her family's social status.

Fundamentally, the design and purpose of a Victorian woman's clothing was to define her virtue and modesty. The fashion for constraining corsets and sizeable skirts became the outward expression of a woman's role as well as of the physical constraints on her movements. It was difficult to breathe in such outfits and the heavy material that made up the gowns impeded movement, but not wearing a corset was often interpreted as loose morality. 'The English conclude if your dress is loose, that your morals are so,' observed Elisabeth Anna Rawdon, Lady Russell. It was felt that if a woman could not constrain her body she could not manage her morals either. Bringing to mind images of Scarlett O'Hara and Prissy in *Gone with the Wind*, Oscar Wilde thought it was 'really sad to think that in our own day a civilised woman can hang on to a crossbar while her maid laces her waist into a fifteen-inch circle'.[167]

As well as the propriety of her outfits, a woman was required to observe codes of dress for the time of day and the venue. A society woman's outfit would be changed several times a day; *The Lady's Manual* stated that 'there are certain dresses adapted to the different hours of the day, and every lady should study these proprieties of polite life'. 'It is in as bad taste to receive your morning calls in an elaborate evening dress as it would be to attend a ball in your morning wrapper,' explained *The Ladies' Book of Etiquette and Manual of Politeness*.

As visitors would not normally arrive until late in the morning, a woman could start off her day in a looser, more comfortable morning dress; this would still be high necked and long sleeved but relatively relaxed. This, of course, meant it was only worn in private, at home, and changed before meeting visitors: 'A lady should never receive her morning callers in a wrapper, unless they call at an unusually early hour, or some unexpected demand upon her time makes it impossible to change her dress after breakfast.'[168]

Ladies were then expected to change out of their morning gowns after breakfast into an outfit suitable for receiving visitors, planned or unexpected: 'When you dress to receive visitors, you are expected to wear something with a high neckline, long sleeves, very little jewellery, and … there should be no cap or headdress worn.' They were also expected to dress fairly modestly so as not to overshadow the visitor.

Dressing up for evenings was, unsurprisingly, more complex. *The Habits of Good Society: A Handbook of Etiquette for Ladies and Gentlemen* was published around 1859 and points out that 'nothing is so vulgar as finery out of place'. So, for example, a woman would wear her ultimate finery of velvet, brocade or jacquard for an evening party, but going for dinner at a hotel required something less showy whilst still ladylike, probably covered by a lace cape, jacket or shawl. Yet a different dress, simpler still, would be worn for an evening dinner at home.

The new middle class displayed their industrial wealth with flamboyance and this was reflected in what their women wore. Women were meant to be decorative and flaunt their status, or that of their husbands, by their outfits. Nineteenth-century women's clothes also began to reflect their purpose in life and social function. As this period also heralded the birth of consumer culture and consequent advances in print techniques, magazines played a big part in conveying to women what their roles should be, what fashions they should wear, how they should be educating their children and what crafts and pastimes they should follow in keeping with their position in society. Whereas men's dress codes were seen to be relatively static and uniform, trends in women's clothes were constantly changing in line with modern life.

Women's clothing evolved dramatically during the Victorian era. From the 1810s onwards, the Empire-line dress waistline had gradually lowered from directly under the bust, approaching the natural waistline by the early 1830s, becoming slightly dropped and pointed by the end of the decade. Skirts and sleeves widened considerably, to emphasise by comparison the small, tightly corseted waist. Gigot sleeves, which flare out and taper to a tight fit around the wrist, were in style and skirts became bell shaped. Many of the younger portraits of Victoria show her wearing white or light-coloured dresses; printed cotton or wool fabric was also popular. The low-waisted, dropped-shouldered dresses of the mid to late 1830s required heavy, boned corsets and layers of petticoats to give them structure and shape. Women often wore large, feathered hats and extravagant hairstyles.

Early Victorian headwear comprised understated close-fitting Neapolitan or 'poke' bonnets, often trimmed with flowers and tied under the chin with a ribbon. Of course a hat or bonnet and a pair of gloves were a Victorian woman's essential accessories. She should

never be seen in public without a pair of gloves; the dinner table was the only exception to the rule.

Hats and bonnets were associated with politeness and respectability as well as with seasonal fashions; for social calls, lunches, church and shopping women were expected to wear their hats indoors, only removing them in their own homes or with close friends and family. In some cases they would have been the most fashionable item in a woman's wardrobe, and as we have seen it was one way for less well-off women to keep abreast of fashion; they were able to update trimmings and decorations, using artificial flowers, ribbons and lace, even if the actual style of the bonnet fell out of fashion. By the mid-1850s the 'spoon bonnet' was the most fashionable bonnet shape and it continued to be worn into the 1860s.

In the 1840s, women's fashions still featured the domed skirt, but these grew more voluminous with each passing year of the decade. Petticoats were more layered and weightier, made of horsehair. Evening dresses could be worn off the shoulder whilst day dresses could be more decorous in their design, but all were characterised with the low V-shaped waist feature. Sleeve seams in dresses were placed quite low. Victorian women already had to contend with society's view of them as helpless creatures and were now restricted and confined even further. Demure colours also featured, making the 1840s gowns more conservative.

The end of the 1840s also saw the introduction of photography, allowing images of Victoria to be seen more widely, often wearing outfits that an upper- or middle-class woman might ordinarily wear, presenting her as a real woman. Charlotte Brontë, however, thought Victoria 'a little stout, vivacious lady, very plainly dressed, not much dignity or pretension about her' when she saw her in Brussels in the 1840s. Photography was not able to reproduce all colours, so photographers recommended specific colours be worn in order to obtain the best image:

Very few ladies know how to dress so as to secure the most pleasing photograph. The best materials to wear are such as are not too glossy, and such as will fold or drape nicely, as reps., poplins, satins and silks. A black silk dress looks well on almost everybody, and if not bedecked with ribbons or lace, which will take whiter, will photograph satisfactorily. So garnet, cherry,

wine colour, sea or bottle green, light and dark orange, and slate colours are all excellent colours to photograph. But pure white is bad, and lavender, lilac, sky blue, purple and French blue take very light, and dresses having bold patterns upon them, should never be worn for a picture. Avoid anything that will look streaky or spotty.[169]

Women's magazines were increasingly widely circulated and began taking over from fashion plates in indicating what was in vogue, who was wearing what and where they were wearing it, covering events like theatre appearances, the opera and court functions. By 1850, paper dress patterns were also becoming available through magazines aimed at the consumer rather than the professional dressmaker; having been taught sewing skills as part of their education, women could make their own dresses. Magazines such as *The Young Ladies' Journal*, *Chatterbox* or *The World of Fashion* started to publish paper patterns and instructions on how to make fashionable outfits at home. A monthly publication edited by Isabella Beeton, *The Englishwoman's Domestic Magazine*, was directed at young middle-class women and shifted 50,000 copies a month in 1856. Featuring illustrations of ladies' fashions and dressmaking patterns, it also offered advice on what to wear for the upcoming season:

This August, the *Englishwoman's Magazine* will, doubtless, find many of its readers seeking health and pleasure by the seaside, making excursions into the country, or at least preparing for some enjoyment of the kind. As regards travelling apparel, the most indispensable article is the HAT, which may be of any coloured straw, crinoline, or a mixture of the two, and trimmed with bindings and bows of velvet and feathers; every description of the latter – ostrich, pheasant, and even bustard-plumes – being used for this purpose. For children's hats, ribbon, and sometimes tulle, mixed with daisies or field-flowers, are much used as trimmings.

Dresses of any soft, dust-colour, washing silk are very cool and pleasant to wear; also those of holland[170] and linen, braided down the front and sides and round the sleeves. Any light material, a mixture of silk and wool, is also suitable, with a cloak of the same.

We believe that our remarks on Fashions are now expected with some amount of anxiety, and will be turned to with more than usual interest this month by our readers. The shape and materials for dresses are now decided upon for the coming winter season; the style of bonnets, mantles and all articles of the toilet must be fixed upon; we will, therefore, give the best information in our power upon these little matters.

To begin, then, the most approved of materials for morning dresses are poplin, rep, French merino, flannel and a very beautiful woollen material called velours Russe – that is Russian velvet. ... the rep dresses and all fancy materials are very generally striped of two colours, as we mentioned in our last article, or have a small pattern broché in silk of another shade; the merinos are mostly self-coloured, in all shades of grey and light brown, or else in very bright and pure violet or blue, these tints being now obtained – thanks to late important discoveries in chemistry – in the most splendid hues.[171]

Some Victorian women found sartorial expectations and the side effects of fashion intolerable. These included pressure on their internal organs, indigestion owing to the tightness of corsets and the weight of their skirts and shortness of breath. In the winter, a woman could wear up to 37 lbs of clothing. The Victorian dress reform movement began to take shape in the early 1850s, with the main objective to design more practical and comfortable alternatives to contemporary fashions. Probably the best-known dress reformer of the mid-nineteenth century was the American Amelia Bloomer, editor of the women's magazine *The Lily*. Libby Miller, a New England women's rights activist, designed an outfit comprising a loose tunic dress worn over ankle-length pantaloon-style trousers and Bloomer shared a picture of herself wearing it in her publication. The garment became known as 'bloomers', even though Amelia herself was not the original designer.

The media 'praised and some blamed, some commented, and some ridiculed and condemned. As soon as it became known that I was wearing the new dress, letters came pouring in upon me by hundreds from women all over the country making inquiries about the dress and asking for patterns – showing how ready and anxious women were to throw off the burden of long, heavy skirts.'[172] A major

source of objection came from women taking it upon themselves to design an outfit that provided freedom, mobility and comfort. This was interpreted as dissent, an audacious kickback against a woman's allotted subservient role. Had the garment been designed by a well-known fashion house, it would have possibly been accepted without question. Still, under considerable press and public pressure, women abandoned the outfit and returned to the domed skirt, though this would be made more wearable by the 1857 invention of the crinoline wire cage. Skirts became even more extravagantly bell-shaped, also now featuring deep flounces and several tiers. Though the crinoline was to become the subject of satirical humour, its spring steel construction represented a fashion revolution as it was far lighter than the heavy layers of horsehair and whalebone hoops that came before it.

As for Victoria herself, an interesting account of her fashion taste can be found in the letters of her German dresser, Frieda Arnold,[173] who was appointed in 1854. These letters along with contemporary press articles describe Victoria keeping up with current trends in her pink or blue ballgowns made of layers of tulle over silk, trimmed with flounces and lace and real diamonds, along with floral embroidery of roses, lilacs, jasmine and orchids.

A corset would support a woman's posture and bearing, but the voluminous petticoats also forced her to walk in a graceful and elegant manner. She would often need to rely on a man for support when walking, which then nurtured the image of female dependency, although it must be noted that the volume of fabric and size of a crinoline enabled a woman to be more visible and to take up space in a world where she was frequently expected to be quiet, submissive and in the background.

A working-class woman would rarely wear a dress that required a crinoline petticoat and if she did it would invariably be homemade or a hand-me-down and would probably comprise her 'Sunday best' outfit. Unimpeded by the constraints of corset and crinoline, a working-class woman possibly carried herself in a less graceful fashion, often unfairly becoming the recipient of comments about her social standing and her lack of femininity.

However, young middle-class women were often thrilled by current fashions and the opportunity to show them off. Amelia Roper loves her silk dress, as she tells her friend Martha Busher in a letter dated

6 January 1857: 'I am going to wear the pink brocade. Oh by the by I have got such a beautiful silk dress trimmed elegantly with deep fringe green you can form an idea from the enclosed bit; I wore it to Rebecca's party, but I am afraid of spoiling it if I wear it too much. Miss Prior made it and I never had a dress to fit like it there is such style about it.'[174]

Amelia clearly loves fashion. The following year, on holiday in Margate in July, she writes to Martha that she is preparing for her trip to the Assembly Rooms: 'I shall be too late if I don't look out, I am going to wear the pink brocade and make myself as much of a screamer as I can, as there is such grand folks there that I shall not look conspicuous.' Here is a young lady who does not want to be repressed and in the background; she dresses for fun and enjoyment, for herself.

The Victorian society woman was, according to the domestic ideology anyway, the moral centre of the family. As she upheld purity, stayed in the house, took care of the family and maintained the perfect home, the only time she would go out would be to visit friends or to attend an event with husband or family. Fashions of the time reflected these restrictions as can be seen in crinolines, corsets and extreme silhouettes. The huge crinolines – the circumference could reach as much as 15 feet – of the 1860s as worn by Scarlett O'Hara in *Gone with the Wind* were followed in the next decade by bustles and long trains, none of which were practical either. The skirt continued to be full and bell-shaped until the middle of the century.

Sophia de Rodes visited Rome with her husband in 1865 and her photograph shows her looking extremely elegant in a formal, handsome daytime outfit typical of the mid-1860s. Her long-sleeved gown with vast circular skirt is supported by the crinoline frame to give its distinctive form. The pale colour of her dress was probably chosen for the location and the fabric looks to be silk, as was usual for fine garments in the 1860s. Most prominent perhaps is the contrasting applied braiding that forms a striking geometric pattern towards the hem of her skirt: this type of ornamentation was especially fashionable among the middle and upper classes in the mid-1860s. The slight backward sweep of her skirt is a feature that would become more pronounced during the next decade when the bulk of the crinoline sat at the back of the skirt, trailing behind the wearer. In 1866 the Parisian fashion magazine *Le Follet* wrote, 'The size of the crinoline

is very sensibly diminished, but it cannot be altogether dispensed with while the dresses are so very long.'

Sophia wears her hair off her face, dressed into a chignon behind her head, in mid-1860s fashion. A fine black lace mantle or shawl is attached behind her head and cascades over her shoulders and bodice. This was a luxury accessory that reflects her social status; black lace mantles were often worn by aristocratic and upper-class ladies in photographs around this time.

An 1862 article, 'Crinoline!', suggests that 'already enough crinoline has been manufactured at Sheffield to encircle the globe again and again'.[175] The Steel City produced 150 tons of crinoline wire a week. However, the structure of spring steel was quite light and it is true that many women would feel somewhat liberated from the heaviness of horsehair, being able to walk and sit down with relative ease. *The Lady's Newspaper and Pictorial Times* commented in 1863:

> ... a lady may ascend a steep stair, lean against a table, throw herself into an armchair, pass to her stall at the opera, and occupy a further seat in a carriage, without inconveniencing herself or others, and provoking the rude remarks of observers thus modifying in an important degree, all those peculiarities tending to destroy the modesty of Englishwomen; and lastly, it allows the dress to fall in graceful folds.

Alongside the women's magazines promoting and advertising the latest fashions sat satirical publications like *Punch*, which poked fun at the crinoline, using hyperbole and exaggeration for comic effect. Cartoons appeared showing women being unable to get through the doors of carriages or floating on the water after being blown off bridges in high winds. Lady Eleanor Stanley wrote in her diary that 'the Duchess of Manchester, climbing hastily over a stile during a paper chase, caught a hoop of her cage, went head over heels, lighting on her feet with her petticoats remaining above her head. They say there was never such a thing to be seen – her underclothing consisted of a pair of scarlet tartan knickerbockers which were revealed to the view of all the world in general and the Duke de Malakoff in particular. *Ma chère, c'était diabolique!*'[176]

Joking aside, the crinoline was blamed for disembowelling women when the steel springs broke, along with crushing their vital organs

and being a fire hazard. In October 1861 *The Guardian* published an article calling the crinoline 'A Real Social Evil'. There is no doubt that the volume of fabric was a fire risk. In 1862, eighteen-year-old Sarah Padley died of severe burns after her muslin dress, worn over a cage crinoline, caught alight. The death of a fourteen-year-old kitchen maid, Margaret Davey, was reported in *The Times* on 13 February 1863 when her dress, 'distended by a crinoline', caught fire as she stood on the fender of the fireplace to reach some spoons on the mantelpiece. *The Cork Examiner* of 2 June 1864 reported the death of Ann Rollinson from injuries sustained after her crinoline was caught by a revolving machinery shaft in a mangling room at Firwood bleachworks. The textile firm Courtaulds stated that 'the present ugly fashion of hoops or crinolines is quite unfitted for the work of our Factories ... we now request our hands at all Factories to leave Hoop and Crinoline at Home'.[177]

The volume of the crinoline became a flamboyant display of extravagance, requiring women to take up so much room that they invaded men's space, knocked them flying from the pavement and barked the shins of those they bumped into. Fashion historian Christina Walkley noted that 'to the Victorians themselves the crinoline had little of submissiveness, seeming rather a monstrous plot to increase women's stature and make man seem insignificant'.[178] Instead of keeping women in their place, the crinoline ensured they were taking up far too much! Lorraine Janzen Kooistra called it 'the skirt that took up more public space than a woman had any right to take', this sentiment being used to criticise the growing women's movement. Another curious point about the crinoline is that whilst it concealed the woman's body, ironically it also had the effect of drawing an observer's gaze down towards the hips, which it was designed to cover.

The Queen magazine launched in 1861 and also specialised in the very latest Parisian fashions. A typical column on 'London Fashions' begins every paragraph with a recommendation for the 'new', emphasising the obligation on a woman to know what is à la mode, along with advertisements for the items themselves, showing the styles readers were subtly directed to copy and purchase, providing paper patterns and instructions for completing needlework.

Society fashion could be exhilarating. It could also be physically and emotionally painful, but it did not wholly turn women into either

slaves or hedonists. Fashion allowed even the Victorian Angel in the House to explore and express her aspirations and identity, albeit within limits. The society woman's wardrobe was now filled with silk and satin evening gowns trimmed with lace and velvet. Dresses and blouses were embellished with lace, ribbons and frills, pearl buttons and gemstone brooches. Long trains and draped, opulent fabric became popular, characterised by flounces and gathers. Gowns featured banana-shaped sleeves and the emphasis on the back of the dress presented a triangular shape.

The launch of synthetic dyes in the early 1860s meant sumptuous fabrics could be produced in vivid hues of magenta, electric blue, emerald, heliotrope and saffron yellow. The 1864 fictionalised version of Helen Codrington in *The Sealed Letter*[179] wore 'an acid lemon dress [and] white lace gloves', her friend remarking that she wanted to 'shake her by her lemon-lace-edged shoulders'. *The Liverpool Mercury*'s 'Fashions for May' article in 1866, meanwhile, promoted the appeal of striped fabrics, stating, 'We still find that striped or plain materials are more in favour than any other, they are so decidedly the most suitable for skirts on the bias.'

Through the 1870s, women's fashion continued the pleats, frills and flounces but with a lower waistline to the dresses, and a consequent lower and squarer neckline for evenings. Skirts now began to lose yet more volume at the front and move the emphasis towards the back in the form of a bustle, furthering the perception of difference between women and men in society. High necklines and tightly buttoned bodices came into vogue. Collars and cuffs of white lace and low, sloping shoulders that flared out into wide sleeves were worn. Pleats and ruffles trimmed skirts and the 'waterfall' bustle cascaded down the back of the dress. Boned linings and padding ensured that women's outfits remained heavy and cumbersome, dragging along the ground and often becoming damaged as well as proving to be a tripping hazard. The bustle would have to be moved aside so the wearer could sit comfortably, which could be discomfiting in polite society.

'Poverty must, above all things, avoid the appearance of poverty,' wrote 'Sylvia' in *How to Dress Well on a Shilling a Day*,[180] a book published in 1876. Lucky Jane Carlyle had a clothing budget of £25 a year. Victorian ladies who had a shilling a day, equating to just over £18 a year to spend on fashion were also rather fortunate; but it would still not allow them to push the boat out for evening wear.

Sylvia's book and the 1873 *How to Dress on £15 a Year* by Millicent Cook aimed to help women to solve this problem. The annual mid-century income of the aristocracy was over £10,000 whilst that of the upper classes was anything between £1,000 and £10,000 per year. Meanwhile, the minimum middle-class annual income would need to be around £300 to cover all necessary outgoings and maintain an upwardly mobile image although pay, along with the cost of living, differed throughout the country.

A woman who was able to afford it would have her clothes made by a couturier at one of the expensive salons, particularly an outfit she intended to wear during the London season. But many other women had much less than a shilling a day. Until the 1850s all garments had been entirely hand-sewn. A lady who moved in less illustrious circles may buy a ready-made dress, or buy a bodice and have a dressmaker make the skirt up from the same fabric. Now, with the patenting of Isaac Singer's sewing machine in 1851, she would be able to do this herself, utilising the sewing skills she learned at school and paper patterns from one of the women's magazines or dressmaking manuals.

Sylvia's book covered the whole gamut of fashion – etiquette, shopping, seasonal sales, 'what to wear and when to wear it' – and gave patterns and detailed instructions on how to make up the garments. Sylvia comments:

> The little maid ... wears a dress of the same form and outline as that worn by our Princesses. True, she wears it 'with a difference' but of that she is scarcely conscious herself ... it is an exact imitation in cheap material of one of her mistress's latest costumes ... that is enough for the little maid, who is not solitary in her experience. A little higher in the social scale, the grocer's wife rustles in trailing silk on her Sunday walk with the children, who are in silks too. Higher still, the wife of a doctor, a young fellow who is making about £400 a year and keeps no carriage, dresses in precisely the same style as the wife of Dr B., a wealthy physician whose horses are among the best in London.

Sylvia goes on to advise how to transform dresses for different seasons and make the best use of accessories, explaining that 'an unmarried girl may appear at a garden party in a costume of muslin over coloured batiste, and a coarse straw hat prettily trimmed, and

if her gloves and her ribbons are fresh and her boots good, she will probably be as "well-dressed" in the best sense of the term, as the most elaborately clothed lady there'.

Dressmaking would also become championed as more of an art form. Oscar Wilde was 'sorry to see that [Millicent] Fawcett deprecates the engagement of ladies of education as dressmakers and milliners, and speaks of it as being detrimental to those who have fewer educational advantages'.[181] He thought dressmaking was a high-level skill, requiring knowledge of fashion, proportion, pattern and design and expressed his satisfaction at the opening of a new technical college in Bedford, with millinery and dressmaking on the curriculum as well as the commencement of a Society of Lady Dressmakers in London.

Of course, a Victorian woman would count chemises, drawers, corsets and petticoats as staples in her wardrobe. She would wear a cotton or linen chemise as an underlayer to the corset, to protect the more expensive corset and keep her comfortable and, most importantly when wearing transparent fabric, safeguard her modesty. If a woman did not wear a corset, she was thought of as indiscreet; it was also often associated with poverty. A pair of drawers, often trimmed with lace, was essential wear underneath a crinoline as the Duchess of Manchester would have found during her paper chase. Lady Chesterfield said in a letter to her daughter that drawers were 'comfortable garments we have borrowed from the other sex which all of us wear but none of us talk about',[182] a view that gave them the nickname 'unmentionables'.

Bonnets remained in fashion until the 1880s with hats becoming de rigueur by then. Magazines such as *The Englishwoman's Domestic Magazine* featured plates of the most fashionable designs, allowing women to make copies of patterns or adapt the fashion plates they saw. Some provided illustrated practical advice on hat and bonnet patterns, construction techniques, materials, tools and the creation of suitable trimmings.

Millicent Cook stresses the importance of putting money aside each year for buying new headwear to keep up with fashion changes.[183] Feathers were prolific as trimmings and decorations in women's hats. Hairstyles were also ornate and piled high, so hats had to accommodate these, and went from one extreme to the other, either tilted forwards or sat well back on the head. On display in the

Victoria & Albert Museum is a hat from 1885 that features an entire mounted and decorated bird.

Tighter-fitting bodices with high necklines came in during the 1880s along with narrower, lace-trimmed or frilled sleeves and a continuation of the luxurious fabrics and rich colours. The excessive cantilever style bustles – that often resembled a shelf at the back of a woman's dress – were supported by a structure known as a lobsterpot crinolette with crisscrossing hoops supporting the weight of the fabric. Women also wore taller hats during this decade.

The early 1890s still saw women wearing tight bodices with high collars though we see the trend emerge for an hourglass figure and the French gigot, more commonly known as leg-of-mutton sleeve, almost a re-emergence of the balloon sleeve popular in the 1830s. Creating a wider-shouldered look, it led to the illusion of a narrower and smaller waist. This fashion statement did receive some unflattering media coverage:

> The gigot sleeve is at its zenith of popularity – everyone wears it, whether it suits them or not ... and it seems to be growing longer, as it often reaches quite to the wrist, and occasionally – but this is, as yet, the *acme* of fashion, and not generally taken up – lies in a point on the back of the hand. These gigot sleeves are usually so tight below the elbow that they require to be buttoned up.[184]

'From the sixteenth century to our own day there is hardly any form of torture that has not been inflicted on girls, and endured by women, in obedience to the dictates of an unreasonable and monstrous Fashion,' Oscar Wilde had remarked in 1882.[185]

Decades earlier, the bloomer movement which originated in America failed to take off amidst the standard male perception that women were attempting – literally – to 'wear the trousers', undermining male positions of authority, and for fear of harming the work of the female suffrage movement. Meanwhile in England, *Punch* published a series of cartoons designed to ridicule, showing frightened men being henpecked by their bloomer-wearing wives, captioned with witty quips like these:

> As the husband, shall the wife be; he will have to wear a gown
> If he does not quickly make her put her Bloomer short-coats down.

But now, with less than ten years left of the Victorian era, women's roles were changing. Their participation in sport was growing and middle-class women were entering the workplace. Whereas the earlier Bloomer crusade fizzled out, the British branch of the Rational Dress Society attempted to ameliorate the health problems caused by petticoats, hoops, bustles and corsets being used to create unnatural shapes for the female figure. Launched in 1881, the society's mission statement 'protests against the introduction of any fashion dress that either deforms the figure, impedes the movement of the body, or in any way tends to injure health'.

Women's rights activists Viscountess Frances Harberton and Emily King intended to encourage a shift in women's fashions away from these constraints through education, publishing pamphlets, giving lectures and producing dressmaking patterns for more practical dress options. The RDS's objective was to 'promote the adoption, according to individual taste and convenience, of a style of dress based on considerations of health, comfort and beauty'. Their ideas incorporated high and loose waistlines, sleeves and skirts that allowed more freedom of movement, and the divided skirt. The fabrics used were also plainer and simpler with limited embellishments. Again, *Punch* was quick off the mark with satire:

> Skirts be divided—oh, what an atrocity!
> To 'dual garmenture' folks must attain.
> True that another skirt hides this insanity
> Miss Mary Walker in old days began;
> Yet it should flatter our masculine vanity,
> For this means simply the trousers of Man![186]

The *Birmingham Daily Post*, while still alluding to women's decorative purposes, commented less cuttingly in the same year:

> It appears from the prospectus that there is no intention on the part of the society to interfere with individual liberty; the desire is to release ladies from the tyranny of mere fashion, by permitting them to consult their own taste and convenience upon the sole condition that their attire shall be pleasing to the eye while conforming to consideration of health and comfort.

Frances Harberton contested the views of doctors and dress designers in a lecture at Westminster Hall in 1887: 'The dresses that men have invented for women have never been a success, whether it be the fashionable garments devised by Worth or the nurse's dress, which was invented by doctors.' She believed that women who followed the latest fashions were unable to think for themselves: 'It is not to be wondered at that women are regarded as perpetual infants, since they voluntarily trammel and bind themselves from head to foot with the garments that the traders in clothes offer them.'

Constance Wilde, wife of Oscar, was a key member of the RDS and also became editor of its newspaper. Oscar Wilde himself had published several articles in *The Pall Mall Gazette*, discussing his thoughts on what women should wear: simple, comfortable outfits with minimal 'fringes, flounces and kilting'.

He also championed the 'divided skirt', which was really at its simplest a wide-legged pair of trousers. As the RDS explicitly linked dress reform with female emancipation – an article in its magazine called on readers to free their bodies and render them fit companions for their enlarged minds – the British press again had a field day, claiming that such an item of clothing would inevitably lead to female immorality.

The Wildes' involvement added celebrity status and drew attention to the movement. In an open letter, Constance Wilde described the garment as trying to 'look as though it were not divided, on account of the intolerance of the British public' and personally modelled it at her 'Clothed in Our Right Minds' RDS lecture in 1888. Those women who did wear it loved 'the delightful sense of freedom that results from the removal of petticoats'. Women were given two legs by God, reasoned Constance, so they ought to be able to have the freedom to use them. At best, though, rational dress reformers faced opposition and ridicule, even when the practical benefits were apparent. Advocates were disdainfully described as simply wanting to dress like men. *Punch* again:

... 'tis hardy and boyish, not girlful and coyish,
We think as we stroll round the gaily-lit room
A masculine coldness, a brusqueness, a boldness
Appears to pervade all this novel costume!
In ribbons and laces, and feminine graces,

And soft flowing robes, there's a charm more or less
I don't think I'll venture on dual garmenture
I fancy my own is the rational dress![187]

Dress reformers not only pointed out the damaging effects corsets and lacing had on women's bodies but also reasoned that forcing them into an unnatural shape for what was essentially male consumption was objectifying women. The irony was that the alternatives presented by Constance Wilde and Frances Harberton were scorned by the press as being morally objectionable.

It would take some time before any trouser-esque garment became acceptable for women. In 1898, Harberton was famously refused entry to the public coffee room of the Hautboy Hotel in Ockham – because she wore a divided skirt. Although the case was ultimately dismissed, she took the proprietor to court in April 1899, and after the case commented: 'I admit that it is probably certain that women will never ordinarily wear knickerbockers. But mark this – short skirts for walking-wear will be a boon that ought to be easily attained, and once attained, cherished like Magna Carta in the British Constitution.' The *Evening Telegraph* stated in her obituary that 'she never tired of exposing the inconveniences of the offending garments, and if argument could kill a fashion there would scarce be a close-fitting costume left in Bond Street by now'.[188]

Women like Frances Harberton, Constance Wilde and Emily King were willing to stand up for what they believed in and face public ridicule and hostility in the process. This had a direct effect on the way women were viewed in society and opened new opportunities to them. Irish writer, cycling enthusiast, suffragist and public speaker Sarah Grand commented that 'the New Woman has too much healthy enjoyment of life to worry about whether her ankles are visible or not'.

As the Victorian era wound to a close, the ideas of a traditional woman's position began to be questioned and this is reflected in mainstream female fashion. The bustle disappeared and separates – skirts, high-necked blouses and tailored, nipped-waist jackets with fuller shoulders – appeared alongside sleeker, more elongated dresses all of one piece. Slimmer, full-length, simple A-line skirts and day dresses were seen; women were now going out into the world to work or to advocate for suffrage and education, and fashion reflected

their more serious role. Fashion was able to exist alongside feminism. Large, wide-brimmed hats secured with a hatpin had gradually replaced bonnets, and women favoured softer hairstyles.

Gowns made from extravagant fabrics with boned bodices and a train were still popular for evening wear. Significantly, women also began to take a more involved role in sports such as walking, swimming, golf and cycling, with fashion changing to reflect these activities. Moreover, the invention of the liberty bodice towards the end of the nineteenth century saw the beginning of the end of body shaping as an essential part of women's daily life.

Women's fashion had changed remarkably through the Victorian age; from Regency romantic dresses to the crinoline and bustle to narrower A-line skirts; from tight sleeves to the extremes of leg-of-mutton, from form-fitting corsets to cantilevered bustles. Outward appearance was a criterion of social evaluation but equally, fashion could express assertion and rebellion as much as it could meekness or submission.

The developing city culture of the late Victorian period meant that shopping as a social pastime now became popular with middle-class women. They quickly learned the advantages of having a female friend to accompany them on their shopping trips to keep up with rapid changes in fashion. Victorian women were interested in fashion and shopping for its own sake and not merely as a response to repression and requests for submission. In 2015 the wardrobe mistress at the National Theatre was given an extraordinary book that had been bought at a junk stall in Camden Market. It turned out to be a dress diary kept between 1838 and the mid-1870s, consisting of over 2,000 carefully pasted fabric samples, each captioned with a date and event where a dress made from the fabric had been worn.

The book was created by Anne Burton, who had married Adam Sykes in September 1838 in Lancashire. Their marriage certificate reveals that the groom's father was a designer and the bride's father a spinner and manufacturer, which probably accounts for Anne's interest in collecting and recording fabric swatches. The book is unique in that it shows how women shopped, dressed and took their sartorial cues from celebrity. The fabric samples include those from outfits worn by Victoria's aunt Queen Adelaide, her daughter Princess Vicky and a swatch of orange fabric captioned 'Dress worn by Queen Alexandra it was given me … by her dressmaker's sister'.[189]

The book contains a wide range of types of fabric and descriptions of designs, revealing that innovative Victorian fashion was not exclusively urban-centric and that provincial women were as open minded and excited by fashion as their city counterparts. It is effectively a series of snapshots of the wardrobes of over 100 women living in the north of England from the beginning of Queen Victoria's reign until the 1870s. The range of fabrics contained in the book show the sartorial landscape of small-town women through fashionable fabrics such as roller-printed cotton, silks, damask, wool, intense aniline dyes and machine lace, demonstrating that fashion taste and style had travelled far beyond the capital.

Kate Strasdin, honorary deputy curator at the Totnes Fashion and Textile Museum in Devon, is currently working on a genealogical study of the women whose dress fragments appear in the album to greater understand their consumption of fashion and fabrics in the north-west of England.

Developing alongside yet separate from mainstream female Victorian fashions were sportswear and wedding gowns. The growth in women's participation in sport began mid-century, but the mood was that respectable women should only participate alongside their husbands rather than by themselves; showing any form of aggression and competitive spirit would threaten the concept of Victorian femininity. At the start of Victoria's reign the word 'sport' had meant field sports, an exclusively male preserve. Sports were still mainly associated with men, but throughout the Victorian era, and particularly as the dress reform movement gained pace, the idea of good health enhancing a woman's true role as homemaker and philanthropist became popular and sportswear came into its own, reflecting the changes in women's lives.

Bathing, it was thought, would improve women's mental health as well as keeping them physically fit and attractive to their husbands. The ideal female body was a healthy one. Moderate exercise became a responsibility for the Victorian woman; the working-class woman would not have this luxury and would get her exercise through walking and the heavy housework she would have to do in the home. Women began to participate in a variety of sports at different levels; swimming, cycling, horse riding, archery, hunting and skating were all popular pastimes.

If swimming was to be promoted as a health-giving activity in which women could take part, a more suitable form of attire was

needed. Women had previously taken dips, wearing a loose-fitting dress like a nightgown for this purpose. This would cling and sometimes balloon with water or air; hardly practical. It may hide the body, but once wet it became transparent and resulted in what was, for the times, indecent exposure. It was still the case that when women partook in these activities in male company the difference had to be drawn so that they maintained gender identity and decorum as mixed bathing was introduced. Could it be that the more stylish yet modest bathing costumes were intended to enable the lady to present herself attractively yet modestly to attract a possible future husband? A swimming costume was now a practical and functional two-piece outfit of camisole, or belted tunic, and knee-length bloomers.

In July and August 1873, *The Englishwoman's Domestic Magazine* published a series of articles encouraging swimming for ladies and giving advice on the best form of bathing dress: 'In order to swim properly it is necessary that the arms and legs should be perfectly free, so that all the muscles may have full play.' It advocated 'a jacket and drawers cut in one piece, adorned with a short peplum with belt, and made out of soft blue serge, trimmed with white or coloured braid'.

In September 1875, fourteen-year-old Agnes Beckwith – future swimmer and aquatic entertainer – swam 20 miles in the Thames wearing a swimming costume that was functional yet allowed her to move freely. On 2 September 1875 *The Pall Mall Gazette* reported: 'Miss Agnes Beckwith, aged fourteen years, daughter of Mr Beckwith, of the Lambeth Baths, swam yesterday from London Bridge to Greenwich, a distance of five miles, in an hour and nine minutes … the event created a great deal of excitement, and all along the route the progress of the swimmer was watched by excited crowds on the wharves and barges.'

A difference would also be drawn between active participation in sports and those activities that were more social occasions. For example, skating and croquet were ideal opportunities for attracting male admirers and it was therefore essential to be dressed accordingly. The outfits a woman would wear in these settings had to enable freedom of movement whilst being modest, feminine and appropriate for mixed company. So a smaller crinoline-enhanced skirt would be worn for skating, fabrics would be less adorned and the outfits not as structured and tight.

Contemporary women's magazines highlighted hunting and shooting outfits towards the end of the 1860s. By taking part in

horse riding, hunting or shooting, women could pursue a prospective husband. For this reason, it was imperative that they appeared feminine and observed decorum.

Physical education for girls also began to appear on the school curriculum in the 1870s. *The British Medical Journal* published an article in the 1870s championing physical education in the new state elementary schools and recreational sports as part of the programme at women's university colleges. From 1894 the BMJ was highly supportive of cycling, although it also wrote about the effects of sport in general on the health of girls: 'The improvement in the physique of women has been very noticeable since the development among them of a taste for cycling, lawn tennis, hockey and other forms of outdoor exercise, which would have been thought very unladylike in the early days of the Victorian Era when girls lay on boards to straighten their spines, and were in all respects compelled to follow what may be called the "prunes and prisms" system of life.'[190]

Cycling had become immensely popular in the 1880s, following Dunlop's invention of the pneumatic tyre and mass production of bicycles. Sarah Grand said in an interview that she was 'devoted to cycling, and you cannot think how much better I am in health since I took to it'.[191] She chose to wear culottes when out on her bicycle. Women cyclists who chose to wear rational dress were often verbally abused both in the press and whilst out cycling, and physically attacked by being pelted with stones. In one shocking incident towards the end of the century, male Cambridge University students made their feelings known towards the proposal to grant full degrees to female graduates by constructing an effigy of a woman astride a bicycle wearing rational dress and hanging it from a building in Cambridge's market square.

By the middle of the nineteenth century, ice skating had become a fashionable sport in England for both sexes; Victoria and Albert famously skated themselves. Skating's popularity, and the fact a frozen lake or ice rink was a suitable occasion for meeting potential partners, ensured that skating attire became a fashion statement. A typical skating outfit, often in bright colours and made of velvet, would consist of a high bodice and a walking-length skirt, a feathered hat, gloves and boots – and fur. Miniver, sealskin and chinchilla often featured although muffs were not worn on the ice as the skater needed to move their arms freely, and women's skirts had to be short enough

to prevent tripping on the ice. Women had to keep themselves warm but still be able to show their feminine charms whilst developing strength and fitness through their time on the ice. Of course, there was also the skating sled; by this method men would push the woman along while she was wrapped in fur, warm coats and blankets.

Garden parties based around lawn tennis often took place in middle-class families. A tennis court symbolised the material success of the family, and a garden party allowed young middle-class men and women to socialise under the supervision of family. Women would conform to the ideal image of femininity whilst observing decorum and having an opportunity to meet suitable men. They could play a serious game whilst maintaining a feminine image through their choice of clothing and advertising the family's social standing. Women's tennis dresses conventionally followed fashion and some even featured a bustle. In the 1880s 'a costume of pale blue flannel with deep kilted skirt and long basque bodice (over stiff stays), an embroidered apron with pocket to hold the balls and an embroidered overcoat which is intended to be removed for playing'[192] was designed. So, women were more and more able to take part in sports, but still sadly impeded by their outfits. Lottie Dod, Wimbledon champion during the late 1880s and into the 1890s, yearned for 'a suitable attire for women's tennis which does not impede breathing'.

Victorian Englishwomen did not sit astride a horse as this was considered highly immoral, despite the discomfort and perils of riding side-saddle. As the female rider required a man to help her into the saddle and a groom to hold the horse still, riding reinforced a woman's dependence on a man. When out in mixed company, a Victorian woman was obliged to ride behind the man; as applicable to gender stereotyping, he was the leader, the decision maker; she the follower.

Archery, croquet and skating all provided a means for middle-class women to find a future husband and their dresses had to show off their femininity. Fashion historians Willett and Phillis Cunnington wrote several books related to Victorian women's fashion and quote a diary entry from 1875: 'Miss Meredith Brown and her beautiful sister Etty came over for tea with us and a game of croquet. Etty ... was dressed in light grey with a close fitting crimson body which set off her exquisite figure ... But the greatest triumph was her hat, broad and picturesque, carelessly turned with flowers and set jauntily on one

side of her pretty dark head, which round her shapely slender throat, she wore a rich gold chain necklace with broad gold links…'[193]

By then also, riding, shooting and hunting dresses in black, dark blue, dark brown, dark green and grey were being advertised in magazines and periodicals, which also promoted these sports as fashionable activities for upper- and middle-class women. Such outfits would be in a simple style and feature a close-fitting jacket or bodice, a long skirt and an invisible 'divided skirt' which had to be invisible, lest it undermine men and their 'rightful power'. These garments were described as the 'English contribution to the development of women's fashions'[194] in both general fashion and sportswear towards the end of the century. The riding habit became more practical, with a much simpler, more formal appearance, often worn with a matching hat and veil.

So, social and cultural values required women to present an image of submissive femininity if they wished to take part in sports alongside men and outfits had to be suited to each event they attended. Sporting activities provided a Victorian woman with opportunities to improve her own health and fitness as well as suitable arenas for courtship and matchmaking. Once a proposal had been accepted, however, there was a trousseau to purchase, and a wedding to arrange. Queen Victoria, writing in her journal on the day of her wedding to Prince Albert, noted:

Slept well & breakfasted at 1/2p. 9, before which Mama came, bringing me a nosegay of orange flowers … Had my hair dressed & the wreath of orange flowers put on my head … I wore a white satin dress, with a deep flounce of Honiton lace, an imitation of an old design. My jewels were my Turkish diamond necklace & earrings & dear Albert's beautiful sapphire brooch.

While Victoria was not the first bride to wear white, she was the first royal bride to do so. Her February 1840 choice of a white wedding dress with satin and heavy silk lace not only became the blueprint for wedding dresses for many future brides, but also marked Victoria's new-found status a symbol of a woman's links with the family, middle-class ideas of morality and home life. Victoria stated that on her wedding day she would make her vows to Albert as his future wife, not as the reigning monarch.

Her dress and veil firstly predisposed the aristocracy, and then gradually the wider public, to associate white with a wedding dress. This romantic, feminine bridal style was adopted later by Albert and Victoria's children in the late 1850s and early 1860s, perpetuating the growing fashion among the wealthy classes for a formal white wedding.

When Sophia Curzon married William Hatfield de Rodes in 1854,[195] she wore a gown of 'white glacé silk' with an over-skirt of lace fashionably flounced with layers of petticoats (the cage crinoline not being invented yet), a veil of matching lace and a bridal headdress, probably a circlet attached to the veil, ornamented with orange blossoms and roses, both fashionable Victorian bridal flowers. The term 'white' meant ivory or cream at that time, and glacé silk would be a glossy silk fabric, glazed or otherwise treated to give a lustrous quality. Empress Eugénie had married the previous year in a dress flounced with Brussels lace, making this style popular.

A Mrs Hardie wore a grey and brown silk taffeta dress for her wedding[196] around 1856/7, trimmed with silk fringing, featuring brocaded flowers and supported by a cage crinoline. The dress featured wide sleeves, which visually balanced the width of the skirt. Middle-class women often reused their wedding dresses for later occasions and so different-coloured wedding dresses were still popular. The majority of Victorian women had to take a pragmatic approach to their wedding attire, and so we see many brides getting married in a dress they already owned, or in a new dress which was of a practical enough colour for them to wear again. Many Victorian wedding dresses were in a palette of grey, green and blue.

Helen Priestman Bright Clark chose a grey moiré silk fabric for her wedding dress in June 1866.[197] White wedding dresses were now becoming traditional, but moiré was particularly fashionable. In April 1865, *The Illustrated Times* described one of the 'latest toilettes' as being constructed of 'grey moiré, opening, in both the front and at the back, over a breadth of blue moiré. On each seam of the grey robe is a handsome passementerie[198] of grey and blue.'

By the 1870s, middle-class couples were enjoying increased spending power. White wedding dresses began to feature full court trains, long veils and sophisticated detailing. By the 1890s a demi-train and larger sleeves were in fashion, with a veil of the same length as the train in lace or silk tulle. From the mid-Victorian era to the 1890s, the veil covered the bride's face and was lifted during the ceremony to

represent a sign of ownership. A father would lower the veil on his daughter's face to 'gift' her to her new husband, and then the groom would lift the veil symbolising his new 'ownership' of the bride.

The white wedding dress remained largely confined to the wardrobes of the rich and privileged. When coalminer's daughter Sarah Griffiths married Daniel Browning in Staffordshire in May 1879, she wore a bodice and skirt ensemble, which meant the skirt could be more easily replaced as she would doubtless wear her outfit again. Sarah's outfit is decorated with bows, lace and tassels with a bustle and therefore may well have been her 'best dress', which she brought out for special occasions.

The majority of Victorian brides wore the best day-dress they could afford; a working-class bride would either borrow a dress or simply wear the best thing she had in her wardrobe. Widows, older brides and the less well-off typically preferred more practically coloured gowns. These could then be worn for Sunday best long after the marriage and would not have looked out of place; wedding dresses in the nineteenth century were often designed in line with contemporary fashions. A local history project in north-east Scotland, focused on mid to late nineteenth-century country weddings, reveals that brides usually wore black – silk if they could afford it – because the dress became their Sunday best for years to come.

In her article 'The Exquisite Slave: The Role of Clothes in the Making of the Victorian Woman', Helene E. Roberts argues that 'clothing of the Victorian woman clearly projected the message of a willingness to conform to the submissive-masochistic pattern, but dress also helped mould female behaviour to the role of the "exquisite slave"'. While Victorian women were part of an often restrictive, not to say coercive fashion system, they still had choice and control over their clothing. Most importantly, they existed within a fashion system; that is, they lived within it, functioning and fashioning their lives in spite of wearing corsets, gloves, crinolines and veils. They moved within the public sphere, holding parasols aloft, both for self-adornment and the protection of their bodies, for their own personal aesthetics and expectations, for mobility, to subvert social expectations, and to transgress limitations placed upon them by a structure larger than the people it encompassed.

DIFFERENCES IN FEMALE STEREOTYPES

The Emergence of the New Woman

Although indivisibly linked with feminism, and not overtly labelled as such until the mid-1890s, the New Woman had been slowly emerging from the constraints of the early Victorian era for several decades through the ongoing debate on the 'Woman Question'. However, it is only through comparison with the True Woman that we can begin to appreciate and understand her.

Were women naturally more pure, more pious and more resistant to temptation than men? Many upper- and middle-class Victorians believed so. The term True Woman and the cult of True Womanhood was popularised by Barbara Welter as late as the 1960s to describe the previous century's beliefs about behaviour and the prevailing value system whereby popular and religious culture ascribed four cardinal virtues – piety, purity, submissiveness and domesticity – to the True Woman. Though Welter's work was focused in America, it is pertinent to note that most of the adherents to this ideology resided in the north-eastern area of the country, which had been colonised by British settlers.

The importance of being a True Woman was promoted to young mid-Victorian girls and the concept of attaining True Womanhood was imprinted on their consciousness from an early age. Girls would receive these messages from their family, through the church, at school and by reading etiquette books and magazine articles. *The Young Ladies' Journal* appeared weekly from 1864 and was

aimed at a young and middle-class audience, featuring articles on fashion, needlework and household topics, along with short stories and serialised fiction. The objective of such fiction was to develop moral sensibilities and reinforce the ideal woman's image as a future pious mother and spiritual guardian. Similar magazines such as *The Family Herald* reinforced and emphasised the role of a woman as a homemaker in a family context.

The Leisure Hour, which styled itself as 'A Family Journal of Instruction and Recreation', published a list of desired female traits to aspire to in late 1856:

> What a Woman should be Alphabetically. A woman should be Amiable, Benevolent, Charitable, Domestic, Economical, Forgiving, Generous, Honest, Industrious, Judicious, Kind, Loving, Modest, Neat, Obedient, Pleasant, Quiet, Reflecting, Sober, Tender, Urbane, Virtuous, Xemplary, Zealous.

The exclusion of Willing and Yielding seems to have been a missed opportunity. One of the paradoxes of being a True Woman was that she had to be morally strong and virtuous yet was treated as fragile and weak. Too much exertion was considered emotionally damaging to women's delicate nervous systems. Intellectual pursuits were discouraged. Her fragility required protection by a male at all times, be that her husband, father or brother. *The Saturday Review* featured a similar piece in 1870 on the subject of 'Womanliness':

> She has always been taught that, as there are certain manly virtues, so are there certain feminine ones; and that she is the most womanly among women who has those virtues in greatest abundance and in the highest perfection. She has taken it to heart that patience, self-sacrifice, tenderness, quietness, with some others, of which modesty is one, are the virtues more especially feminine; just as courage, justice, fortitude, and the like, belong to men.
>
> Passionate ambition, virile energy, the love of strong excitement, self-assertion, fierceness, and an undisciplined temper, are all qualities which detract from her idea of womanliness, and which make her less beautiful than she was meant to be; consequently she has cultivated all the meek and tender affections, all the unselfishness and thought for others which have hitherto been

the distinctive property of woman, by the exercise of which she has done her best work, and earned her highest place.

Before marriage, a woman was expected to defer to her father in all choices and decisions. Once married, she was to be submissive to her husband's desires and needs; submissiveness was said to fulfil a woman by making her the perfect dependent companion. True Women were expected to willingly and cheerfully surrender to the powerlessness of their lives. Only in willing submission to a man could a woman find true happiness, it was supposed.

Alongside the emergence of True Womanhood, fashions became impractical, ensuring that women were restricted; whilst it was important to be fashionable, fashion itself was correspondingly designed to literally keep women in their place. Many young Victorian women felt incredibly restrained and suffocated. Florence Nightingale felt constrained by the confines of her middle-class home, believing she had nothing useful to do. But if women did not marry, there was no alternative social role for them. Furthermore, large numbers of strong single women would radically upset the cultural balance of Victorian Britain.

Most female magazines of the time advocated the True Woman ideal. 'Periodical readers were offered a model of femininity as undifferentiated and uncontested, focused on the private and domestic as distinct from the masculine world of politics, law and [business].'[199] Initially, *Woman* magazine projected the desirability of a certain kind of woman:

The women whose good-will we value are those who are content and proud to be women, and to set a noble example to husbands, sons, and brothers, encouraging and inspiring them in private and public life, not by striving – and so often failing – to get ahead of them in every sphere, but, as far as they are fitted to do so, by working with them, earning the respect, and not the ridicule, of all men whose respect is worth having, and thus ennobling the world in which Providence has called upon them to play an important part.[200]

Woman did discuss the 'educated' woman but presented her as a 'bluestocking' to be mocked. Women were encouraged to read, but

woe betide them if they became bluestockings who knew too much, read too widely, began to question politics at dinner or started reading the classics in Greek or Latin. No sensible man would want to marry this kind of girl, for she had made herself masculine. There was a focus on learning, but not learning too much and not learning the wrong things. Attractiveness was emphasised, but if a woman thought too much about her looks, heaven forbid that too as she may be accused of expressing sexual desire through her outward appearance. Kitty and Lydia in *Pride and Prejudice* were depicted as foolish girls far too concerned with what they looked like, and this frivolity in Lydia's nature was subsequently blamed for the debacle with Wickham.

By 1892 women's magazines had grown both in volume and in content, as a changing social landscape and increasing female readership were accommodated. The British magazine *Young Woman* realised that as the end of the century approached, women were moving beyond the domestic realm and gender roles were progressively questioned. The strong and educated New Woman had arrived and became sensationalised in the popular press.

Four years on, 1896 was a 'watershed year in which ideas were being recalibrated, following the Wilde trials and the public burning of Thomas Hardy's *Jude the Obscure*. New magazines for women after this date had an important role to play in the reinvention of womanhood: would she retain her outspokenness or return to submissiveness?'[201]

The advent of the New Woman took place largely in a literary context. Though she was actually labelled as late as 1894 by Sarah Grand, who published an article in *The North American Review*,[202] she appears in several publications in an often 'show, don't tell' manner. In *Dracula*, for example, published in 1897 but possibly set several years earlier, Stoker compares and contrasts the different characters of Mina Harker and Lucy Westenra. Grand refers to a series of novels in her piece, discussing the place of women in their own sphere and the outside world as well as considering their subjection in these contexts and by doing so 'expanded the nineteenth-century imagination by introducing what we would now call feminist issues and feminist characters into the realm of popular fiction'.[203]

But did novels influence political activity or vice versa? Even if the New Woman was originally a symbol, she still gave contemporary

women an exemplar of how they could free themselves from the domestic conventions that dominated their place in the Victorian era. But as she chose independence, liberation and a career over marriage and children, literary critics decried the New Woman as a threat – to middle-class dominance, domesticity and the established order. She did not depend upon men; having had enough of male authority, she instead supported social change and progress for women as individuals. In Grand's words:

> Man deprived us of all proper education, and then jeered at us because we had no knowledge. He narrowed our outlook on life so that our view of it should be all distorted, and then declared that our mistaken impression of it proved us to be senseless creatures. He cramped our minds so that there was no room for reason in them, then made merry at our want of logic. Our divine intuition was not to be controlled by him, but he did his best to damage it by sneering at it as an inferior feminine method of arriving at conclusions; and finally, after having had his own way until he lost his head completely, he set himself up as a sort of god and required us to worship him and, to our eternal shame be it said, we did so.[204]

Men dominated and subjugated women but, in Grand's view, then made sport of them for following the male-prescribed social rules of the era. She also questions whether it is good for men to be 'worshipped' by women and highlights the ironic injustices of how women are expected to be sparkling conversationalists yet denied a proper education, and teased if they could not hold their own in debate. Yet it had always been in the male interest to block female education through fear that women could prove able to hold their own against men. It is safe to say that before the genesis of the New Woman, men had no idea what women really wanted. As Grand enquires, 'If women don't want to be men, what do they want?'

Whilst acknowledging the complicity of women in strengthening this construct – 'We are not blameless in the matter ourselves. We have allowed him to arrange the whole social system and manage or mismanage it all these ages ... we have endured most poignant misery for his sins, and screened him' – Grand recognises that men should not automatically assume they are superior: 'We have meekly bowed

our heads when he called us bad names instead of demanding proofs of superiority which alone give him a right to do so.'

Sarah Grand seems to be issuing a rallying call for change in attitudes of both men and women, emphasising that women could take responsibility if they so chose whilst highlighting the hypocrisy of men. Women are, she argues, capable of change – and the New Woman was going to be the instigator.

Celebrated as the domestic ideal, the True Woman became the personification and symbol of the separate spheres ideology. The New Woman, as an active participant in the world outside the home, personified progress, vibrancy and independence. She contrasted sharply with the True Woman's modest and submissive nature, religious and moral virtue, complete dedication to home, husband and family, combining, 'in her most perfect form ... total sexual innocence, conspicuous consumption and the worship of the family hearth'.[205] The True Woman became a whole personal construct, far more than just a set of attributes that were understood to be instinctive for True Women. These characteristics directed a woman's social activities, interests, behaviour and her choice of acquaintances.

The attributes and characteristics of a True Woman were assumed to be innate in middle-class women, and moreover were to be cultivated and developed. As such, this view contributed to class identity, particularly as the middle classes sought social elevation and separation from the working classes, which a True Woman would support through the behaviours expected of her.

It is probably arguable that the notion of the True Woman was allowed to thrive because of the perceived weakness of women and the fact they were alleged to be ruled by their hearts whereas the pragmatic male used reason and logic. Here is an excuse for the separation of responsibilities and subordination of women, wrapped up in the assumption that this was the natural order of the sexes, as designed by God, where work, politics and business was the domain of men and the woman was home-focused, purportedly to achieve perfect domestic harmony. In fact, too much thought, work and indeed education would, it was supposed, send women into a state of hysteria and be damaging to their health. (Note that hysteria was not physically possible for a man!) With this in mind, the home was thought to be the safest place for a woman, supposedly unable to operate on an equal intellectual level with men.

An upper-class woman would have unfettered leisure time at home, and middle-class women would aspire to the same by endeavouring to ensure it was unnecessary for them to work. The development of industrialisation throughout the Victorian era, which meant that fewer women were required to work outside the house, amplified this construct. Moreover, a man was meant to be able to provide for his wife and family, and an Angel in the House was not only a symbol of success and social mobility, it emphasised the separate spheres philosophy. Of course, this notion meant that a woman's social status was dependent on that of her husband, and not earned in her own right, as it would have been linked to that of her father before marriage. Middle-class women found themselves with increased leisure time, helping them to align with their upper-class aspirations. A middle-class girl was also expected to stay at home and help her mother with the house, sustaining her father – and brothers – until the time came for her to leave home and do it all over again with a husband of her own.

The Victorian True Woman should be meek, patient, content and calm, hold no thoughts of independence or a career, and wait for the time she would marry. And when she did, she would be devoted totally to husband, home and hearth.

Although not named as such until Sarah Grand's article, the late 1880s saw the emergence of the independent New Woman. She was capable and zealous, determined to earn her own living. The concept of the New Woman was more than female involvement in activities previously firmly fixed in the male domain such as business and politics, university, sports and the workplace. Here we have a new ideology of women and their roles in society, forcing a re-evaluation of the meaning of masculinity and femininity, and a shift from the ideal of the True Woman. Women's lives transformed and advanced through changes to education systems, political rights and fashions. Women joined clubs and societies purely for themselves, with a view to educating and improving their intellectual capacities, joining debates and advancing politically. This unsurprisingly drew scathing comments but the resultant ridicule and attacks essentially opened up a space for sympathetic discussion and caused the New Woman to finally stand up and be counted.

Improving the standard of female education was one of the key factors in narrowing the inequality gap between men and women

in the late Victorian era. Before this, female education had been limited by the aim of preparing for marriage and motherhood alongside developing submissiveness to perceived authority. Critical thinking was not encouraged in young women, lest it damage their marriage prospects. The New Woman provided a contrast. She was interested in her own personal development and pursued it for its own sake rather than to attract a husband. Though she ran the risk of being labelled a 'bluestocking', the New Woman was noted for her increased level of education. By the time the New Woman was being talked about, Bedford College had been open for forty years and Girton College, Cambridge, had been admitting women for twenty years. By now Lady Margaret Hall and Somerville, both colleges at Oxford University, also allowed female students through their doors.

London University opened up the general examination for women to female students aged seventeen or over in 1868. To pass, they needed to succeed in at least six papers out of a range of subjects including geography, English history, English language, Latin, mathematics and natural philosophy in addition to a science subject and a modern language. Although academic success only afforded them a Certificate of Proficiency, ten years later London University became the first British university to admit women to a degree programme. By 1880 four women had achieved a BA degree whilst the following year saw two female BSc successes. By the turn of the twentieth century, 30 per cent of London's graduates were female.

Alongside these educational developments and the emergence of the New Woman in novels and journalistic output, Britain was in the midst of an imperialistic zeitgeist and socialist attitudes were growing. Around this time, writer and society hostess Blanche Crackanthorpe wrote an article for *Nineteenth Century*[206] in which she reasoned that a single woman was 'an individual as well as a daughter' and should be afforded every right to a social life, education and travel.

Indeed, explorer and traveller Isabella Bird Bishop shared this view and in 1891 became the first woman to be elected a fellow of the Royal Scottish Geographical Society. But this did not prevent a show of contempt from George Curzon in a letter to *The Times* following a debate on RGS fellowships for women:

We contest in toto the general capability of women to contribute to scientific geographical knowledge. Their sex and training

render them equally unfitted for exploration: and the general professional female globe-trotters with which America has lately familiarised us is one of the horrors of the latter end of the 19th century.[207]

Although Isabella was married, general opposition to the New Woman seemed heavily grounded in the perception of the risk she posed to the traditional establishment of marriage.

Along with the New Woman's association with sport and particularly the bicycle, the history of the department store in the UK and the rise of the New Woman also go hand in hand. Jenner's of Edinburgh was the first major department store in the UK, followed by Harrods, which was established on the Brompton Road in 1849, and Kendal Milne of Manchester the following year. The 1851 Crystal Palace Great Exhibition had a huge impact on consumer culture in Victorian England. Department stores followed the exhibition's example of categorising and displaying items in a large space to great visual effect, allowing customers to browse and mingle.

A visit to a department store became a social event. As the stores with their vast spaces and huge windows were firmly aimed at women, here was an opportunity for the New Woman to expand her visibility in the public realm whilst exercising freedom and choice. Upper- and middle-class Victorian women became major consumers. They required several changes of outfit during their day in order to carry out their social lives, and this demand created jobs for working-class women as sales assistants and dressmakers; in turn, these women saw opportunities to progress into roles such as department store buyer. By the 1870s, Marshall and Snelgrove had three stores in London, Leeds and Scarborough. The New Woman contributed to the success of department stores as both consumer and worker, alongside which the development of public transport systems allowed women to safely travel to cities to shop and partake in other social activities.

Women were also now entering the workforce in increasing numbers, not only in the retail sector but in offices too. The 1871 British census reveals more than 1,400 female office clerks – although magazines like *Young Women* still advised female secretaries and clerks to work quietly and dutifully whilst their male counterparts were coached to aim for promotion by demonstrating their intellect, self-assurance and leadership. Whilst most working-class women were

working out of necessity, there were many single women entering the workforce from middle-class families. By the end of the Victorian era, teaching, clerical work and nursing – which required formal and advanced education – remained the almost exclusive domain of the middle-class woman. Higher education was now supportive of women's pursuits, particularly those upper- and middle-class women who could afford the fees for higher education.

Representing as she did the change to androcentric Victorian culture, the New Woman was met with resistance and fear. The Victorian era saw unprecedented social and industrial change, and the 'woman's sphere' and feminine dependence was a way of preserving the status quo as the turn of the century approached. The New Woman became the personification of the erosion of long-held gender ideology.

But what were these fears? The most obvious concern was that a liberated and financially independent New Woman would see no reason to get married or produce children. Education and careers were considered to be distractions from a woman's true destiny. Women who followed the path of education and learning were considered strange at the very least, a traitor to their sex at worst, with these views backed up by the medical and scientific professions. An 1883 edition of *The Popular Encyclopedia*[208] described such a woman as a bluestocking, a 'pedantic female' who has surrendered the 'excellencies of her sex' to education and self-development.

Both the middle and upper classes held reservations about the new role women were carving out for themselves in society. Fears for a woman's health abounded. Doctors put forward the notion that a woman was incapable in both mind and body of carrying out activities outside the house such as work and sporting activities. This was thought to have a negative effect on her nervous system and overall health. Charles Darwin exercised huge influence on the medical profession's attitudes towards women because his model of evolution provided an apparently rational justification of conventional Victorian beliefs. Darwin's 1859 *Origin of Species* and his views on natural selection provided supposedly evolutionary arguments for doctors to back up the separate spheres ideology with supposed biological and anthropological certainty. His 1871 work *The Descent of Man*, stating as it did that 'the chief distinction in the intellectual powers of the two sexes is shown by man's attaining to a higher eminence

in whatever he takes up, than can woman – whether requiring deep thought, reason, or imagination, or merely the use of the senses or the hands', suggested that men had developed an intellectual superiority through millennia of hunter-gatherer activity. A woman's role, he claimed, was to attract a powerful man by dressing elaborately and focusing on femininity. Equality was scientifically impossible.

The Girl's Own Paper began life in 1880 as a sixteen-page weekly paper published by the Religious Tract Society, which eventually became incorporated within the Lutterworth Press, and was unique in that it provided a real insight into the changing world of a young Victorian woman. Although it initially promoted the ideals related to the True Woman, articles highlighting the advantages of higher education began to appear along with informative pieces about the dangers of corsets and crinoline.

An early article explained that women may engage in sports only amongst friends and not with any sort of competitive zeal; a few years later the magazine abounded with how-to articles enabling women to engage in a host of sports, including the much-bemoaned 'cycling craze'. Craft articles, far from being limited to pieces on embroidery and knitting, encouraged girls to take up wood carving, metalwork and many other physically challenging projects. Several articles covered the growing number of career paths available for 'gentlewomen'.

A contemporary article that became popular because of its scandalous and controversial nature, Mona Caird's 'Marriage' had appeared in the *Westminster Review* in August 1888. Caird fiercely criticised 'old fashioned' Victorian middle-class morals and likened marriage to slavery and prostitution. She wrote about the New Woman with zeal and set out a blueprint for an equal relationship between the sexes. Women were, she believed, entitled to full citizenship and always had been; the fact that men and women were not considered as equals was a result not of nature, but of nurture and the promulgation of separate spheres; put simply, inequality was the consequence of a patriarchal society. It was now time to stop. It was time for the New Woman to step forward.

Rather inconsistently, then, *The Girl's Own Paper* talked in 1894 of a 'widespread feeling, especially amongst the lower middle class, that a woman becomes unwomanly when she enters into the same field of labour as a man, in direct competition with him'.[209] Depending on the viewpoint, such articles warned that once a

woman chose to become educated, widen her sphere and enter into a profession outside of the home she would inevitably reject the option of marriage and end up as a spinster. The single middle-class woman was presented either as a social problem or a cautionary tale of liberation – or, rather more subtly, the old ways of doing things were treated humorously.

Thanks to Sarah Grand, 'New Woman' soon became a popular catchphrase in newspapers and books, but not always for the right reasons. The New Woman became a cultural phenomenon of the *fin de siècle* and a departure from the stereotypical Victorian woman. She was intelligent, educated, emancipated, independent and self-supporting, and among her ranks were middle-class female activists as well as factory and office workers: 'Contemporary with the new socialism, the new imperialism, the new fiction and the new journalism, she was part of cultural novelties which manifested itself in the 1880s and 1890s.'[210]

Some magazines and articles featured caricatures of the New Woman, presenting her as tomboyish or an elderly spinster, featuring cartoons of her smoking or looking physically masculine – often compared with the 'perfect' wife and mother or juxtaposed with effeminate-looking men to get the message across: men, this is what the New Woman will reduce you to! Between 1885 and 1900, *Punch* included over 200 New Woman cartoons, showing her participating in sports or fitness-related activities. The message was clear – she was unfeminine and invited comparison with the True Woman. However, the real effect was that publications such as *Punch* inadvertently provided a platform for the New Woman construct to thrive. She was acknowledged and brought to life by being depicted as compelling and liberated yet controversial:

The New Woman was by turns: a mannish amazon and a Womanly woman; she was oversexed, undersexed, or same sex identified; she was anti-maternal, or a racial supermother; she was male-identified, or manhating and/or man-eating or self-appointed saviour of benighted masculinity; she was anti-domestic or she sought to make domestic values prevail; she was radical, socialist or revolutionary, or she was reactionary and conservative; she was the agent of social and/or racial regeneration, or symptom and agent of decline.[211]

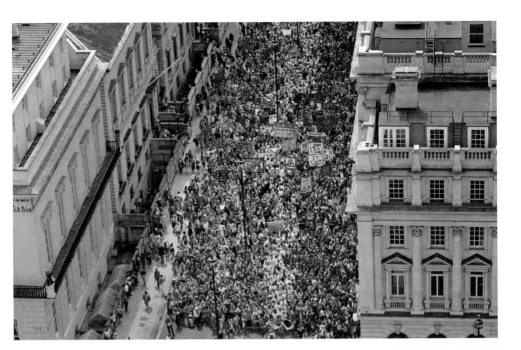

Above: 1. Processions, Central London, 10 June 2018. Women and girls in Belfast, Cardiff, Edinburgh and London came together wearing the colours of the suffragette movement in a mass-participation 'moving artwork' to celebrate the centenary of Votes for Women. (1418Now.org.uk)

Right: 2. *First Class: The Meeting... and at First Meeting Loved* by Abraham Solomon, 1854. This young man and young woman were, by Victorian standards, behaving scandalously by carrying on a conversation without her father's presence, who was seen as a figure of authority in her life. This version of the painting challenged Victorian sensibilities and the artist produced a second version. (National Gallery of Canada)

Below right: 3. Solomon's reworked version, more reflective of Victorian views. (National Gallery of Canada)

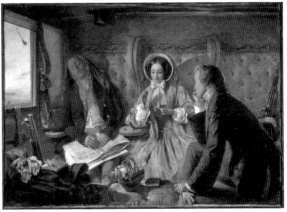

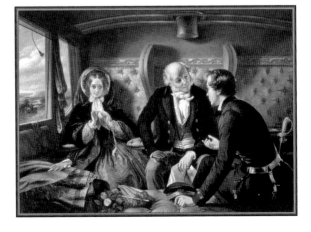

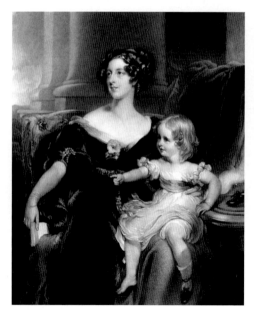

Above left: 4. Harriet Elizabeth Georgiana Leveson-Gower (*née* Howard), Duchess of Sutherland, by George Henry Phillips, 1841. Harriet used her strong religious values to make a difference both politically and charitably. She was one of the leading early Victorian society hostesses, a friend and Mistress of the Robes to Queen Victoria, and a leading philanthropist and political debate organiser. (National Portrait Gallery)

Above right: 5. Scissors by William Whiteley & Sons Ltd, who made scissors for the 1851 Great Exhibition. This is one of two pairs produced in 1838, presented to Queen Victoria and displayed in Sheffield Museum. Ten years later, the founder died and his wife, Elizabeth Whiteley, took over the company, running it successfully until 1868. (Courtesy of Sally Ward of William Whiteley & Sons (Sheffield) Ltd)

6. Mona Caird, novelist, writer and critic of marriage laws. In an account of a party Caird held at her home, the London correspondent of the *Evening Telegraph* (31 March 1890) describes the 'tall and graceful figure' and 'sensitive, mobile face' of the hostess. The *Leeds Times* (10 March 1894) describes her as a 'small, nice-looking woman, always well-dressed, still in early middle-life' while the *Daily Evening Bulletin* (30 March 1889) claims an unstated English paper described Caird as 'young and beautiful, tall, with a fine carriage and Oriental eyes shaded by heavy lashes'. (Canterbury Christ Church University and *The Review of Reviews*, 10, July–December 1894)

Right: 7. Caroline Norton by Daniel Maclise, published by James Fraser, lithograph, 1831. A social reformer and author, Norton left her husband in 1836, following which he sued Lord Melbourne, then Prime Minister, for 'criminal conversation'. The jury threw out the claim, but, unable to obtain a divorce and refused access to her three sons, she began a forceful campaign to change the law, leading to the Custody of Infants Act 1839, the Matrimonial Causes Act 1857 and the Married Women's Property Act 1870. Norton modelled for the fresco of Justice in the House of Lords by Daniel Maclise, who chose her because she was seen by many as a famous victim of injustice. (National Portrait Gallery, London)

Below: 8. Children at a Victorian dame school in Twelveheads, West Cornwall. The inadequacies of dame schools in Britain were illustrated by a study conducted in 1838 by the Statistical Society of London that found nearly half of all pupils surveyed were only taught spelling, with only a small few being taught mathematics and grammar. (Courtesy of Kresen Kernow Archives)

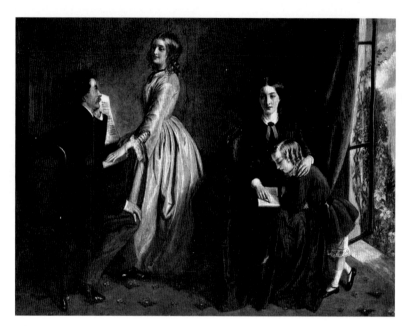

Above: 9. The Governess by Rebecca Solomon, 1854. The Royal Academy of Art Schools, where Solomon's brothers studied, would not admit women so Rebecca attended the Spitalfields School of Design. She studied with Pre-Raphaelite artists John Everett Millais and Edward Burne-Jones. The establishment of Queen's College (1848) by the Governesses' Benevolent Society and Bedford College (1849) in London kick-started the advancement towards equality of middle-class girls' education. (Magnolia Box, 2020)

Below: 10. Staff of the Victoria Press, *Illustrated London News*/Mary Evans Picture Library. At the time women were campaigning for equality in marriage, law, employment and education, solidarity and friendship between women was crucial to achieving these aims. This can be seen clearly in the network of the Langham Place group and organisations such as the Victoria Press. (Courtesy of the British Library)

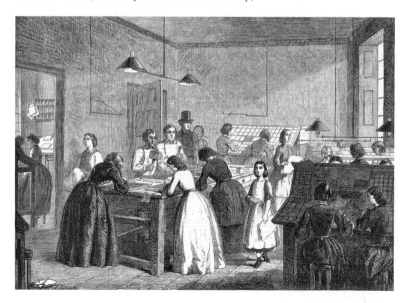

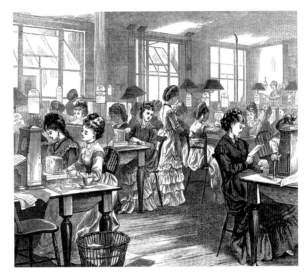

11. The first telegraph clerks were recruited in the early 1840s. This was a completely new industry requiring large numbers of staff to operate the innovative equipment. Moreover, it was viewed an acceptable role for women owing to limited exposure to men and the fact employers could pay them less than male clerks. (From *Rab Bethune's Double* by Edward Garrett, 1894)

12. Early professional female stained glass artist Mary Lowndes, an alumna of the Slade School of Fine Art. Lowndes started out as an assistant to stained glass designer Henry Holiday in his studio-workshop, drawing cartoons for several of their stained glass commissions. This set her on the path to learn the techniques of stained glass and gain work as a designer for James Powell & Sons from 1887 to 1892, creating tableware, bold decorative glass and stained glass windows.

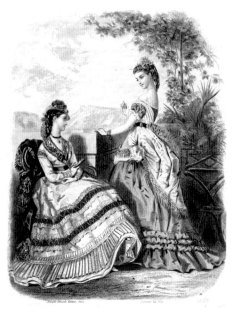

13. Fashion plate featuring day and evening dresses, hand-coloured etching, line and stipple engraving, 1869. Young women would look at fashion plates and imagine themselves attending balls, parties and other social occasions dressed in the outfits they saw there. Magazines such as the *Englishwoman's Domestic Magazine* featured plates of the most fashionable designs, allowing women to make copies of patterns or adapt the fashion plates they saw. Some magazines gave illustrated practical advice on sewing techniques, materials and tools. (National Portrait Gallery, London)

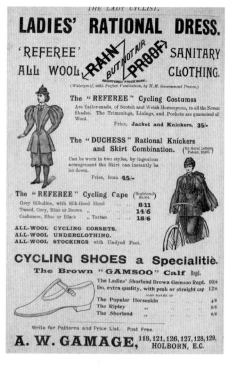

Above left: 14. Hon. Sophia Felicité de Rodes (*née* Curzon), 1865. Sophia wears a formal daytime outfit typical of the mid-1860s. Most prominent perhaps is the bold contrasting applied braiding that forms a striking geometric pattern towards the hem of her skirt: photographic evidence indicates that this type of ornamentation was especially fashionable among the middle and upper classes around 1864/65. (National Portrait Gallery, London)

Above right: 15. Ladies' rational dress advert in *The Lady Cyclist*, March 1896. The British branch of the Rational Dress Society was launched in 1881. (Warwick University Library)

16. Young crinoline-wearing ladies poke fun at Regency fashions, *Harper's Weekly*, 1857. Satirical publications like *Punch* made fun of the crinoline, using hyperbole and exaggeration for comic effect. This image shows crinoline-wearers oblivious to the irony of their mockery. (Warwick University Library)

"ARABELLA MARIA. "Only to think, Julia dear, that our Mothers wore such ridiculous fashions as these!"
BOTH. "Ha! ha! ha! ha!"

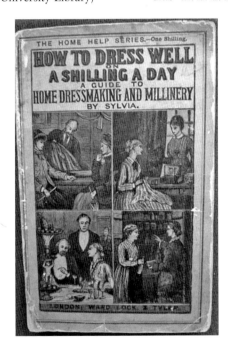

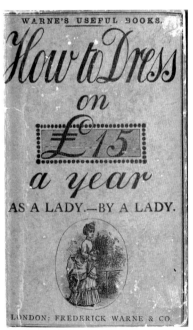

Above left: 17. Cover of *How to Dress Well on a Shilling a Day* by 'Sylvia'. 'Poverty must, above all things, avoid the appearance of poverty,' wrote 'Sylvia' in 1876. Sylvia's book covered everything a Victorian woman needed to know about fashion and included patterns and detailed instructions on how to make up the garments. (book purchased from Priory Antiques & Collectables, Orpington)

Above right: 18. Cover of *How to Dress on £15 a Year* by Millicent Cook, 1873. The annual mid-century income of an aristocrat was over £10,000 whilst the minimum middle-class funds to cover necessary outgoings and maintain an upwardly mobile image was around £300. (Image courtesy of Google Books)

Above: 19. The Edinburgh Seven's signatures. Sophia Jex-Blake led the campaign for the right to higher education for women after applying to study medicine in March 1869. Whilst the Medical Faculty was in favour of welcoming Jex-Blake, the University Court rejected the application stating they could not change the rules 'in the interest of one lady'. After a newspaper appeal, six other women joined her and they became collectively known as the Edinburgh Seven. The other women were Mary Anderson, Emily Bovel, Matilda Chaplin, Helen Evans, Edith Pechey and Isabel Thorne. (Leonie Paterson, Royal Botanic Garden Edinburgh Archives)

Above right: 20. Hertha Ayrton by Helena Arsène Darmesteter. Many Victorian women engineers obtained their successes through collaboration, like Ayrton. She excelled in research, and her husband William commented to a friend that whilst they were 'able people … Hertha is a genius'. He fully supported his wife's research and abilities in the face of both the conventions of the time and the criticism of his colleagues. (Girton College, University of Cambridge)

Middle right: 21. Queen Victoria kept a journal for most of her life, starting at the age of thirteen in 1832, writing her final entry shortly before she died in 1901 at the age of eighty-one. (Royal Collections Trust)

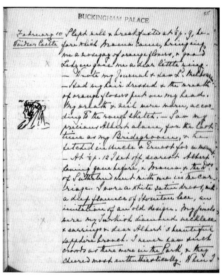

Below right: 22. One of several portraits of Princess Vicky by Queen Victoria. Whilst she did openly say she disliked babies, Victoria also wrote letters praising her children, saying how delightful and charming they were. (Royal Collections Trust)

As the century wound down, the New Woman philosophy became inseparable from the social changes that led to a redefinition of gender roles. It was a time when 'all of the laws that governed sexual identity were breaking down'.[212] As we have noted, women had become more active in the labour force, divorce laws had changed, universities were admitting women, consumer culture was on the rise and women's rights were being consolidated. Women became concerned with socialist politics. It was time to start seeing women as individuals, to consider what they were thinking, doing and beginning to achieve for themselves. One of the outward indications of these changes was the world of fashion.

The New Woman differentiated herself from the True Woman by dressing in a functional yet still feminine style. The combination of a plain fitted skirt and separate blouse became popular in the 1890s, and introduced a new phase in women's dress design and an end to the frills, bustles and flounces that characterised the True Woman's clothing, and allowed them to move without restrictions and discomfort, reflecting the ambitions of women's rights activists. The New Woman's outfits were far simpler to construct and gave rise to the ready-to-wear garment revolution. They were able to be purchased from department stores and were widely adopted by women working in offices, small businesses and factories, showing them to be confident and capable of work and leisure activities.

Representations of the New Woman in novels, and particularly those written by men, were perhaps responsible for much of the fear and alarm about the future of womanhood. The status quo was threatened and New Women, real and literary characters alike, were torn to shreds in the popular press. Hugh Stutfield's fiercely anti-feminist 1895 essay 'Tommyrotics'[213] refers to the 'desexualized half-man' who 'loves to show her independence by dealing freely with the relations of the sexes. Hence all the prating of passion, animalism, "the natural workings of sex" and so forth, with which we are nauseated. Most of the characters in these books seem to be erotomaniacs. Some are "amorous sensitives": others are apparently sexless, and are at pains to explain this to the reader. Here and there a girl indulges in what would be styled, in another sphere, "straight talks to young men".'

But in reality, the New Woman's activities were generally less centred on sexual freedom and liberation than their statutory rights,

although it has to be said that essayist and novelist Mona Caird's writings on the former proved somewhat vociferous. The last census of the nineteenth century, taken in April 1891, showed that single women outnumbered men by around 900,000 and certainly the 'surplus women' question had been debated for the preceding forty years since it was brought to popular notice by Harriet Martineau in the *Edinburgh Review*.

Although few lower-class women immediately benefited directly from the New Woman's changing ideas, the advancements made by the upper and middle classes in education, political and legal rights were the beginnings of a process of change in collective thinking about the role of women in society.

Mona Caird saw marriage primarily as a means of female exploitation and institutional violence, preserving male power and degrading women – she even likened it to prostitution, as had Mary Wollstonecraft before her – to the extent that mothers could even influence their daughters to be less than they could be:

> The ideal marriage ... should be free ... Even the idea of 'duty' ought to be excluded ... it need scarcely be said that there must be a full understanding and acknowledgement of the obvious right of the woman to possess herself body and soul, to give or withhold herself body and soul exactly as she wills.[214]

Along with education for women, these issues had been debated mid-century. But Caird was now writing of her views in more enlightened times. Whilst the sexual oppression of women had been on the table for contemporary debate for some time, Jack the Ripper was currently slaughtering prostitutes in Whitechapel. Until 1863, police were able to arrest women who were suspected of working as prostitutes in military or seafaring towns under the Contagious Diseases Acts and carry out a forced examination, at which point they were locked up if found to be infected. These actions did not extend to the women's male customers and the system was open to abuse, victimising these working-class women, restricting their movements in public and effectively giving them a criminal record until Josephine Butler succeeded in repealing the Acts in 1886.

In *The Morality of Marriage and Other Essays* (1897),[215] Caird calls for 'equal rights for the two sexes; the economic independence of

women ... real freedom in the home [which] at last would bring us to the end of the patriarchal system'. Women should not be tempted to marry for the 'sake of bread and butter'. She envisaged men and women being comrades and fellow workers as well as lovers, husband and wife.

Caird likened the concept of respectability, which curtailed women from freedom of expression, to vampirism, which 'sucked the lifeblood of all womanhood'. She also thought that there was no reason why motherhood should limit a woman's ability to work outside the home, whereupon the 'Woman Question' would be at least partially solved, as women would no longer have to choose between a career or marriage and children. She analysed John Stuart Mill's work and argued that the entire separate spheres philosophy was predicated on a misrepresentation of the true nature of women, to the extent that it was no longer possible to discern what their attributes and capabilities were: 'What John Stuart Mill saw so clearly about half a century ago is gradually and slowly coming to be recognised and proved, bit by bit, through observation and research directed to the subject.'

Mary Wollstonecraft had begun to question inequalities in power between the sexes in the preceding century. Although subtle changes began before the *fin de siècle*, literary interpretations of the New Woman – and the use of the term New Woman itself – proliferated during this time.

As well as her published articles, it was through her novels and short stories that Caird helped to establish the archetypal New Woman. In *The Yellow Drawing Room*, Vanora Haydon speaks out against Victorian customs when she rebelliously paints the drawing room in yellow – considered a most unsuitable colour at the time, associated as it was with emancipation and individuality. Told through the eyes of her admirer, who attempts to compel Vanora to conform to the contemporary ideal of femininity, turn-of-century anxieties regarding threats to male dominance are exposed.

Contemporary literature therefore has much to tell us about how Victorian women were viewed and represented. In the mid-nineteenth century, novel writing was not a 'high-status career', but as it grew in prestige it became more desirable to male writers, leading to women disguising their identity through a *nom de plume*. Additionally, women were initially portrayed in more constrained fashions in much Victorian writing. Mary Shelley and Ann Radcliffe's heroines are more enlightened than those in later novels as the image of the Angel

in the Home increasingly features as the Victorian era progresses. Female writers would have gender ideology and ideas of femininity and decorum to consider in their work. Later New Woman writers such as Mona Caird, Sarah Grand and Charlotte Perkins Gilman used their works to intentionally explore female oppression and to unmask repressive social conventions whereas fewer male authors used this strategy deliberately.

Blanche Crackanthorpe had written that 'marriage is the best profession for a woman; we all know and acknowledge it; but, for obvious reasons, all women cannot enter its straight and narrow gate'.[216] Jane Hume Clapperton agreed with this view, remarking that 'even if they had the fascinations of Helen of Troy and Cleopatra rolled into one',[217] there were far more single women than there were men to go round. But were the New Woman and a wife really opposite limits of a dichotomy?

Compare and contrast the roles of Mina Harker and Lucy Westenra in *Dracula*. Both women write. However, whilst Lucy writes about boyfriends and dresses, Mina has a professional role, can type and read shorthand and curates her husband's letters into a book. Whilst both women are a part of the same circle as the group of men in the novel, Mina works with them whilst Lucy's ultimate demise is at their hands owing to her complete reliance and their insistence on treating her as Queen Victoria would advocate. Mina eventually becomes a wife and mother but manages to be both a domesticated woman whilst acknowledging her intelligence, strength and integrity as an individual. She embodies social decorum whilst at the same time challenging the patriarchal structure of the times, proving that it is possible to simultaneously be a New Woman and a married woman.

But male authority was not restricted to the marriage relationship. In *Felix Holt*,[218] George Eliot's creation of Arabella Transome, who had so far been 'master, had come of high family, and had spirit', is sidelined and demeaned by her son Harold after years of successfully managing the family's estate. Although the action takes place around the time of the first Reform Bill in 1832, the novel was published just before the 1867 Reform Bill and became part of the debate about democracy and women's rights.

Returning from a fifteen-year absence in the colonies, Harold's actions in removing his mother from the role of estate manager reflect the comment in the novel that giving women power would 'hinder

men's lives from having any nobleness in them'. Patriarchal society norms prevent Arabella from having a voice regardless of her obvious ability in keeping the estate afloat for a decade and a half. Harold does not listen to his mother's account of her managerial responsibilities, nor does he involve her in future plans:

Ah, you've had to worry yourself about things that don't properly belong to a woman – my father being weakly. We'll set all that right. You shall have nothing to do now but to be grandmamma on satin cushions.

Arabella emphasises her capability in the role she has occupied:

You must excuse me from the satin cushions ... that is a part of the old woman's duty I am not prepared for. I am used to be chief bailiff, and to sit in the saddle two or three hours every day.

By his dismissive attitude to his mother, Harold exemplifies the male perspective that women should not think or make decisions for themselves. If women are unsettled or unhappy, why, that is a consequence of transgressing their role and stepping outside their domestic sphere. They should, indeed, know their place. This applies across all relationships, not only that of husband and wife.

Boys were brought up to think themselves the superior sex from childhood. 'Think what it is to be a boy, to grow up to manhood in the belief that without any merit or exertion of his own ... by the mere fact of being born a male he is by right the superior of all and every one of an entire half of the human race,' wrote John Stuart Mill. 'How early the youth thinks himself superior to his mother, owing her forbearance perhaps but no real respect; and how sublime and sultan-like a sense of superiority he feels, above all, over the woman whom he honours by admitting her to a partnership of his life. Is it imagined that all this does not pervert the whole manner of existence of the man, both as an individual and as a social being?'[219]

Ironically a senile husband had afforded Arabella such authority but she now finds herself isolated in a traditional female role, all individuality stifled. Male dominance is 'as pleasant ... as if it had been cut in her bared arm ... what is the use of a woman's will? – if she tries, she doesn't get it, and she ceases to be loved. God was cruel

when he made women.'[220] Having proved herself beyond her domestic role, Arabella argues that even though she is now middle-aged, she is still intellectually and influentially capable of carrying out a political role. No, the problem is simply that she is female.

In the same year, George Eliot had written to John Morley, then a journalist, acknowledging that their views on female emancipation were very similar but 'as a fact of mere zoological evolution, woman seems to me to have the worse share in existence'. Arabella Transome discovers that for herself. Even though she 'had been used to rule in virtue of acknowledged superiority' she must now renounce her authority to her son as, after all, it should 'properly belong to men'. Through Arabella's experiences, Eliot created a powerful literary commentary on the problem of the obstacles to emancipation for women and their whole existence.

Male novelists also had something to say about the 'Woman Question'. Grant Allen challenged the traditional male-controlled society and the opinion that marriage and motherhood were the most suitable occupations for women through Herminia Barton, protagonist of *The Woman Who Did* (1895). Herminia's perceived choices are clear: marry and accept serfdom, or stay single and embrace freedom. She not only declines to marry her lover, Alan, but refuses to live with him too:

To do as other women do; to accept the HONORABLE MARRIAGE you offer me, as other women would call it; to be false to my sex, a traitor to my convictions; to sell my kind for a mess of pottage, a name and a home, or even for thirty pieces of silver, to be some rich man's wife, as other women have sold it. But, Alan, I can't. My conscience won't let me. I know what marriage is, from what vile slavery it has sprung; on what unseen horrors for my sister women it is reared and buttressed; by what unholy sacrifices it is sustained, and made possible. I know it has a history, I know its past, I know its present, and I can't embrace it; I can't be untrue to my most sacred beliefs. I can't pander to the malignant thing, just because a man who loves me would be pleased by my giving way and would kiss me, and fondle me for it. And I love you to fondle me. But I must keep my proper place, the freedom which I have gained for myself by such arduous efforts ... Marriage itself is still an assertion of man's

supremacy over woman. It ties her to him for life, it ignores her individuality, it compels her to promise what no human heart can be sure of performing; for you can contract to do or not to do, easily enough, but contract to feel or not to feel, – what transparent absurdity! It is full of all evils, and I decline to consider it. If I love a man at all, I must love him on terms of perfect freedom. I can't bind myself down to live with him to my shame one day longer than I love him; or to love him at all if I find him unworthy of my purest love, or unable to retain it; or if I discover some other more fit to be loved by me.[221]

Allen's intention was to jolt his readers to consider the key questions surrounding *fin de siècle* sexual politics, having styled himself as an 'enthusiast on the Woman Question' and seeking to bring this to public attention:

I have the greatest sympathy with the modern woman's desire for emancipation. I am an enthusiast on the 'Woman Question'. Indeed, so far am I from wishing to keep her in subjection ... that I would like to see her a great deal more emancipated than she herself as yet at all desires ... I feel sure that while women are crying for emancipation they really want to be left in slavery; and that it is only a few exceptional men, here and there in the world, who wish to see them fully and wholly enfranchised.[222]

But Herminia's defiant actions were destabilised by her tragic fate; her daughter rejects her mother's feminism, aligning herself as a True Woman, and Herminia commits suicide. Millicent Garrett Fawcett, in her review of the book, states that 'the central idea of Mr Grant Allen's book is that marriage means slavery',[223] and as he offers no way for the heroine to work towards positive change for all women but rather make extreme and drastic personal choices, Fawcett rebuked Allen for detracting from the real motive of New Women: ensuring equality for women through law reform.

Like Herminia, Thomas Hardy's Sue Bridehead[224] also thoroughly embraces educational opportunities. She reads J. S. Mill, Mary Shelley and Swinburne. She is unenamoured with the idea of marriage, dismissing it as restrictive and a source of inequality: 'I think I should begin to be afraid of you, Jude, the moment you had contracted to

cherish me under a Government stamp and I was licensed to be loved on the premises by you – ugh, how horrible and sordid.'

Sue's unorthodox attitude to society leads her to quest for a new way of being female. Hardy describes her as 'almost as one of their own sex' and being in possession of a 'curious unconsciousness of gender' in relation to men as well as being 'more independent' than most contemporary women. Sue, however, whilst holding enlightened and emancipated views, is afraid of sex as well as of marriage. Whilst she lives unwed with Jude in an ostensibly equitable relationship, doing what was right for themselves rather than society, she ultimately bows to the pressure of society 'because of the awkwardness of [the] situation', rejecting her own truth about cohabitation. She has the potential to be emancipated, individual and a feminist but the frigid aspect of her nature is at odds with that of the representative New Woman. She is required to be subordinate to her husband within marriage and accepts that she 'must conform' to assuage her guilt at living with a man out of wedlock.

Hardy's treatment of Sue as a New Woman through her relationships is thus confusing, although can be read as an indictment on the inequality of marriage and its double standards. Sue's ultimate tragic fate highlights the failings of society in relation to the difficulties that face women who choose not to conform. Patriarchal society, too, limited the licence Hardy had to present Sue as an emancipated woman, and like Grant Allen he gives her no happy ending.

Critics of this type of novel included writer Walter Besant, who accused writers of deliberately setting out to damage the institution of marriage, the family and consequently society by advocating free and adulterous love, whilst an article by author Margaret Oliphant denounced Herminia Barton and Sue Bridehead as figureheads for 'The Anti-Marriage League'.[225] Discussing the New Woman that she perceives these characters to represent, she declares, 'Faithfulness is bondage in her eyes. She is to be free to change her own companion if she discovers another more fit to be loved. And if one, also another no doubt, and another.' Though, of course, women who wanted several sexual partners were doubtless in the minority.

Whilst the intention of New Woman writers was to present a different approach towards gendered behaviour, particularly in sexual relationships, they failed in their aim through the unhappy fate of some of their heroines. Although somewhat melodramatic, 'The Yellow

Wallpaper' (1892) is based on the experience of the author, Charlotte Perkins Gilman, following her treatment for what we now know to be postnatal depression. Reading, writing, painting and independent thought were forbidden, based on the premise that women would be happier without striving towards modern ideas such as votes for women, education and work. The unnamed woman in the short story claims to see a female figure underneath the yellow wallpaper in her room, representing her repression. Gilman had been told to stop writing, painting and drawing as part of her 'cure' but stated that she came perilously close to losing her mind as a result of inactivity.

Mary Elizabeth Braddon's *Aurora Floyd* features another suggestively characterised, independent young woman who challenges the limitations of Victorian feminine decorum. With the book published in 1863, the eponymous Aurora predates the New Woman by several decades, but she nevertheless personifies her philosophies. Although clearly beautiful – an absolute requisite of a Victorian woman – Aurora is also strong willed and most definitely does not embody the idealised qualities of women such as passivity, dependence or submission. She has been a competent horsewoman since childhood, attends races and bets on horses – all male qualities which are disparaged as unladylike behaviour by a male character who 'ridiculed, abused, sneered at and condemned [Aurora's] questionable tastes … He lashed himself into a savage humour about the young lady's delinquencies, and talked of her as if she had done him an unpardonable injury by entertaining a taste for the Turf.' Unfairly, Aurora is criticised as being impure because she is not impassive. A woman's purity determined the role she played in Victorian society and also contributed to the regulation of that society. A man was expected to naturally govern and a woman to naturally obey, but Aurora did not follow this pattern.

To show how far Aurora had strayed from the image of the ideal Victorian woman, Braddon contrasts her with her cousin Lucy, who is gentle, compliant, pure, simple and obedient: 'There are so many Lucys but so few Auroras … she was exactly the sort of woman to make a good wife … purity and goodness had watched over her.' Her husband's 'fair young wife's undemonstrative worship of him soothed and flattered him. Her gentle obedience, her entire concurrence in his every thought and whim, set his pride at rest.' This, after he had rejected Aurora for her New Woman tendencies and chosen instead to marry Lucy, who matched society's expectations.

Aurora is not a typical Victorian heroine, especially so in contrast to Lucy. But while Lucy is presented as the nineteenth-century ideal and Aurora as unwomanly, Braddon neither judges nor disapproves of Aurora; nevertheless she does conclude the story with her being restrained in the typical Victorian female role of wife and mother, her progressive tendencies having been tamed, though it is fair to say that the marriage between Aurora and John is more of an equal balance.

Another early New Woman-ish representation was 1856's *Madame Bovary*. Emma harbours her own desires, thoughts, feelings and emotions that are neither prim nor proper. Flaubert takes apart the Victorian idea that women should not be expected to have ambition, and focuses more on similarities between the sexes than the differences. However, Emma is a paradox: a traditional Victorian wife on the outside, underneath she is struggling to reconcile her emotions and the problems these have wrought in the restrictive social climate. Of course, there can be no happy ending for Emma, reflecting the judgemental nature of contemporary society and serving as a warning to the would-be New Woman.

Then again, one of the most effective personifications of a New Woman in Victorian literature who represents the Victorian attitude to changes in society in a reasonable and accessible way is that of Mina Harker in *Dracula*. The New Woman was a challenge to traditional values, and 'family structures upon which the middle class had based its moral superiority were disintegrating'.[226] The New Woman was campaigning for control over her personal and professional life; equal rights to education, employment and the franchise meant independence, and an independent woman was threatening to patriarchal society. Mina Harker and Lucy Westenra are both New Women in their individual ways but are presented differently, Mina as pure and rational, and Lucy as rebellious and voluptuous.

Punter and Byron wrote that society was controlled by 'defining and delimiting the nature and roles of the sexes in a manner that particularly constrained women', and by the late Victorian period the New Woman was, as examination of previous novels of the period have demonstrated, outraging conservative Victorians. Mina, however, is a moderate New Woman who calmly and competently uses her intelligence, practicality, organisational skills and rational thinking to lead men in the defeat of Dracula as well as to be useful to her husband.

Van Helsing describes her thus: 'Ah, that wonderful Madam Mina! She has a man's brain – a brain that a man should have were he much gifted – and a woman's heart. The good God fashioned her for a purpose, believe me, when He made that so good combination … up to now fortune has made that woman of help to us.' In this way, she presents the most positive depiction of the New Woman, avoiding pejorative stereotypes, remaining within the Victorian tradition whilst all the time presaging the way forward for the modern enlightened woman. She loves and cares for Jonathan in a traditionally supportive way but still questions long-established values, and assists him practically through using modern shorthand, typing and technological skills rather than performing solely in the domestic realm. She is married yet empowered.

Lucy, meanwhile, is juxtaposed against the practical Mina. Lucy represents the side of the New Woman that attracts criticism – the sexually charged, sensual female. Yet interestingly, whilst seeking sexual equality, Lucy simultaneously yearns to be the traditional wife and her girlish demeanour represents this. The stereotypical New Woman was not interested in decorum or the expectations to marry young and acquiesce to her husband, and the social significance of this attitude becoming widespread amongst single women was drastic.

Unlike many of the recognised New Woman novelists discussed here, Bram Stoker has contributed almost accidentally to the canon. The irony is that whilst most of the New Woman creations were sexually liberated or rejected male dominance and the symbols of society in general, they met an unfortunate fate and often returned to patriarchal norms out of necessity or shame at having overstepped the boundaries. Mina, however, whilst still preserving the social order, holds down a career as a schoolmistress, gains the respect of men for her strength and abilities and draws no criticism. She is not attempting to ape men, but instead works with them for the good of society using her own innate qualities. She is already in a leadership role through her job, and manages to be both progressive and domesticated at the same time. Mina writes to Lucy that she is extremely busy with her full-time work outside the house, indicating her commitment and professionalism, and draws further comparison with Lucy, a traditional Victorian woman who has no job and waits for marriage. Mina can be considered equal to her husband Jonathan, cultured and self-sustaining. She understands herself and her personality traits

and is able to use these selectively; she knows when to lead, when to encourage, when to be strong, when to be feminine and when to be logical – and, crucially for the story, when to outperform a man.

This is true emancipation. In fact, Van Helsing learns his mistake when he treats Mina as a typical Victorian woman and leaves her open to danger from Dracula. When discussing Jonathan and Mina's son at the end of the novel, and remarking on Mina's contribution to their battle with Dracula, Van Helsing shows his respect and pride for her: 'We want no proofs; we ask none to believe us! This boy will someday know what a brave and gallant woman his mother is. Already he knows her sweetness and loving care; later on he will understand how some men so loved her, that they did dare much for her sake.' Brave, kind and intelligent, yet in many ways a traditional wife and mother operating within conventional societal norms, Mina Harker is a True New Woman who did not feed into the deep anxieties implicit in mid-Victorian views of female power.

The intention of New Woman writers was to redefine how the sexes related to each other, bring women's issues and aspirations to the fore and support female professional objectives, though it must be said that not all men were opposed to women making their own way in the world. 'Some of the New Women writers will some day start an idea that men and women should be allowed to see each other asleep before proposing or accepting. But I suppose the New Woman won't condescend in future to accept; she will do the proposing herself,' says Mina, which reflects the conventions of the day rather than Stoker's opposition to the New Woman.

Neither did all women support the New Woman. Mary Augusta Ward was a paradoxical case in point. An immensely successful novelist who chose to write under her married name of Mrs Humphrey Ward to project her desired self-image of wife and mother, she was simultaneously an advocate of women's education. She acted as committee secretary for Somerville College at Oxford, one of the first women's colleges, and was instrumental in setting up the 'Lectures for Women' programme, assisting the drive for university entrance for women. Yet she harboured anxieties centred on the destruction of moral influence in the home through female emancipation and loss of respect as a mother and homemaker, eventually becoming the figurehead of the Anti-Suffrage League.

Arguments for and against the New Woman in literature were here to stay, and notwithstanding authors' intentions, their work contributed to major changes in women's lives. But as the New Woman continued to develop her own thoughts and debates, make her own decisions and choices, what was she looking for in the ideal Victorian man? Indeed, did she have the right to make this choice, and should she continue, like Lucy Westenra, to wait to be chosen? Women were the victims of morality, noted Emma Goldman.[227] The Victorian man divided women into 'two classes – those who must be respected, and those who need not be'. Goldman suggested that the New Woman would be able to make a choice of husband for herself:

Woman is awakening, she is throwing off the nightmare of Morality; she will no longer be bound. In her love for the man she is not concerned in the contents of his pocketbook, but in the wealth of his nature, which alone is the fountain of life and of joy. Nor does she need the sanction of the State. Her love is sanction enough for her. Thus she can abandon herself to the man of her choice, as the flowers abandon themselves to dew and light, in freedom, beauty, and ecstasy.

The rigid societal expectations made of a Victorian woman did extend to men, but though men had more freedom to make choices, they still faced the demands of society to be what was anticipated of them. Both Victorian women and the rest of society had their own ideas about what constituted the ideal Victorian man. John Tosh[228] claimed that in order to be an attractive proposition as a mate, a man should have achieved a certain level of material and business success, which led on to recognition by one's peers, thus affirming his male status. Men had to gain the respect of a woman before they were accepted as a marriage proposition whilst at the same time making an impression on society, and in particular the close scrutiny of their male peers with regard to their achievement, or lack of. Men did face pressures; having a family was a marker of success for a man, and Victorian men were not only competing for respect within their own sex but had to impress the women too.

Supporting a wife and family and providing direction, authority and protection within a secure home was a clear indication of male achievement and prosperity. These indicators reflected a man's

material and business success, gaining respect and meeting ideals; this was the type of man a Victorian True Woman dreamed of marrying. Lucy Westenra leads a life of leisure and is courted by several such men. In her letters to Mina, Lucy writes: 'My dear Mina, why are men so noble when we women are so little worthy of them? ... Why can't they let a girl marry three men, or as many as want her, and save all this trouble?' Several scholars have analysed this to mean that Lucy desires all three men sexually and is not in control of her sexual impulses; however, it might simply reveal a coquettish girl who enjoys being pursued and is taking her time to decide which, if any, of the men meet contemporary female ideals before making her final choice. Who could maintain, protect and provide for her best?

Pressure from Victorian society influenced the way that some women, like Lucy, viewed men. They dreamed of the perfect man to take them as their wife, believing this to be the only way to satisfy the view of marriage that Victorian True Women had visualised since childhood. In this, they were appropriating the Victorian concept of the ideal man to shape their expectations of their potential husbands. Men in Victorian society also had to understand the conventions, or rules, of life and not repeat the historical mistakes of their predecessors. A model Victorian man should be able to understand the differences between right and wrong whilst also living by those rules.

Being able to earn an income to support herself, a New Woman would be able to avoid having to marry an unsuitable man just to have somewhere to live; she could provide for herself until she found a suitable man whom she would freely choose for herself, or she could choose not to marry at all.

The possibility of being dismissed as a suitable marriage partner may have also led individuals to engage in deception in order to be accepted; the impact of this is explored by Oscar Wilde in *The Picture of Dorian Gray*, where he uses the device of his portrait to present himself as a man whom Victorian women wanted to marry, with the right credentials of youth, wealth and status.

In the eponymously titled 1895 New Woman novel by Menie Muriel Dowie, Gallia rejects the man she truly loves because of his hereditary heart condition and instead marries Mark, whom she does not love but considers a superior physical specimen: 'I have wanted the father of my child to be a fine, strong, manly man, full of health and strength.' The work has been criticised for touching on eugenics

although Gallia's decision can be interpreted as a protest against women being selected by men as broodmares, turning this on its head in an assertive stance.

Middlemarch's Dorothea Brooke imagines that 'a really delightful marriage must be that where your husband was a sort of father ... that would deliver her from her girlish subjection to her own ignorance, and give her the freedom of voluntary submission to a guide who would take her along the grandest path'. She ultimately resents the man she does marry because he doesn't match up to her expectations about marriage, even though her sisters had warned her that she was making the wrong choice and the couple also fail to adequately communicate. Dorothea discovers her true match in Will, whose personality is the opposite of her teenage ideals.

Although combined social and economic circumstances often ruled out lower-working-class women from attaining either the ideal True or New Woman status, Martha Vicinus stated that 'we can now judge Victorian women to have been more varied, active, and complex than previously considered, we must not create a new stereotype that ignores the limits within which Victorians lived and changed'.[229] In truth, focusing on the paradigm of either domestic femininity or aggression is an oversimplification that fails to treat the issue as a holistic one. Victorian women were not identical and their very differences led to the debate on the 'conflicting, unstable characteristics of nineteenth century domestic ideology and femininity'.[230]

By the end of Victoria's reign, the country found itself in a world of new opportunities and new risks. Society was developing and advancing through imperialist explorations and scientific discoveries but was paradoxically attempting to hang on to traditional institutions. The real New Woman of the 1890s – quite apart from the fictional construct – had multiple roles, but what is not in doubt is that she was the forerunner of the militant suffragists of the 1910s.

4

CHALLENGING THE NORMS

Calls for change and challenges to societal norms for Victorian women began as early as 1843 when Scottish feminist Marion Kirkland Reid wrote *A Plea for Woman*. This work focused on the theoretical power of female influence, on the use of the term 'woman's or domestic sphere', a comparison of domestic and business roles, and women's calls for equal rights through demands for the recognition of women's equal status in society. Reid's pamphlet was 'designed to show that social equality with man is necessary for the free growth and development of woman's nature ... we shall now proceed to enumerate more precisely the disadvantages which, in this country, we conceive woman in general labours under'. Reid described these disadvantages as the lack of equal civil rights, subjection to unfair and unjust legal discrimination, and lack of opportunity 'for obtaining a good substantial education'.

Marion Reid thought the latter two of these inequities 'essentially evil and unjust' and that equal civil rights for women would prove to be the instrument that led to redressing them; securing of equal rights in society was her main objective. This would, it was argued, enable the interests of women to be fairly represented and injustices rectified. Whilst this is true, it must also be noted that female financial independence, the ability to earn money and take care of themselves through an education equal to that of men, was the highest priority.

Accordingly, there were women in Victorian society who did begin to question and challenge what was presented to them as their main role in life. Did they really want to marry and support their husbands' interests and business? They began to reject traditional gender roles and

sought strategies to escape these societal assumptions. But knowledge and education obtained outside of the house was frowned upon because it was still a man's world, as one critic, Richard D. Altick, puts it: 'A woman was inferior to a man in all ways except the unique one that counted most [to a man]: her femininity. Her place was in the home, on a veritable pedestal if one could be afforded, and emphatically not in the world of affairs.'[231] Of course, these expectations to prepare for marriage afforded women hardly any freedom. And increasingly, girls no longer wanted to spend their adolescent years in preparation for marriage and then spend their adult lives expecting men to take care of and provide for them based on the assumption that they were unable to provide for themselves. But since the Industrial Revolution and consequent urbanisation and political developments, society had changed with unparalleled rapidity, leading to a quietly advancing contravention of these traditional values. Another key area of change at this time was religion.

As Britain became the 'workshop of the world' in the nineteenth century through the impact of the Industrial Revolution and its steady advances towards democracy, the so-called Victorian Gospel of Work gradually took over from religious culture alongside the gradual secularisation of Victorian society. The 1851 census revealed that out of a population of nearly 18 million, only 5.2 million attended Church of England services, with 4.9 million attending other Christian places of worship. Alan Gilbert[232] maintains that the Industrial Revolution began the 'great discontinuity' in British history, leading to a modernisation that changed the concept of work and initiated secularisation in the 1840s. This modernisation seemed to provide the answer to many problems of society, including poverty, by improving living standards, medical care and mortality rates, and providing opportunities for self-actualisation through work.

Gilbert argues that in this context, people began to rely more on themselves than on God; perhaps the old adage 'God helps those who help themselves', quoted by Algernon Sydney in the seventeenth century in his *Discourses Concerning Government*, was beginning to be adopted and complete reliance on religion seen as questionable and impractical. The challenges presented by an urbanised industrial society were addressed very well by the established church, especially when division occurred owing to Methodism. The result was an increasingly secular society, but even so, people needed something to

believe in. Out of this arose the Gospel of Work. Gilbert calls this a 'metamorphosis', with the view being readily accepted that the way to salvation was through hard work with virtue and duty forming part of the new 'gospel' – work was glorified and idleness scorned. People should work for the common good, not just for themselves, thought Thomas Carlyle, for instance.

But for Victorian women, the division of the home and public spheres had resulted in them being assumed to be the cornerstone of family virtue where they were expected to set a religious and moral example for their husband and children. It is highly possible that Victorian men and women interpreted religion differently because of their 'allotted' roles and, of course, single women were meant to remain chaste until they married. As religion had a part to play in forming Victorian culture this consequently consolidated opinions about gender roles. But these viewpoints may not all have been interpreted as repressive. For example, as a so-called spiritual role model, would a woman not command equal rights with the allegedly less moral male, at least in principle? Could women use their idealised feminine image as leverage in the public arena to lobby for equal rights, or even demand that men be held to the same moral standards as them – which, after all, would be equality in its truest sense? Furthermore, such women could use their influence and authority in philanthropic and charitable activity, which gave them a platform of their own from which to work without being necessarily subversive.

The ideas of piety and femininity being inextricably linked did continue to some extent. But, what did Victorian women think about the Gospel of Work? In the face of prejudice and misrepresentation, women did challenge the norms. Writer Anna Brownell Jameson began to argue mid-century that this principle could be applied to women as she saw no merit in confining them to the domestic, private sphere. Jameson said that 'the communion of love and the communion of labour' would enable a balance between their home life and work; it was an 'essential law of life'[233] that women should work even after marriage to contribute to the greater social good, as Thomas Carlyle also thought, and indeed Jameson herself practised what she preached.

The predominant ideology prescribed that women should be occupied at home, but involvement in charitable work was not only

accepted, it was encouraged. Barbara Bodichon embellished this in the publication of her pamphlet *Women and Work:*

> Women must, as children of God, be trained to do some work in the world ... Think of the noble capacities of a human being. Look at your daughters, your sisters, and ask if they are what they might be if their faculties had been drawn forth – if they had liberty to grow, to expand, to become what God means them to be. When you see girls and women dawdling in shops, choosing finery, and talking scandal, do you not think they might have been better with some serious training?[234]

An article by an author identified only as A.R.L. representing the Victoria Press, a feminist printing press, was published in *The English Woman's Journal* in 1861.[235] The author somewhat radically claims that domesticity is a virtue or a quality, not a location, and therefore asks why a woman should be confined to the home: 'Work is the spell which brings forth the hidden powers of nature: it is the triumph of the spirit over matter, the rendering serviceable, remodelling, or transforming the material substances for the use and embellishment of life.' Here is a counter-argument to the separate spheres hypothesis, which insisted that it was undignified and demeaning for women to work outside the house. In fact, A.R.L. argues that it is perfectly normal:

> With this conception of the true meaning of work, can anyone imagine it to be a degradation and not a privilege? Nevertheless, an idea seems to be fixed in the opinion of the public, that work has a lowering tendency as regards women, therefore it has become a confirmed usage to keep girls, after what is called their education has been completed, (which, by the way, is no education at all), in positive idleness. The fruits of this noxious prejudice women are compelled to eat in bitterness of heart; and men, fettered by this chain of custom, afraid of being thought singular, persevere in perpetuating the error whose roots are so deeply embedded in our social soil.

Also, from the 1871 census onwards, the growth of the population slowed and a gradual demographic change was observed. Smaller families became the norm and whilst there were 295 births per 1,000

women in the 1870s, by the end of the century this had declined to 222. One of the main reasons for this was the growth of the professional middle class; without 'old money', families such as these would be dependent on the male breadwinner's income to sustain the lifestyle that they had both acquired and continued to aspire to and encourage their children to adopt. Children too would require the right education – particularly sons – but as we have seen, girls were now finding their feet educationally. And limiting the number of children was not only an effective financial strategy but freed up women to consider what they really wanted to do with their lives. Millicent Garrett Fawcett summed up the emergent mood when she wrote that 'the womanly and domestic side of things [should] weigh more and count for more in all public concerns. Let no one imagine for a moment that we want women to cease to be womanly; we want rather to raise the ideal type of womanhood.'[236]

Although some saw charitable work as an alternative to equality and emancipation, philanthropy did provide a bridge between the public and private spheres and allowed women a way of introduction to community life on the path to empowerment. But this may have been very subtle. Women taking on a philanthropic role in their own society were not seen as a threat to the public domain. Mary Augusta Ward, for example, felt that women taking roles in local government could make a positive contribution to society on home and domestic matters. Of course, there may well have been a distinct difference between the behaviour of a married couple in public and at home to keep up appearances; many women may have been subjugated to a far lesser degree than was known for certain.

There are, however, many examples of intellectually curious women in the Victorian era who broke the androcentric moulds in their particular field. Some entered the world of work, some did not, but they all had a hand in not only destroying barriers and constraints for themselves but laying foundations for professional women of the future. We begin with a focus on early norm-challenger Harriet Howard, Duchess of Sutherland, who provides us with a somewhat general early example of a married woman making a difference to women's rights, even if she was not essentially in agreement with the vision of votes for women.

On the accession of Queen Victoria, Harriet had been appointed Mistress of the Robes, a position which she held under several Whig

administrations, and became a social influencer, aided by her friendship with Queen Victoria as well as her family's great wealth; Harriet was descended from the Cavendishes of Chatsworth in Derbyshire.

By marrying the 2nd Duke of Sutherland, one of western Europe's largest landowners, in 1823, Harriet managed to be instrumental in the purchase and rebuilding of the Cliveden estate in 1849 following substantial fire damage. As Duchess of Sutherland, Harriet saw herself as apolitical but still she subtly used her social position to make powerful statements. She was a friend of Caroline Norton, and by continuing to associate with Norton following her acrimonious split from her husband she lent her personal yet very public support.

On 1 May 1851, Queen Victoria and Prince Albert opened the Great Exhibition. By October that year, 6 million visitors had been to the Crystal Palace and Harriet herself was a frequent visitor. She turned the family home Stafford House, St James into a key centre of society and it thus became the starting point of various philanthropic undertakings. Harriet became one of the foremost political hostesses of the early Victorian era and pioneered the country house weekend as a vehicle for political collaboration and debate.

Harriet contributed substantially to the organisation of Prince Albert's exhibition, which gave her a sense of purpose additional to that of her place in society. She now realised she was in a position to take an active role, and perhaps make a real difference, so she organised a ladies' committee which became the first step towards her becoming a prolific social and political campaigner – at last! At the age of forty-eight, Harriet had now decided to make her own political agenda.

The inaugural speech of Harriet's ladies' committee, on 26 November 1852, included this passage:

> But very few words will be required as all, I am sure, assembled here must have heard and read much of the moral and physical suffering inflicted on the race of negroes and their descendants, by the system of slavery prevalent in many of the States of America. Founded on such information, a proposition appeared a short while ago in several of the newspapers, that the women of England should express to the women of America the strong feeling they entertained on the question, and earnestly request their aid to abolish, or at least to mitigate, so enormous an evil.[237]

Harriet felt it was the moral responsibility of women to speak out against slavery and formed the committee to decide on a vision and support its purpose and aims. The head office was at 13 Clifford Street, off Bond Street, but for this Harriet received staunch criticism from the aristocracy. She was accused by Thomas Carlyle[238] of holding a 'big foolish meeting' at 'Aunt Harriet's Cabin', and the involvement of 'quality people' proved that she was 'irrational'. This says more about Carlyle than it does about Harriet – his comments seem to indicate that he thought championing the causes of slaves proved women's unfitness for equality or freedom. The fundamental difference between Harriet and the middle-class woman was that, through her social standing, she already had a public platform from which to launch her committee.

'The Duchess of Sutherland's Address amuses me,' wrote J. B. Estlin. 'It is useful for exciting discussion; it is too very satisfactory to see people of the Established Church condescending to think and speak, if not very sensibly on American Anti-Slavery ... of course we oppose none of these harmless amusements.' This view makes it clear that socially prominent individuals in general and married women in particular could be useful up to a point but would never been seen as more than undertaking 'harmless amusements'.[239] This patronising view seemingly came about because aristocratic women often combined charitable activities with social events, which was not understood nor taken seriously by middle-class philanthropists. This detracted from women like Harriet obtaining real visibility for their work. Harriet's support for anti-slavery had significance in the fact that her prominence gave the movement publicity, and her contacts with politicians, particularly Gladstone, helped to keep the issue high up on the political agenda. The intensity of the opposition to Harriet's advocacy of abolition is an important indicator of attitudes to philanthropy on the part of aristocrats, and particularly towards women.

The address that Harriet read at Stafford House in November 1852 appealed to women as 'sisters, wives and mothers':

We shall not be suspected of any political motives, all will readily admit that the state of things to which we allude is one peculiarly distressing to our sex; and thus our friendly and earnest interposition will be ascribed altogether to domestic, and in no respect to national feelings.[240]

The paradox here was that it seemed natural to women to engage or at least empathise with the anti-slavery movement, but those who opposed their involvement put forward the argument that women were becoming publicly exposed by aligning themselves with what amounted to the male-oriented business world, and by doing so they demeaned the nature of womanhood and tarnished their perceived moral superiority. Yet during the election in 1847 the Duke of Sutherland had been abroad, and management of the electoral affairs of Staffordshire had been left to Harriet. It is significant that she was considered the natural alternative to the duke, rather than a male relative or proxy.

Letters to *The Times* following its report on Harriet's address called for 'common sense' and the wish that the women had been 'for the first, and I trust for the last, time in their lives ... to address a public audience, to move, to resolve, to form committees and sub-committees and to engage offices and a secretary'.[241]

Harriet was fortunate to be able to use Stafford House for meetings between prominent abolitionists and British politicians. Her address on slavery was signed by over 571,000 British women and presented to an American anti-slavery meeting in 1853, the same year as she invited Harriet Beecher Stowe, author of *Uncle Tom's Cabin*, to a reception at Stafford House. Harriet Sutherland therefore played a key role in keeping the slavery question alive in Gladstone's mind, a role of some importance at the time of the American Civil War. For all the criticism levelled against Harriet she was courageous in using her personal platform to raise awareness and make a real call for change. Women were not usually criticised in public, because they were not, as a rule, part of public debate. Harriet had, however, crossed boundaries by her actions and therefore became fair game for her critics.

Women in the Professions

How would women who wanted to enter male-dominated professions, and sought educational opportunities to enable them to get there, actually progress in their careers? Taking the arts as an example, Victorian women were excluded from joining Royal Academy schools to train as artists despite two women, Mary Moser and Angelica Kaufmann, being among the Royal Academy's founding members in 1768.

Access to artistic training was highly dependent on finances, and as most women did not earn their own money they would be reliant on

the patronage of a husband or a wealthy family. Most female artists of the time are only known relative to their male counterparts, or through discussions about their more famous husbands, fathers and brothers. But in recent years, they have begun to be recognised as talented pioneers in their own right. Women were therefore excluded from professional networks, purchasing committees and many exhibitions, and were also less likely to secure themselves an art dealer, which was a key means of commercial success in the nineteenth century.

Lizzie Siddal was a professional artist and poet and a key figure in the Pre-Raphaelite movement. But the Victorian art industry was typically patriarchal and despite her inherent talent, ability and influence on other artists, Siddal is chiefly remembered as an artist's muse, as John Everett Millais's Ophelia and as Mrs Dante Gabriel Rossetti rather than in her own right or for any of her own body of artistic work.

Originally a muse of artists Walter Deverell and William Holman Hunt, her 1862 obituary in the *Sheffield Telegraph* states: 'Miss Siddall [the original spelling of the family name] showed some outlines, designs of her own leisure hours to the elder artist Mr D.' This referred to Walter's father, who was head of the Government School of Design, through whom she met Walter and began her artistic career. In fact, she made a significant contribution to the Pre-Raphaelite movement before stepping to the other side of the easel to prove her artistic merit – only to be overshadowed by men and talked about in relation to men.

By 1852 she was sitting regularly for Rossetti and the two were also in a tempestuous personal relationship, but had it been smooth running it is probable that Lizzie would not have had the impetus to go to Sheffield and take up her studies at the School of Art there. Several years after her death, one of her fellow students at the Sheffield School of Art, known only as 'A.S.', wrote to the *Sheffield Telegraph*: 'It was a slight acquaintance I had with her, but it made a lasting impression on my memory.'

Upon meeting Lizzie through Rossetti, feminist Barbara Bodichon, also a landscape artist, saw her potential and wrote a letter of introduction to her poet friend Bessie Parkes:

Now my dear I have got a strong interest in a young girl formerly model to Millais and Rossetti, now Rossetti's love and pupil. She

is a genius and will, if she lives, be a great artist. Alas! her life has been hard and full of trials, her home unhappy and her whole fate hard. Dante Rossetti has been an honourable friend to her and I do not doubt if circumstances were favourable would marry her.[242]

For the remainder of the century it proved difficult for women artists to achieve recognition, but several managed through sheer talent and determination. In 1850, a small group of women formed an informal association called the 'Art Sisters' to provide mutual support in their artistic endeavours. The Pre-Raphaelite movement was a positive influence here: 'In fact, as a movement and a style, Pre-Raphaelitism was comparatively welcoming to women, while not mitigating the disadvantages of access and esteem which they faced in the world of art, as in society as a whole ... women artists played a crucial role in shaping, defining, developing and perpetuating the movement over its half century.'[243] Rossetti was also extremely supportive towards Lizzie as an artist and poet and was an influence on the development of her artistic style, encouraging her to collaborate with him on occasion.

Art critic John Ruskin bought Siddal's drawing 'Pippa Passes' along with several others in her collection, enabling her to buy her own equipment with the proceeds. She was then sponsored by Ruskin to produce artwork, which brought her recognition and a yearly income of £150, as Rossetti wrote to William Allingham:

About a week ago, Ruskin saw and bought on the spot every scrap of designs hitherto produced by Miss Siddal. He declared that they were far better than mine, or almost anyone's, and seemed quite wild with delight at getting them ...

As a result, her work was exhibited in Charlotte Street and several of Lizzie's works were also included in the Pre-Raphaelite exhibition in May 1857 — where she was the only female artist on show. These were immense achievements in a day and age where females couldn't even become members of the Royal Academy: 'During that spring, in her absence, Rossetti and Ruskin were busy promoting Lizzie as an artist and some of her paintings were displayed in an exhibition in Charlotte Street, London.'[244]

Lizzie produced a sizable repertoire of paintings, sketches, and poetry as a result of both her coaching with Rossetti and her art school

studies. In fact, she could almost be viewed as an accidental feminist and a prefigure of the New Woman of the later nineteenth century; she lived with Rossetti prior to their wedding, which foreshadowed the choices made by many New Women, and her complete independence from the cult of domesticity lent her a bohemian aspect. She decided to stop her patronage with Ruskin – a brave move in a time when women found it almost impossible to obtain funding – in order to attend the School of Art in Sheffield. Dr Serena Trowbridge, a senior lecturer in English literature at Birmingham City University, has written a book which included Siddal's poetry[245] and says, 'For too long, Siddal has been seen as the face of the pre-Raphaelite painters, the muse and wife of Dante Rossetti, and the model for Millais' Ophelia. I'm really happy to be able to show her as a creative woman in her own right.'

Many young female artists wrote to John Ruskin for advice and support, but his responses are a clear indication of the androcentric nature of the Victorian art world. In 1858, his response to a letter from Sophia Sinnett read: 'You must resolve to be quite a great paintress; the female termination does not exist, there never having been such a being as yet as a lady who could paint. Try and be the first.' John Batchelor observes that while Ruskin 'was often generous and encouraging to women, he expected obedience in relationships with 'bullying [...] demands that were actually a form of constraint'.[246] The use of the term 'paintress' effectively sets women apart from men as a diminutive, suggesting that being an artist and being a woman were mutually exclusive. Ruskin's attitude provides a sound explanation for Lizzie Siddal's move to Sheffield and rejection of his patronage, even though her formal education in an arts establishment was brief.

Meanwhile, female artists were able to exhibit their work in the Royal Academy Summer Exhibition, though none of them were elected to membership. The only other part that women played in the RA was as life models, but they soon began to press for an artistic education on a level playing field with men. In 1860, a drawing was sent for approval by a certain 'L.H.' who was accepted as a student of the Royal Academy schools on the quality of her work; the 'L' stood for Laura (Herford). Once the door was opened, thirty-four further female students were admitted over the next ten years, but it would be thirty years before they were able to take life classes and they did not receive the same training or benefit from the same facilities as male

students. The acceptance of women became scornfully referred to as the 'Invasion'.[247]

A year prior to Laura Herford's admission, a petition was presented to the Royal Academy seeking admittance for women, which was published in *Athenaeum* magazine.[248] Tuition was 'given gratuitously' to 'young men' and women wanted to be treated in the same way. They argued that once they had received the same training as men, they would be able to work and achieve 'the position for which their talents might qualify them'. Of course, the fact that they would, if on a par with men, attend life classes was used as a reason to object.

The petition was signed by thirty-eight women, including Sophia Sinnett, who eventually went on to have her work exhibited in Australia and was reviewed thus:

> With the exception of ... [the landscapes], these pictures reflect the highest credit on her talent ... They have finish, rich colour, breadth of light and shade, and would be more fitted to grace the walls of the British Institution than an Adelaide Exhibition. We hope this lady will turn her attention to the incidents of colonial life. She will find ample scope for her genius in this unique field.[249]

Other signatories included Eliza Fox, Anna Mary Howitt, Anna Jameson and Barbara Bodichon, all of whom had participated in the Petition for Reform of the Married Women's Property Law which was presented to Parliament on 14 March 1856. Lord John Lyndhurst had given a speech at the Royal Academy in 1859 in which he stated that tuition was open to all Her Majesty's subjects, but in truth financial discrepancies existed between male and female artists which largely precluded women's admittance. They had to pay a great deal for adequate education and instruction which men received for free; the petition asked for equal opportunities for women and in particular for the financial inconsistencies between the sexes to be addressed.

Barbara Bodichon had written in her pamphlet *Women and Work* in 1857:

> Cries are heard on every hand that women are conspiring, that women are discontented, that women are idle, that women are overworked, and that women are out of their sphere. God only

knows what is the sphere of any human being ... to think a woman more feminine because she is frivolous, ignorant, weak, and sickly, is absurd; the larger-natured a woman is, the more decidedly feminine will she be; the stronger she is, the more strongly feminine. You do not call a lioness unfeminine, though she is different in size and strength from the domestic cat, or mouse.[250]

This was the landscape against which Victorian women artists found themselves campaigning.

According to Cherry's *Painting Women*,[251] 'patrons seldom competed to buy women's pictures. Questions of merit were not involved, purchases being largely a matter of critical favour and financial investment.' In 1874, Elizabeth Thompson Butler's painting *The Roll Call* was exhibited at the annual exhibition at the Royal Academy. Her work was immensely popular, featuring British military scenes, and subsequently she was put forward for election as an associate member of the Royal Academy in 1879. She lost by two votes, and it would be over forty years before the first female member was elected, but Butler's achievement had stirred members to put forward a motion that women no longer be eligible for election as members. The motion failed to pass – Butler had started to break the barriers.

In 1878, a petition signed by thirty-five female students asked for equal rights with respect to Royal Academy life drawing classes:

We the undersigned lady students of your Academy fully recognise and appreciate the very great advantages and opportunity of study afforded us. At the same we cannot but feel conscious that at the present time one material want remains and that without the knowledge which the supply of that want can alone give we cannot hope to rise above mediocrity at any rate in the highest branch of our art. We venture therefore knowing that you have ever been our true friend very respectfully to ask you to take into consideration the practicability of making some arrangement for which we might be enabled to study from the figure [semi draped]. If you can make such an arrangement we assure you that we shall be very grateful for the favour conferred upon us, that we shall diligently and consciously avail ourselves of the help thus given to our striving after excellence.'

This was turned down, and in 1883 another petition, this time with ninety signatures, requested similar concessions. The general assembly refused this in January 1884, the minutes reporting that: 'The petition having been read and discussion having ensued, the resolution was put to the vote and not carried nine against twenty-four.' By 1893, life classes for women were becoming more widely available across the country, and the Academy's resistance to sexual equality was beginning to be perceived as old-fashioned and part of a fading Victorian societal attitude, and they finally relented to allow women to take life classes which had already been happening at the Slade School of Fine Art since it opened in 1873 – but only before 5 p.m. This was nonetheless a huge step forward for female art education. Kate Greenaway had also complained how she was held back by not being able to take life classes until she joined the Slade.

The Slade opened its classes to women on equal terms to men, and also served as a feeder for University College London. Evelyn De Morgan (*née* Pickering) was one of the first women to enrol. De Morgan's biographer – and sister – Wilhelmina Stirling wrote that Evelyn defied their parents to attend classes and typified the late nineteenth-century New Woman by rejecting feminine conventions and excelling in a male-dominated world, winning prizes and scholarships at the Slade. Their mother stated that she wanted a 'daughter, not an artist' and also attempted to sabotage Evelyn's opportunities by bribing her tutor to play down her abilities to dissuade her from pursuing art as a career. Ellen Clayton addressed this issue in her book *English Female Artists*:

In the early part of the present century, although many ladies of rank and consideration were distinguished by their skill as amateurs in drawing and painting, an odd-prejudice existed among some heads of families and schools against young girls learning art. It was regarded as 'a sad waste of time', and as clashing with the interest of music and French exercises. Poonah painting, and similar grotesque absurdities, were permissible, but drawing was almost vigorously tabooed in most instances.[252]

As did Philip Hamerton in his 1862 *Thoughts About Art*:

A feeble dilettantism in drawing seems to be considered essential to every young lady. But as Society requires that ladies should

draw badly, so she carefully makes it impossible that they should ever have a chance of drawing well; the truth being, that respectable persons, for the most part, have no interest in art sufficiently powerful to overcome their intense horror of whatever they are pleased to consider Unfeminine ...

Evelyn's father's journals reveal that he paid for her private lessons and trips to Europe to study Old Masters. Without this backing, she would not have had the means to pursue her career. Evelyn supported women's emancipation through her approach and her work itself. She championed the call for votes for women, and married into a progressive family whose members shared her suffragist views. Indeed, George Frederic Watts described her as being 'a long way ahead of all the women ... and considerably ahead of most of the men. I look upon her as the first woman artist of the day – if not of all time.'[253] Female artists were an important element in answering the 'Woman Question', and even against the backdrop of challenges experienced by female artists they did manage to achieve some nineteenth-century firsts.

In 1871, Sophie Anderson's painting *Elaine* became the first painting by a female artist to be purchased with public funds, for display in the Walker Art Gallery in Liverpool. But it was somewhat later on in the century that female stained glass artists began to make their mark on the profession. Leeds-born artist and suffragist Emily Ford trained at the Slade from 1875 and exhibited at both the Grosvenor Gallery and the Royal Academy. Along with her sister Isabella, she set up the Leeds Suffrage Society and used her artistic talents to design publicity material for the suffrage movement and stained glass windows for churches throughout the country.

The Arts and Crafts movement was inspired by the writings of John Ruskin and the work of William Morris. In working with stained glass, the artists appreciated that their art could only reach the height of the mediaeval tradition by understanding the materials and techniques of their craft. Successful design was derived from the material, not imposed upon it. In the 1880s and 1890s a group of craftspeople reimagined the art form of stained glass in a modern context. This was not without its challenges; the stained glass trade was driven by profits, which did not sit well with the artistic mindsets of those who looked upon it as an artisanal craft.

However, the large-scale construction of church buildings inspired by medieval design during the Victorian Gothic revival emphasised the relationship between architecture and the creative arts, opening up space for the artisan work of stained glass through the creation of storytelling windows. And though it was very rare for women to make this their profession – 'hardly any women had been employed during the nineteenth century revival of stained glass, in its late 1830s pioneering antiquarian phase, in the developing workshops of the 1860s, or in the increasingly industrialized firms of the 1870s and 1880s'[254] – they may have, in the early days at least, assisted with window design alongside male artists, giving them an insight into the profession.

One of the early pioneers in self-taught stained glass art was Mary Jane Newill of the Birmingham School of Art, a little-known but important early contributor to the nineteenth-century Arts and Crafts tradition. Significantly, and unusually given her gender, she was a member of the Bromsgrove Guild, which gave her the exposure she needed to gain commissions for stained glass window work. This is significant because the Art Workers' Guild, established in 1884, did not allow women to become members.

In 1893, her cartoon – the drawing used as a guide when making stained glass windows – for her *Babes in the Wood* stained glass panel became the first design by a future successful female commercial artist to be displayed at the annual Arts and Crafts Exhibition Society in London. The drawing was later used by renowned stained glass artist Christopher Whall as an illustration in his 1905 publication *Stained Glass Work: A Text-book for Students and Workers in Glass*, which became a manual for future generations of artists worldwide. Newill was noteworthy in that she proved that crafts undertaken by middle-class women were not simply based in the traditional Victorian accomplishments and female pastimes. She demonstrated that women were capable of earning their own money by making a significant and lasting contribution to the Arts and Crafts movement.

Another early professional female stained glass artist was Mary Lowndes, an alumna of the Slade School of Fine Art. Lowndes started out as an assistant to stained glass designer Henry Holiday in his studio-workshop, drawing cartoons for several of their commissions. This set her on the path to learn the techniques of stained glass and

gain work as a designer for James Powell & Sons from 1887 to 1892, creating tableware, bold decorative glass and stained glass windows.

Now a glass artist in her own right, Lowndes became influential in the Arts and Crafts movement. She founded the successful stained glass studio and workshop Lowndes and Drury on an equal footing with fellow stained glass artist and commercially experienced glazier Al Drury in 1897 in Chelsea. Drury was an instructor of stained glass with Christopher Whall at the Central School of Arts and Crafts, and their collaboration afforded Mary an opportunity to further develop and perfect her craft. The studio provided stained glass artists with the facilities, staff and equipment to carry out their commissions on a freelance basis, making them independent artisans separate from commercial stained glass businesses.

Lowndes wanted to make it possible for women to establish themselves as artisans after completion of training at art school once admission was opened up to them following extensive campaigning. However, most female art students wanted their training to lead to professional careers and Lowndes' studios and in-house facilities were made available to both male and female artists, leading to independent working, integration, emancipation of women in the workplace and the development of the Arts and Crafts movement.

Lowndes was also a suffragist and combined her beliefs with her work. She later became chair of the Artists' Suffrage League, and her poster art was an asset to the movement. Through her work Mary Lowndes created opportunities for later female stained glass designers and artists like Florence Camm, who enrolled on a programme at the University of Birmingham in 1892, and later Wilhelmina Geddes, who worked at Lowndes' Glass House Studio, to become influential and successful in the industry.

When eighteen-year-old Florence Camm joined the Birmingham School of Art,[255] she discovered that the staff openly supported female artists, allowing them to attend life drawing classes and encouraging them in seeking work as artists and designers. One of their most influential lecturers was Henry Payne, who worked as a stained glass designer alongside teaching. Girls were allowed to take practical classes in stained glass, gaining the skills they needed without the commitment of taking on the working-class trade apprenticeship, which could have been seen as harmful to middle-class respectability. Camm gained commercial experience alongside

her studies by working in her father's studio-workshop producing stained glass, mosaics, tapestry and fresco paintings. Margaret Rope started her training alongside Florence Camm. She was one of the lucky few to get a workshop in Mary Lowndes' Glass House Studios and went on to produce seven stained glass windows for Shrewsbury Cathedral.[256] Such was the success of these courses that in 1901 Henry Payne established a Stained Glass Department at the Birmingham School of Art. A newspaper cutting from 1954 states:

> When [Florence Camm] joined her father and brothers in the family business, she became what her brothers Robert and Walter describe as 'the best man in the whole affair' ... the designs in delicate watercolours for the windows of the great churches are hers. The large-scale drawings or 'cartoons' are hers. And she also paints the glass ...[257]

Here we see how these women made important contributions to the philosophy of the Arts and Crafts movement as designers, artisans and technicians, leading to real parity with their male colleagues.

Meanwhile, female authors faced more difficult cultural exclusion challenges. Men had constructed and dominated the literary world and it was almost impossible for women to gain access to the marketplace without some form of male patronage in the first instance. Publishing was part of the business sphere in which women were not supposed to entangle themselves. Both Christina Rossetti and Elizabeth Barrett Browning not only began their careers as poets but were fortunate to have their work privately published by family members, enabling them to enter the literary marketplace despite women being discouraged from pursuing writing careers or indeed any work outside the home.

It was usual for Victorian girls and boys to typically read very different types of books, and contemporary children's literature was often didactic and moralistic. Boys' reading material regularly featured strong male heroes and adventure stories. Girls would have very little opportunity to read any form of literature that presented them as capable or strong. This would have been considered completely inappropriate, because such works might cause girls to become dissatisfied with their feminine sphere and want to break out, threatening the female role and society itself. They

were directed towards books like Christina Rossetti's *Speaking Likenesses*, published in 1874, which features reworkings of fairy tales that punish or reward girls in context of their perceived good or bad behaviour.

Reading could even be dangerous: 'If there was one thing a Victorian gentleman liked more than worrying, it was reading about worrying things. The same, it was commonly felt, was true of his wife; indeed, of all the worrying things, few were more worrying than the thought that women were reading too much. Indeed, it was commonly supposed that women like Ellen Ternan fell[258] because they read novels written by men such as Charles Dickens.'[259]

But by overcoming the challenges they faced in becoming professional writers, female authors confronted the concept of the domestic sphere and the idea that women were primarily meant to be wives and mothers. In this, they contributed to the empowerment of women and influenced the course of history.

The Brontë sisters were aware that female writers were not taken seriously and might even face social censure. Charlotte wrote to Robert Southey, the Poet Laureate, enclosing some of her poetry for constructive criticism. After positively commenting on her work – 'You evidently possess & in no inconsiderable degree what Wordsworth calls "the faculty of verse". I am not depreciating it when I say that in these times it is not rare' – Southey then gets to the point and advises Charlotte that to pursue a literary career is not the preserve of a woman:

There is a danger of which I would with all kindness & earnestness warn you. The daydreams in which you habitually indulge are likely to induce a distempered state of mind, & in proportion as all the 'ordinary uses of the world' seem to you 'flat & unprofitable', you will be unfitted for them, without becoming fitted for anything else. *Literature cannot be the business of a woman's life: & it ought not to be. The more she is engaged in her proper duties, the less leisure she will have for it*, even as an accomplishment & a recreation. To those duties you have not yet been called, & when you are you will be less eager for celebrity. You will not then seek in imagination for excitement.[260]

Of course the irony here is that whilst Charlotte's novels are considered classics, Southey has been largely forgotten – though he

does appear to have unwittingly provided inspiration for some advice given to Frances Evans Henri in *The Professor*, written by Charlotte before she produced *Jane Eyre* but published posthumously:

> ... she rather needs keeping down than bringing forward; and then I think, monsieur – it appears to me that ambition, LITERARY ambition especially, is not a feeling to be cherished in the mind of a woman: would not Mlle Henri be much safer and happier if taught to believe that in the quiet discharge of social duties consists her real vocation, than if stimulated to aspire after applause and publicity?[261]

According to John Sutherland,[262] the writing profession did not discriminate; it was society that did, and this is what led to women disguising their gender. The Brontë sisters initially self-published their work under male *noms de plume*, fully aware of the prejudice and double standards they would encounter. They wanted to be judged on a level playing field, critically and fairly, not considered second-rate or patronised – as Charlotte Brontë would put it, using 'for their chastisement the weapon of personality ... flattery that [is] not true praise'.[263] In short, they wished to be judged as writers, not women.

Charlotte's *Jane Eyre* was published in 1847, closely followed by *Wuthering Heights* and *Agnes Grey* by Emily and Anne respectively. Their success would cause them to be unmasked as women. According to Lauren Livesey, audience development officer at the Brontë Parsonage Museum, 'They were called ungodly, unchaste, unfeminine. One review drew a direct line between *Jane Eyre*, the Chartist movement and revolution in Europe. There were people saying the book was going to lead to the downfall of civilized society. If those people had known for a fact that it was written by a woman, it would have added a whole other *frisson*.' Zoe Brennan remarks that *Jane Eyre*'s route to publication demonstrated that a woman could compete both on literary merit and in the marketplace owing to its contemporary popularity and its classic status today.[264]

The Brontës revealed their identities after one of their publishers suggested the books were all written by the same person. Charlotte in particular was, according to Elizabeth Gaskell, struggling with

managing the separate identities of author and woman. Charlotte's publisher, George Smith, however, recalled his reading of *Jane Eyre*:

> For my own part I never had much doubt on the subject of the writer's sex; but then I had the advantage over the general public of having the handwriting of the author before me. There were qualities of style, too, and turns of expression, which satisfied me that 'Currer Bell' was a woman, an opinion in which Mr Williams concurred. We were bound, however, to respect the writer's anonymity, and our letters continued to be addressed to 'Currer Bell, Esq.'[265]

Jane Eyre was full of violence, frustration and repressed desire. Rochester asks: 'You examine me, Miss Eyre ... do you think me handsome?' As a heroine, Jane was by turns angry, outspoken and well aware of injustice. She was also emotionally independent, with a fierce determination to make her own way in the world, even when sent away to a brutal boarding school. When Charlotte Brontë wrote this novel she wanted her writing to be judged on merit and not with any reference to her gender, not least because she was writing frankly about a woman expressing desire and striving for mental ability equal to a man – in other words, breaking down barriers. She was challenging convention by her style of writing, advocating for female identity and passion to be taken seriously. The style of the book – an intimate first-person voice – was pioneering, and its perspective inspired future generations of novelists.

Although a proliferation of publishers and editors seeking new authors began to emerge in the 1840s and beyond, many opportunities for women writers were hindered by literary critics, who were prone to judging women on their gender rather than literary merit, and by the need to manage the balance between literature and femininity. Female authors were seldom taken seriously.

The Brontë sisters offer an example of female authors who challenged the patriarchal society not only by their personal experiences but through the actions of their female heroines. They had a lot to say about equality, gender roles, female education and the role of women. John Stuart Mill had said that women were imitators, not innovators, when applied to the art of writing, 'imitating men rather than developing her own capabilities',[266] presumably because of the distance between their

prevailing image as kind, passive, nurturing creatures and the darker literary emotions of fury, passion, anger and desire.

Whilst publishing her work under her own name, Harriet Martineau nevertheless assumed a strident, firm tone in her writing that was seen as more authoritative than feminine. In fact, Elaine Showalter writes that it was commonly thought by critics that they 'did not believe that women could express more than half of life'.[267] Anyone who has read *Wuthering Heights* would disagree completely. And Charlotte wrote to her friend Ellen Nussey, 'If you knew my thoughts; the dreams that absorb me; and the fiery imaginations that at times eat me up and make me feel Society as it is, wretchedly insipid, you would pity and I daresay despise me.'[268]

George Eliot is another male pseudonym, created by Marian Evans in 1857 to conceal the fact that she was female, unmarried and living with George Henry Lewes, a married man, as well as to ensure that her work was taken seriously. Before this, she had been lodging with John Chapman, a political publisher, and had been the only woman involved in protest meetings about price fixing by the Booksellers' Association. By 1859 she was revealed to be female, which at first shocked the public – but by now *Adam Bede* was a bestseller. Her career took off, and even Queen Victoria read her novels.

Women writers like the Brontë sisters as well as George Eliot and Mary St Leger – both of whom wrote controversial novels under male pseudonyms – made publishing under a woman's name possible by overcoming alienation and prejudice to practise and excel in their craft, proving that they had passion, ambition and were equal to men.

Furthermore, the heroines these writers created were resilient women who challenged the mores of the male-dominated society in the fictional world they inhabited, carefully constructed to reflect real Victorian society. These female authors became what Alexis Easley calls 'first person anonymous'[269] in order to do this; they would have to challenge entrenched business practices, gender discrimination and social conventions that favoured men in order to get their work published and reviewed as well as to manipulate opportunities as they presented themselves.

Another advantage that male writers had was that they were a part of professional associations, socialised in gentlemen's clubs and forged new connections and opportunities. To succeed as a female author was made even more difficult as women were excluded from such

networks. This made it difficult for them to profit from their work financially. They were also criticised unfairly – as we have seen when Charlotte Brontë sought feedback from Robert Southey – for wishing to join a profession that was thought the preserve of men. Charlotte's aim was to widen the profession so that women were not competing within the limited zone afforded to the world of women writers. She wanted them to be judged, criticised and indeed published on their own merits as she mentioned in a letter to George Henry Lewes: 'I had said earnestly that I wished critics would judge me as an author, not as a woman.'[270] Like their male counterparts, female writers would also use literary agents and approach critics to review their works but they had to be more creative than men in order to get around the conventions of the time.

Caroline Norton had been a published author of poetry and a magazine editor since before the Victorian age. Her first poetic work, published in 1829, received a favourable review in *Blackwood's Magazine* and launched her literary career. However, she was criticised for her allegedly self-centred form of campaign work, being accused of championing causes that only reflected her own experience. Alan Chedzoy, for example, quotes Harriet Martineau's view that 'Caroline's reforms were never undertaken to help other women, but purely for her own selfish ends'.[271] Whilst this assessment can be disputed – her campaigns resulted in legislative change that had the potential to impact all women – it is clear that her work was influenced by her own concerns about the society of which she was part. Moreover, she came from an established literary family, which would have made it easier for her to secure publication of her works than, for example, the Brontës or George Eliot. Caroline Norton's literary career continued into the 1860s but, though she was reasonably well known as a poet, her first novels, *The Wife* and *Woman's Reward*, were published anonymously in 1835, the same year that she left her husband. As these novels tackled male abuse of domestic power, the identification of the author may have undermined the calls for change she was so fervently pursuing at this time.

As well as using male *noms de plume*, some female writers made use of their male friends to negotiate with publishers. However, once Charlotte Brontë had been accepted by the industry, more women were at liberty to publish under their own names without censure.

This was an important development for acceptance by the publishing industry and the public. Because of the persistence and resolve of these women authors, they became accepted as writers and forged a path for other women to be published without resorting to male pseudonyms. Very shortly after Charlotte Brontë was revealed to be female, Christina Rossetti had a piece published in *Athenaeum* magazine under her own name.

Literary critics did appear to be more scathing towards women writers, whom they felt had very little, if anything at all, to say about the world outside the house. Their literary output became a convenient vehicle to criticise them for not conforming to female stereotypes. The irony of this is that such critical reviews had not been applied to female writers from earlier in the century such as Jane Austen, Mary Shelley or even Caroline Norton, perhaps suggesting that the progress of separate spheres ideology was to blame. This proliferated particularly in the 1850s and 1860s, corresponding to the rise in publication of works by women. This comment by George Henry Lewes in *The Westminster Review* seems to imply he thinks women writers should stay within their allotted sphere:

> Of all departments of literature, Fiction is the one to which, by nature and by circumstances, women are best adapted ... The domestic experience which forms the bulk of woman's knowledge finds an appropriate form in novels; while the very nature of Fiction calls for the predominance of Sentiment which we have already attributed to the female mind.[272]

In other words, what women wrote about should be purely confined to their place in society. Unsurprisingly, his partner George Eliot disagreed with this and wrote the essay 'Silly Novels by Lady Novelists', originally published anonymously in 1856 in *The Westminster Review* but later under the name George Eliot in order to critique female novellas, distance herself from female romance novelists of the time and to ensure that her works were taken as seriously as those of her male counterparts. She was clear in her view that there existed women who were equal to men in their ability to write fiction whilst holding up examples of female writers who produced fluffy romance stories in order to flatter themselves. However, whilst she challenged society by living with a married man and criticising less able but ostensibly

respectable female writers, she was forced to adopt a male pseudonym to secure her position in the literary marketplace.

Charlotte Brontë had a spirited exchange of correspondence with Lewes, and his review of her novel *Shirley* appeared in the *Edinburgh Review* in 1850:

> The grand function of woman, it must always be recollected, is and ever must be, MATERNITY: and this we regard not only as her distinctive characteristic, and most endearing charm, but as a high and holy office-the prolific source, not only of the best affections and virtues of which our nature is capable, but also of the wisest thoughtfulness, and most useful habits of observation, by which that nature can be elevated and adorned.[273]

Following this uncomplimentary review of *Shirley*, Brontë wrote to Lewes: 'I can be on my guard against my enemies, but God deliver me from my friends.'[274]

But was it not the case that women were able to draw such challenging characters and write about their lives and aspirations because they had developed themselves beyond the domestic sphere? Arguably this is a unique position of power and authority for a woman writer rather than a constraining position that some male critics sought to keep them in. George Eliot picks this up perfectly when she says that women writers had a 'precious speciality, lying quite apart from masculine aptitudes and experience', grounded in the maternal emotions.[275]

In an 1853 review of Elizabeth Gaskell's *Ruth*, J. M. Ludlow concedes, 'We have to notice the fact that at this particular moment of the world's history the very best novels in several great countries happen to have been written by women.'[276] By the end of the nineteenth century, women's opportunities as professional writers had developed considerably. Between 1871 and 1891, the number of women listing themselves as authors on the census increased from 255 to 660.[277] Elaine Showalter refers to the nineteenth century as 'the age of the female novelist',[278] and although still outnumbered by male authors, many women wrote on travel, science and history as well as fiction, which gave them further credibility and professionalism.

As a writer for *All the Year Round* put it in 1889, 'Do but think how, with the spread of elementary education, and the growth of the

press, the field for writers has been enlarged since Isaac Disraeli's time ... and in no particular is the revolution more strongly foreshadowed than in the prevailing multitude of women who, by means of their pens, disseminate the influence of their minds over all the civilised parts of the globe.'[279]

Not so for all industries. The Victorian prevailing view of the medical profession was that it was an unsuitable occupation for women. Unless, that is, they wanted to become nurses. Harriet Martineau's 1859 *Edinburgh Review* article entitled 'Female Industry' became the catalyst for the debate that crept through the cracks of the accepted views of women's roles in society and possibly inspired many women with medical ambitions.

Martineau had, in fact, drawn on the figures from both the 1841 and 1851 England and Wales census, Barbara Leigh Smith Bodichon's *Women and Work* treatise, *The Laws of Life* by Elizabeth Blackwell (published the previous year), and reports by the Poor Law Commissioners on the employment status of women. She drew attention to the disproportionate numbers of 'surplus' single women compared to men, arguing that they should be able to earn their own living without being forced to marry as a survival mechanism. This debate became more significant when the 1861 census was published showing 2.5 million unmarried women. There were, as Honnor Morten puts it, 'not enough husbands to go round'. The notion that 'all women of the richer classes should be wives, and work only on the domestic hearth'[280] was no longer a possibility.

For women who wished to work in medicine, nursing was their only option for some time. Florence Nightingale's work in the Crimean War raised awareness and generated a high level of publicity for the profession, but at this time female nurses were still unpaid volunteers. Although she was instrumental in the professionalisation of nursing, in her 1859 work *Notes on Nursing: What it is and What it is Not*, Nightingale actively encourages nurses to be the 'helpmeets' of doctors and to avoid aspiring to be the 'the arrogant equal of men'.[281] This indicates how nurses were accountable to physicians, who were all male. Indeed, a male doctor of the time described nurses as 'dull, unobservant, untaught women; of the best it could be said that they were kindly and careful and attentive in doing what they were told'.[282]

After the Crimean War, Nightingale established the Training School for Nurses at St Thomas' Hospital, Southwark in 1860. Nurse

training had been provided by Protestant sisterhoods since the 1840s, but this was the first non-religious organisation delivering highly skilled professional nursing training along with opportunities for progression. Nursing was now an acceptable profession for middle-class women, further endorsed by Princess Helena – who had been the first chair of the British Red Cross Ladies' Committee and had a strong commitment to nursing recruitment – becoming the first president of the British Nursing Association on its creation in 1887.

But many women wanted more than nursing could offer them as a profession. For all its professionalism and importance, the role of a female nurse was still seen as a subservient one. Now, a number of enterprising women began to push open the doors to careers as doctors, beginning with Elizabeth Blackwell.

Blackwell, the first British woman to receive a medical degree, lived concomitantly with Florence Nightingale. She was noteworthy as the first woman to be entered on the register of the General Medical Council, but what was also significant is that she achieved this alone, without the support of any movement or campaigning.

Born in Bristol, Blackwell moved across the Atlantic with her family at the age of eleven, settling first in New York and then in Cincinnati, Ohio. On taking up a teaching role in Kentucky – with which she grew disillusioned – a family friend became terminally ill and confided in Elizabeth that if only she had been able to speak to a female doctor, avoiding the embarrassment of discussing personal issues and symptoms with a male, she might have lived. She went as far as to encourage Elizabeth to study for a medical career, something she had never considered. In fact, Elizabeth wrote that she 'hated everything connected with the body, and could not bear the sight of a medical book ... my favourite studies were history and metaphysics, and the very thought of dwelling on the physical structure of the body and its various ailments filled me with disgust'.[283] But as her friend pointed out, she had 'health and leisure; why not study medicine?' And so the idea began to take root. Her unnamed and now deceased friend had a point. Many women, wishing to appear modest and feminine as they were expected to be, were uninformed about the workings of their own bodies and often embarrassed to seek advice or even a diagnosis when they realised something was wrong. Elizabeth Blackwell was smart enough to spot a gap in the market and sufficiently self-aware to realise she could do something about it: 'The idea of winning

a doctor's degree gradually assumed the aspect of a great moral struggle, and the moral fight possessed immense attraction for me.' However, finding a course to accept her as well as the money to pay for it proved prohibitive.

In 1845 she took a job teaching at an academy in North Carolina. Either by accident or design, the principal was a former doctor. John Dickson began to mentor Elizabeth, lent her his medical books for self-study and encouraged her to read contemporary medical journals. After Dickson closed his college Elizabeth took a job at a school in Philadelphia. She now began to search for somewhere to take up formal studies, applying to every medical school in Philadelphia and New York, along with several in the north-eastern states.

Employing shrewdness when writing her personal statements, she cleverly selected the most positive comments in her rejection letters to put a positive spin on her applications. It bore fruit in November 1847, when Geneva Medical College in New York took Elizabeth Blackwell as the first ever female medical student. She had also received an acceptance letter from another institution. But her admission to Geneva had occurred as the result of a prank. The faculty put the issue of Elizabeth's admittance to a vote by the all-male student body, who all voted 'yes' as a joke, assuming that refusal would be a given.

Even after acceptance on the programme Elizabeth was asked to avoid reproductive anatomy classes in case the male students were embarrassed by her presence; she had the confidence to refuse, recognising her right to be treated equally, and recorded in her journal how she stirred curiosity:

> Very slowly I perceived that a doctor's wife at the table avoided any communication with me, and that as I walked backwards and forwards to college the ladies stopped to stare at me, as at a curious animal.
>
> I afterwards found that I had so shocked Geneva propriety that the theory was fully established either that I was a bad woman, whose designs would gradually become evident, or that, being insane, an outbreak of insanity would soon be apparent...[284]

Elizabeth's single-minded focus on her studies and refusal to be intimidated by any chauvinism or disapproval secured the respect

and support of her fellow students and remarkable academic success. On her graduation in January 1849, she was not merely the first woman to graduate with a medical degree in the United States but had achieved the highest marks in her class. Furthermore, her thesis on typhoid fever became the first published medical article in the United States by a female student when it appeared in the *Buffalo Medical Journal*.[285]

The *Geneva Gazette* reported on her graduation: 'She is good looking – a face that wins favourably on you; affable in her manner she pleases you; intelligent and witty she amuses you; amiable and confiding she wins upon you.' It is impossible to imagine a male graduate being described thus; regardless of her outstanding examination results, Elizabeth was still treated as an irregularity and a novelty.

But the fact remains that Elizabeth Blackwell was the first British woman to receive a medical degree, and the first woman to do so in the United States. Now it was time to achieve some practical experience. This became almost as much of a challenge as obtaining a degree, as the hospital doors were not opening very widely either in Philadelphia or in Paris where Elizabeth had expressed a desire to work. She began practical midwifery training in Paris but suffered an injury that left her blind in one eye. This led to her options becoming limited and her goal of becoming a surgeon was abandoned. Instead, she returned to England in 1850 to take up hospital training at St Bartholomew's Hospital to become a general practitioner on the recommendation of Sir James Paget:

> Mr Paget who is very cordial, tells me that I shall have to encounter much more prejudice from ladies than from gentlemen in my course. I am prepared for this. Prejudice is more violent the blinder it is ... but a work of the ages cannot be hindered by individual feeling. A hundred years hence women will not be what they are now.

She found this to be true. When women worked in mixed hospitals, they were restricted to junior positions, and Elizabeth realised that the answer was to start her own hospital for women and children. On completion of her training, she returned to New York to set up her practice only to face obstructions and discrimination yet again:

I had no medical companionship, the profession stood aloof, and society was distrustful of the innovation. Insolent letters occasionally came by post, and my pecuniary position was a source of constant anxiety.

However, through delivering a series of public lectures, 'Laws of Life with Special Reference to the Physical Education of Girls', Elizabeth found a new level of acceptance, enabling her to set up her own small dispensary on the Lower East Side in 1854. This provided her with so much exposure to female medical problems – she treated over 200 women in the first year alone – that she and her colleagues were able to use that knowledge to establish a hospital. The New York Infirmary for Women and Children was opened in 1857. This was the first hospital managed and staffed by women for women, successfully overcoming social objections. So many patients flocked there that additional staff had to be recruited.

The next step was to provide training and experience for female doctors. As Elizabeth wrote to Barbara Bodichon:

Until women have a very large experience their consciousness will stand in their way and they will either be less ... or more reliable physicians than men ... when ... properly supported by thorough culture and a very wide practical experience then they will become the better physicians – they will never I think stand on the same level.[286]

She now needed to raise sufficient funds to open a medical college at the hospital and encourage 'Miss Garrett or some other English girl' to study and work there. Elizabeth Garrett had attended Blackwell's lectures and mentioned in a letter to Barbara Bodichon that she was now determined to study and practise medicine; she would later be the first woman to gain a medical qualification in England. Once the Women's Medical College of New York Infirmary opened in 1867, Elizabeth Blackwell returned to England, satisfied that medical training for women and adequate care for patients was being provided.

What is striking about Elizabeth Blackwell is that although she disassociated herself from radical feminism, she was a doctor in her own right and in this sense was an unintentional feminist. The fact she was female seemed almost incidental but was a key factor in the

realisation that women should not be precluded from pursuing a medical career. In her own words:

> The great object of education has nothing to do with woman's rights or man's rights, but with the development of the human soul and body. My great dream is of a grand moral reform society, a wide movement ... combined that it could be brought to bear on any outrage or prominent evil.[287]

She had proved that women could indeed pass examinations, demonstrate tenacity and were equally as proficient as men. The old excuses that women's fragile minds and constitutions could not cope with the rigours, demands and unpleasantness of academic medical study and practical experience were debunked once and for all. Any anxiety about entering the male sphere, where women had previously been denied access, was put aside by the example of Elizabeth Blackwell. Now she had scaled the wall of prejudice there were many other talented, determined and able women ready and willing to follow her. And follow her they did.

But they were faced with other walls. Elizabeth Blackwell had registered with the General Medical Council in 1858, whereupon the rules were swiftly changed to veto other women from doing so. Registration now was only possible with a medical degree obtained in England, and as women were prohibited from entry to UK universities, this was unachievable. And every legally qualified medical practitioner had to be recorded on the register.

Enter Sophia Jex-Blake, who spearheaded the movement to grant women the right to study and practise medicine. After qualifying and working as a mathematics teacher, Hastings-born Sophia decided to study medicine. She had already defied her parents' wishes to begin her studies at Queens' College London in 1858, ten years after it opened with the aim of training women to become teachers. On 8 October that year she expressed her excitement in her journal:

> Very delicious it is to be here. 'Oh, if there be an Elysium on earth, it is this, it is this!' I am inclined to say. I am as happy as a queen. Work and independence! What can be more charming? Really perfection. So delicious in the present, what will it be to look back upon?

After only two months of study, she was invited to teach mathematics but reluctantly carried out this work on an unpaid basis after her father had raised objections in a letter:

> ... to be *paid* for the work would be to alter the thing *completely*, and would lower you sadly in the eyes of almost everybody. Do not think about it, dearest, and you will rejoice greatly by and bye with all who love you best ... if you take money payment, you will make a sad mistake, debase your standing, and place yourself in a position that people in general, including many relations and friends, will never *as long as you live* understand otherwise than as greatly to your discredit. You would be considered mean and illiberal, – tho' I am sure you are neither the one or the other—accepting wages that belong to a class beneath you in social rank, and which (it would be said) you had no right, under any circumstances, to appropriate to yourself ...

Letters between Sophia and her father demonstrate the attitudes to women's work and Sophia's resolve. Conversely, her brother Tom took up a teaching post for which he was paid, and which was justified by her father thus:

> ... Tom's being a *man* makes *all* the difference, he has just taken the *plain path of duty*. I am very pleased with the spirit in which you write, darling, but I must be sincere, which I should not be if I told you that I had the shadow of a doubt that you ought not to be a *paid* teacher ...

She promised her father 'for this term only (not ceding the principle) not to take any fees, but if they come (which I do not yet know) to return them as a free gift to the College', but came to regret the decision: 'Feb. 13th ... Like a fool I have consented to give up the fees for this term only – though I am miserably poor. I am sorry. It was foolish. It only defers the struggle.'

After qualifying, navigating the fallout of a broken relationship and starting her teaching career – again in the face of complaint from her father – Sophia took up teaching posts firstly in Germany and in 1865 in the United States, pursuing her plan of reforming education for women. With a letter to recommend her to Lucy Sewall,

a hospital physician at the New England Hospital for Women and Children, Sophia became seriously interested in qualifying as a doctor. Applying firstly to Harvard and being turned down because there was no provision for women to study there, she applied to Elizabeth Blackwell's medical school. Her father once again halted her plans, this time by dying before she could properly begin her education. Realising she would have difficulty in becoming accepted at a medical school in England, Sophia decided to try her luck in Edinburgh. Lucy Sewall wrote to her that: 'If you don't come back to America, you won't give up the work. You will open the profession to women in England.'

Elizabeth Garrett, who had been inspired by Elizabeth Blackwell and become acquainted with Sophia, had now obtained a chemistry degree at Edinburgh. She sent applications to several medical schools, all of which refused her entry. Undeterred, she went to Middlesex Hospital to study nursing, undergoing private tuition and attending lectures for male medical students until she was forbidden from doing so after complaints from the men. Together with Sophia, Elizabeth Garrett discovered an ambiguity in the Society of Apothecaries' examination regulations: there was no clause in their charter which overtly stated women could not be admitted or sit their examinations. Having been awarded a certificate in anatomy and physiology, Garrett began studying in 1862 and three years later became the first fully qualified female doctor in British history.

During the next year Elizabeth Garrett established St Mary's Dispensary, run by qualified female practitioners. The aim was to help women struggling with poverty to access the medical help they required. Moreover, just as the General Medical Council had done immediately upon Elizabeth Blackwell's registration, the Society of Apothecaries promptly changed their regulations so that women were no longer able to use their examinations as a 'back door' qualification to becoming doctors. *The Medical Times and Gazette* thought the 'admission of women in the ranks of medicine is an egregious blunder, derogatory to the status and character of the female sex, and likely to be injurious to the highest degree to the interests and public estimation of the profession which they seek to invade ... We hope ... that the Court of Examiners will ... distinctly refuse to admit any female candidate to examination.'[288]

Sophia now decided she too would move north to continue her studies. Recognising that Scotland was enlightened, forward-looking

and progressive, she applied to study at Edinburgh. With such burgeoning organisations as the Edinburgh Ladies' Educational Association, the city appeared open to furthering the professional and academic ambitions of women. Moreover, the Ladies' Edinburgh Debating Society was formed in 1865 by women who were or would go on to be prominent figures in education, suffrage, health and welfare.

But even with all this progressive thought, Sophia still had a fight on her hands. She applied to the Edinburgh Medical Faculty in March 1869:

> As I understand that the statutes of the University of Edinburgh do not in any way prohibit the admission of women, and as the Universities of Paris and Zurich have already been thrown open to them, I venture earnestly to request from you and the other gentlemen of the Medical Faculty permission to attend the lectures in your Medical School during the ensuing session.[289]

She was accepted, but not without problems. Robert Christison, chair of medicine, objected on the supposed grounds that professional standards would be lowered by having women attend the university, as their intellectual ability and stamina was no match for that of men. Sophia therefore had her offer withdrawn after an appeal by Claud Muirhead, senior assistant physician at the Royal Infirmary, following complaints from more than two hundred male students. The reason given by the University Court, who ruled against her admittance, was that as the only female student adjustments would have to be made that were untenable in 'the interest of one lady':

> That the Court, considering the difficulties at present standing in the way of carrying out the resolution of the Senatus, as a temporary arrangement in the interest of one lady, and not being prepared to adjudicate finally on the question whether women should be educated in the medical classes of the University, sustains the appeals and recalls the resolution of the Senatus.

Sophia resolutely turned this into an advantageous opportunity to gain support. She described the necessity for female doctors to treat female patients who might be reluctant to consult men in her uncompromising essay 'Medicine as a Profession for Women',

in which she also put forward her thoughts about equal access to medical education.

She was also busy advertising in local and national newspapers to find like-minded prospective women medical students to apply alongside her. In *The Times* she wrote that 'it would be well if any ladies intending to join these classes would at once communicate with me on the subject',[290] and *The Scotsman* commented that 'the arbitrary exclusion of women from opportunities of professional education belongs to a past age ... It is a matter for rejoicing to see a new state of things thus inaugurated by the leading University of Scotland, now that "a fair field and no favour" are at length accorded, the real capabilities of women for the study and practice of medicine will be fairly tested.'[291]

Teaching several female students, not just one, would prove to be far more cost-effective and now there were five 'lady' applicants to counter the University Court's ruling and sit the matriculation examinations in the autumn of 1869 – the first women ever to do so at a university in the United Kingdom. Four of the women were in the top seven graded students out of a total of 152 when the examination papers were assessed. Furthermore, Edith Pechey achieved the highest marks of any student who had ever taken the entrance examinations. Word spread, and, with two more women joining them, they became known as the Edinburgh Seven. The university fees were twice as high for the women as for male students, and because lecturers were not required to teach women – meaning they could, and did, refuse to do so – the Seven had to arrange their own lectures at the extramural medical college. As Elaine Thomson of Napier University explains:

> The issue of mixed classes once more came to the fore. In the wards of the hospital, it was argued, women would witness the most hideous diseases and illnesses, the sights, sounds and smells of which would shock and offend their delicate sensibilities. As a result, sixteen out of the nineteen members of the medical staff voted against allowing women into the Infirmary for clinical instruction.

Some men were supportive, but these exceptions were few and far between. On campus, the women were bullied by male students who shouted abuse and slammed doors in their faces. They even faced

harassment and intimidation from the general public when out in the street and were afraid to walk out alone. Sophia recounts the abuse they received from male students in her journal:

> ... they had further distinguished themselves by affixing a Catherine wheel to my door and burning off ... the paint. These, however, were only the tricks of utterly unmannerly boys; and when they did not proceed to personal violence, we could, on the same ground, forgive some half dozen of the lowest students for standing about in the doorways through which we had to pass, smoking in our faces, bursting into hoarse laughs at our approach, etc. But this was not all. The filthiest possible anonymous letters were sent to several of us by post; and the climax was reached when the students took to waylaying us in some of the less frequented streets through which we had to pass, and shouting indecencies after us, making use, sometimes, of anatomical terms ... [292]

They were also discriminated against in their examinations the following March. All the women passed, four of them with distinction, demonstrating that their intellectual excellence was not in doubt. In fact, Edith Pechey's results in both chemistry and physiology were the highest of the entire student cohort – across both genders – of students sitting the examination for the first time.[293] Pechey's results entitled her to the Hope Scholarship, awarded to the four students who achieved the highest marks at first sitting in the first-term examinations in Chemistry. Professor Alexander Crum Brown therefore proposed to senate – perhaps fearing a backlash from students and faculty colleagues – that the scholarship be handed to lower-placed male students. This decision was absurdly justified by a margin of one vote on the grounds that the women had been taught in separate classes, which of course they had been forced into through the inflexibility of the university. Even more confusingly, Crum Brown had earlier insisted that the women's chemistry classes, a core element for admission to medical school, were identical to those attended by the male students.

Having earlier threatened to resign if the women were admitted to the university, 'Mrs A. [wife of one of the professors], tells me Christison actually threatened to resign if women are admitted! – and

to the Medical Faculty this is a formidable threat'.[294] Robert Christison now waded into the row, maintaining that women really should be content with working as midwives or nurses. Never mind that they had indisputably demonstrated that they could compete on equal terms with the men in medical school. Sir James Stansfeld in his retrospective piece in 1877 wrote:

> It is one of the lessons of human progress that when the time for a reform has come you cannot resist it, though, if you make the attempt, what you may do is to widen its character or precipitate its advent. Opponents, when the time has come, are not merely dragged at the chariot wheels of progress – they help to turn them. The strongest forces, whichever way it seems to work, does most to aid. The forces of greatest concentration here have been, in my view, on the one hand the Edinburgh University led by Sir Robert Christison, on the other the women claimants led by Dr Sophia Jex-Blake.[295]

But Christison was inadvertently inviting public sympathy for the Seven. The Hope Scholarship controversy made national headlines. *The Times* remarked:

> [Miss Pechey] has done her sex a service, not only by vindicating their intellectual ability in an open competition with men, but still more by the temper and courtesy with which she meets her disappointment.[296]

The British Medical Journal commented:

> Whatever may be our views regarding the desirability of ladies studying medicine, the University of Edinburgh professed to open its gates to them on equal terms with the other students; and, unless some better excuse be forthcoming in explanation of the decision of the Senatus, we cannot help thinking that the University has done no less an injustice to itself than to one of its most distinguished students.[297]

The Spectator commented on the 'bitter and, so far as we know, the unprecedented malignity with which women who aspire to be Doctors

are pursued by the literary class',[298] and the following poem appeared in *The Period*, a London review magazine:

> Shame upon thee, great Edina! Shame upon thee, thou hast done
> Deed unjust, that makes our blushes flame as flames the setting sun.
>> You have wrong'd an earnest maiden, though you gave her honour's crown,
>> And eternal shame must linger round your name, Professor Brown.[299]

The injustice caused an outcry and support began to build. In April, Dr Alleyne Nicholson, an extramural lecturer, showed a willingness to help the women in their quest to gain equal access to classes by drawing an analogy with the zoology lectures delivered at the university:

> The course of lectures on Zoology which I am now delivering to a mixed class is identically the same as the course which I delivered last winter to my ordinary class of male students. I have not hitherto emasculated my lectures in any way whatever, nor have I the smallest intention of so doing. In so acting, I am guided by the firm conviction that little stress is to be laid on the purity and modesty of those who find themselves able to extract food for improper feelings from such a purely scientific subject as Zoology, however freely handled.[300]

Eventually, separate classes for women were judged inadequate for qualification to take professional exams and although this was evidence of progress, harassment towards the women not only grew but now became more overt. Sniggering and name-calling had been going on for some time, but now they had proved themselves without doubt equal to men, antagonism stepped up 'a gear. The women were followed. Their property was damaged. They received obscene and threatening correspondence. Most disturbing of all is that this campaign of harassment from male students training to prove their suitability as doctors was supported by Robert Christison himself. But Edith Pechey avowed: 'If the wish of these students is to bar our progress and frighten us ... I venture to say that never was such a

mistake made. Each insult is an additional incentive to finish the work begun.' She also passed judgement on the character of some of the male students and their suitability to practise medicine:

> I began the study of medicine strictly from personal motives; now I am also impelled by the desire to remove women from the care of such young ruffians. I am quite aware that respectable students will say, and say truly, that these are the dregs of the profession, and that they will never take a high place as respectable practitioners ... I should be very sorry to see any poor girl under the care of such men as those for instance who the other night followed me through the street ... when a man can put his scientific knowledge to such degraded use, it seems to me he cannot sink much lower.

In November 1870, the antagonism against the women came to a shocking crescendo. Due to sit an anatomy examination in the Surgeons' Hall, they found themselves up against a crowd of angry male students – Sophia records 'almost two hundred' in her journal, in addition to public onlookers – attempting to prevent them from entering the examination room. Insults and mud were flung at them on the way to the hall, the door of which was closed in their faces and locked as they attempted to enter. They did sit their examination – with the distraction of a sheep that had been sent into the hall to disrupt proceedings – and some sympathetic male students escorted them home afterwards. These women displayed great strength of character and determination by sitting the examination covered in muck. Conversely, it is telling that the male students were only prepared to carry out their campaign of harassment as a group. Also, the prevalent idea in Victorian society of women as delicate objects had been totally disregarded by them. Sophia's account of the examination ran thus:

> We passed rather good examination. Then at end H. asked if we would go out by back door. 'Oh, no,' I said, 'I am sure there are enough gentlemen here to prevent any harm to us.' And so we went, Hoggan and Sanderson pioneering, – S. M. M. said she got hit, – Wilson came up and took Mrs K.'s arm (to our momentary fright), then we proceeded home, escorted by ... gallant cavaliers.

Charles Reade, in his novel *A Woman Hater* (1876), uses the voices of his fictional medical students Ina, Rhoda, Zoe and Fanny, who attempted to qualify in Edinburgh, to contrast female strength with male cowardice:

> Now, it so happened that we had a lioness for our leader. She pushed manfully through the crowd, and hammered at the door: then we crept quaking after. She ordered those inside to open the gates; and some student took shame, and did. In marched our lioness ...

They had demonstrated that they were, in fact, superior to the majority of the men in this context. Rhoda Gale recounts the events of the Surgeons' Hall riot:

> They dragged a sheep into the lecture-room, lighted pipes, produced bottles, drank, smoked, and abused us ladies to our faces, and interrupted the lecturer at intervals with their howls and ribaldry: that was intended to show the professor he should not be listened to any more if he admitted the female students. The affair got wind, and other students, not connected with medicine, came pouring in, with no worse motive, probably, than to see the lark. Some of these, however, thought the introduction of the sheep unfair to so respected a lecturer, and proceeded to remove her; but the professor put up his hand, and said, 'Oh, don't remove her: she is superior in intellect to many persons here present.'

The Scotsman reported on the riot:

> A certain class of medical students are doing their utmost to make sure that the name of medical student synonymous with all that is cowardly and degrading, it is imperative upon all ... men ... to come forward and express ... their detestation of the proceedings which have characterised and dishonoured the opposition to ladies pursuing the study of medicine in Edinburgh.

The extensive publicity led to greater public support for the women's campaign for a university education. Following the riot, sixty-six

male medical students signed a petition which they forwarded to the Royal College of Surgeons complaining that 'the presence of women at the classes of anatomy and surgery, and in the Dissecting room of the College, gives rise to various feelings which tend to distract the attention of the Students from important subjects of study'. It is risible that these men were in fact drawing attention to their own lack of ability. If they were unable to focus on their studies because of the presence of women, this says more about their own capacity for study than that of any woman.

Sophia Jex-Blake was now sued for libel after blaming Robert Christison's classroom assistant, Edward Cunningham Craig for inciting the riot, using abusive language and drunkenness. The jury found in favour of Craig, awarding him a mere farthing in damages, with legal costs to be paid by Sophia. But the male students had done the women a favour. The issue of women's rights to study at university had been brought to a wider national level and the legal costs were adequately covered by supportive public donations. The deliberate attempts to block them from a university education had backfired.

Even so, 1871 through to 1872 proved yet another challenging couple of years. By the time the Seven were ready to take their first professional examinations, three of them had married. While Sophia and the remaining four focussed on canvassing for access to the wards, other women who had been inspired by these events were ready to register. The University Court now ruled that their decision to allow the women to matriculate in 1869 was beyond the legal powers, i.e. *ultra vires*. The Court of Session ruled that it was now illegal for universities to admit women. The women were not allowed to graduate.

Another route had to be found, but in the meantime, Sophia became involved in another project – the London School of Medicine for Women. Opened in October 1874, this was the first UK institution purposely intended to provide medical training for the examination of Apothecaries Hall, and moreover to do this by legal means instead of the loopholes used by women in the past. With support from the likes of Lord Shaftesbury, who held a 'belief in the inherent right of choice possessed by all persons as to their occupations', twenty-three women were enrolled in the first academic year.[301]

It would be another twelve years before any other medical school would admit women to train as doctors. By 1887, the London School

of Medicine for Women was training seventy-seven students, with 300 on the register by the end of Queen Victoria's reign. But at the outset, although they could train, women could not sit their examinations in the UK.

Sophia and her colleagues had won support from several prominent MPs, and in 1875 an Enabling Bill was introduced into Parliament to allow women to receive university degrees. Furthermore, with specific reference to the Edinburgh Seven, it was intended 'to remove the badge of illegality and invalidity which had been stamped upon the proceedings of the University by the decision of the Court of Session'. The Enabling Act was passed in August 1876 amid weighty opposition. Any woman who had trained overseas could now be registered as a doctor in the UK on completion of the requisite examinations. Women had been admitted to classes at the Museum of Irish Industry since 1850 and the Royal College of Science had allowed them to register when they opened in 1865. Now, the College of Physicians in Dublin swiftly decided to offer women who had taken their medical degrees at a foreign university a means of qualifying as registered medical practitioners.

This was, Sophia claimed, 'the turning point in the whole struggle'. Eliza Dunbar was the first woman to qualify with a medical licence through this route, having taken her degree in Zurich. Sophia and Edith Pechey, having by now taken their degrees in Berne, sat the examinations at the College of Physicians – after seven long years, they were now registered doctors.

In 1878, Sophia marked another milestone when she became the first Scottish female doctor. Moving back to Edinburgh, she first established a dispensary to cater for underprivileged women before opening the Edinburgh School of Medicine for Women. Ironically, the school closed several years after the University of St Andrews began to admit female students in 1892.

As for Elizabeth Garrett, the first Englishwoman to qualify in medicine; back in March 1869, Sophia wrote to Lucy Sewall:

I have two nice little bits of news about Miss Garrett. One is that the Princess Louise went to see her, and, after enquiring about the medical prospects of women, expressed strong hopes of their complete success. This is really worth a great deal, and I hope you will have too much sense to sneer at it. Secondly, I see in the

British Medical Journal (which I shall try to send you) a notice that Miss Garrett had 'by special order of the minister' been admitted to the first examination for M.D. [in Paris] and had passed it in the presence of a crowded audience with very great éclat. That woman certainly has great power of study and work, hasn't she?

But Elizabeth was still refused entry onto the British medical register and would have to wait until 1876 and the Enabling Act.

In 1872, the dispensary became the New Hospital for Women. By 1874, Garrett had become involved with Sophia Jex-Blake in establishing the London School of Medicine for Women, where she appointed Elizabeth Blackwell, who had mentored her in the early days, as professor of gynaecology.

In contrast to some of her colleagues, Elizabeth Garrett was a true feminist. A member of the Kensington Society along with Barbara Bodichon and others, she was the first Englishwoman to qualify as a physician and surgeon in Britain, a founder of the first hospital run by and for women, the first woman in Britain to be elected to a school board following the 1870 Education Act and the first female mayor in Britain. The London School of Medicine became incorporated into the University of London within three years of opening, and in 1883 Elizabeth Garrett Anderson became the first dean of any British medical school – of either gender. She was competent, determined and politically astute, often taking a creative approach to obstacles which caused clashes with the more strident Jex-Blake, whom Anderson thought had a 'jarring personality, with a judgement and temper she could not bring herself to trust'. Jex-Blake had moreover raised objections about Anderson's appointment as dean. They clashed on the question of medical co-education; whilst Jex-Blake was perhaps understandably cautious following the experiences in Edinburgh, Anderson's view was that such an approach would normalise the role of female doctors in public consciousness.

The Surgeons' Hall riot is remembered as a turning point not just for the Edinburgh Seven, but for women's education as a whole. Sophia Jex-Blake and Edith Pechey earned for themselves a reputation of being aggressive and combative. But they had to be. They were far from on a level playing field and without their deviation from the expected conduct of a Victorian woman, other women would have

had to wait far longer to be able to study and practise medicine. They challenged the worst of male opposition and proved to be excellent networkers. By 1881 there were twenty-five women doctors in England; when Queen Victoria's reign ended, there were more than over two hundred. And in 1889, largely as a result of their work, an Act of Parliament sanctioned degrees for women. Perhaps Sophia's influence is best described by Sir James Stansfeld, supporter of the 1875 bill that sought to legalise granting of university degrees to women, in his summing-up of the events: 'Dr Sophia Jex-Blake has made the greatest of all contributions to the end attained.'[302]

Elizabeth Blackwell, Sophia Jex-Blake and Elizabeth Garrett Anderson fought not only for themselves but for the future of all women who wanted to become doctors. They set a precedent for aspiring female physicians and championed women's rights. In Britain, even after the 1876 Enabling Act allowed medical examining boards to grant licences to women, universities could still legally exclude women from their medical schools. By 1881, women doctors in England and Wales made up a total of only 0.17 per cent of the profession.

Female students were finally admitted to Edinburgh University in 1892, but they were still taught separately from the men. The university allowed women to graduate in 1894 and the first female doctors graduated in 1896.

But in 1896, Dr Annie Reay Barker found herself diagnosed with 'Chronic Mania' and was admitted to a sanatorium. She had studied at the University of Edinburgh and the Sorbonne in Paris, and was the first female doctor to be appointed to a senior hospital position when she took the role of outpatient physician at the Birmingham and Midland Hospital for Women in 1878. *The Medical Examiner* wrote that 'this is the first occasion on record in which a lady has, in competition with gentlemen, been chosen a member of honorary medical staff'.[303] In October 1881 she gave the inaugural address at the London School of Medicine for Women but the following year she suffered mental health problems, causing her to resign her post at the hospital. She worked sporadically over the following decade but chose to live out of the public eye; perhaps the fear of her own illness reflecting on women physicians prevented her from drawing attention to herself.

Women had fought long and hard to become doctors and to be recognised as professionals. It is not hard to imagine that they would

put themselves under pressure to succeed and not to show any signs of weakness for fear of setting back the cause and proving the male dissenters right after all:

> It is necessary ... to recognise that the standard of professional attainment expected by women, will for some years be higher than that expected of the ordinary male practitioner. Women can less easily afford to be second-rate; their professional work will be more closely scrutinised; mistakes will ruin them more quickly than they will men.[304]

But what of other disciplines? Ada Lovelace once told her mother in a letter that 'owing to some peculiarity in my nervous system, I have perception of some things, which no one else has; or at least very few, if any ... I can throw rays from every quarter of the universe into one vast focus.'[305] She chose to accept this distinctiveness and forge a path of originality in early Victorian society.

In 1833, seventeen-year-old Ada Byron was an enthusiastic mathematician. Her mother had insisted on her studying mathematics and logic, most probably to ensure she didn't follow in the footsteps of her father, the flighty Lord Byron. Ada's childhood mentor had been polymath Mary Somerville, described by Scottish physicist Sir David Brewster as 'certainly the most extraordinary woman in Europe – a mathematician of the very first rank with all the gentleness of a woman',[306] and who was working on her 1834 publication, *The Connection of the Physical Sciences*, when she introduced Ada to mathematician and inventor Charles Babbage at a house party in London. For almost a decade, Babbage had been working on his early prototype calculator, the Difference Engine, which was designed to create numerical tables using a mathematical technique known as the method of difference. Babbage aimed to eliminate human error in the production of nautical tables by automating mathematical calculations. Fascinated by the working prototype, Ada began sustained communication with Babbage about the designs. But the project was never completed.

Babbage subsequently began work on what he thought was a better idea, the more flexible and sophisticated Analytical Engine, whilst Ada married William King, Earl of Lovelace, and started a family. But Babbage's aspirations were ahead of his time. In fact, he was

'effectively sketching out a machine for the electronic age during the middle of the steam-powered mechanical revolution', according to Steven Johnson in his 2010 book *Where Good Ideas Come From*. And in a letter to the physicist Michael Faraday, Babbage spoke of Ada as 'that Enchantress who has thrown her magical spell around the most abstract of Sciences and has grasped it with a force that few masculine intellects (in our own country at least) could have exerted over it'.[307]

In 1840 Babbage was invited to speak about the design at a university in Turin, with a paper being published, in French, two years later. Ada translated the report of the seminar to English with a view to publication. At this point it is worth mentioning that she was fortunate that William was an atypical Victorian husband in that he championed her work and recognised that his wife's success reflected back on him. As women were not allowed to use the Royal Society library, William copied articles for her. (Ironically, the entrance of the building boasted a statue of Mary Somerville, but even she was not allowed entry.) 'William especially conceives that it places me in a much *juster* & *truer* position & light, than anything else can,' she wrote. 'And he tells me that it has already placed *him* in a far more agreeable position in this country.'[308] Ada and Babbage also, unusually for the time, worked as a team, collaborating as inventor and programmer and discussing their findings with a view to improvement and advancement. James Gleick describes their symbiotic relationship: 'Lady Lovelace adored her husband but reserved much of her mental life for Babbage. She had dreams, waking dreams, of something she could not be and something she could not achieve, except by proxy, through his genius.'

At Babbage's suggestion, Ada incorporated her own notes and observations in her translation. As well as demystifying the workings of Babbage's machine so it could be understood by a wider audience, Ada also included details of a machine-generated algorithm that would enable further uses that Babbage had not considered:

Many persons ... imagine that because the business of the Engine is to give its results in numerical notation the nature of its processes must consequently be arithmetical and numerical, rather than algebraical and analytical. This is an error. The engine can arrange and combine its numerical quantities exactly

as if they were letters or any other general symbols; and in fact it might bring out its results in algebraic notation, were provisions made accordingly.[309]

The Analytical Engine was never built or patented, but Ada Lovelace realised its potential far better than Babbage had. She discovered that it would be able to manage complex tasks and problems and generate results without pre-programming. In fact, it was possible to translate music, text, graphics and sounds into a digital format and then manipulate them.

One of her tutors, Augustus De Morgan, wrote to Ada's mother about her thus:

> Had any young beginner, about to go to Cambridge, shown the same power, I should have prophesied first that his aptitude at grasping the strong points and the real difficulties of first principles would have very much lowered his chance of being senior wrangler; secondly, that they would have certainly made him an original mathematical investigator, perhaps of first rate eminence.[310]

Although Ada Lovelace is often referred to as the world's first computer programmer, it should be remembered that the original programming was carried out by Charles Babbage. Ada's skill and originality lay in her lateral thinking and her perception of the broader application and potential of the work, including the first algorithm ever published for implementation on a computer. Her ideas were so far ahead of their time that it would be one hundred years before her work was fully appreciated, when it inspired Alan Turing to decipher the Enigma Code.

Although Ada's work attracted scant attention during her lifetime and she died aged just thirty-six, her translation and notes were original and became the main influence on future developments in computing, owing to Babbage's refusal to publish his findings. She rightly owns her place as a female pioneer of computing as the first true computer programmer; not merely the first woman, but the first individual. What is remarkable is that Ada Lovelace, not Babbage himself, wrote the addendum, notes and published program. Why? It is simple to compute that at the time Babbage was working on his

invention, there was simply no one else around who understood the implications of the machine or possessed the scientific imagination to take these ideas forward. And that person proved to be a thirty-something mother of three.

How did Victorian women find careers in engineering? Back in 1811, Sarah Guppy had devised the engineering technique of driving pilings deep enough into the ground to provide sufficiently strong uprights to support a suspended bridge. This was patented and Sarah gave Brunel her designs at no cost, considering public safety to be more important than financial return or personal recognition. In fact, she said that 'it is unpleasant to speak of oneself – it may seem boastful particularly in a woman'.[311]

Career paths for women engineers didn't become available until the first half of the twentieth century, but without the impact made by Victorian pioneers there would have been even fewer opportunities for women. No professional body or learned society existed for female engineers; admittance would only be possible after the First World War, when women had secured their place in the industry through proving their worth in place of an absent male workforce. Most women engineers developed their career paths through family connections rather than the formal educational routes seen in the medical profession. However, this does not detract from their significant contributions to science and to the role of women in engineering.

Notwithstanding her invention – and being a founder of the Society for the Reward and Encouragement of Virtuous, Faithful and Industrious Female Servants – Sarah Guppy remained relatively unknown, and so a 1983 article in *The Journal of the Women's Engineering Society* credits Henrietta Lowe Vansittart as Britain's first female engineer:

> That a young married woman succeeded in entering and making her mark on the totally male preserve of mid-Victorian heavy engineering, engaged in the monumental task of girding the world with steam and steel, is surprising to modern people and may cause some of us to revise our ideas about the constraints in Victorian society.[312]

Henrietta was not the typical Victorian women. Her engineer father, James Lowe, had invented and patented a submerged marine

screw propeller in 1838, and he recognised her scientific aptitude, encouraging her to work with him on his inventions and patents, which was remarkable for the age. Henrietta accompanied him when he tested out the screw propeller on HMS *Bullfinch* and put forward her thoughts on how it could be improved; following his death she took over the work, refining the design and obtaining a UK patent for what became the Lowe–Vansittart propeller in 1868. This was swiftly followed by a US patent in 1869. The *London Evening Standard* wrote on 25 November 1869 that 'Mrs Vansittart has devoted herself to the task of working out the invention to a greater state of perfectness.' Throughout the 1870s she attended many exhibitions worldwide, being awarded a series of medals and diplomas for her invention.

Contradicting the expected feminine modesty of the times, Henrietta was involved in a well-publicised extramarital affair with MP Edward Bulwer Lytton, who left her £1,200 in his will. Her obituary in the *Journal of the London Association of Foreman Engineers and Draughtsmen* noted:

> She was a remarkable personage with a great knowledge of engineering matters and considerable versatility of talent ... how cheery and thoughtful for the happiness of others, she was helping she was the only lady, it is believed, who ever wrote, and read a scientific paper, illustrated with diagrams and drawings, made by herself, before members of a Scientific Institution.

Henrietta Vansittart became a more successful engineer than her father, holding a patent for nearly twenty years, and her propeller featured on various naval and civil vessels including HMS *Druid* and SS *Lusitania*. She demonstrated that it was possible for women in the Victorian era to establish career paths in engineering through hard work, self-study and an aptitude for science.

Most Victorian women engineers obtained their successes through collaboration, as did Hertha Ayrton and Katharine Parsons, the latter of whom supported her husband's experimental work on prototype torpedoes in the 1880s, leading to the invention of the modern steam turbine. This symbiosis helped them to overcome the barriers they encountered regarding both education and membership of professional institutions and learned societies.

Through attending suffrage campaigns with a friend, Phoebe Sarah 'Hertha' Ayrton met Barbara Bodichon, who introduced her to further education and the suffrage movement. Being encouraged to study independently because evening classes and lectures open to women were few and far between at this time, in 1874 Hertha passed the Cambridge University local examinations for women with honours in English and mathematics. She was, however, unable to afford the entrance fees and failed to secure a scholarship to allow her entry to Girton College. Nevertheless, the suffrage sisterhood proved supportive and advanced her a loan to enable the commencement of her studies at Cambridge in 1876.

She passed the highly demanding, week-long Mathematical Tripos in 1880, albeit with third-class results.[313] The rigour of the Tripos was used by educational campaigners to highlight the intellectual capability of women to compete with men. Even so, at the time Cambridge would not grant degrees to women. Hertha took an external examination at the University of London in 1881, leading to a Bachelor of Science degree. Barbara Bodichon raised funds to enable her to patent her line divider,[314] and thus began her career in patenting and invention. The line divider was demonstrated at the 1885 Exhibition of Women's Industries in Bristol, bringing female inventions to the attention of the press and the wider scientific industry. An 1885 review in the *Academy* journal declared the line divider to be a useful tool for 'all those who have to do with the line and the rule', while *Nature* magazine called it 'a very handy instrument for architects, engineers and practical drawing'. A London engineering manufacturing company produced and distributed the instrument, and Ayrton gave a paper[315] at the Physical Society in 1885, explaining how it would be used:

> The divider would also be useful on board ships for drawing lines on charts parallel to other lines at some distance. It would be much better for this purpose than an ordinary parallel ruler on account of its very large range and capability of being fixed ...

But her biggest successes came after her marriage to a professor of electrical engineering whom she had met at night school. She excelled in research, particularly in the field of electric arc lighting. William Ayrton commented to a friend that whilst they were 'able people ... Hertha is a genius.' He fully supported his wife's research and abilities

in the face of both the conventions of the time and the criticism of his colleagues.

Hertha's knowledge enabled her to design advanced performance cinema projectors and anti-aircraft searchlight carbons for the British Admiralty. Her research formed a series of articles in *The Electrician* periodical and led to further recognition; towards the end of the century she became the first woman to present her own paper at the Institution of Electrical Engineers and the first female member of the Institution. She gave speeches at both the International Congress of Women in London and the Paris Electrical Congress. This inspired her cousin to use her work to persuade the British Association for the Advancement of Science to allow women to join their scientific committees. However, though her paper 'The Mechanism of the Electric Arc'[316] was presented to the Royal Society in 1901, she was barred from reading it herself due to the view that 'married women are not eligible as fellows of the Royal Society'. John Perry, former professor of engineering and mathematics at Finsbury Technical College, where Hertha had taken her evening classes, read it on her behalf.

What is notable is how supportive Hertha's husband was of her scientific pursuits, and this leads to a serious reflection on the different path electrical engineering research might have taken had he disapproved of her work or taken credit for it. She was a true innovator, both as a female and an engineer, bringing engineering into public consciousness as a path for other women to follow. She is an exceptional example of a Victorian woman who succeeded in engineering, demonstrating what can be achieved through backing from other women in terms of eradicating gender limitations. She also understood that it was possible for women to be curious, inventive and original, possessing the right qualities to carry out scientific work to a high level of success. Andrew Stewart wrote in an article in *The Woman Engineer* in 1923 that:

> Mrs Hertha Ayrton was I think the first member of the fair, but no longer frail sex, to distinguish herself in the engineering world, though perhaps the woman engineer would not have arrived yet, had not the war, which upset so many masculine traditions, proved that woman was capable of doing many things which had hitherto been considered strictly within the provenience of the more assertive male ...[317]

Without her achievements it is disputable whether the increased opportunities available to women in engineering during and after the First World War and beyond would have existed.

The advent of the Industrial Revolution, leading to broader social and professional opportunities, also provided openings for women to achieve success as musicians, financially and professionally. Alongside this, though, as with other professions, they had obstacles to confront. The Industrial Revolution established the change from a primarily rural and feudal economy to one that was urban and industrialised. The increased level of technology and the arrival of an upwardly mobile, aspirational urban middle class created the need for the public concert hall.

In the mid-century, at least, musical women were often associated with charitable activity, which fell within the traditional role ascribed to them. But as time passed, barriers to female participation in the professional music world began to disappear as opportunities presented themselves that began to blur the boundaries and at the same time attenuate the ideology of separate spheres.

Philanthropy became the main mechanism that enabled many women to develop careers in music, or have influence in the musical arena. A notable example is female conductor Lady Radnor, Helen Pleydell-Bouverie, and an examination of her life and work provides a positive template for later twentieth-century female conductors. Lady Radnor was a highly trained musician and public performer. Having taken lessons from childhood, she sang and played the organ at charitable events held at Covent Garden Opera House and at St James's Hall, along with appearing in public concerts such as that at the Albert Hall, produced by Prince Alfred, Duke of Edinburgh, in 1873. As her star rose, she 'began to take a more serious view of what might be done with music'.[318]

The Kyrle Society was an organisation initiated by Miranda Hill in 1876. Her sister, social reformer Octavia Hill, first acted as its treasurer and would become a key figure in its history. Owing to the growth of urbanisation, the sisters understood that towns and cities provided limited aesthetic opportunities for the working class:

Men, women and children want more than food, shelter and warmth. They want, if their lives are to be full and good, space near their homes for exercise, quiet, good air, and sight of grass,

trees and flowers; they want colour, which shall cheer them in the midst of smoke and fog; they want music, which shall contrast with the rattle of the motors and lift their hearts to praise and joy; they want suggestion of nobler and better things than those that surround them day by day.[319]

The Kyrle Society organised choirs of volunteer singers to perform concerts and oratorios in the poorest parts of London. Miranda Hill's philosophy was that art and beauty had the power to transform lives, and these opportunities should be available to all strata of society. This led to several branches being formed in cities around the country for the same purpose – refining and civilising the poorer elements of society. 'There is probably no way in which music can be more closely or helpfully brought into the lives of the working people than by training them in the practice of part-singing or instrumental music amongst themselves,' said the Kyrle Society's annual report of 1890.

Around this time, amateur musician Charles Bethune initiated the People's Entertainment Society with the aim of raising aspirations of the working class beyond the public houses and music halls and their parodies of 'all that was smug and conventional in the Victorian code of respectability'.[320] The PES organised a series of free concerts and though female musicians were on the setlist, women were not admitted to the concerts. The *Saturday Review* stated that it wished to draw men away from the public houses but keep women at home. Whilst philanthropic in nature, the society continued to enable androcentricity in its aims. This, unsurprisingly, led to lampooning in the popular press, in particular *Punch*, as well as scathing criticism from George Bernard Shaw. But during the first few months of 1879, the society performed sixty-six concerts that included female musicians.

However, for Helen Radnor, this was where her public musical career really took off. She regularly performed for the PES and other charitable organisations: 'I sang a good deal more than once a week, for I find on looking over my old files, that I never took part in less than sixty concerts in a year, and, as I was away from London three or four months out of the twelve, that meant two or three concerts a week regularly when I was in town.' She also organised singing classes for working people, which were remarkably well received

and fulfilled the philanthropic aim of improving speech, diction and language use.

From this platform, whilst also continuing with her singing career and appearing at concert halls and the Oswestry Festival of 1881, Helen Radnor formed and conducted a ladies' string orchestra which performed at such upper-class venues as Prince's Hall in Piccadilly and St James's Hall and ran until 1896, donating some of the proceeds to the PES. Women's orchestras had been a feature of the musical landscape of Austria and Germany for some decades by the time Lady Radnor's Orchestra was founded. This orchestra was not only much larger but managed to attract members and audiences because the conductor was a member of the aristocracy and therefore fitted social norms; she was talented, she was female, but she had decorum. Here is an 1881 report on their inaugural concert:

> Imagine a string band of twenty-four young girls of the highest station from about twelve to seventeen years old, beautiful for the most part, playing magnificently, producing a pianissimo that would do honour to a professional band; the chorus consisting of twenty-four ladies (many of them Peeresses of the Realm), and all these ladies necessarily showing what musical aptitude is that of English girls and women ... There was no fault to be found with the programme so far, but wherever there is a band, the Conductor is invariably mentioned. This was not so here. You think it was Sir Michael Costa? No. Or Henry Leslie? Not a bit. Perhaps Hans Richter? Never. Give it up? It was Lady Folkestone, and beautifully she did it. What a gifted organization hers is, those who know her are well aware of it; but here, she showed herself in a new light ... Lady Folkestone handled the baton like a Costa, and led with the greatest grace ...[321]

By 1886, *The Musical World* was happily reporting that 'the cultivation of violin music among amateurs is a welcome sign of general musical culture'. Here was progress. Only a few decades earlier, women violinists had been frowned upon and even informally banned up until around 1870 for various reasons, including the notion that playing stringed instruments was not feminine. It was considered aesthetically disagreeable for a woman to manoeuvre her body into

the shapes required to play a violin; tucking it under her chin and facing the public whilst performing was regarded as unladylike.

With the rise of the feminist movements and the New Woman in particular, and the fame and achievements of Czech violinist Wilma Norman-Neruda, whose performances demonstrated that women could be at least equal to men without being unfeminine, attitudes began to change and female violinists even became fashionable. Lady Caroline Lindsay, who accompanied Norman-Neruda and other violinists on the piano, wrote:

> It is she who, uniting with the firmness and vigour of a man's playing, the purity of style and intonation of a great artist, as well as her own perfect grace and delicate manipulation, has proved to the public at large what a woman can do in this field, at least (...) Madame Neruda, like a musical St. George, has gone forth, violin and bow in hand, to fight the dragon of prejudice.[322]

That Helen Radnor achieved a 'fairly well-filled hall' demonstrated the success of the ladies' orchestra. By 1887 the orchestra was reported in the *Monthly Musical Record* as having 'eighteen first, eighteen second violins, nine violas, nine violoncelli, and three double-basses, in addition to a female chorus of nearly sixty voices'.[323]

Helen Radnor proved an inspirational example to female musicians of the era because her career flourished after she was married and her orchestra was favourably compared with those of her male counterparts. Her professionalism was described in a report of one of her concerts in the *Monthly Musical Record*:

> ... such precision, correct intonation, demarcation of light and shade, piquancy, and *entrain*, have seldom if ever characterised any other instrumental amateur performance, male or female, and rarely been surpassed, as far as the chorus is concerned, in a London concert room. That a considerable share of such exceptional success is due to her devotion to the cause, energy, and excellent conductorship, in thorough sympathy with the intelligent forces under her sway, is a matter of course. It was a pleasure to watch the readiness with which the slightest indication of the *bâton* was followed.[324]

Helen Radnor's final public concert in England was at the Double Cube Room in Wilton on 2 May 1900. Her obituary in *The Times* on 12 September 1929 stated that she

> ... had done much to help in the foundation of the Royal College of Music, and her band gave its first concert in aid of the college at Stafford House in 1881, when £1,000 was obtained. Fifteen annual concerts were given by the band under her conductorship at the old St. James's Hall and elsewhere in London, and also in the provinces, much to the benefit of various good causes, particularly the People's Entertainment Society, in which she took a keen interest.

Notwithstanding the influence of the New Woman, the effect of female orchestras such as Lady Radnor's on both the public and musicians had been to associate chamber music with both femininity and ability. By the end of Queen Victoria's reign, articles such as this one in *Etude* magazine gave favourable reports:

> It may come as a surprise to those who associate woman and the violin with the 'innovation' of quite recent years (...) a century ago violin playing was hardly considered an 'elegant' accomplishment for any young lady. Indeed, most parents had very decided views on this question, and they did everything in their power to discourage, rather than encourage their daughters in a field of art which seemed to them to promise only social degradation. The ignominy attached to the ancient usage of 'fiddler' had not yet entirely lost its force. It was surely bad enough for a man to be a fiddler; but the mere thought of a refined genteel woman playing the violin, either in private or in public, was, indeed, intolerable. Nowadays all this is changed. Narrow prejudices of earlier days have given place to common-sense appreciation.[325]

Although the Royal Academy of Music did allow female students, they were excluded from organisations such as the Royal Society of Musicians. To counter this, mezzosoprano Elizabeth Masson – who had been refused membership – founded the Royal Society of Female Musicians in 1839. Over the next twenty-five years this society was

able to further the careers of women musicians, thanks to a series of benefit concerts, public contributions and a higher level of debate about women's roles and rights. The success of this campaign led to a merger with the Royal Society of Music, and women were allowed to become members from 1866.

Florence Marshall studied at the Royal Academy of Music in the early 1870s and subsequently at Trinity College. Like Helen Radnor, her musical career started in earnest following her marriage. She became headmistress at Dulwich High School in London and performed in chamber concerts that helped to raise her profile. She was also active as a pianist and composer, having several operettas, orchestral works and chamber music published by Novello, Ewer & Co. But whilst Lady Radnor conducted a female orchestra, Florence Marshall founded the mixed amateur and professional South Hampstead Orchestra in 1886, proving that a woman conductor did indeed have the skill and competency to direct a mixed orchestra. Indeed, *The Times* reported in June 1899 on the outstanding musicianship of the 'excellent band' she conducted at a concert in St James's Hall, commenting on her 'remarkable skill as a conductor, which is sufficiently well known to cultivated musicians; not only does she establish the magic rapport with her orchestra without which the most intelligent musician must fail, but she has the fine taste and musicianship which is lacking in so many of the virtuosi of the conducting stick'.[326]

By the turn of the century, the South Hampstead Orchestra had Florence Marshall to thank for its reputation as a notable London symphony orchestra. Her obituary:

When she began this work the fact of a woman conducting a full orchestra at all was sufficiently unusual to excite remark, but Mrs Marshall was the last person to wish to found a reputation on the sex qualification. She was a genuine musician who knew what was good and was determined to give it in the best possible way. Musicians were attracted to her concerts because they found there, played with intelligence and care, works which were often passed over by the more commercial institutions. In particular Mrs. Marshall gave some notable performances of the symphonies of Brahms at a time when they were not considered to be the popular attractions they are to-day. She secured the cooperation of the most eminent solo artists, such as Kreisler and

Casals, and their performances of concertos with her, who so well understood the art of orchestral accompaniment, will long be remembered.[327]

As a result of the work of both Helen Radnor and Florence Marshall, the first professional female orchestra, which was founded and conducted by 'first-rate all-round musician and [a] most capable conductor' Rosabel Watson, gained prominence. Florence Fidler wrote in *Etude* magazine just after the end of the Victorian era:

Enough has been said, perhaps, to show that, as far as the orchestra goes, we English women musicians of the rank and file are far ahead of those of any other country. We have not reached our goal till we are admitted to the very best orchestras on an equal footing with men, but that end will assuredly be gained before the century becomes much older.[328]

She was not wrong. In 1913, the first women at last played in a major professional mixed orchestra when the Queen's Hall Orchestra in London recruited six female violinists.

Music had been one of the methods employed by middle- and upper-class families to differentiate themselves from the working class. Refined young ladies would be encouraged to play the piano and sing as this was how they exhibited both their accomplishments and their social standing, which was a significant asset in the marriage market. This also conformed to the contemporary ideals of female modesty as they would be seen as controlled and calm. However, women did make careers out of their piano skills.

Lucy Anderson, from a musical family in Bath, became one of the most eminent Victorian piano teachers, tutoring Queen Victoria and her children. She was appointed pianist to Queen Victoria, and was the first female pianist to perform for the Royal Philharmonic Society. An enthusiast of Beethoven, she was also the first pianist to play Beethoven's Emperor Concerto with the Royal Philharmonic. Her performances of Beethoven's concertos became legendary and she was awarded an honorary membership of the society. Tutoring the royal family naturally brought Lucy Anderson a positive reputation, and she was able to attract the very best students including Arabella Goddard, who became the most important British female concert

artist of the late nineteenth century, dubbed 'Queen of Pianists' by *The New York Times*. Lucy's example paved the way for British female pianists, setting the standard that many future generations of women would follow.

Arabella Goddard had studied piano with both Lucy Anderson and Sigismond Thalberg, becoming part of a Grand National Concert at Her Majesty's Theatre in 1850, which led to her formal debut in 1853 playing works by Beethoven. She memorised many of her recitals and was a favourite of the Philharmonic Society's Monday Popular Concerts. Throughout the late 1850s she introduced the Beethoven piano sonatas to new audiences, and following receipt of the Gold Medal of the Royal Philharmonic Society in 1871 she embarked on a three-year world tour, taking in the United States, Canada, Australia, New Zealand, India, Shanghai, Hong Kong, Singapore and Java. She also composed several original piano pieces, including six waltzes, and retired from performing in 1880. But this was only the beginning of a new career.

When the Royal College of Music was opened by the Prince of Wales in 1883, Arabella Goddard was appointed to a teaching role, possibly the first female piano teacher to be appointed to a conservatoire in its first year of operation. Notably, Jenny Lind was also appointed to teach singing. From this point we can trace the professionalisation of teaching piano. Less than a decade later, Emma Ritter-Bondy was appointed the first professor of piano at the Glasgow Athenaeum School of Music – the first female professor in a higher education establishment in the United Kingdom.

Consequently, female students flocked to English conservatoires in the last decades of Queen Victoria's reign to study singing, piano or violin. But the question was, where were the opportunities for professional women musicians once they had completed their training? They had achieved recognition for their abilities and their talent was not in doubt, but by now there were so many successful students being turned out that they could not all forge a successful musical career, as this end-of-century article by two professional female conductors describes:

Ten years or so ago gifted students on finishing their musical education would become professional singers or instrumentalists, and find a very lucrative and happy career awaiting them. But now that the various academies are sending out each year such

vast numbers of highly qualified musicians the question of adopting music as a profession has become a serious one. It seems as if, in spite of the growth of suburban musical societies, which generally need professional help on occasion, there are more artistes than engagements ... There is certainly no opening whatever for either solo pianists or violinists; the supply already immensely outruns the demand.[329]

Meanwhile Mary Wakefield, who came from a wealthy Quaker banking family, was busy organising and training a number of choirs in the county of Westmorland. A talented singer and musician, she developed the idea of a singing contest in which several choirs would compete to raise money for the church. The first competition took place in 1885. These competitions eventually developed into a full-scale festival and, as Wakefield had hoped, inspired similar events nationally. Such exposure enabled her to widen the appeal of music as part of the nation's social fabric, for if 'music as a serious art is ever to be appreciated and understood as it is in Germany, the formation of an educated, enlightened public is the first requisite'.[330] From here, Wakefield – supported by John Ruskin – had a platform to develop choral musical performances by other women as well as mixed choirs, performing works by Coleridge-Taylor, Sibelius and Somervell alongside her work in the suffrage movement.

Female Friendships

As well as challenging norms through infiltrating male-dominated professions, women often chose not to marry but to find fulfilment in female friendships instead:

> The Victorian gender system, however strict its constraints, provided women latitude through female friendships, giving them room to roam without radically changing the normative rules governing gender difference.[331]

Female friendships were central to the lives of Victorian women, seen varyingly as a precursor to and a preparation for marriage, and often as an alternative. As we have seen, many women stayed single for a variety of reasons which included personal choice and the shortage of marriageable men. The 1851 census had shown a population

disproportion of half a million 'surplus' unmarried women and gave rise to the 'Woman Question'. These women needed to work to earn a living, but the networks of professional associations and clubs available to men were not initially open to them. Friendships therefore held increased importance for many women.

There were also many unhappily married women still expected to devote themselves to their husband and family, placing those interests above their own and supporting their husband's career – a win-win situation for men. It was practically unheard of for men to manage the household or care for the children, which left them free to pursue their business, social and networking interests. A Victorian husband's business activities would not clash with or constrict his ability to interact and socialise, yet his wife would be prevented from her own social life by convention, ideas of modesty and societal pressure.

Of course, many women were happy to be wives, mothers and homemakers and sought little else, but for others this way of life could be constricting and devoid of emotional connections. Many women developed close, socially acceptable friendships that were consistent with the norms of society as they did not challenge or threaten the domestic 'ideal'. It may also have been thought that socialising between married women in this way would enable them to reinforce their commitment to subservience and domesticity. Feminine virtues would be nurtured and cultivated, enabling women to be even better wives and mothers by spending their social time talking about such topics as childrearing, homemaking and sewing; furthermore, where younger women were included it provided an early opportunity to impress upon them the importance of a domestically focused environment. This notion is summed up by Sarah Stickney Ellis:

> Thus while her sympathy and her tenderness for a chosen few is strengthened by the bond of friendship into which she has entered, though her confidence is still confined to them, a measure of the same sympathy and tenderness is extended to the whole sisterhood of her sex, until, in reality, she becomes what woman must ever be – in her noblest, purest, holiest character – the friend of woman.[332]

This appears to suggest that close bonding with other women is an opportunity to achieve the highest levels of submissive femininity in

order to relate to men in the accepted fashion, rather than to advocate female emancipation.

In one way, however, not all women were defined in relation to men and formed independent relationships with one another. Female friendship groups and relationships not only provided opportunities to socialise, they gave women meaning to their lives, space to discuss their feelings on the marriage contract, find support and solace in times of difficulty and partake in intellectual pursuits which enabled them to imagine a more emancipated future for themselves. As more middle and upper-class women took their places in society through charitable work, they began to transgress sphere boundaries, enabling the feminist movement to gain momentum. Women were thus able to encourage and mentor each other by cultivating ambition, independence and aspirations.

At this time women were working relentlessly to obtain equality in marriage, law, employment and education. Solidarity and friendship between women was crucial to achieving these aims and can be seen clearly in the network of groups and organisations such as the Victoria Press. In fact, the relentless battle for equality often strengthened the sisterhood: 'Women with ambition to make a name for themselves looked for kindred spirits to appreciate their achievements and sympathise with them for the coldness with which the world greeted their efforts.'[333]

Constance Maynard studied at the Slade School of Fine Art and was one of the founders of all-female Westfield College, where she became principal in 1882. As recorded in her autobiography and journals, she often found her work to be alienating and stressful, relying on friendships with other women for support and positivity (she had turned down an offer of marriage to concentrate on her career). From her own experience she recognised that this may prove the case for other professional women and therefore initiated a unique form of 'correspondence circle' amongst alumnae, creating a solid female community and group identity to share both personal and college news. As she explains in a letter to alumnae in the summer of 1887:

How many of you would like to join a Correspondence Society? I have no name for it but the thing I understand very clearly, and I for one want to belong to it. There is quite a long list of you now out in the world ... Now and then, especially when any

change takes place, we want to have a little picture of what you are saying and doing and experiencing and striving after![334]

The way this worked was for Maynard to create a list of alumnae and write a letter to the first person along with a copy of the list. After reading it, the recipient would then write to the next person, sending the original letter and so forth, until the final recipient sent the whole batch back to Westfield. Later, these would be shared with more alumnae who in this way learned about the history of the college and the lives of the women who preceded them, fostering a learning community and a network of professional contacts where all correspondents related to each other as equals.

Emily Faithfull of the Society for Promoting the Employment of Women and the Victoria Press gave a lecture, 'Woman's Needs', at Steinway Hall in New York in April 1873, in which she stated:

True marriage is the crown and glory of a woman's life; but it must be founded on love, and not on the desire of a home or of support, while nothing can be more deplorable, debasing, and corrupting than the loveless marriages brought about in our upper society by a craving ambition and a longing for a good settlement. Loveless marriages and a different standard of morality for men and women are the curses of modern society.

By way of women's alliances and friendships, which were often as a result of, or closely bound up with, independent work outside the domestic sphere, Victorian women were able to navigate and break through prescribed gender roles. Emily Faithfull became an advocate for women's education and employment, founding the Victoria Press. She was also a friend and close confidante of Helen Codrington, subsequently becoming embroiled in her divorce case in 1864:

... while Admiral Codrington was doing his duty to his Sovereign and his country in the Crimea, he was obliged to leave his wife alone in this country, but he made arrangements for her comfort, and at her desire a lady whom she had selected became her companion during his absence. That lady was Miss Emily Faithfull, of the Victoria Press ...[335]

The story of the Codrington divorce is fictionalised in Emma Donoghue's *The Sealed Letter*, where the two women are portrayed as opposites. Helen Codrington was easily able to manipulate Emily for her own ends, and with Emily's friendship circle being solely contained within the Langham Place group, she naively became drawn in. The clear difference between Helen and Emily is that whilst Helen embraced the private sphere for all that she clearly found it restrictive, limiting and full of trivialities, Emily chose to belong to the public sphere against all prescribed gender-based customs, working towards a more egalitarian future for women. Women such as Helen often found it difficult to fill their days with meaningful activities. As we have seen, Helen was accused of adultery 'with David Anderson and divers other persons'. Many women were dissatisfied with the lack of emotional support in their marriages and relied on the sisterhood to meet these needs. Harry Codrington chose to interpret his wife's relationship with Emily as beyond platonic:

> From time to time Mrs Codrington had proposed that she should sleep with Miss Faithfull, stating that she was subject to asthmas, and in the spring of 1857 she positively and absolutely declined again to enter the same bed with the Admiral, and she insisted on having a separate bed and sleeping with Miss Faithfull.[336]

It is of course entirely possible that Helen exploited Emily's friendship to fulfil her own emotional needs within an increasingly dispassionate marriage.

Friendships between Victorian women often highlighted the differences between the public and private spheres and undeniably some of these did embrace same-sex desire, and women did live together in long-term domestic partnerships akin to marriage. Sophia Jex-Blake lived with her biographer, Margaret Todd, although this was never overtly acknowledged either in the biography or in reviews of the work. Her relationship with Octavia Hill was also not acknowledged, even though same-sex relationships between women were not illegal. However, Frances Power Cobbe made several references to her relationship with the sculptor Mary Lloyd and the house they shared in her autobiography;[337] she also referred to her as 'wife' in correspondence. Of course, because women – virtuous

ones at any rate – were considered to be uninterested in sex, the idea that they would partake in an activity that did not involve a man to whom they were married and did not result in childbirth was largely unimaginable.

Relationships like the one between Frances Power Cobbe and Mary Lloyd were de facto marriages that embraced equality and provided a template for the heterosexual model of marriage that female activists were seeking to create through legal reform. The balance of power in a true friendship was equal, and they felt that this reciprocal relationship should be the basis of marriage. Additionally, promoting a positive and satisfying model of single life for women would cease to make marriage an essential requirement, as seen in the latter part of the century with the emergence of the independent New Woman. This, of course, meant that men would be marrying an entirely different breed of woman.

Sixteen-year-old Elizabeth Lee, from Birkenhead in Merseyside, kept a diary between the years of 1884 and 1892. Her entries reveal how the emergence of the New Woman created conditions for younger women to socialise and construct their own identity:

> Went to L'pool. Had tea at the Shop, and then we had a dance up
> in our ballroom to show some of the fellows how to dance. The
> 2 Heathcocks[338] came. We had such fun. So tired.[339]

Her entries are of particular interest because they give us a glimpse into life for a young, single, suburban middle-class New Woman. A considered study of her journals shows that her interests, style of writing, friendships and choice of fashion were modern and fresh and jarred with convention. She had plenty of time for socialising and visiting her friends; her family did not pressure her to help around the home or bring up her younger siblings. She pursued her social life mainly outside the house, and this provides an illustration of how at last female friendships were beginning to extend beyond the domestic realm as Elizabeth often prioritised her friendships above her family.

It was also very common for Victorian women to participate in platonic same-sex friendships that were somewhat emotionally charged, frequently featuring impassioned correspondence, locks of hair as keepsakes and the creation of friendship albums. This was

often thought of as an opportunity to cultivate femininity and a practice ground for marriage.

Writer Eliza Lynn Linton became the first salaried female journalist in 1849 when she joined the newspaper *The Morning Chronicle* but was surprisingly anti-feminist and critical of the nature of friendship between women, arguing that they were more often than not antagonistic towards each other and 'would confess to a radical contempt for each other's intellect'.[340]

But as friendship for friendship's sake, Emily Faithfull thought that there was 'more sympathy, and therefore more true tenderness ... more gentle charity [and] ... a much greater capability in a woman of friendship with another woman than with a man'. Faithfull seems to be saying that one of the hallmarks of female friendships was equality, which could not be achieved within a marriage unless the husband also provided affection and companionship, which was rare. Frances Power Cobbe seems to agree with her:

> If she have no sister, she has yet inherited the blessed power of a woman to make true friendships, such as not one man's heart in a hundred can ever imagine; and while he smiles scornfully at the idea of friendship meaning anything beyond acquaintance at a club or the intimacy of a barrack, she enjoys one of the purest of pleasures and the most unselfish of all affections.[341]

Gender-separate societal structure and the consequent norms would mean that any close bonding or emotionally dependent friendship could, for propriety's sake, only be with another woman. Through gender-role differentiation, society encouraged this, even if inadvertently. Friendships between members of the opposite sex would have been virtually impossible as they were encouraged to only converse with one another in the context of future marriage contracts rather than pure friendship.

Sharon Marcus helpfully explains the key difference between female friendships and relationships between men and women: 'Friendship provided a realm where women exercised an authority, agency, wilfulness, and caprice for which they would have been censured in the universe of male-female relations.'[342]

The label 'friend' was often used to cover both sexual and non-sexual intimacies between women. Consider Christina Rossetti's

poem 'Goblin Market', in which best friends Laura and Lizzie share a bed:

> Golden head by golden head,
> Like two pigeons in one nest
> Folded in each other's wings,
> They lay down in their curtain'd bed...[343]

The depiction of them as close friends allows them to be involved in an affectionate and intimate relationship that is presented to the reader in a socially acceptable style. For example, it was quite common for women to greet one another with a kiss on the lips that could be either a romantic declaration or a social greeting. The term 'love' was used by many women in correspondence and conversation to develop a close bond with other women, whilst being used as a term of friendship and not necessarily signifying attraction.

Born a year and a day apart, Charlotte Brontë and Ellen Nussey met at Roe Head School and were close friends for almost a quarter of a century until Charlotte's death. Charlotte describes her enduring relationship with Ellen in a letter to her publisher:

> Friendship, however, is a plant which cannot be forced. True friendship is no gourd, springing in a night and withering in a day. When first I saw Ellen I did not care for her; we were school fellows. In course of time we learned each other's faults and good points. We were contrasts still we suited. Affection was first a germ, then a sapling, then a strong tree. Now, no new friend, however lofty or profound in intellect not even Miss Martineau herself could be to me what Ellen is: yet she is no more than a conscientious, observant, calm, well-bred Yorkshire girl. She is without romance.[344]

This exchange of correspondence allowed the women to confide their secrets and concerns. Charlotte confessed to Ellen her anxieties surrounding her role as a governess and her longing to become a published author. Elaine Miller explains how the strength of their relationship transcended Ellen's perceived rejection upon Charlotte's marriage; she had hoped that she and Charlotte would live together,

although they became estranged for a year when Charlotte became engaged to Arthur Bell Nicholls.

In fact, female friendship was often an ingredient in a successful marriage rather than in conflict with it.[345] Charlotte and Ellen's letters[346] show a lively exchange of opinions on such subjects as careers, writing, finances, marriage and women's rights. Victorian women were supposed to be passive around men, but in the company of their female friends they were able to display an agency and expression that was otherwise not an option for them. It seems entirely plausible too that married women would rarely be able to have such conversations with their husbands, and these friendships were a fundamental source of emotional satisfaction and intellectual stimulation for single and married women alike. But some women were open to exploitation. Consequently, Emily Faithfull's involvement in the Codrington divorce case 'proved very damaging to her reputation' within the Langham Place Group; Adelaide Procter ended her friendship with Emily in 1862 and Bessie Rayner Parkes withdrew her contract to publish *The English Woman's Journal* in December 1863, before the divorce case came to court.[347]

And how did Victorian novels treat female friendships? Sharon Marcus reflects that 'in Victorian fiction, it is only the woman who has no bosom friend who risks becoming, like Lucy Snowe,[348] one whom no man will ever clasp to his heart in marriage, a friendless woman who remains perpetually outside the bosom of the family'. Novelists, then, endorsed the view that strong female friendships anticipated the relationship a woman would ultimately have with her husband. The Victorian characters with close women friends or a female support network are those who become happily married: Esther in *Bleak House*, Jane in *Jane Eyre*, Dorothea in *Middlemarch*. But like Lucy Snowe, Cathy Earnshaw in *Wuthering Heights* and Becky Sharp in *Vanity Fair* both fail to find marital bliss; is their lack of female bonding a significant factor? The friendships between women depicted in these novels all contain characteristics of positive feminine qualities: compassion, altruism, constancy, kindness; this leads the characters to develop a strong sense of self and gives them the confidence to question the ways that women are confined by societal expectations.

Frances Power Cobbe provides a decisive observation on models of friendship for women. She imagines a society where girls are

encouraged to think that marriage is not the only relationship in which women's emotional needs can be met:

> There are, I suppose, some women (rather perhaps of the clinging order) whose natures could never find their complement or be quite satisfied, except in Marriage, and for these I can only wish – a good husband! But if I am not mistaken, there are a considerable number who are capable of being quite as completely satisfied by Friendship; and not a few whose dispositions are such that they are better suited for Friendship than for Marriage ... who do not need to lean but to clasp hands along the journey of life. More and more, I expect, as time goes on, women who have not the blessing of sisters who can live with them, will form these lifelong sisterly friendships with other women; and find in them the affection and the comradeship which will fill their hearts and cheer all their later years.[349]

She asserted that friendship is not a substitute for marriage, something that the 'surplus females' are resigned to, but a positive, independent choice. Relationships between women would, she hoped, reflect strong female identity and consist of 'friendships founded on the community of noble and disinterested aims', nurturing women's strengths rather than their dependency.

5

INJUSTICES FACED AND BREAKING THE BARRIERS

Following the end of the Industrial Revolution the British professional population expanded enormously. Industrial development and imperial expansion resulted in a growth in the civil engineering, educational, legal and medical professions as well as banking and accountancy. With the growth of the British Empire, bodies and societies set up to represent and advocate for members of these professions were therefore tied up with nation-building at a time of innovation and professionalisation.

In Victorian Britain, the idea of women entering male-dominated professions was considered absurd. Consequently they found themselves marginalised, isolated and excluded from professional societies and organisations. Women's entry into the professions coincided with the growth of feminism; towards the turn of the century, networks of educated and professional women became the foundation of an organised suffrage campaign. It is fair to say that women's occupational choices often shaped their feminist beliefs, and the suffrage movement in turn provided the experiences and networks from which women could advance their professional positions. Accordingly, they would see no reason why they should not be able to join the related professional organisations to develop their careers. As context, women had been admitted to the Zoological Society of London from the date of its incorporation in 1829, and the Royal Entomological Society had also welcomed women members from 1833.

Notwithstanding these early precedents and the development of women's career aspirations, they were precluded from joining many other professional organisations and often had to form their own. With the probable exception of teaching, most women in the professions belonged to middle-class families with their fathers occupying roles such as doctor, lawyer, clergyman or industrial manager, and therefore they provided examples of education – along with the ability to pass exams – speaking for itself. They had neither the inherited wealth nor the social influence of the upper classes behind them, and they had achieved their positions on merit, represented by credentials.[350] Though they were frequently forced to adopt a 'separatist strategy' to organise themselves professionally, these women did not operate in a totally separate female sphere. But they were a small part of a male-dominated professional culture and thus encountered isolation in the workplace.

Although eventual access to higher education for women would theoretically have meant that they were able to seek a career in academia, in practice it was very difficult for them to obtain research funding. Academic postings were achieved gradually; women professors would initially teach in women's colleges at universities or take pro bono posts. For example, when a women's hostel was founded in Cardiff in 1883, the college authorities suggested 'that some Lady interested in the work of Women's Education might be willing to undertake it ... at any rate for the first year or two, without a salary'.[351] Though there were women who did take up paid teaching posts, most were treated differently from men and also marginalised financially.

Mary Paley studied teaching at Newnham College, Cambridge, having been one of the first five women to enter the university. She passed the final Moral Sciences Tripos – intended for men – in 1874 along with fellow student Amy Bulley, but the women were not allowed to graduate. The following year, however, Paley was invited to become Cambridge's first female lecturer when she was offered a residential post to teach economics at Newnham. By then, a further fifteen women students had entered the university and Mary had taken over the teaching of economics from her former lecturer, Alfred Marshall, whom she later married. She also wrote a book to accompany her lectures, which became the basis of *The Economics of Industry*, co-authored with her husband and published in 1879 – but to which he later denied her intellectual property rights.

She later also became the first female lecturer at University College Bristol, teaching there until 1881, but was only paid by having her salary deducted from that of her husband, who was by then the establishment's principal. Mary continued her lecturing career, teaching once again at Newnham when she and her husband moved back to Cambridge, continuing beyond the Edwardian era and remaining a member of the college council. Somewhat disappointingly, Alfred Marshall opposed the proposal to grant women degrees at Cambridge, writing pamphlets arguing against a mixed university. The proposal was rejected in 1897. John Maynard Keynes wrote that their relationship was

an intellectual partnership ... based on profound dependence on the one side (he could not live a day without her) and, on the other, deep devotion and admiration, which was increased and not impaired by extreme discernment ... Neither in Alfred's lifetime nor afterwards did she ever ask, or expect, anything for herself. It was always in the forefront of her thought that she must not be a trouble to anyone.[352]

Mary Paley Marshall continued her connections with Cambridge by membership of the Ladies Dining Society, a discussion club formed by twelve Cambridge women, most of whom were in some way connected with Newnham College. She played a large part in the development of the Marshall Library of Economics in Cambridge and became a volunteer librarian. It appears vastly unjust that she received scant recognition for the work she had undertaken in supporting her husband to write his economics textbooks, and that she did not live to see women eventually graduating from Cambridge. Austin Robinson was scathing in his assessment:

Mary Marshall was enslaved to forty years of self-denying servitude to Alfred: the 'foolometer' by which he measured the popular intelligibility of his writing, the organizer of his materials, the breakwater between himself and the irritations of life ... Why indeed ... did Alfred make a slave of this great woman and not a colleague?[353]

But recognition of Mary's contribution to breaking down prejudice in women's higher education came at last with the conferment

of an honorary doctorate by Bristol University – at the age of seventy-seven.

The very first female professor of a UK higher education institution was appointed in the last decade of Queen Victoria's reign. In 1892, Emma Ritter-Bondy became professor of piano at Glasgow Athenaeum School of Music, now the Royal Conservatoire of Scotland. Although the establishment did not issue degrees at that time, their curriculum content compared equally with contemporary higher education institutions.

There were already female teachers at the school when Emma joined. The principal, Allan Macbeth, had studied at the Leipzig Conservatorium and wished to establish a similar European-influenced institution in Scotland. Serendipitously, this coincided with Emma's decision to leave Europe following the death of her husband. Her elevation to a professorship was a distinct honour that had never been given to a woman before, fortuitously taking place the same year that women were finally permitted to enter Scottish universities. Professor Anna Birch, the Royal Conservatoire of Scotland's research lecturer in drama, agrees that 'Emma was a pioneer and broke the glass ceiling, attesting to the egalitarian and enlightened attitudes of [our] nineteenth century founders. She helped to pave the way for... many strong and successful women.'

Emma was unique in being the only woman to hold a professorship in an entirely male environment, and as such she made it possible for arts education to flourish in the UK, particularly in Scotland, and inspired many future talented women musicians.

As for women scientists, the mere thought of them was considered preposterous in Victorian times. Anthropologist and biologist Thomas Huxley wrote to a geologist friend, Charles Lyell, that 'five-sixths of women will stop in the doll stage of evolution, to be the stronghold of parsonism, the drag on civilisation, the degradation of every important pursuit in which they mix themselves – *intrigues* in politics and *friponnes* in science'.[354]

This view embodies Victorian assumptions that women were physiologically inferior, their brains incapable of handling scientific laboratory procedures, mathematical equations and experiments. Allegations of psychological, physiological and temperamental differences between men and women rendering the latter unsuited to the stress and competition that was a natural part of the professions

was commonplace. Little wonder they were precluded from joining the Royal Society.

Professional bodies were particularly emphatic in keeping women out in the nineteenth century, most notably in the medical profession. Such elite groups had long-established structures, with male power institutionalised within them. By preventing women from gaining access to the universities that could provide them with the credentials for entry into the professions, they entrenched the structures further. But exclusionary practices operated in a more complex way than simply the closing of institutional doors.

Middle-class women attempted to take up space in areas that allowed their participation, such as charity and philanthropic work, which opened up career opportunities as well as access to the women's movement. Another line of thinking was that women professionals would be eagerly sought to offer services to female clients and customers. Catriona Blake, in *The Charge of the Parasols*, likens feminist campaigning for entry to the medical profession to a battlefield on which they finally won following 'determined resistance from the professions as a whole, the extreme misogyny of individual men and a final resolution through legislation, marred by the male professional establishment'.

Separatism became the primary approach to support women into professional roles, societies and wider public society. When Jessie Boucherett read Harriet Martineau's 1859 piece in the *Edinburgh Review*, highlighting the 'surplus' or 'superfluous' women in relation to men in Britain, she was driven to do something. Martineau had written that 'three out of six million adult English-women work for subsistence, and two out of three in independence. With this new condition of affairs, new duties and new views must be accepted.'

Together with colleagues from the Langham Place group, Boucherett set up the Society for Promoting the Employment of Women later in 1859. This society was pioneering in that it provided interest-free loans to women for training and was the first to secure female access to accounting and bookkeeping. Female solidarity was paramount in these aims, and female-run hospitals such as those founded by Sophia Jex-Blake were the beginnings of a professional female network. Professional women methodically launched their own organisations, networks and societies on their own terms which replicated male structures yet had their own unique sense of community. One question

is – were these as institutionalised as the male organisations they had set out to parody and campaign against in the first place? And as more women entered the professions as the Victorian era progressed, was there still a place for single-sex professional bodies? If true equality was achieved, women would be involved with professional, social and political associations with a considerable amount of overlap.

Women were able to exploit the ideology of domesticity to give themselves entry into public life. Closely linked as it was to femininity, domesticity helped to progress middle-class values and identities and allowed women to contribute in a philanthropic capacity. But this naturally led to a demand for opportunities for women's paid work. The women's movement required a balancing act between equality and differences. Complete gender equality and social improvements in women's lives were not always mutually inclusive.

Arguments for women entering the professions focused on their unique contributions. For example, women doctors would have intricate knowledge of the female body and be more acceptable to women patients. Proving their intellectual ability would, it was hoped, naturally open doors to more professions, but as we have seen this was a long and twisting path. Opponents claimed the purely feminine traits of virtue, compassion and propriety would be sacrificed by professional competition with men, as well as distracting women from their true calling as wives and mothers to the detriment of the family unit. However, with a significant 'surplus' of single women, it was clear that not all of these would become wives or mothers for a number of reasons. What was to become of them if they were not allowed to support themselves? Surely women were capable of undertaking professional duties just as well as men? Given the examples set by Sophia Jex-Blake, Elizabeth Garrett Anderson and Elizabeth Blackwell, all of whom had proved their competency by passing examinations, what was to stop them from joining the appropriate professional organisations? Entering these organisations was far from easy but there were women who were determined to try for their own sake and that of future female professionals.

Mary Harris Smith attended bookkeeping classes at Boucherett's society in 1860 before commencing work as a bookkeeper. She 'began as an accountant to a mercantile firm in the City, where I stayed for nine years; and, indeed, I think the happiest and proudest moment of my life was when the chief partner handed every book relating

to the accounts, balance-sheets, etc., entirely over to my charge'.[355] Later appointed accountant to the Royal School of Needlework, Harris Smith was in demand to carry out audits for several other organisations, setting up in public practice in 1887, offering her services as a 'duly qualified ACCOUNTANT and AUDITOR of many years' experience'.[356] As a qualified practitioner, she wanted to join a society that represented auditors and bookkeepers in a professional capacity. The Society of Accountants and Auditors had been founded in 1885, and she started there. She wanted to prove that women could fulfil the role of accountant and auditor just as well as men:

> It was in 1887 that I took offices first, and then it occurred to me why should I not become a member of the Society of Accountants and Auditors Incorporated; and so I somewhat startled that conservative body by appealing to them on my own behalf; and for any ladies who should come after, to join their ranks. I based my request on the grounds of 'Admission equal and status equal with men members.' Require of me what you would require of a man, and I will fulfil it.[357]

Harris Smith's application was considered by the council at a general meeting and whilst some members had no issue, the president, Reginald Emson, was in complete opposition. At the 1888 Society General Meeting, Emson derisively stated that there was a difference of opinion on the council in respect of the question of 'a lady claiming to be a qualified public accountant, and applying for admission to membership',[358] and a motion to admit 'qualified ladies' was withdrawn. In October 1888 Harris Smith wrote to Millicent Garrett Fawcett:

> I cannot make application again until the next general meeting but in the mean time I shall do all I can do as to more firmly establish my claim. My name will be entered professionally in the P.O. Directory for 1889, & a business friend who has office in Royal Bank Buildings has kindly had my name written on his offices so that I may have a City address also if necessary. I think it will help me greatly to have my name announced an auditor on prospectuses of public companies, & I think the Woman's Printing Socy. will be one. I am already auditor to

the Needlewomen's Cooperative Association (Ltd Liability Co). Private accounts, & Receipt, & Expenditure accts will not help me with regard to the Society of Accountants, although of course for other reasons I shall be glad to undertake such. I am hoping eventually to take articled pupils.[359]

Harris Smith campaigned up to 1891. Upon receiving a negative outcome one last time, she decided to attempt membership of the more prestigious Institute of Chartered Accountants in England and Wales (ICEAW). Supplying referees, qualifications and practical experience, she applied to become a fellow of the institute. *The Accountant* magazine ran a piece about 'Lady Accountants' which referred to 'one lady who practises accountancy as a profession, and who ... has achieved a considerable measure of success, having established a connection among the now numerous institutions got up by ladies for the benefit of their sex'.[360]

Harris Smith also wrote to the magazine herself, using the pseudonym 'Fair Play' in which she contrasted competent practising women accountants with female clerks and bookkeepers who were not qualified: 'I think my speciality is in investigating and reporting upon the prospects of various undertakings; planning and remodelling books of accounts so as to save labour, and to ensure a good check system; unravelling neglected accounts and restoring order and good form out of chaos and confusion.' In other words, she could do just as good a job as a man. *The Accountant* commented that the author appeared 'to be universally regarded as a successful practitioner'.[361]

The ICAEW did consider her application and decided to recommend her for admission – dependent upon the organisation's solicitor confirming whether or not 'a lady' was eligible for membership. Their response stated that 'we fear it is not competent for the Council to admit a lady as a Fellow of the Institute. The Charter, which must be construed strictly, refers to males, the words "he" and "his" being invariably used. In June 1850 an Act was passed enacting that in all Acts of Parliament words importing the masculine gender should be deemed and taken to include females, but that enactment was limited expressly to Acts of Parliament, and cannot, we fear, be extended to a Charter granted by Her Majesty.'

It was therefore decided to reject the application, given that 'solicitors state males only eligible' and so exclusion was continued.

Where the word 'person' was mentioned throughout their charter it was ambiguous at that time whether it could be legally interpreted to mean 'her' and 'she'. Charles Fitch Kemp, ICAEW president between 1894 and 1896, reportedly said that 'it would be so embarrassing to manage a staff composed partly of women, that ... [he] would retire from the position rather than contemplate such a position'.[362]

Meanwhile, in 1898, Ethel Charles became the first woman architect to be accepted as a member of the Royal Institute of British Architects (RIBA). Having been excluded from attending the Architectural Association School she became apprenticed to renowned architect Ernest George, who was extremely supportive of encouraging architectural training and took on several apprentice students. On completing her apprenticeship Ethel worked with Walter Cave and passed her RIBA associate membership examinations.

Ethel Charles found herself up against similar hurdles to Mary Harris Smith. Her application to join RIBA along with a reference from Ernest George initially met with a challenge based on the premise that 'it would be prejudicial to the interest of the institute to elect a lady member'. But when put to the vote, she was voted in by fifty-one votes to sixteen. This set a precedent, not least because RIBA's charter was similarly worded to the ICAEW with its references to 'he' and 'his'. *The Woman's Signal* reported on the admission of Ethel Charles in December 1898 in expectation of other professional bodies following suit:

> ... we must congratulate the architects on ... proving their liberality, and on that readiness to meet the competition of the inferior sex which some of the upholders of man's superiority are so strangely unwilling to encounter. Will the Institute of Chartered Accountants not follow this good example, and open their doors to the oft-repeated application of Miss Harris Smith?

Mary Harris Smith continued her attempts to gain membership of the ICAEW up to 1898. She submitted a summary of her accountancy experience and noted, 'It is not my intention to trench on what is considered men's ground, but to establish myself as a competent and qualified Accountant for Women.'[363] This negotiation was predicated on the idea of a gender-differentiated market for professional services but ran the risk of being appropriated by men arguing for exclusion

of women from professional bodies on the basis of them employing separatist strategies. They would therefore be able to claim women were differentiating themselves rather than seeking full equality.

In January 1899, Harris Smith was told that the council 'has no power under the Charter to admit ladies as members'. Though she would have to wait until 1920 to finally be admitted as a fellow of ICEAW, following the Sex Disqualification (Removal) Act of 1919 her persistence had paid off not just for herself but for all women in the profession. Her approach to membership had always been, as she had stated in her *Woman's Signal* article, 'admission equal, and status equal with male members'.

Formed in 1841, the Pharmaceutical Society also validated the first British pharmaceutical qualifications. It founded a School of Pharmacy in London's Bloomsbury Square in 1842 with the aims of 'advancing chemistry and pharmacy and promoting a uniform system of education [for] the protection of those who carry on the business of chemists and druggists'. This included preparation of candidates for examinations, although these did not become compulsory until the Pharmacy Act 1868 became law. Examinations then became the only route to qualification and women were allowed to take the society's Modified examinations and register as qualified pharmacists; the first female to do so was Fanny Deacon in 1869.

The society then promptly withdrew the Modified examinations. The only way to now qualify as a pharmacist was to pass the society's Minor examinations. Alice Vickery became the first woman to do so, in June 1873, also qualifying as a midwife. She then went on to qualify as a doctor and was one of the founders of the Malthusian League, promoting contraception and education in family planning. But registration did not mean that women were able to join the Pharmaceutical Society. The society's president, George Sandford, could not 'help thinking the tendency of the present day is too much towards upsetting that natural and scriptural arrangement of the sexes which has worked tolerably well for four thousand years'.[364]

In March 1873, *The Pharmaceutical Journal* published the following piece of poetic acerbity as a complaint against women's admittance to the society:

I could not bear to see their hands as soft as alabaster
Begrimed all o'er with dirty pill and nasty smelling plaster.

Oh! May I never see them with their chignons in confusion
Attempt to shake the tinctures or prepare the cold infusion.
How could they climb the shaky steps to clean the bottles dusty
Or go below amongst the wets into the cellar musty?
Their sleek round arms were never made to work the iron mortar
But some opine they might assist to cut the salary shorter.

The University of Edinburgh had closed its lectures to women in 1872, just as the Pharmaceutical Society was opening its examinations to them. Men who successfully passed the society's examinations were invited to apply for membership but this privilege was denied to those women who had achieved the same examination successes. Several women had passed the Preliminary, Minor and Major series of examinations and applied for membership on several occasions, only to be repeatedly refused. One of these was Isabella Clarke.

Upon qualification in 1875, Clarke opened a pharmacy in Paddington and registered as a pharmaceutical chemist. Rose Minshull and Louisa Stammwitz were two other registered chemists who also had their membership applications turned down. Women pharmacists now had to fight to get their voices heard, and they were fortunate in that many male members of the council were sympathetic to their cause. One such supporter, Robert Hampson, campaigned for the admittance of women to the Pharmaceutical Society's school and then to have those who had passed its examinations admitted to the society's membership as soon as he was elected to the council in 1872. Alongside Elizabeth Garrett Anderson and members of the Society for the Promotion of Employment for Women, Hampson was a keen supporter of equal rights for women within the profession.

Letters continued to be sent to *The Pharmaceutical Journal* outlining why women should not be admitted to the profession, such as this one from a Charles Fryer in 1877 emphasising their supposed unsuitability: 'There is a considerable amount of drudgery connected with it, which must be repugnant to ladies, and which I should seriously be disposed to think their constitution would not be adapted to endure ... there are many cases brought to the notice of an ordinary chemist which would be exceedingly undesirable to bring [women] in contact with.'[365]

But women pharmacists had proven themselves to be capable. Rose Minshull had beaten 166 entrants to achieve the highest marks in her

1873 Preliminary Examination, a feat she repeated in her 1877 Minor Examination. Both women went on to take the Major Examination, the highest level examination offered, at which Isabella Clarke came fourth out of thirty-nine entrants, with only twenty-three of those candidates passing the examination at all.

In 1878 the society approved a motion, carried by just two votes, that it was inappropriate for women to be admitted to membership. The following year, however, the society's council finally and reluctantly agreed that Isabella Clarke and Rose Minshull, both of whom had worked with Garrett Anderson at her St Mary's Dispensary for Women and Children in Marylebone as part of their requisite three years' experience, could become members.

Yet, rather than because of any belief in equal rights for women or acknowledgement of their proven ability through exam results, the decision to allow female membership was more likely driven by the need to inhibit confrontation and curtail further debate. Still, pharmacists did become one of the first groups to accept women into their professional bodies, and in the midst of the campaigning by women to gain entry to other male-dominated areas, in particular medicine and higher education, it has to be seen as a success. It took ten years from the inception of the Pharmacy Act of 1868 before equal status for women pharmacists would be established. At that time, Robert Hampson declared that 'it was part of the executive duty of the Council to elect all eligible persons, irrespective of their sex. It would be as reasonable to ask what church they attended as to inquire as to the sex of eligible persons who applied for admission.'

By 1901, the Pharmaceutical Society named over 15,000 pharmacists on its registers with 1 per cent of these being female, putting the society in front of other professions for granting equal membership rights to all its members. In 1905, the 195 female pharmacists on the register represented 1.2 per cent of the total.

And what of Isabella Clarke? She became the first president of the Association for Women Pharmacists, founded shortly after the end of Victoria's reign. Using her professional knowledge and experience of the Pharmaceutical Society, alongside a group of fellow women pharmacists she set up a professional body for women, run by women, to promote and improve opportunities and conditions of employment for all female pharmacists. Rose Minshull became a dispenser at the North Eastern Hospital for Children in London.

Women were determinedly making their way into a state-regulated, male-dominated profession.

However, it took a forty-year campaign for women to be accepted into the Institute of Chemistry of Great Britain, which eventually merged into the Royal Society of Chemistry. The 1870 Surgeons' Hall riot in Edinburgh had been instigated by male chemistry students – along with a chemistry professor – to prevent women from sitting examinations which would give them entry to medical school. But not all male chemists were opposed to women joining the society; rather like Robert Hampson in his support of female pharmacists, Augustus Vernon Harcourt championed the admission of women to the Institute of Chemistry. The institute had been founded in 1877, with an entrance examination being the prerequisite for membership – and it was open to men only.

Harcourt, who was one of the founding members of Somerville College, Oxford and had secured mixed chemistry classes there, put forward a motion in 1880 to include women in the institute regulations alongside men, but this first attempt was overruled. A similar motion was instigated in 1888 by the future Nobel prize-winning chemist William Ramsay, but when it became apparent that it would be refused he withdrew the motion. The council had, around the same time, recorded in official minutes that women were not permitted to become institute members.

But then, Emily Jane Lloyd, who had achieved a BSc in chemistry from the University of London in 1892, became the first female associate member of the Royal Institute of Chemistry – somewhat accidentally. She had passed the examination with the committee being unaware that she was a woman, entering simply as E. Lloyd. Having passed, the institute was forced to allow admittance not only to Lloyd but to subsequent female entrants. Emily Lloyd also succeeded in sitting a public analyst's examination with the institute, again almost by stealth as the council had not considered that women would wish to take this route and so had put no amendment in place to bar them. Ramsay saw an opportunity here for all qualified female chemists to be granted fellowship of the Chemical Society, and his colleague and later biographer William Tilden supported this by seconding the motion, which again was defeated.

Nevertheless Lloyd had opened up the door for subsequent women chemists and in 1893, Rose Stern became the first female student

member of the Institute of Chemistry, a year before she too completed her BSc in chemistry at the University of London. A year later the Institute of Chemistry had its first woman fellow in Lucy Boole, elected to fellowship on the strength of her years of pharmacy research, lecturing and demonstrating work at the London School of Medicine for Women.

Changes were happening, though slowly. Women were not admitted to membership of the Chemical Society until 1920 after tireless campaigning and support from Tilden and Ramsay, who realised the potential and professionalism of the women chemists they worked with, supervised and treated as equals.

After ten arduous years of study to become qualified as a doctor following rejections from numerous medical schools, Elizabeth Garrett Anderson was keen to secure professional status not only for herself but for the female doctors who would follow her. She felt that institutional and cultural change was necessary for women to be accepted as doctors and this meant professional recognition as well as the requisite qualifications. After obtaining her medical degree in Paris in 1870, Anderson applied for membership of the British Medical Association. Sponsored by two of her physician colleagues at the Middlesex Hospital and St Mary's Hospital, she was accepted as a member in 1873. At that time, the rules and regulations of the association did not preclude female members because it was assumed that all medical practitioners were male. Two years later, however, she was set to read a paper on obstetrics at the BMA meeting in Edinburgh. This was a success, but feelings were stirred amongst the male contingent about women practising medicine, leading to a referendum on whether women should indeed be elected to the BMA. Although Anderson's membership was ruled to be legal on the grounds that she was a registered doctor, the only other female member, Frances Hoggan, was not on the medical register and was eventually expelled. It is revealing that the hundred unregistered male members were nevertheless re-elected.

Dr Wilson Fox requested a change in the constitution of the association to prohibit women from joining to maintain 'the rules of propriety and delicacy ... between the sexes',[366] and in February 1878 the 'two lady members' were asked to 'respect that voice and retire from the Society which had declared that their presence was unacceptable'.[367] At the annual meeting later that year, Anderson

sought to clarify the true purposes of the association alongside stating the key argument for the equality of female doctors:

> We have heard a good deal of this Association being described as a 'club', a club for social purposes, and so on. But this is not what it states itself to be in its Articles of Association. There we see that the object or purpose of the Association is twofold: 1. The promotion of medical science; and 2. The promotion of the interests of the profession. With regard to the first of these objects, no one can venture to say that medical science will be promoted by excluding from the Association a body of honest and painstaking workers, who will bring to the study of many important problems some experience of their own essentially different from that of male practitioners.[368]

The argument continued over several more years, with Anderson using the line of reasoning that since women could now sit examinations, qualify and practise as doctors they should be regulated by professional codes and agreements in the same way as men by 'keeping true to its largest purposes, which in our case are the promotion of science and the promotion of fellowship'.[369]

Meanwhile, in May 1879, the Association of Registered Medical Women was formed in response to the BMA's stance to speak on behalf of all medical women and represent their interests. Women doctors were denied membership of the organisation allied to their profession, but as ambassadors of change they developed their own. There were fourteen women doctors on the medical register by 1879, although only nine formed the ARMW's core membership; Frances Hoggan refused because only fully registered women were eligible. It was said that the 'convivial atmosphere at branch meetings encouraged socializing [sic], thereby helping to foster an ethos of sympathetic "sisterhood" among medical women'.[370] Whilst the association had been established to both counter the sense of isolation felt by female doctors and provide professionalisation and integration, it was also a regulatory mechanism. Women who joined the medical register were expected to join the ARMW in accordance with professional ethics.

The ARMW would eventually develop into the Medical Women's Federation by the time of the First World War. However, in 1878 there were only eight practising women doctors. This quickly changed, and

by 1892 there were 135 practising women doctors. This in itself was a compelling argument for their acceptance into the British Medical Association, and led to a motion to remove the barriers to their inclusion at an extraordinary general meeting of that year. This was seconded by Anderson, who emphasised the need for cohesion rather than division within the medical profession. The membership 'needed no convincing of the justness of her demands ... she had already by her professional and public life done this very thoroughly',[371] and the resolution was carried by 297 votes to four in favour of women's admission to the BMA.

In 1896 Anderson was elected as president of the East Anglian branch of the British Medical Association. A *Lancet* article of 1861 reflects her perseverance and commitment:

> A lady has penetrated to the core of our hospital system, and is determined to effect a permanent lodgment. The advanced guard of the Amazonian army which has so often threatened our ranks, on paper, has already carried the outposts and entered the camp.

As women were seeking equality – in voting, education, employment and wages – men continued to feel their prerogative threatened. When the resolution to admit women to the BMA was carried, one of the speakers, a Mr Brown, was heard to suggest that they 'let them see what women could do. He felt sure that they could not do much harm.'[372]

Women were not going to be silenced now they had got into their groove, but the male scientist was in a prime position to counter-attack the feminist movement. Women were considered to be intellectually inferior to men and highly emotional, and this line of reasoning was extended to claim that women were incapable of abstract thought and unsuited to decision-making in general. Physicians affirmed the idea that the female body was inferior to that of the male; they had smaller brains, which were naturally less capable, and expending mental energy on rational thought or problem-solving was thought to exhaust the blood supply, leaving little to nourish their reproductive capacities: 'Maternal functions diverted nearly 20% of women's vital energies from potential brain activity.'[373]

Charles Darwin – thought of as the greatest biologist in history – wrote in this vein to American scientist and women's activist Caroline Kennard in January 1882:

I certainly think that women though generally superior to men [in] moral qualities are inferior intellectually; & there seems to me to be a great difficulty from the laws of inheritance, (if I understand these laws rightly) in their becoming the intellectual equals of man. On the other hand there is some reason to believe that aboriginally (& to the present day in the case of Savages) men & women were equal in this respect, & this wd. greatly favour their recovering this equality. But to do this, as I believe, women must become as regular 'bread-winners' as are men; & we may suspect that the early education of our children, not to mention the happiness of our homes, would in this case greatly suffer.

I have written this letter without any care of style, as it is intended only for your private use.[374]

The incongruity of this viewpoint is exposed by studying the women with whom Darwin kept professional company, including writer and social reformer Josephine Butler, scientist Lydia Becker and female medical pioneer Elizabeth Garrett Anderson. Philippa Fawcett, for one, was a brilliant mathematician from an intellectual family who scored top marks in the 1890 Cambridge Tripos, beating every other candidate – the majority of whom were men. Her achievement shocked male academics, made the international press, bolstered the argument that women should have the vote and made Darwin's claims look foolish. How could he not view the women he associated with as intelligent, capable and strong minded?

It is true that the majority of women of this time were not achieving as highly as men – for the simple reason that they had so far been given very limited opportunity to prove their ability on a playing field that was also far from level. Any direct comparison in this situation was unarguably inequitable. Was Darwin simply lazy in his thinking, making generalisations whilst regarding his female friends as outliers or oddities? Caroline Kennard responded that women could support 'propagation of the best and the survival of the fittest in the human species'. The views of such a respected scientist were undoubtedly damaging to any progress made by women's campaigners and were seized on by naysayers as fact. As Darwin was so meticulous and painstaking in his scientific work, it seems as if he simply chose not to think it through and examine his biases. As women had hitherto

not made great intellectual achievements – because they had been prevented from so doing – he chose to interpret, or even promulgate, this as evidence of intellectual inferiority.

According to Dr Edward H. Clarke of Harvard Medical School, women had less blood circulating than did men, and therefore less energy, owing to the fact that they have periods. Menstruation was referred to as a disability or an illness and presented women as a liability. Clarke also claimed in his 1873 publication *Sex in Education; or, a Fair Chance for Girls* that education damaged girls' reproductive chances, that period pain was a symptom of this and further warned that women who studied would suffer with 'monstrous brains and puny bodies; abnormally active cerebration and abnormally weak digestion; flowing thought and constipated bowels'. Coincidentally, the publication of this book and his other utterances corresponded with a sharp rise in female applications to study at Harvard Medical School. Other common beliefs were that hysteria was caused by overstimulation of the female mind. So in the face of these arguments, women had an even steeper uphill battle to get themselves recognised professionally.

Another method of keeping women within their allotted sphere was to denigrate them publicly as 'bluestockings'. The Bluestocking Society had originally been a tea-and-literature group organised by social reformer Elizabeth Montagu in the 1750s and recruited several intellectual and accomplished female members who were committed to education and opportunities for women in previously male-dominated fields. Bluestocking Society member Hester Chapone produced *Letters on the Improvement of the Mind Addressed to a Young Lady* for her fifteen-year-old niece, which was widely praised by Mary Wollstonecraft as containing 'good sense, and unaffected humility, and ... many useful observations'.[375] The Bluestocking Society pushed the door open just that bit wider to enable women to flourish and be seen as intellectual equals.

But how did the term 'bluestocking' come to be used as an insult? With the 'Woman Question' becoming more highly debated from the mid-century, the word became associated with women who were outspoken, demanding and who knew their own mind. Diametrically opposed, of course, to the True Woman. And for that reason any such woman became stereotyped as 'a stiff, stilted, queer literary woman of a dubious age'.[376] In fact, the 1883 edition of the *Popular*

Encyclopedia defined a bluestocking as a 'pedantic female' who has thrown away the 'excellencies of her sex' in unnatural pursuit of education and learning. Books were more important to her than marriage. The inference here was that these women were unfeminine and unattractive because of their educational choices and that they were attempting to appropriate men's supposed 'natural' intellectual superiority. Subscribers to this belief alleged that there was an incompatibility between femininity and intelligence and a woman's worth was linked to her appearance and womanliness. And it was also used as an explanation for the 'unwelcome' situation of being single in later life.

Intelligent, forward-thinking women were not prepared to accept this pejorative label, nor Darwin's assertions. Among them were women like Frances Buss, founder of North London Collegiate School, and Emily Davies, founder of Girton College.

In 1835 Lydia Howard Sigourney had published a guide entitled *Letters to Young Ladies* with advice on such subjects as the improvement of the mind, dress manners and accomplishments, books, conversation, philanthropy and self-motivation. This was followed by a new and enlarged edition published in 1841 and though these two versions illustrate the changes in society that had taken place in just over six years, Buss overhauled the curriculum to provide girls with the same educational opportunities as boys. She included maths, French and other intellectual subjects at the expense of the traditional female accomplishments that Caroline Bingley and Lydia Howard Sigourney recommended.

When women began to campaign for equal admission to university, it is feasible to imagine that male lecturers were bemused by the fact. Why waste university places on women when they can and should go to men? What is the point of an indulgent and wasteful university education when the women will simply marry and raise a family? It is also not beyond the realms of possibility to imagine that male students felt threatened; as indeed the highest marks in a chemistry examination at Edinburgh University were achieved by one of the 'Edinburgh Seven', Edith Pechey.

It is not difficult to suppose that the female infiltration of the male academic world – particularly when they achieved results such as Philippa Fawcett and Edith Pechey – caused men to feel fearful, insecure and possibly wryly undeserving about their 'privileged'

positions. A full-scale riot erupted in 1897 when the Cambridge Senate voted on whether women should be allowed to receive their degrees. Male students burned effigies of feminists and caused mayhem. It is open to question whether this was rational, professional behaviour.

This impertinent poem, entitled 'The Woman of the Future', appeared in *Punch* in May 1884:

The Woman of the Future! She'll be deeply read, that's certain,

With all the education gained at Newnham or at Girton;

She'll puzzle men in Algebra with horrible quadratics,

Dynamics, and the mysteries of higher mathematics;

Or, if she turns to classic tomes a literary roamer,

She'll give you bits of Horace or sonorous lines from Homer.

You take a maiden in to dine, and find, with consternation,

She scorns the light frivolities of modern conversation;

And not for her the latest bit of fashionable chatter,

Her pretty head is well-nigh full of more important matter;

You talk of Drama or Burlesque, theatric themes pursuing,

She only thinks of what the Dons at Oxford may he doing.

A female controversialist will tackle you quite gaily,

With scraps from Pearson on the Creed, or extracts culled from Paley;

And, if you parry these homethrusts just like a wary fencer,

She'll floor you with some Stuart Mill, or else with Herbert Spencer.

In fact, unless with all such lore you happen to be laden,

You'd better shun, if you've a chance, an educated maiden.

The Woman of The Future may be very learned-looking,

But dare we ask if she'll know aught of housekeeping or cooking;

She'll read far more, and that is well, than empty-headed beauties,

But has she studied with it all a woman's chiefest duties?

We wot she'll ne'er acknowledge, till her heated brain grows cooler

That Woman, not the Irishman, should be' the true home-ruler.

O pedants of these later days, who go on undiscerning,

To overload a woman's brain and cram our girls with learning,

You'll make a woman half a man, the souls of parents vexing,

To find that all the gentle sex this process is unsexing.

Leave one or two nice girls before the sex your system smothers,

Or what on earth will poor men do for sweethearts, wives, and mothers?[377]

Then there was Gertrude Bell, from an upper-middle-class family in County Durham, who was a pupil at Queen's College in Harley Street before going up to Margaret Hall, Oxford, in 1886. Highly intelligent and sporty, she became the first woman to complete a first-class degree in modern history in only two years.

The legal profession was still unwavering in its refusal to admit women, however well educated, even up to the end of the nineteenth century. Women could study for degrees, but at many universities they were not allowed to graduate. Although women were not prevented from working in the legal profession, their employment was limited to clerical and office work. Since 1860, women had been able to obtain training in drafting and copying legal and other business documents by social reformer Maria Susan Rye at her Lincoln's Inn Fields law engrossing office.

Eliza Orme was the first woman to apply to take Law Society examinations to enable her to qualify as a solicitor. Women clients needed legal advocacy, she argued, particularly in light of the advancing campaigns for property rights and divorce. By 1875 she had several years' experience in her own Chancery Lane offices preparing paperwork for property transactions, wills and mortgages. In 1888, at the age of thirty-nine, she became the first woman in Britain to graduate with a law degree after successfully applying to University College London.

But even after formal barriers to admission had been eliminated women still met with some difficulty in obtaining articles or employment, particularly if they did not have family connections in the profession. Additionally, stereotypes remained within both the

profession and society and many women still faced the challenge of balancing a career with family life.

Some nineteen years following the death of Queen Victoria, the Sex Disqualification (Removal) Act 1919 finally stipulated that a person should not be disqualified 'by sex or marriage from entering or assuming or carrying on any civil profession or vocation'. The first woman was called to the Bar the following day.

Although there was no professional body for natural historians in the Victorian age – this did not come into being until 1905 – female naturalists were not generally welcomed by their male counterparts. Mary Anning was an early Victorian palaeontologist who discovered not only the skeleton of the first ichthyosaur but the first two plesiosaurs, and though her work was not always attributed to her, male colleagues unobtrusively sought her advice regarding fossils they couldn't identify. Despite this, they would not give her credit. The Geological Society had been operational from 1807 but female geologists, including Anning, were denied membership and barred from lectures as the content was considered beyond their intellectual capability.

Two Victorian women were given Geological Society awards, but neither were allowed to collect them in person as they could not attend meetings. Catherine Raisin was a mineralogy and petrology researcher and recipient of the Lyell Fund in 1893. Seven years later, Gertrude Elles – who received first-class honours in the Natural Science Tripos at Newnham in 1895 – was awarded the same prize for her work with graptolite fossils. By 1900, several male fellows had attempted to overturn the disbarment and Elles' professor, who collected the award on her behalf, remarked that he was 'glad to have been asked to receive the Award from the Lyell Fund for transmission to Miss Elles, who is debarred by circumstances over which she has no control from standing here to receive for herself this mark of recognition which the Council of the Society have bestowed upon her'.[378] Several other female geologists received prizes and submitted papers but were not allowed to collect or publish them.

Catherine Raisin and Gertrude Elles both went on to forge successful academic careers – Raisin was the first female head of a geology department at Bedford College – and though they were unable to become members of the Geological Society until 1919, their significant work as palaeontologists and educationalists set them apart as role models for future female geologists to gain professional recognition.

Following campaigns and proposals from as far back as 1847, the Royal Geographical Society included twenty-two female 'Lady Fellows' in 1892, one of whom was the Victorian traveller Isabella Bird Bishop, who had been a founder member of the Royal Scottish Geographical Society. Several requests from women for admission led to a proposal which argued that excluding women from membership would contradict the society's charter. The resolution was published in the press and the society's *Proceedings*:

> The increasing number of ladies, eminent as travellers, and contributors to the stock of geographical knowledge, and the number of women now interested as students, or teachers, in our branch of science, coupled with the evidence brought forward of a desire among both classes to enjoy the practical privileges conferred by our Fellowship, were, in the opinion of the Council, sufficient reasons for at once making the proposed extension which will, it is believed, be to the advantage of the Society, and meet with general approval among Fellows.[379]

The decision to allow women as fellows was a controversial one and met with opposition from male members, mainly from the military. It became a highly charged public matter, with scathing letters appearing in the press, including from Lord Curzon. Admiral John Halliday Cave stated that he would be 'very sorry to see this ancient Society governed by ladies'.[380] Thus in 1893 the proposal was submitted to admit women as honorary fellows only, meaning they would not be allowed to stand for office. Legal advice was taken by campaigners but the ultimate conclusion was, following inconsistent policy decisions and intervention by 'noisy and unmannerly Fellows', that women were barred, leading to the resignation of the society's lawyer and advocate of professional recognition for women, Douglas Freshfield, in protest at the inconsistency and intransigence of the council, which he felt could no longer be taken seriously.

Eventually, a special general meeting in 1913 authorised the admission of women to the society, with the support of Lord Curzon:

> Among the members of our Council the proposal is advocated by some of the most strenuous opponents of the political enfranchisement of women on the ground that this is precisely

the kind of field in which equality of intellectual and practical opportunity ought to be conceded to women, and in which a sex barrier cannot be logically defended or equitably maintained.[381]

Curzon had belatedly realised that women had already proved their geographical competence. Lady Jane Franklin received the Royal Geographical Society Founder's Medal in 1860 – the first woman to do so – for her 'self-sacrificing perseverance in sending out expeditions to ascertain the fate of her husband'. Sir John Franklin's expedition set sail for the Arctic in 1845 to locate the last 900 miles of the Northwest Passage. When no word was heard from the party by 1847, Jane Franklin was one of the first people to realise that something had gone awry. She began to advocate for search parties; knowing her husband's plans as she did, she became a driving force, using her knowledge and connections, writing countless letters to the Admiralty and the President of the USA amongst others and financing five search ships. She not only became an expert on the Arctic through her determination to acquire knowledge but proved influential in shaping public opinion.

Later, Mary Somerville, 'who throughout her very long life has been eminently distinguished by her proficiency in those branches of science which form the basis of Physical Geography',[382] published the first English textbook on physical geography as far back as 1848 and in 1869 she was awarded the Victoria (or Patron's) Gold Medal by the society.

As Curzon conceded: 'In our teeth are thrown the names of one or two distinguished ladies, such as Mrs Bishop, whose additions to geographical knowledge have been valuable and serious. But in the whole of England these ladies can be counted on the fingers of one hand!'[383]

There were female geographers who travelled extensively, evoking acute indignation from men – and some women – who looked upon their actions as offensive to female decorum. Lord Curzon, extremely well travelled himself referred to the 'genus of female globetrotters' as 'one of the horrors of the latter end of the nineteenth century'.[384] *Punch* echoed his derision thus:

A Lady an Explorer? A traveller in skirts?
The notion's just a trifle too seraphic.
Let them stay at home and mind the babies
Or hem our ragged shirts;
But they mustn't, can't and shan't be geographic.[385]

The implication was clear: by travelling, a woman was neglecting domestic duties and involving herself in unladylike activities. 'Travellers are privileged to do the most improper things with perfect propriety. That is one charm of travelling,'[386] wrote Isabella Bird Bishop, who stitched trouser legs underneath her skirts to make riding more comfortable. The written accounts of Bird and her contemporaries set them further apart from the domestic ideal and drew scorn. Although travel writing was not yet a recognised genre of work, men saw this as their own territory and declared that 'inexperienced novices', 'superficial coxcombs' and 'romantic females' were lowering the standards of travel writing, or so stated *Blackwood's Edinburgh Magazine*.[387]

Domestic Manners of the Americans, published by Frances Trollope in 1832, set the scene for female travellers before the commencement of the Victorian era and gave an example to geographers like Harriet Martineau and later Isabella Bird Bishop. Travelling granted women some sense of liberation as well as opportunities for scientific research. Harriet Martineau had been forced to 'work hard and usefully ... [to] think and learn and to speak out with absolute freedom what I had thought and learned.' She felt that she had 'truly lived instead of vegetated'.[388]

As a unique figure in Victorian culture, Martineau became a key contributor to a wide range of intellectual and social debates. She chose to regard the death of her fiancé, although it saddened her immensely, as an opportunity to escape the confines of a conventional Victorian marriage. Her trips were a dramatic escape from the restrictions and expectations of everyday life back home. Women travellers were aware that they needed to leave a lasting impression of their voyages, so they documented their travels. And here is where they left their mark. British law may have denied most women the right to hold their own property for most of the Victorian age, but by writing about other lands, particularly America, they had an approximation of a claim to property for themselves.

Florence Dixie was a Scottish writer and traveller who also hunted game and worked as a war correspondent for *The Morning Post* during the First Boer War and the Zulu War. She was president of the British Ladies' Football Club when it was formed in 1895 and held strong views on equal rights within marriage, education, rational dress and overturning the primogeniture ruling. 'There is no reason why football should not be played by women, and played well too,

provided they dress rationally and relegate to limbo the straitjacket attire in which fashion delights to attire them,' she wrote in 1895 to *The Pall Mall Gazette*.

Perhaps one of the most notable examples of success in learned society membership was that of Hertha Ayrton, possibly the first female professional electrical engineer. At the start of the 1890s, she began assisting her husband with his research into electric arcs. In 1884, after studying mathematics at Girton College, she took evening classes in electricity and physics at Finsbury City and Guilds Technical College – one of three women out of the student body of 121. She married her tutor, Will Ayrton, and began to collaborate with him on his research. But it was not long before she took over the research herself and indeed surpassed her husband in her findings. In March 1899 she was invited to present a paper to the Institution of Electrical Engineers, 'The Hissing of the Electric Arc', which resulted in its publication[389] in the *Journal of the Institution of Electrical Engineers* and her subsequent election to membership of the IEE – its first female member – in recognition of her research and expertise in electrical engineering.

These are notable examples of professional women who challenged perceived injustices and in doing so broke through professional barriers. Working-class women nonetheless remained on the bottom rung of the economic ladder, undertaking menial and unpleasant jobs out of necessity and fighting a battle against discrimination on both class and gender – if they even felt the motivation to do so, that is. They may not have seen the point. It is true that there were different levels of support afforded to working-class and middle-class women; the knights in shining armour who fought for women's admittance to professional organisations were not knowingly fighting for the working-class woman, but their efforts might nevertheless have caused awareness to filter down the social classes.

First-wave feminist organisations experienced successes and failures in their attempts to advance rights for all women, leading to tensions between suffragist groups and socialist reformers. What was the priority: socialism or women's rights? At times, these internal disagreements led to contradictions rather than synergies. Suffrage based on age and property qualifications may have enfranchised some women before 1918 and could have led to the earlier acquisition of voting rights for all women over the age of twenty-one had it been

the focus. It was no easy task to separate the socialist agenda from the feminist cause.

Additionally, it is important to remember that female pioneers such as those discussed in this chapter were not necessarily feminists. Whilst passionate about their profession and expertise they may not have been advocates of votes for women. But what contribution did they make towards the women's movement? Gertrude Bell, the first woman to be awarded a degree at Oxford, the first to work for British military intelligence and the first to write a government White Paper, had proved herself more than equal to men. Perhaps women like her, who excelled in fields dominated by men, believed they were influencing female emancipation by the mere fact of their attainments. Certainly they were achieving personal liberty. Many also felt that women could accomplish as much as men without the vote. But not all women had the benefit of Bell's wealthy family background, without which she is unlikely to have attained her level of education or scaled the Alps.

An 1859 article in *The English Woman's Journal* explains the key issue behind the barriers that these women faced:

> Far be it from us to make an assertion which the experience of almost everyone must prove to be untrue; for to whom do we turn for assistance in an affair of difficulty, to our male or female relatives. When we want a good investment for our money, do we ask the advice of our aunts or of our uncles?
>
> A stout asserter of the present equality of the female intellect will say, Yes, but we apply to our uncle instead of our aunt not because she is inferior in intelligence, but because he has had the most experience in money matters and has studied the subject of investments for years, while she has never turned her mind that way; and this is exactly the point at which we wish to arrive. Men are superior to women because they know more, and they have this knowledge because they have three times the opportunities of acquiring it that women possess.[390]

But even though they encountered prejudice, discrimination and intolerance, Victorian women from a variety of backgrounds persevered. In doing so, they paved the way for the generations of women who have since followed them into professional organisations.

Conclusion

THE MODERN VICTORIAN WOMAN

On the surface, wives and mothers seemed to be held in high regard in Victorian times. However, in reality their world encompassed discrimination and prejudice. The nineteenth century as a whole, and in particular the sixty-four years of Queen Victoria's reign, was characterised by change at a rate never witnessed before. Britain metamorphosed from an agrarian nation to become the ultimate global industrial power through coal, iron, steel and textile production, entrepreneurship, free trade and of course the railway age. The economy grew, salaries remained relatively low and industries became more competitive in terms of exports. Moreover, this transformation took place at the zenith of the British Empire, the largest Empire the world had ever seen, 'on which the sun never set', and with Queen Victoria as its nominal head.

To be a Victorian was ultimately to be changed by one's own personal experiences and the impact of societal and industrial advancement. What had to be navigated were the rigid morals and social customs. But unyielding adherence to these gave no consideration to the realities and individuality of human nature. British Victorian etiquette was contemptuous of anyone who behaved in a way that opposed the social code. Conformity was almost assured in order to avoid confrontation and censure. Respectability was highly valued and equalled morality; evidence 'included sobriety, thrift, cleanliness of person and tidiness of home, good manners, respect for the law, honesty in business affairs, and, it need hardly be added, chastity'.[391]

The Industrial Revolution had irrevocably altered business, trade, science, culture, society and the thinking of individuals within that society. Britain was a key player in the development of modern thinking about property, capitalism and parliamentary democracy, as well as making significant contributions to literature, the arts and science and technology. It was therefore inevitable given the condition of human nature that the 'Woman Question' would arise out of this societal shift. Gender history became one of the most important facets of any consideration of the Victorian age and led to the advent of organised feminism.

Changes to the social order made women think about their own lives and roles, and how they should, could or would be able to achieve some form of independence. Queen Victoria paradoxically portrayed herself as a traditional wife and mother whilst carrying out her role as the ruler of a nation and empire, and in some ways presented an ambiguous model for women to follow. She voiced her thoughts about the ideology of separate spheres and the supposed natural differences between the sexes, advocating that each should act according to their gendered characteristics. These attitudes were backed up by art critic John Ruskin in 'Sesame and Lilies', his public lectures on gender ideology, which served to further entrench societal expectations as well as thoughts on psychological and biological differences between the sexes.

A man was presented as 'eminently the doer, the creator, the discoverer, the defender, with an intellect for speculation and invention and energy for adventure, war and conquest', whilst women possessed 'a power for rule and an intellect for sweet ordering, arrangement and decision'.[392] Public lectures, literature, magazines and the queen's opinions helped to enforce public understanding of men and women and their roles in society.

Though women gradually became aware that they could achieve more, the public perception of them – more emotional, less capable of abstract thought and reason than men – was the biggest stumbling block to female emancipation. Brought up with behaviour manuals, religious teaching and messages from their family as to the correct way to behave, young women would be instructed about the importance of male authority and the requirement for women to submit to that authority, even to the extent of 'suffer[ing] and be[ing] still'[393] in instances of marriages that were unhappy and unsatisfying. A young

woman's education was meant to 'enable her to understand and even aid the work of men', according to John Ruskin. Beauty, truth and art were emphasised, and modern novels and young women's magazines were discouraged. Part of the role of a wife was to, in effect, second-guess her husband's prevailing mood and meet his needs accordingly by staying home and submitting to the requirements of marriage and the will of her husband without complaint.

Ruskin had already spelled out the differences between the sexes.[394] Women were to be the providers of peaceful, calm domesticity and ensure the home was a safe retreat. They were to cultivate wisdom, but 'not for self-development, but for self-renunciation: [she should be] wise not that she may set herself above her husband, but that she may never fail from his side'. A 'general and accomplished education' was sought after, but only for 'daily and helpful use'. Women were expected to subjugate their own needs and requirements, and obey their fathers, and then their husbands:

> The law regarded a married couple as one person. The husband was responsible for his wife and bound by law to protect her. While the middle class husband usually spent long hours professing as a doctor, clerk or banker, the wife had her own perfectly defined occupation at home. Household management and motherhood were regarded with sanctity by the Victorians and were treated with the utmost seriousness and devotion.[395]

The Victorian age may have initially been steeped in androcentrism, but many women were unhappy with the strict rules of social conduct and strongly opposed the legal subservience to which they were consigned purely on grounds of gender. They began to fight for their rights – not simply to vote, but to have the ability to make choices for themselves. They wanted to choose whether they got married and to whom, to be single by choice and not be written off as a spinster, bluestocking or social delinquent to be pitied. They aspired to challenge themselves through education and work and, equally, to be the Angel in the House if that was what they truly wished for themselves.

As John Stuart Mill observed, 'There are men, and there are marriages.' Not all Victorian men wished to restrict or constrain their wives, but some were able to exercise power and control with

impunity under the guise of male ideals of chivalry and protection. The idea of safeguarding femininity, society and consequently empire also enshrined oppression within it. But as we have seen, many men supported and championed the ideas of female emancipation and practically assisted them in many ways. Mill supposed that the ideal of separate spheres did more harm than good, and that this dichotomy would continue to be divisive when in fact a sort of social Venn diagram would have better represented a more authentically organic society:

> If men had ever been found in society without women, or women without men, or if there had been a society of men and women in which the women were not under the control of the men, something might have been positively known about the mental and moral differences which may be inherent in the nature of each. What is now called the nature of women is an eminently artificial thing – the result of forced repression in some directions, unnatural stimulation in others.[396]

It was expected that people followed the standards of Victorian society to maintain social integrity, and because of this many people had to hide 'undesirable' behaviour and personal wants and wishes, sometimes to the point of suppressing their natural character. Nobody did this more than women. John Stuart Mill recognised that each individual had interests which only he or she could represent for themselves, and this meant female emancipation simply had to happen. Women began to rise and challenge the ideal of Victorian womanhood, and by doing so inspired other society women to do and be far more than the Angel in the House. In fact, they found that without the angel wings, they could really fly.

The Langham Place Group – in particular Adelaide Proctor, Barbara Bodichon and Bessie Rayner Parkes – and other feminist organisations campaigned tirelessly to give women opportunities for education and self-actualisation outside the domestic sphere. In fact, in less than a century, the whole traditional Victorian mentality was radically challenged.

Throughout the course of the Victorian age, women were on the verge of a vast change in the laws that had constrained them since medieval times. They were able to forge an escape route from

domesticity and the social structures that kept them confined, and in doing so they provided inspiration and set highly achievable examples for other women. With the expansion of education, participation in the workforce and the growth of feminist gròups, women began to question their outdated roles. Dorothy Thompson shows the unusual occurrence 'that in a century in which male dominion and the separation of spheres into sharply defined male and female areas became entrenched in the ideology of all classes, a female in the highest office in the nation seems to have been almost universally accepted'.[397] Nancy Armstrong's belief that 'the modern individual was first and foremost a woman'[398] could apply as much to Victoria herself as to her female subjects, who began to demand – and achieve – freedom of choice, independence and direct participation in their own lives.

Postscript

WHAT IF ALBERT HAD LIVED?

Without embarking on a full counterfactual history analysis, I have often mulled over possible answers to the question: 'How different could Victoria's influence have been on contemporary women if Albert had not died a premature death at the age of forty-two?'[399]

Although never known as a feminist, during her life the queen's persona as a public and politically active woman still inspired other women to re-evaluate the role and purpose of being female and consider what they could achieve for themselves. Women therefore related to her and in this way, most likely unintentionally, she did influence the development of the women's movement. Drawing attention to the anomaly of their own position of disenfranchisement whilst pointing out that a woman was head of state was a key tactic of women's rights campaigners. Women looked to Victoria as a role model because of her position in order to further their cause and achieve equal rights for themselves. The very fact of a woman on the throne provided a starting point for discussing the 'Woman Question'. But this was a different kind of woman on the throne. She was the youngest monarch for 290 years. How would she reconcile her dual roles as wife and ruler?

Victoria's diary from Monday 10 February reads: 'The last time that I slept alone. Albert is so excessively handsome. My heart is quite going.' Up to this time royal weddings had taken place in the evening, but this one was held in the daytime and the public had already related to the couple. The crowds were enormous outside Buckingham Palace, with people scrambling up trees to get a better view of Victoria and her wedding dress. She continues: 'At half past 12

I set off. I wore a white satin gown.' What she wore was a statement that she wanted to be married as a woman, not as a monarch. At the time, white was more of a symbol of wealth than purity. Victoria 'never saw such crowds as there were in the park, and they cheered enthusiastically. I entered the chapel. At the altar, to my right, stood my precious angel.'

The big question about the wedding vows was whether Victoria was going to agree to obey Albert or not. The decision to obey was, of course, about power. Nobody was supposed to have power over Victoria as the monarch, yet the promise of marital obedience was a key part of the Victorian wedding service. Any other woman would make the vow, but would a queen? 'Wilt though obey him, and serve him, love, honour and keep him, so long as you both shall live?' asked the Archbishop of Canterbury. Victoria replied, 'I will.' The queen had emphatically promised to obey her husband. She was trying to build the secure, happy family she had not experienced as a child, and she wanted her public to see this. Victoria wished to be a wife to Albert, but how easy would it be for her to obey her husband in practical terms? Neither of them got any sleep on their wedding night, according to her journals: 'His excessive love and affection gave me feelings of heavenly love and happiness I never could have *hoped* to have felt before!'

When Albert discovered they were only to have a three-day honeymoon he asked for a longer break. 'You forget, my dearest love, that I am the sovereign and that business can stop and wait for nothing. It is quite impossible for me to be absent from London.' Victoria had always been stubborn and determined, and here she was, already disobeying! As a royal prince, Albert expected status and power in his marriage and right from the beginning obeying was always going to be an issue. Victoria was conscious of status, and to suddenly have someone else, a man she had actually only met three times before their marriage, making demands did not sit well with her. In fact, here was a marriage that had a 'fault line' running through it from the outset. The facts were this: she was the queen, the superior commander; Albert was not the king, but simply her husband. In the early 1840s, the large, flouncing silhouettes that were in fashion were important to Victoria as they literally took up space and afforded recognition and attention. Although always by her side, Albert was quieter and more bookish than his wife. She was very much in charge of both the country and the marriage, and often got her way.

But the British public had lost faith in the monarchy. The rulers preceding Victoria had been debauched and immoral, with illegitimate children scattered around. The royal family was satirised in the press, mocked by its subjects and low on support. Victoria challenged and changed that view by making it her mission to restore respect for the royal family. In many ways, her wedding day may even have been seen as more important than her coronation two years previously as it represented the start of a new family. She was also making herself available to her public, being seen in her carriage around London and making a point of demonstrating her trust in the people. Her response to a failed assassination attempt during her first pregnancy also demonstrated a strength and bravery that won public respect.

As 'it is a female that assumes to rule this nation', by the middle of the century women felt they were entitled to 'our rights as free women (or women determined to be free) to rule ourselves'. Whilst a woman sat on the throne with all the trappings of a head of state, at first her female subjects could not vote, attend university or retain ownership of their property. American women such as Amelia Bloomer were also bemused by this contradiction: 'If it is right for Victoria to sit on the throne of England, it is right for any American Woman to occupy the Presidential Chair at Washington.'

Millicent Fawcett wrote, 'Within its own prescribed limitations [monarchy had] repeatedly given in our own history, a chance to an able woman to prove that in statesmanship, courage, sense of responsibility and devotion to duty, she is capable of ruling in such a way as to strengthen her empire and throne by earning the devoted affection of all classes of her subjects.'[400] No wonder women looked up to her.

In a letter to Scottish poet Theodore Martin,[401] Victoria makes her feelings clear:

The Queen is most anxious to enlist every one who can speak or write to join in checking this mad, wicked folly of 'Women's Rights', with all its attendant horrors, on which her poor feeble sex is bent, forgetting every sense of womanly feeling and propriety. Lady [Amberley] ought to get a good whipping ... Woman would become the most hateful, heartless, and disgusting of beings were she allowed to unsex herself ... God created man & woman different – & let each remain in their own position.

Such comments were confined to Victoria's private correspondence, and her opinions on women's rights and other issues were not known to the public until years after her death. Even though her sentiments towards women are now well known, during her reign the very fact of a female sitting on the throne was inspiration enough for other women to question the prevailing beliefs held about gender and consider emancipation, or the 'Woman Question'.

Furthermore, she had made a revealing comment in a letter to King Leopold eighteen years earlier, in 1852: 'We women are not made for governing.' Even as head of state, she felt 'good women' should naturally dislike masculine occupations and certainly not aspire to them. Her role was, as she liked to claim, not her occupational choice. Nor was it necessarily a utilisation of her inherent skills and abilities; rather it was her inescapable duty. It should be recalled that she was fifth in line to the throne when she was born and was never expected to rule.

After Victoria married Albert, she was initially reluctant to include him in state matters. Why this was is unclear; although inexperienced in politics on accession and mentored by Lord Melbourne in this area at the start of her reign, she became heavily reliant on Albert's international and political insight.

But was Victoria unwittingly becoming a role model for true teamwork between husband and wife? She did write that 'woman [should] be what God intended; a helpmate for a man – but with totally different duties & vocations'. Yet here she was reversing the roles. Albert's knowledge of political and international affairs was far greater than hers, and by involving him in political decisions that supported her work as monarch she developed an early business and family partnership, giving an alternative interpretation of what the separate spheres ideology could rightly represent. By working together with Albert in this way, she was able to develop her role and raise the couple's visibility through their support of middle-class pursuits such as industry, finance and technology.

Albert wrote to Prince William of Lowenstein in May 1840 shortly after he was married, expressing some frustration: 'In my home life I am very happy and contented; but the difficulty of filling my place with proper dignity is that I am only the husband, and not the master in the house.' Victoria had placed her faith and trust in Albert to work with her so closely, as a deputy she considered

smarter than herself, that diarist Charles Greville wrote: 'He is become so identified with her that they are one person, and as he likes and she dislikes business, it is obvious that while she has the title he is really discharging the function of the Sovereign. He is King to all intents and purposes.'[402]

But the reconciliation of their relationship as husband and wife as well as monarch and spouse was not straightforward. Women conventionally consented to obey their husbands when they married but the paradox of a legal ruler obeying one of her subjects both confused and amused the British public.

After some reluctance, Parliament officially conferred the title of Prince Consort upon Albert in 1857. It was felt that it had been earned through establishing his influence over the years, the success of the Exhibition and the responsibilities Albert assumed whilst Victoria was pregnant.

Victoria was effectively pregnant for the first seventeen years of her reign. Her journals and letters show that she was not happy being pregnant: 'I am really upset about it and it is spoiling my happiness.' The news had ruined her marriage: 'I have always hated the idea. I cannot understand how anyone can wish for such a thing especially at the beginning of a marriage.' The diary of her doctor, Robert Ferguson, published in 2016, offers a remarkable behind-the-scenes insight. In labour at Buckingham Palace, Victoria did not want to have the Prime Minister, Archbishop of Canterbury and Home Secretary present as tradition dictated, watching her give birth. 'The very first words I heard were from the Queen, "I fear it will create great disappointment",' wrote Ferguson when baby Vicky was born. Victoria had wanted a boy. She was the first ruling monarch ever to give birth in England, balancing the duties of wife, queen and now mother.

Not only did Victoria dislike pregnancy, but she didn't have much fondness for babies either. A letter to Vicky shows that motherhood did not come naturally:

I am no admirer of babies generally – there are exceptions – for instance (your sisters) Alice, and Beatrice were very pretty from the very first – yourself also – rather so – Arthur too ... Bertie and Leopold – too frightful. Little girls are always prettier and nicer.

Writing to her uncle King Leopold I of Belgium, she lamented:

> ... I think, dearest Uncle, you cannot really wish me to be the *'Mamma d'une nombreuse famille,'* for I think you will see with me the great inconvenience a large family would be to us all, and particularly to the country, independent of the hardship and inconvenience to myself; men never think, at least seldom think, what a hard task it is for us women to go through this very often.

And she thought that babies moved with a 'terrible froglike action'. She did, however, go on to have a further eight children.

A further contradiction to the separate spheres ideology was Albert's involvement with the children. Along with her unhappiness at being pregnant, Victoria's writings indicate that Albert took on a more nurturing role than his wife, at least whilst the children were small. Again, Victoria expressed this in the letter to uncle Leopold when Vicky was newly born:

> Our young lady flourishes exceedingly ... I think you would be amused to see Albert dancing her in his arms; he makes a capital nurse (which I do not, and she is much too heavy for me to carry), and she already seems so happy to go to him.

Writing to Vicky again, Victoria's views become clear:

> When I think of a merry, happy, and free young girl – and look at the ailing aching state a young wife is generally doomed to – which you can't deny is the penalty of marriage...

But she loved her children. She drew several sketches of Vicky; looking at them gives an impression of a mother besotted with her child and eager to record her looking particularly cute, being drawn from a place of love. Whilst she did openly say she disliked babies, she also wrote letters praising them and saying how delightful and charming they were. She was a queen, but she was a woman too. Three weeks after the birth of her next child, and heir, Bertie, Robert Ferguson was summoned to see Victoria. His diary reveals why. 'She had been gloomy and despondent. There were illusions both of the eye and the ear. By the one sense she was deceived into a belief that she saw spots

on people's faces which turned into worms and that coffins floated before her.' During his visit Ferguson spoke to Albert: 'His face close to mine and with pale and haggard looks he broke out "the Queen has heard that you have paid much attention to mental disease and is afraid that she is about to lose her mind".' When Ferguson met Victoria he found that 'she was lying down and the tears were flowing fast ... as she addressed me. Overwhelmed with shame at the necessity of confessing her weaknesses.' What we would now recognise as post-natal depression brought back a fear that haunted the royal family. Victoria was the granddaughter of George III, after all, and she feared she had inherited the same mental illness. She found being mother, wife and queen more difficult to manage and was grateful to her supportive husband.

Albert was very closely involved in his children's lives, especially for the standards of his day. He was present for all of their births and regularly played with them while they were growing up. Of course, this may have been a decision of expedience, but it could equally have been an expression of their individual natures. This was the first royal family to act as an example for middle-class families, being seen as a unit in public appearances and in portraits, and sending their sons to the universities of Oxford and Cambridge. This gave them a less 'distant' image and appealed to the growing British middle class.

Victoria was a wife and mother but also queen of one of the most powerful nations on earth. With an empire rapidly encircling the globe, the country needed both a strong government and dedication from Victoria. Government boxes arrived daily for her perusal and signature, and whilst she welcomed Albert's support, at first she had no intention of sharing any of her duties with her husband. He, however, had other ideas. Right from the start he wanted to see what was in the government boxes. He wished to influence the country's direction and contribute to government policy.

Gradually she began to relent. Once she was giving birth regularly it was impossible for her to manage the workload alone. He was ambitious, and this was matched by his work ethic. He would get up early and work late, and eventually Victoria came to see that if she had a competent, hardworking person by her side, there would come a point when she could share some power and control: 'His love and gentleness is beyond everything ... was ever a woman so blessed as I am?' But problems arose surrounding Louise Leizen,

Victoria's childhood governess. Deeply attached to the queen, in her scrapbook Leizen kept a piece of Victoria's wedding dress, locks of hair and pressed flowers from the wedding bouquet. Albert disliked her influence over his wife and the fact that Victoria listened to her, and he came to realise that if he was to establish an ascendancy within the household, Leizen had to go. When baby Vicky became ill in January 1842 a heated argument broke out between them over the child's illness and care, resulting in Albert dismissing Leizen without Victoria's permission. She obeyed her husband in this as she was backed into a corner. This demonstrates how much she was now willing to concede to him; whatever her power, she was also a vulnerable woman exhausted by the demands of her job and motherhood.

All this took place at the advent of the railway age, with convenient travel becoming increasingly accessible. Victoria quickly gave birth to two more children, and she could see her many duties were putting her marriage under pressure. With London growing faster than ever, in 1842 Victoria and Albert escaped to the Scottish Highlands: 'We took a most beautiful drive ... a really delightful country.' Keren Guthrie, archivist at Blair Castle, explains that they still keep letters and documents belonging to Victoria. Scotland gave them a chance to spend time together as a married couple: 'Dearest Albert so delighted with everything and in high spirits...' She was allowed to be a wife and move away from being queen for a short while. Soon, though, she would find herself jostling with Albert for her crown.

Baby Helena soon followed, as did Osborne House, her dream home on the Isle of Wight. They bought the estate for £28,000 and constructed an Italian Renaissance villa. This became a family retreat where they could be husband and wife rather than rulers. Osborne House was run as a much simpler affair than Buckingham Palace, with the intention of it being a private palace for small-scale entertaining and family life. 'It is really a paradise,' Victoria wrote. But there was trouble in paradise. 'I find no especial pleasure or compensation in the company of the older children.' Perhaps she was not a natural mother as she had not had a positive childhood experience herself, whereas Albert seemed to have an innate skill for parenting. She was happiest when she was alone with Albert and possibly resented her children for taking time away from Albert.

She resented constant childbearing because she felt she should be making decisions, meeting politicians, reading documents. Pregnancy

impeded this through exhaustion and busyness, so Albert took on more and more beyond simply assisting Victoria and began dealing with politicians himself. In fact, it was almost that a co-monarchy arose whereby he took increasing control and statesmen found it hard to consult Victoria without Albert. After seven children, Albert felt confident enough to step onto the national stage.

Albert became president of the Society of Arts in 1843 and began putting forward ideas about a series of exhibitions to showcase and develop concepts in British industrial design. In 1849 the Fine Arts Commission agreed to such an exhibition: 'It was considered that ... particular advantage to British industry might be derived from placing it in fair competition with that of other nations.'[403]

The first exhibition was held in Birmingham later that year and was followed by the Great Exhibition of 1851 – or, more correctly, the Great Exhibition of Products of Industry of All Nations – which showcased British manufacturing along with international specialisms, becoming the country's first international trade show. Albert's insistence on an international exhibition initially raised eyebrows among those responsible for the public purse. Government funding was not forthcoming, and a royal commission was set up to take these ideas further. Albert chaired the commission, arranging fundraising events and charity dinners. As soon as it became clear that the event would be self-financing, enthusiasm and support grew.

The structure for the exhibition, Crystal Palace, was built in only seven months and opened in May 1851. Albert was, to Victoria 'immortalised ... It was the happiest, proudest day of my life and I can think of nothing else.' She remembered the event with 'tremendous cheering, the joy expressed in every face, the vastness of the building, with all its decorations & exhibits, the sound of the organ (with 200 instruments & 600 voices, which seemed nothing), & my beloved Husband the creator of this great Peace Festival, inviting the industry & art of all nations of the earth, all this, was indeed moving, & a day to live forever'.

This was a celebration of innovation and technology, full of commercial objects, demonstrations and materials from all over the British Empire. Six million people visited. This was proof that Victorian Britain was the greatest nation on earth, and Albert was the mastermind behind it. Victoria herself was a visitor; it was not her show. She was effusive in her praise: 'This day is one of the greatest

and most glorious.' Though Victoria cut the ribbon, Albert was the star and it was the defining moment of his life. He became almost a co-ruler, stepping into the spotlight with Victoria in his shadow. Now Victoria suffered a crisis of confidence. Four months after the exhibition, she began to question her right to rule: 'I am every day more convinced that we women if we are to be good women, feminine, and amiable and domestic, are not fitted to reign.'

Soon pregnant with her eighth child, a medical breakthrough – chloroform – afforded her pain relief during childbirth. Not everybody supported this development. Religious figures claimed women were meant to suffer during labour as the Bible stated. Doctors thought it potentially dangerous and fatal, but despite the risks Victoria chose to have it when she gave birth to Leopold, commenting that 'the effect was soothing, quieting and delightful beyond measure'. She had made up her mind, and the impact of this decision went beyond the palace. Pain relief in pregnancy became socially acceptable.[404] Victoria was doing something positive for other women, though her obstetrician, John Snow, was criticised: 'He had no right to rob God of the deep, earnest cries of women in childbirth!'

But post-natal depression and arguments quickly followed. Victoria tended to back down in arguments and kept a record of her 'bad behaviour': 'I have great difficulties in my own poor temper, violent feelings, which tend to make one selfish.' She listed her failings in a notebook: 'Have I improved as much as I ought? I fear not.' As the years went by, Albert became more dominant. He told her what to wear and what wallpaper to choose. Her clothes were less flattering. As his power grew, the once feisty Victoria faded from view. Then political tensions exploded in the Crimean War. Victoria was constantly asking questions about equipment and medical treatment. As the ordinary troops were her soldiers, fighting for her and the country, she wanted them to be recognised. In January 1856, she gave her name to a military award – the Victoria Cross – which would be awarded to all ranks for valour.

Both Albert and Victoria were involved in the design of the medal. She used the subsequent medal ceremonies to forge a new relationship with her people. Her willingness to meet with those who had carried out extreme acts of bravery and her understanding demeanour when speaking to them showed a very human side to her. Pinning a medal on a humble private was something new, a turning point in what was

expected of a monarch. The war allowed her to play the different roles of queen, wife and mother at the same time, presenting her as the mother of the nation as well as her own family.

A year after the end of the war, Bertie was becoming a playboy prince – exactly what the monarchy did not need. Victoria was concerned about his intellect and laziness, realising he had been indulged too much, and she dreaded him inheriting the throne; he would make a terrible king. His behaviour when training in the army led Victoria to think that he had undone all her efforts to present a morally upright, relatable royal family.

In 1861, Albert caught a chill in the rain when visiting Bertie at Cambridge and took to his bed. He never recovered. Having been inseparable for twenty years, the man Victoria relied upon completely was dead, and she was on her own: 'My life as I considered it is gone, past, closed. It is like death in life; utter desolation, darkness and loneliness.' It was the end of one of the greatest and most important partnerships in British history. They had reinvented the monarchy, stamped it with a quality that people could admire and relate to. Monarchies were toppling in Europe and yet this one had survived. Victoria had managed to do what no Englishwoman had done before, but now she was alone. How could she start all over again without the optimism of youth? She had totally depended upon Albert. The grief left her unable to carry out her duties as a monarch. Instead of relying on Bertie, however, she turned to her daughter Alice.

The death of Albert at the end of 1861 was a turning point for Victoria. She sank into depression, all but withdrew from public life and mourned him obsessively for the rest of her life. She expressed her grief to her daughter Vicky shortly after his death, wondering 'how I, who leant on him for all and everything – without whom I did nothing, moved not a finger, arranged not a print or photograph, didn't put on a gown or bonnet if he didn't approve it – shall go on, to live, to move, to help myself in difficult moments'.

Chancellor Benjamin Disraeli said of Albert, 'If he had outlived some of our old stagers, he would have given us, while retaining all constitutional guarantees, the blessings of absolute government.'[405] Albert presumably thought that he and Victoria would be able to understand what the people really wanted and deliver this independently of politicians, which seems unlikely.

Victoria's seclusion and absence from the public eye throughout the 1860s gave rise to heavy criticism from several quarters and led to calls for republicanism. She opened Parliament only seven times in the remainder of her reign. What was the purpose of a monarchy if the head of that monarchy was not performing and never to be seen? As a result, over fifty republican organisations were formed in the early 1870s. And following Albert's death, Victoria engaged a number of private secretaries to work for her, dispassionate regarding politics, introducing the separation that now forms modern constitutional monarchy.

As Albert's widow, Victoria was in danger of being perceived to now reject her role, causing immense public discontent and the escalation of anti-monarchism. While the Crown was more influential during Victoria's reign, it seemed to be less about political authority than social influence and there were still serious limits – traditional and constitutional – on the monarch's ability to engage in any kind of partisan politics. In reality of course, Albert was not the sovereign; Victoria had a mind of her own, and Albert's German origins always made him somewhat suspect. Albert's ties to German aristocracy probably would have been a tool of diplomatic influence, although it is hard to say whether it would have tempered rising nationalism in any robust fashion. Ruling without Albert was devastating, but Victoria had no choice but to rediscover the confidence she had shown as a young woman. In any case, she would not give away power again: 'No one person may he be ever so good is to lead or dictate to me.'[406]

Because of her own privileged position, Victoria had limited understanding of, or empathy with, British women arguing for their own rights. Whilst the country's ideology was focused on female domesticity, Victoria was an emblem of female authority within that society. Historian Lucy Worsley told an audience at the 2019 Hay Festival that, in her view, Albert manipulated Victoria into having so many children so that he could rule in all but name and appropriate her duties and power. Worsley thinks that Victoria possessed more emotional intelligence than Albert, contrasting her morale-raising letters of thanks to the troops following the Crimean War with Albert's slew of pages to the government telling them how they got it wrong.

If Albert had lived, it seems likely that Victoria would have at least continued to challenge gender roles without necessarily being an active

feminist or a supporter of the cause. Although without women's rights activists no change would have occurred, the simple fact of a woman on the throne would have resonated with women and started that process of change. Though Victoria may not have been a role model and her personal views were at odds with the feminist movement, she was certainly an inspiration for change. Her attitudes towards the gender question were not straightforward; she saw herself as a wife and mother, and centred her position as queen on those roles, though she did present an example for women to follow by fusing power and feminine virtues, and this they did in their own different ways in order to effect change. Women could look to her as an example and consider their own situations with regard to female submission, their public role, right to education and of course the franchise.

This seems inevitable because Victoria continued to present a contradiction to the prevalent ideology. Women were supposed to support and be subject to their husbands; Victoria's husband was not only her subject but championed her to carry out her role. Women were meant to be at home and not on public display, but by virtue of her role Victoria was constantly in the public and political eye. Once married, women had no legal existence, but by contradiction a woman was not only ruler of the nation but supreme governor of the Church of England. Victoria was seen as a liberating influence, albeit a moderate one. She was outwardly visible as a mother but enjoyed her own income and the full rights which were denied to her female subjects.

The first and most obvious thing that comes to mind is that, on a personal level, Victoria would doubtless have been happier if Albert had lived for longer. Sustained and united work would have enabled Victoria and Albert to continue to act as an exemplary couple. With their work and mutual support subverting the separate spheres ideology, perhaps they would have subtly aided the women's movement. Victoria would have been able to further embrace her image as a female leader, yet in some ways she may have remained a contradiction. According to H. G. wells, she began a stir of emancipation once she took the throne. He wrote that she could 'command her husband as a subject and wilt the tremendous Mr Gladstone with awe. How would it feel to be in that position?'[407] With Albert's intelligence and influence allied to her own, Victoria would have been far more politically active in a partnership than she

was as a widow. Gladstone and Disraeli might also have been more effectively controlled.

Albert displayed concern about the working classes, and his relatively liberal and progressive outlook for the times could have influenced Victoria to consider lending more convincing support to women's rights, the vote and education for women, or even universal suffrage, which would have somewhat muzzled the escalating Labour movement and possibly realised votes for women earlier. Her own daughters were progressively educated, so it is fair to assume that Victoria was not wholly opposed to reforms in women's education.

When Victoria passed away in 1901, the Sunday newspaper *Reynold's News* wrote that she had 'taught us the power we are willingly allowing to go to waste in the womanhood of the nation ... there are many thousands of possible Victorias in the kingdom. No longer can it be argued [that] women are unfitted for public duties.' Josephine Butler's view was that Victoria's influence on men had melted away 'some of their roughness and contempt of women'. Grace Greenwood, who wrote a biography of Victoria in 1883, mused on whether Victoria had actually ever truly realised how privileged she was 'in being able to converse freely with the first men of the age ... without fearing to be set down as a strong-minded female out of her sphere'. Perhaps Albert's enlightened attitude would have galvanised Victoria into more considered action on behalf of her female subjects.

Victoria would have been more focused on official business with Albert's support, and as the children grew she would have had more time to develop her own skills in dealing with the mountain of official business. She would also not have been criticised for taking money from the Civil List with little to show for it. Her withdrawal from public life following Albert's death had already given rise to republican feelings. Her husband had worked assiduously for over twenty years on a treadmill of official duties to cement not only his own position but that of his wife. Sir Sidney Lee described George III, George IV and William IV as an imbecile, a profligate and a buffoon, respectively.[408] The Hanoverians had been a dissolute bunch. By contrast, Victoria and Albert presented a simple family image that increased the popularity of the royal family and made them relatable. Unusually for male aristocrats of the time, Albert also appears to have been strictly monogamous.

William Thomas Stead observed the role of monarchy in elevating women when compared with republicanism:

> It may, at least, be said for Monarchy as it has been said for the Stage – it has given woman an opportunity and a career, denied her elsewhere. No system of Government as yet devised by man, save Monarchy alone, could have secured for a woman such an innings as our Queen has had. All existing Republican systems have carefully provided against the possibility of any women ever having any such chance, by denying to all women any right even to stand as candidate for supreme office. And from my point of view, this alone, other things being equal, would turn the balance in favour of the Crown.[409]

Albert succeeded in moderating Victoria's tendency towards impartiality shortly after their marriage, and with his strong support on matters of state and political obligations at their adjacent desks it is likely that he would have also influenced her views on the 'Woman Question'. Although Victoria had declared that women weren't suited to public life, she was influential in it herself despite embodying some traditional wifely aspects. Albert himself had remarkable energy and vision, and as chancellor of the University of Cambridge he proposed an extensive reorganisation of the syllabus to include history, science and languages.

It is tempting to think that Albert would have continued to encourage Victoria to support her daughters in their endeavours to improve the lives of women. For example, Princess Louise was a supporter of female education and getting women into work through her involvement in the Ladies' Work Society. She was also president of the Women's Education Union from 1871 and patron of the Girls' Day School Trust in 1872, designed to provide affordable day schooling for girls.

Victoria acknowledged the achievement of Agnata Ramsay in her Tripos examinations of 1887; my own personal view is that together, the main joint contribution of Albert and Victoria would have been the influence on the education of women.

NOTES

Introduction: Suffragette Cities

1. Results of a YouGov Survey, February 2018.
2. Sophie Ellis, interviewed for South Essex College, May 2018.
3. Suffragists believed in peaceful, constitutional campaign methods. After the suffragists failed to make significant progress, a new generation of activists emerged. These women became known as suffragettes, and they were willing to take direct, militant action for the cause.
4. Julia Margaret Cameron, *Illustrations by Julia Margaret Cameron of Alfred Tennyson's Idylls of the King and Other Poems* (Henry S. King 1875).
5. G. B. Tennyson, *A Carlyle Reader* (Cambridge University Press 1985).
6. Jane Carlyle, Letter to Martha Lamont, 29 December 1843 (Duke University Press).
7. Marie Corelli, *Woman, or Suffragette? A Question of National Choice* (Pearson 1907).
8. William Ewart Gladstone, Letter to Samuel Smith MP, 11 April 1892 (from collection in Gladstone Library, Hawarden).
9. Mrs Humphry Ward, 'An Appeal Against Female Suffrage' in *The Nineteenth Century* (1889).

1 The Culture of Domesticity

10. Reverend John Rusk, *The Beautiful Life and Illustrious Reign of Queen Victoria* (P. A. Stone & Co 1901).
11. Margaret Homans, 'To the Queen's Private Apartments: Royal Family Portraiture and the Construction of Victoria's Sovereign Obedience', *Victorian Studies*, vol. 37, no. 1 (1993), pp. 1–41.

12. 'Victoria, the Queen' in *Christian Parlor Magazine*, no. 148 (May 1844).
13. Helen Rappaport, *Queen Victoria: A Biographical Companion* (ABC-CLIO 2003).
14. Natalie J. MacKnight, *Suffering Mothers in Mid-Victorian Fiction* (Macmillan 1997).
15. Anthony Trollope, *Framley Parsonage* (1860, Reprint Penguin Classics 1984).
16. Alfred, Lord Tennyson, *The Princess* (1847, in *Selected Poems*, Penguin Classics 2007).
17. Kim D. Reynolds, *Aristocratic Women and Political Society in Victorian Britain* (Clarendon Press 1998).
18. Theodore K. Hoppen, *The Mid-Victorian Generation 1846–1886* (Oxford University Press 2000).
19. Daisy Goodwin and Helen Rappaport, *The Victoria Letters* (Harper Collins 2016).
20. *ibid.*
21. Sarah Stickney Ellis, *The Women of England, their social duties, and domestic habits* (Fisher Son & Co 1839).
22. Carolyn Stevens, 'The Objections of "Queer Hardie", "Lily Bell" and the Suffragettes' Friend to Queen Victoria's Jubilee, 1897', *Victorian Periodicals Review*, vol. 21, no. 3 (1988).
23. Elizabeth Gaskell, *The Life of Charlotte Brontë* (Smith, Elder & Co. 1857).
24. Goodwin & Rappaport (n. 19).
25. Marvin S. Robinson, *A Popular Treatise on the Law of Marriage and Divorce* (Cornell University Library 2010).
26. Roy Porter and Leslie Hall, *The Facts of Life: The Creation of Sexual Knowledge in Britain, 1650–1950* (New Haven and London 1995).
27. *The Times*, 16 September 1868.

2 Expectations and Limitations

28. The Statutes of the United Kingdom of Great Britain and Ireland, 32 & 33 Victoria, 1869.
29. G. D. H. Cole and A. W. Filson, *British Working Class Movements* (Macmillan 1951).
30. Quoted in Leconfield *et al.*, *Three Howard Sisters* (John Murray 1955).
31. *Hansard HC Deb*, vol. 14, 3 August 1832.
32. *ibid.*

33. G. M. Trevelyan, *British History in the 19th Century and After, 1782–1901* (Longmans Green & Co. 1934).
34. Charlotte Brontë, *Shirley* (1849, Reprint Wordsworth Classics 1993).
35. Jennifer Aston, 'Female Business Owners in England, 1849–1901' (University of Birmingham thesis, 2012).
36. *The Observer*, 7 February 1993.
37. The *Englishwoman's Review*, January 1868.
38. Janet Horowitz Murray and Myra Stark (eds.), *The Englishwoman's Review of Social and Industrial Questions, 1879* (Routledge 2018).
39. *Regina v. Harrald*, 1872.
40. George Nathaniel Curzon, Letter to Mary Leiter, 21 June 1893 (from collection in the Oriental Department of British Library).
41. Antonia Raeburn, *The Suffragette View* (St Martin's Press 1976).
42. Norman and Jeanne Mackenzie, abridged by Lynn Knight, *The Diaries of Beatrice Webb* (Virago 2000).
43. *Regina v. Harrald* (n. 39).
44. Elizabeth Chudleigh Bristol, *The Laws Respecting Women: As They Regard Their Natural Rights or their Connections and Conduct* (1777, Reprint 2016).
45. Carroll Smith-Rosenberg, *Disorderly Conduct: Visions of Gender in Victorian America* (Oxford University Press 1985).
46. Catherine Hall, *White Male and Middleclass: Explorations in Feminism and History* (Polity Press 1992).
47. Charles and Frances Eliza Grenfell Kingsley, *Charles Kingsley: Letters and Memories of his Life* (London 1877).
48. Catherine Hall and Leonore Davidoff, *Family Fortunes: Men and Women of the English Middle Class 1780–1850* (University of Chicago Press 1987).
49. Charles Petrie, 'Victorian Women Expected to be Idle and Ignorant', in *Victorian England*, ed. by Clarice Swisher (Greenhaven Press Inc. 2000).
50. Jane Austen, *Pride and Prejudice* (1813, Reprint Macmillan Collectors' Library 2016).
51. The Honourable Mrs Yelverton, *Martyrs to Circumstance* (R. Bentley 1861).
52. Diana Postlethwaite, 'Mothering and Mesmerism in the Life of Harriet Martineau', in *Signs*, Spring 1989 (University of Chicago Press).
53. 'Warwick Economic Research Papers', Department of Economics (University of Warwick 1976).
54. Such women would be born between 1831 and 1851.

55. *Journal of the Statistical Society of London*, vol. 21, no. 3 (September 1858).

56. Quoted in Lisa Surridge, *Bleak Houses, Marital Violence in Victorian Fiction* (Ohio University Press 2005).

57. Papers of Louisa Garrett Anderson, held in The Women's Library, London University, London School of Economics.

58. Anne Brontë, *Agnes Grey* (1847, Reprint Oxford University Press 2008).

59. Mona Caird, 'Marriage', *The Westminster Review*, vol. 130, no. 1 (1888).

60. Clementina Black, 'On Marriage: A Criticism', *The Fortnightly Review*, vol. 53 (April 1890).

61. Sandra Stanley Holton, 'Free Love and Victorian Feminism: The Divers Matrimonials of Elizabeth Wolstenholme and Ben Elmy', *Victorian Studies*, vol. 37, no. 2 (1994).

62. Sir William Holdsworth, *History of English Law* (Methuen 1923–1966).

63. Herbert Henry Asquith, Letter to Frances Horner (from archive of Herbert Henry Asquith, 1st Earl of Oxford and Asquith, Oxford, Bodleian Libraries, 11 September 1892).

64. William Acton, *The Functions and Disorders of the Reproductive Organs* (John Churchill 1857).

65. Haydn Brown, *Advice to Single Women* (James Boden 1899).

66. Ruth Smythers, *Sex Tips for Husbands and Wives* (1894, Reprint Summerscale Publishers 2017).

67. Claire Tomalin, *Several Strangers: Writing from Three Decades* (Penguin 2000).

68. Viscount Esher (ed.), *The Girlhood of Queen Victoria: A Selection from her Majesty's Diaries Between the Years 1832 and 1840* (John Murray, 1912).

69. *ibid.*

70. Robert Lawson Tait, *Diseases of Women* (1877 Reprint London 2nd edn 1886).

71. Clelia Mosher, *The Mosher Survey: Sexual Attitudes of 45 Victorian Women* (Arno Press 1980).

72. John Ruskin, 'Sesame and Lilies', in *The Broadview Anthology of Victorian Prose 1832–1901*, ed. by Mary Elizabeth Leighton and Lisa Surridge (Broadview 2012).

73. Walter Houghton, *The Victorian Frame of Mind* (1957, Reprint 1985 Yale University Press).

74. Margaret Blunden, *The Countess of Warwick* (Cassell & Co 1976).

75. Christopher Hibbert, *Edward VII: The Last Victorian King* (1976, Reprint St Martin's Press 2007).
76. Joanne Bailey, 'Favoured or Oppressed? Married women, property and "coverture" in England, 1660–1800', *Continuity and Change*, vol. 17 (Cambridge University Press 2002).
77. Kim D. Reynolds, *Caroline Norton: Oxford Dictionary of National Biography* 2004-2014 (Oxford University Press 2004; online edition, September 2014).
78. Claire Tomalin (n. 67).
79. Caroline's uncle.
80. Lawrence Stone, *The Road to Divorce* (Oxford University Press 1990).
81. Kieran Dolin, 'The Transfigurations of Caroline Norton', *Victorian Literature and Culture*, vol. 30, no. 2 (2002).
82. Caroline Norton, *English Laws for Women in the Nineteenth Century* (Privately published 1854).
83. *ibid.*
84. Diane Atkinson, *The Criminal Conversation of Mrs Norton* (Preface/Random House 2012).
85. John Copley, 1st Baron Lyndhurst, quoted in Henry Finlay, *To Have But Not To Hold: A History of Attitudes to Divorce and Marriage* (The Federation Press 2005).
86. E. S. Turner, *Roads to Ruin: The Shocking History of Social Reform* (Faber 1950).
87. David Cecil, *Lord M: Or the Later Life of Lord Melbourne* (Constable 1954).
88. Barbara Leigh Smith, *Brief Summary in Plain Language of the Most Important Laws Concerning Women Together with a Few Observations Thereon* (Privately published 1854).
89. Caroline Norton (n. 82).
90. Caroline Norton, 'A Letter to the Queen on Lord Chancellor Cranworth's Marriage & Divorce Bill' (privately published 1855).
91. Queen Victoria, Letter to Theodore Martin quoted in Jeremy Paxman, *The Victorians* (Ebury Press 2010).
92. Ray Strachey, *The Cause: A History of the Women's Movement in Great Britain* (G. Bell and Sons 1928).
93. Statutes of the United Kingdom and Ireland (1857).
94. Kate Summerscale, *Mrs Robinson's Disgrace* (Bloomsbury Publishing 2012).
95. *Newcastle Guardian and Tyne Mercury*, 6 August 1864.
96. *Waterford Mail*, 3 August 1864.
97. *Sydney Morning Herald*, 3 February 1865.

98. *The Pall Mall Gazette*, 11 March 1875.

99. John Stuart Mill, *The Subjugation of Women* (Longman 1869).

100. *Jackson v. Jackson* 1891.

101. Neil Smelser, *Social Paralysis and Social Change: British Working Class Education in the Nineteenth Century* (University of California Press 1991).

102. Ruth Perry, *The Celebrated Mary Astell: An Early English Feminist* (University of Chicago Press 1986).

103. Harriet Martineau, 'On Female Education', *Monthly Repository* (February 1823). This article was signed 'Discipulus' as were many of Harriet Martineau's early articles for the MR.

104. Harriet Martineau, 'Household Education', *The People's Journal 1848* (Edward Moxon 1849).

105. June Purvis, *Hard Lessons: The Lives and Education of Working Class Women in Nineteenth-Century England* (Cambridge Polity Press, 1989).

106. J. H. Higginson, 'Dame Schools', *The British Journal of Educational Studies*, vol. 22, no. 2 (1974).

107. Mary Smith, *The Autobiography of Mary Smith, Schoolmistress and Nonconformist, A Fragment of a Life* (Bemrose & Sons 1892).

108. Minutes of the Committee of Council on Education (William Clowes and Son 1840).

109. Marianne Farningham, *A Working Woman's Life: An Autobiography* (James Clarke & Co 1907).

110. Sara Delamont, 'The Contradictions in Ladies' Education', in *The Nineteenth Century Woman: Her Cultural and Physical World*, ed. by Sara Delamont and Lorna Duffin (Taylor and Francis 2012).

111. Jo Manton, *Elizabeth Garrett Anderson* (Dutton 1965).

112. Frances Power Cobbe, *Life of Frances Power Cobbe as told by Herself* (Richard Bentley & Son 1894).

113. David Holbrook, *Charles Dickens and the Image of Woman* (New York University Press 1993).

114. Charlotte Brontë, *Jane Eyre* (Smith Elder & Co. 1847).

115. Frances Power Cobbe (n. 112).

116. Charlotte Brontë (n. 114).

117. Elizabeth Gaskell, *The Life of Charlotte Brontë* (Smith Elder & Co. 1857).

118. *ibid.*

119. June Purvis, *A History of Women's Education in England* (Open University Press 1991).

120. George Eliot, *The Mill on the Floss* (William Blackwood & Sons 1860).

121. Report of the Schools Inquiry Commission Volume I: Taunton Report (HM Stationery Office 1868).

122. Records of Sheffield Archives.

123. Records of Sheffield Archives.

124. Emily Davies, *The Higher Education of Women* (Alexander Strahan 1866).

125. Elizabeth Seymour Eschbach, *The Higher Education of Women in England and America, 1865–1920* (Garland Publishing 1993).

126. Deborah Gorham, *The Victorian Girl and the Feminine Ideal* (Routledge 1982).

127. Catherine Hall and Leonore Davidoff, *Family Fortunes* (Routledge 1987).

128. 'A Woman's Thoughts About Women', *Chambers' Journal of Popular Literature, Science and Arts* (1857).

129. Elaine Showalter, *A Jury of her Peers: American Women Writers from Anne Bradstreet to Annie Proulx* (Virago 2010).

130. George Sand, *My Convent Life* (Academy Chicago Publishing 1977).

131. 'Marriage in High Life', *Derby Mercury*, 13 September 1854.

132. 'Editor's Note', *Quarterly Review*, vol. 84 (December 1848).

133. Joan N. Burstyn, *Victorian Education and the Ideal of Womanhood* (Croom Helm 1980).

134. Census of Sleights, North Yorkshire, 2 April 1911.

135. Sara Burstall, *Frances Mary Buss: An Educational Pioneer* (Society for Promoting Christian Knowledge, 1938).

136. *ibid.*

137. Anna Stoddart, *Life and Letters of Hannah E. Pipe* (William Blackwood & Sons 1908).

138. Hannah Lynch, *Autobiography of a Child* (Dodd Mead & Co. 1899).

139. 'History of College', https://www.cheltladiescollege.org/ (Accessed 14 November 2020).

140. Alice Zimmern, *The Renaissance of Girls' Education* (A. D. Innes 1898).

141. Clarendon Report: Inquiry into the Revenues and Management of Certain Colleges and Schools and the Studies Pursued and Instruction Given Therein (H.M. Stationery Office 1864).

142. Philippa Levine, *Victorian Feminism 1850–1900* (University Press of Florida 1994).

143. Muriel C. Bradbrook, *'That infidel place': a short history of Girton College, 1869–1969* (Chatto & Windus 1969).

144. Leonora Blanche Alleyne Lang (ed.), *The Poetical Works of Andrew Lang* (Longmans, Green & Co. 1923).

145. Susan Williams, *Domestic Science: the Education of Girls at Home*, in Richard Aldrich (ed.), *Public or Private Education?: Lessons from History* (Woburn 2004).

146. Jo Manton (n. 111).

147. Helen Blackburn, *A Handbook for Women Engaged in Social and Political Work* (J. W. Arrowsmith 1881).

148. London Metropolitan Archives LCC/MIN/4644, L.C.C. Establishment Committee Papers 1898.

149. Sara Burstall (n. 135).

150. Arlene Young, *From Spinster to Career Woman: Middle Class Women and Work in Victorian England* (McGill-Queen's University Press 2019).

151. Arthur L. Bowley, *Wages and Income in the United Kingdom Since 1860* (1937, Reprint 2016 Cambridge University Press).

152. Ellen Ross, *Love and Toil: Motherhood in Outcast London, 1870–1918* (Oxford University Press 1993).

153. Gregory Anderson (ed.), *The White-Blouse Revolution* (Manchester University Press 1988).

154. Jessie Boucherett, *On the Obstacles to the Employment of Women* (Victoria Press 1860).

155. Annual Report of the Society for Promoting the Employment of Women (1901).

156. E. H. Butler, *The Story of British Shorthand* (Sir Isaac Pitman & Sons 1951).

157. Bram Stoker, *Dracula* (1897, Reprint Puffin Classics 2019).

158. The 1871 Census for England and Wales listed 91,042 commercial clerks; only 1,446 of these were women.

159. *Office Magazine*, 22 September 1888; journals catering for shorthand writing rapidly followed.

160. Prudential Insurance Company 1874 quotation in Gregory Anderson (n. 154).

161. Pamela Cox and Annabel Hobley, *Shopgirls: The True Story of Life Behind the Counter* (Hutchinson 2014).

162. Sarah J. B. Hale, *Manners: or, Happy homes and good society all the year round* (J. E. Tilton 1868).

163. Raymond Vernon, '"The Theory of the Leisure Class" by Thorstein Veblen', *Daedalus*, vol. 103, no. 1 (1974).

164. Vivienne Richmond, *Clothing the Poor in Nineteenth-Century England* (Cambridge University Press 2013).

165. Charles Walter Masters, *The Respectability of Late Victorian Workers: A Case Study of York, 1867–1914* (Cambridge Scholars 2010).

166. Vyvyan Holland, *Hand Coloured Fashion Plates 1770–1899* (Batsford 1955).

167. Oscar Wilde, *The Works of Oscar Wilde, Essays, Criticisms and Reviews* (Reproduction, Nabu Press 2014).

168. Florence Hartley, *Ladies' Book of Etiquette and Manual of Politeness* (1860, Reprint Hesperus Press 2014).

169. 'How to Dress when Sitting for a Photographer', *The Ladies' Journal*, 30 October 1880.

170. Opaque Dutch linen or cotton fabric.

171. *Englishwoman's Domestic Magazine*, August 1860.

172. Dexter C. Bloomer, *Life and Writings of Amelia Bloomer* (Arena Publishing Company 1895).

173. Frieda Arnold, *My Mistress the Queen: Letters of Frieda Arnold, Dresser to Queen Victoria, 1854-59* (Weidenfeld & Nicolson 1994).

174. Amelia Roper, Letters to Martha Busher (Museum of London Collection).

175. *The London Journal*, 17 May 1862.

176. Lucy Worsley, *If Walls could Talk: An Intimate History of the Home* (Faber & Faber 2012).

177. Shelley Tobin, *Inside Out. A Brief History of Underwear* (The National Trust 2000).

178. Christina Walkley, 'Nor Iron Bars a Cage: The Victorian Crinoline and its Caricaturists', *History Today*, 25 October 1975.

179. Emma Donoghue, *The Sealed Letter* (Harper Collins 2008).

180. 'Sylvia', *How to Dress Well on A Shilling A Day: A Ladies' Guide to Home Dressmaking and Millinery* (Ward Lock 1876).

181. Oscar Wilde, *The Collected Works of Oscar Wilde* (Wordsworth Editions 1997).

182. Lucy Worsley (n. 176).

183. Millicent Cook, *How to Dress on £15 a Year as a Lady* (Frederick Warne & Co. 1874).

184. *The Blackburn Standard*, 12 April 1890.

185. Oscar Wilde (n. 181).

186. *Punch*, June 1881.

187. *Punch*, June 1883.

188. *Evening Telegraph*, 3 May 1911.

189. Kate Strasdin, 'Pattern As Memento – the Case of the 19th Century Dress Diary' (British Association of Victorian Studies 2018, unpublished).

190. Intentionally formal or prudish speech or action; the phrase originated in Charles Dickens' novel *Little Dorrit* as an example of proper speech.

191. *Humanitarian Magazine*, March 1896.

192. Cecil Willett Cunnington, *Fashion and Women's Attitudes in the 19th Century* (Courier Corporation 2003).

193. *Journal of the Kilvert Society*, October 1968.

194. James Laver, *The Concise History of Costume and Fashion* (Scribner's 1969).

195. *The Derby Mercury* (n. 131).

196. On display at Tullie House Museum, Carlisle.

197. On display at Gallery of Costume, Platt Hall, Manchester.

198. Trimmings such as tassels, borders, braids, gimp, fringes and more.

3 Differences in Female Stereotypes

199. Rosalind Ballaster, Margaret Beetham, Elizabeth Frazer, and Sandra Hebron, *Women's Worlds: Ideology, Femininity, and the Woman's Magazine* (Macmillan 1991).

200. Margaret Beetham, *A Magazine of Her Own? Domesticity and Desire in the Woman's Magazine, 1800–1914* (Routledge 1996).

201. Clare Mendes, 'Representations of the New Woman in the 1890s Woman's Press' (University of Leicester thesis 2013).

202. Sarah Grand, 'The New Aspect of the Woman Question', *North American Review*, vol. 158 (March 1894).

203. Teresa Mangum, *Married, Middlebrow, and Militant: Sarah Grand and the New Woman Novel* (University of Michigan Press 1998).

204. Sarah Grand (n. 202).

205. Martha Vicinus, *Suffer and Be Still; Women in the Victorian Age* (Indiana University Press 1972).

206. *Nineteenth Century*, vol. 3 (January 1894).

207. George Nathaniel Curzon, Letter to *The Times* of 30 May 1893.

208. A. Whitelaw (ed.), *Popular Encyclopaedia, Or Conversations Lexicon* (Blackie & Son 1883).

209. 'Women's Work: Its Value and Possibilities', in *Girl's Own Paper*, vol. 16 (1894-95).

210. Sally Ledger, *The New Woman Fiction and Feminism at the* Fin de Siècle (Manchester University Press 1997).

211. Angelique Richardson and Chris Willis (eds), *The New Woman in Fiction and in Fact: Fin-de-siecle Feminisms* (Palgrave Macmillan 2001).

212. Elaine Showalter, *Sexual Anarchy, Gender and Culture at the* Fin de Siècle (Viking 1990).

213. Hugh M. Stutfield, 'Tommyrotics', *Blackwood's Edinburgh Magazine*, vol. 157 (1895).
214. Mona Caird, 'Marriage', *Westminster Review*, vol. 30 (1888).
215. Mona Caird, *The Morality of Marriage: and Other Essays on the Status and Destiny of Woman* (G. Redway 1897).
216. Blanche A. Crackanthorpe, 'The Revolt of the Daughters', *Nineteenth Century*, vol. 3 (January 1894).
217. Jane H. Clapperton, *Margaret Dunmore: Or, a Socialist Home* (Swan Sonneschein Lowrey & Co. 1888).
218. Bonnie Zimmerman, 'Felix Holt and the True Power of Womanhood', *English Literary History Journal*, vol. 46, no. 3 (1979).
219. John Stuart Mill (n. 99).
220. George Eliot, *Felix Holt, The Radical* (William Blackwood & Sons 1866).
221. Grant Allen, *The Woman Who Did* (John Lane, 1895).
222. Grant Allen, 'Plain Words on the Woman Question', *Popular Science Monthly*, vol. 36 (December 1889).
223. Millicent Garrett Fawcett, [review of] 'The Woman Who Did', *Contemporary Review*, vol. 67 (1895). Reprinted in *The Late-Victorian Marriage Question: A Collection of Key New Woman Texts* (Routledge/Thoemmes Press 2000).
224. Thomas Hardy, *Jude the Obscure* (1895, Reprint Barnes Noble Classics, 2003).
225. Margaret O. W. Oliphant, 'The Anti-Marriage League', *Blackwood's Edinburgh Magazine* (1896).
226. David Punter and Glennis Byron, *The Gothic* (Blackwell Guides to Literature 2004).
227. Emma Goldman, 'Victims of Morality', *Mother Earth*, vol. 8, no. 1 (March 1913).
228. John Tosh, *A Man's Place: Masculinity and the Middle Class Home in Victorian England* (Yale University Press 1999).
229. Martha Vicinus (ed.), *A Widening Sphere: Changing Roles of Victorian Women* (Methuen & Co. 1977).
230. Kathryn Ledbetter, *British Victorian Women's Periodicals: Beauty Civilization and Poetry* (Palgrave Macmillan 2009).

4 Challenging the Norms

231. Richard D. Altick, *The Weaker Sex: Victorian People and Ideas* (W. W. Norton & Co. 1973).
232. Ian D. Gilbert, *Religion and Society in Industrial England: Church, Chapel and Social Change* (Longman 1976).

233. Judith Johnson, *Anna Jameson: Victorian, Feminist, Woman of Letters* (Scolar Press 1997).

234. Barbara Leigh Smith Bodichon, *Women and Work* (Bosworth & Harrison 1857).

235. A.R.L., 'Facts Versus Ideas', *The English Woman's Journal*, vol. 38 (1861).

236. Quoted in Jane Lewis, *Before the Vote Was Won* (Routledge 2001).

237. *The Standard*, 29 November 1852.

238. Thomas Carlyle, Letter to Arthur Clough 12 May 1853 (Bodleian Library Collection).

239. J. B. Estlin, Letter to Maria Weston Chapman December 1852 in Clare Taylor, *British and American Abolitionists: An Episode in Transatlantic Understanding* (Edinburgh University Press 1974).

240. *The Times*, 29 November 1852.

241. Letter to *The Times*, 3 December 1852.

242. Jan Marsh, *Elizabeth Siddal 1829–1862: Pre-Raphaelite Artist* (Ruskin Gallery 1991).

243. Jan Marsh and Pamela Gerrish Nunn, *Pre-Raphaelite Women Artists* (Manchester City Art Galleries 1997).

244. Lucinda Hawksley, *Lizzie Siddal, The Tragedy of a Pre-Raphaelite Supermodel* (Andre Deutsch Ltd. 2008).

245. Serena Trowbridge (ed.), *My Lady's Soul, the Poetry of Elizabeth Eleanor Siddall* (Victorian Secrets, 2018).

246. John Batchelor, *Lady Trevelyan and the Pre-Raphaelite Brotherhood* (Chatto & Windus 2006).

247. G. D. Leslie, *The Inner Life of the Royal Academy* (John Murray 1914).

248. *The Athenaeum*, 30 April 1859.

249. *South Australian Register*, 1 December 1863.

250. Barbara Leigh Smith Bodichon (n. 234).

251. Deborah Cherry, *Painting Women: Victorian Women Artists* (Rochdale Art Gallery 1987).

252. Ellen C. Clayton, *English Female Artists* (Tinsley Brothers 1876).

253. Elise Lawton Smith, *Evelyn Pickering De Morgan and the Allegorical Body* (Fairleigh Dickinson University Press 2002).

254. Nicola Gordon Bowe, *Wilhelmina Geddes: Life and Work* (Four Courts Press 2015).

255. City of Birmingham, Birmingham Municipal School of Art List of Awards Made to Students of the Central & Branch Schools, the Department of Science & Art of the Committee of Council on Education, 1892.

256. Birmingham Institute of Art and Design, SA/AD/14/1, Student Records, Session 1899–1900.

257. Newspaper cutting held at Birmingham Museum and Art Gallery, dating from *c.* 1950.

258. She was classed as a fallen woman because of her affair with Charles Dickens.

259. Ian Ward, *Sex, Crime and Literature in Victorian England* (Hart Publishing 2014).

260. Robert Southey, Letter to Charlotte Brontë, 12 March 1837, held at Brontë Parsonage Museum, Haworth, West Yorkshire.

261. Charlotte Brontë, *The Professor* (1857, Reprint Wordsworth Classics 1994).

262. John Sutherland, *The Victorian Novelists: Who Were They?* (Athlone Press 1976).

263. Anne Brontë, Charlotte Brontë and Emily Brontë, *Wuthering Heights and Agnes Grey, with a Preface and Memoir of Both Authors* (Smith, Elder & Co. 1870).

264. Zoe Brennan, *Brontë's Jane Eyre: A Reader's Guide* (Continuum International Publishing Group 2010).

265. George Smith and Sidney Lee, *George Smith: A Memoir With Some Pages of Autobiography* (London: For Private Circulation 1902).

266. John Stuart Mill (n. 99).

267. Elaine Showalter, *A Literature of Their Own* (1977, Reprint Virago Press 2009).

268. Juliet Barker, *The Brontës, A Life in Letters* (Little, Brown 2016).

269. Alexis Easley, *First Person Anonymous: Women Writers and Victorian Print Media, 1830–1870* (Ashgate 2004).

270. Charlotte Brontë, Letter to George Henry Lewes, October 1849.

271. Alan Chedzoy, *A Scandalous Woman: The Story of Caroline Norton* (Allison and Busby 1992).

272. George H. Lewes, 'The Lady Novelists', *Westminster Review*, vol. 2 (1852).

273. George H. Lewes, from an unsigned review in the *Edinburgh Review*, January 1850.

274. Charlotte Brontë, Letter to G. H. Lewes, January 1850, in *The Letters of Charlotte Brontë with a Selection of Letters by Family and Friends Volume II, 1848–1851*, ed. by Margaret Smith (Clarendon Press 2000).

275. George Eliot, 'Silly Novels by Lady Novelists', *Westminster Review*, October 1856.

276. Review of Gaskell's *Ruth* in *North British Review*, vol. xix (1853).

277. Census of England and Wales 1871–1891.

278. Elaine Showalter, *A Literature of Their Own* (n. 278).
279. 'Authorship: Past and Present', *All the Year Round*, vol. 1 (23 March 1889).
280. Honnor Morten, 'Questions for Women IV: Woman's Invasion of Men's Occupations', *Queen*, 28 January 1899.
281. Florence Nightingale, Letter to Nurses (London Metropolitan Archives: Nightingale Collection 1900).
282. Florence Nightingale, *Notes on nursing. What it is and what it is not* (Harrison & Sons 1859).
283. Elizabeth Blackwell, *Pioneer Work in Opening the Medical Profession to Women* (2005 reprint of Longmans, Greene 1895 edition, Humanity Books).
284. Elizabeth Blackwell (n. 283).
285. Samuel Sanes, 'Elizabeth Blackwell: Her First Medical Publication', *Bulletin of the History of Medicine*, June 1944.
286. Elizabeth Blackwell, Letter to Barbara Bodichon (Collection of Fawcett Library, London School of Economics).
287. In reply to an invitation from the Convention for Women's Rights in Worcester, Massachusetts, 1850.
288. *Medical Times and Gazette*, 23 February 1867.
289. Shirley Roberts, *Sophia Jex-Blake: A Woman Pioneer in 19th Century Reform* (Routledge 1993).
290. Sophia Jex-Blake, 'Medical Education for Women', *The Times*, 28 July 1869.
291. *The Scotsman*, 24 July 1869.
292. Sophia Jex-Blake, *Medicine as a Profession for Women* (2nd ed. Oliphant Anderson & Ferrier 1886).
293. Two male students passed with higher marks than Pechey, but they were resitting as they had originally failed.
294. Sophia's journal quoted in Margaret Todd, *The Life of Sophia Jex-Blake* (Macmillan & Co. 1918).
295. Shirley Roberts (n. 289).
296. Shirley Roberts (n. 289).
297. *The British Medical Journal*, 16 April 1870.
298. *The Spectator*, 3 December 1870.
299. *The Period*, 14 May 1870.
300. Sophia Jex-Blake (n. 292).
301. *The Times*, 3 June 1875.
302. Shirley Roberts (n. 289).
303. *The Medical Examiner*, vol. III, January to June 1878, ed. Oakley Coles (C. W. Reynell 1878).

304. Elizabeth Garrett Anderson in C. B. Keetley, *The Student's Guide to the Medical Profession* (Macmillan and Co. 1878).

305. James Gleick, *The Information: A History, a Theory, a Flood* (Harper Collins 2011).

306. Ada Byron, Letter to her mother Lady Byron (from collection in University of St Andrews Archive).

307. Frank A. J. L. James (ed.), *The Correspondence of Michael Faraday, Volume 3* (Institution of Engineering and Technology 1996).

308. Emily Arnold McCully, *Dreaming in Code: Ada Byron Lovelace, Computer Pioneer* (Candlewick Press 2019).

309. Notes attached, by Ada Lovelace, to *Sketch of the Analytical Engine*, L. F. Menabrea, from the Bibliothèque Universelle de Genève, October 1842, no. 82 in B. V. Bowden, *Faster Than Thought: A Symposium on Digital Computing Machines* (Sir Isaac Pitman & Sons 1953).

310. Augustus de Morgan, Letter to Lady Byron, 21 January 1844, in Christopher Hollings, Ursula Martin & Adrian Rice, *The early mathematical education of Ada Lovelace, BSHM Bulletin: Journal of the British Society for the History of Mathematics* (2017).

311. Rachel Bentham and Alyson Hallett (eds.), *Project Boast* (Triarchy Press 2018).

312. B. M. E. O'Mahoney, 'Henrietta Vansittart – Britain's First Woman Engineer?', *Journal of the Women's Engineering Society*, vol. 13, no. 4 (April 1983).

313. Claire G. Jones, *Femininity, Mathematics and Science 1880–1914* (Palgrave Macmillan 2019).

314. GB Patent 1884/5443 Improvements in Mathematical Dividing Instruments, granted 25 March 1884.

315. Hertha Ayrton, 'The Uses of a Line-Divider', *Proceedings of the Physical Society of London*, vol. 7 (1885).

316. Hertha Ayrton, 'The mechanism of the electric arc', *Proceedings of the Royal Society*, vol. 68 (1901).

317. Andrew Stewart, 'On Making the Best of It', *The Woman Engineer*, vol. 1 (1923).

318. Helen Pleydell-Bouverie, Countess of Radnor, *From a Great-Grandmother's Armchair* (Marshall Press 1927).

319. Octavia Hill, 'The Kyrle Society', *Charity Organisation Review*, 1905.

320. Stella Margetson, *Victorian High Society* (Holmes and Meier 1980).

321. Helen Pleydell-Bouverie (n. 318). Her husband was styled Viscount Folkestone from 1869 to 1889.

322. Colleen Denney, *At the Temple of Art: Grosvenor Gallery, 1877–1890* (Associated University Press 2000).

323. *The Monthly Musical Record*, 1 September 1887.

324. 'Viscountess Folkestone's Concert', *The Monthly Musical Record*, 1 September 1887.

325. 'Woman's Position in the Violin-World', *The Etude*, September 1901.

326. *The Times*, 15 June 1899.

327. *The Times*, 7 March 1922.

328. *The Etude*, October 1901.

329. Florence Fidler and Rosabel Watson, 'Music as a Profession', *The Englishwoman's Year Book of 1899*.

330. Rosa Newmarch, *Mary Wakefield – A Memoir* (Atkinson & Pollitt 1912).

331. Sharon Marcus, *Between Women: Friendship, Desire, and Marriage in Victorian England* (Princeton University Press 2007).

332. Sarah Stickney Ellis, *The Daughters of England* (Fisher Son & Co. 1842).

333. Lillian Faderman, *Surpassing the Love of Men: Romantic Friendship and Love Between Women from the Renaissance to the Present* (William Morrow & Co. 1981).

334. Constance Maynard, 'Green Book' diaries and unpublished autobiography. Courtesy of Queen Mary University of London Archives, AIMG-0766.

335. *The Times*, 30 July 1864.

336. *ibid.*

337. Frances Power Cobbe (n. 112).

338. Two girlfriends.

339. Colin G. Pooley, Siân Pooley and Richard Lawton, *The Diary of Elizabeth Lee: Growing up on Merseyside in the Late Nineteenth Century* (Liverpool University Press 2010).

340. Pauline Nestor, 'Female friendships in mid-Victorian England: new patterns and possibilities', *Literature & History*, vol. 17, no. 1 (2008).

341. Frances Power Cobbe, 'Celibacy v Marriage: Old Maids, their Sorrows and Pleasures', *Fraser's Magazine*, no. 65 (1865).

342. Sharon Marcus (n. 331).

343. Christina Rossetti, *Goblin Market and Other Poems* (1863, in Penguin Classics 2017).

344. Charlotte Brontë, Letter to William S. Williams 3 January 1850, Brontë Parsonage Museum Collection.

345. Elaine Miller, 'Through all changes and through all chances: The relationship of Ellen Nussey and Charlotte Brontë', *Lesbian History Group, Not a Passing Phase* (1989, Reprint 1993).

346. Brontë Parsonage Museum Collection.

347. James S. Stone, *Emily Faithfull: Victorian Champion of Women's Rights* (P. D. Meany Publishers 1994).

348. Charlotte Brontë, *Villette* (Smith Elder & Co. 1853).

349. Frances Power Cobbe, *The Duties of Women: A Course of Lectures* (1881, Reprint Cambridge University Press 2011).

5 Injustices Faced and Breaking the Barriers

350. Martha Vicinus, *A Widening Sphere: Changing Roles of Victorian Women* (Methuen 1977).

351. Ladies' Hall Committee, Aberdare Hall, November 1884–1893 in Carol Dyhouse, *No Distinction of Sex? Women in British Universities 1870–1939* (Routledge 1995). Isabel Bruce and Isabel Don, the first two principals of Aberdare Hall, worked without a salary.

352. John Maynard Keynes, *Obituary of Mary Paley Marshall* (Macmillan & Co. 1944).

353. E. Austin Robinson, 'Review of What I Remember by Mary Paley Marshall', *Economic Journal*, vol. 58 (1948).

354. Thomas H. Huxley, Letters and Diary: 1860 (Records of Thomas Henry Huxley Collection, Imperial College London, Library Archives and Special Collections Abstract).

355. 'Man's Monopoly. An Interview with a Lady Accountant', *Woman's Signal*, 1 August 1895.

356. *Work and Leisure*, 13 March 1888.

357. *Woman's Signal* (n. 355).

358. *The Accountant*, 9 June 1888.

359. David Rubinstein, *A Different World for Women: The Life of Millicent Garrett Fawcett* (Harvester Wheatsheaf 1991).

360. *The Accountant*, 18 July 1891.

361. ibid.

362. ICEAW, *Celebrating Women in Chartered Accountancy* (ICEAW 2020).

363. Rosalie Silverstone and Allan Williams, 'Recruitment, Training, Employment and Careers of Women Chartered Accountants in England and Wales', *Accounting and Business Research*, vol. 9 (1979).

364. *The Pharmaceutical Journal*, March 1873.

365. *The Pharmaceutical Journal*, 17 November 1877.

366. 'The Admission of Ladies to the British Medical Association', *British Medical Journal* (1878).

367. *ibid.*

368. Annual Meeting of the British Medical Association, *British Medical Journal* (1878).

369. *British Medical Journal* (n. 365).

370. Kaarin Leigh Michaelson, *Becoming Medical Women: British Female Physicians and the Politics of Professionalism, 1860–1933* (University of California 1993).

371. 'Obituary: Elizabeth Garrett Anderson, M.D.', *British Medical Journal* (1917).

372. Tara Lamont, 'The Amazons Within: Women in the BMA 100 Years Ago', *British Medical Journal* (December 1992).

373. John S. Haller and Robin M. Haller, *The Physician and Sexuality in Victorian America* (W. W. Norton & Co. 1977).

374. Charles Darwin, Letter to Caroline Kennard, January 1882 (from collection in Darwinian Project resources).

375. Mary Wollstonecraft, *Vindication of the Rights of Woman* (Thomas & Andrews 1792, Reprint Vintage Classics 2015).

376. Lynn Peril, *College Girls: Bluestockings, Sex Kittens, and Co-eds, Then and Now* (W. W. Norton & Co. 2006).

377. *Punch*, 10 May 1884.

378. The Geological Society, '100 years of Female Fellowship' (Geological Society Blog Page 20 May 2019).

379. *Proceedings of Geographical Society*, vol. 553 (August 1892).

380. Royal Geographical Society Archives 1892.

381. Royal Geographical Society Archives 1912.

382. Royal Geographical Society, *Medals and Awards* (RGS 2020).

383. George Curzon, Letter to *The Times*, 30 May 1893.

384. Shirley Foster, *Across New Worlds: Nineteenth Century Women Travellers and Their Writings* (Prentice Hall 1990).

385. 'To the Royal Geographic Society', *Punch*, 10 June 1893.

386. Dea Birkett, *Spinsters Abroad: Victorian Lady Travellers* (Sutton Publishing 2004).

387. *Blackwood's Edinburgh Magazine*, 1828.

388. Harriet Martineau, *Retrospect of Western Travel* (1838, Reprint Cambridge University Press 2011).

389. Hertha Ayrton, 'The hissing of the electric arc', *Journal of the Institution of Electrical Engineers*, vol. 28, no. 140 (June 1899).

390. 'Are Men Naturally Cleverer than Women?', *The English Woman's Journal* (1859).

Conclusion: *The Modern Victorian Woman*

391. Richard D. Altick (n. 231).
392. John Ruskin (n. 72).
393. Martha Vicinus (n. 205).
394. John Ruskin (n. 72).
395. Diana O. Cordea, 'The Victorian Household and its Mistresses: Social Stereotypes and Responsibilities', *Journal of Humanistic and Social Studies* (1 November 2011).
396. John Stuart Mill (n. 99).
397. Dorothy Thompson, *Queen Victoria: The Woman, the Monarchy, and the People* (Pantheon 1990).
398. Nancy Armstrong, *Desire and Domestic Fiction* (Oxford University Press 1987).

Postscript: *What If Albert Had Lived?*

399. All quotations and letters by Victoria mentioned in this chapter are from the Royal Collections Trust.
400. Millicent Garrett Fawcett, *Life of Her Majesty Queen Victoria* (1893, Reprint Albion Press 2016).
401. Dated 25 May 1870.
402. Jules Stewart, *Albert: A Life* (Tauris/Bloomsbury 2011).
403. Kenneth W. Luckhurst, 'The Great Exhibition of 1851', *Journal of the Royal Society of Arts*, vol. 99 (1951).
404. Donald Caton, *What A Blessing She Had Chloroform: The medical and social response to the pain of childbirth from 1800 to the present* (Yale University Press 1999).
405. Asa Briggs, *The Age of Improvement, 1783–1867* (Pearson 1959, Reprint 2000).
406. Diaries by courtesy of the Royal Collections Trust.
407. H. G. Wells, *Experiment in Autobiography* (Victor Gollancz Ltd 1934).
408. Sidney Lee, *King Edward VII, a Biography* (Macmillan & Co. 1923).
409. William T. Stead, *Her Majesty the Queen: Studies of the Sovereign and the Reign* (Review of Reviews Office 1897).

ACKNOWLEDGEMENTS

I have so many people to thank for turning my passion for Victorian women's history into a real book.

Firstly, Connor and Nikki at Amberley Publishing who very kindly championed my initial book idea and helped me to turn it into reality. To my loyal 'History Heroines', Helen Fisher, Katie Lamb, Mary Milner, Maureen Sanderson and Liz Ward, who encouraged me throughout and also Juliet Green, who read the early drafts. To Jacky Gray who proofread with patience, and extra-extra special thanks to Nick House for his ongoing commentary, feedback and support.

Thanks are also due to those who gave me first-hand information and shared their views, especially staff at various record offices, universities and museums, and particularly in the challenging circumstances we all found ourselves in during 2020. These include Carry van Lieshout at the University of Cambridge; staff at Lichfield Record Office; Bedfordshire Record Office; the University of Sheffield; and especially the University of Nottingham for allowing me access to the Drury-Lowe Collection and the diaries of Robert Holden for background information on Sophia Curzon. Also Lauren Livesey, audience development officer at the Brontë Parsonage Museum; Professor Anna Birch, the Royal Conservatoire of Scotland's research lecturer in drama; Kate Strasdin, honorary deputy curator at the Totnes Fashion and Textile Museum in Devon; Sally Ward of William Whiteley & Sons (Sheffield) for talking to me about her ancestors; Keren Guthrie, archivist at Blair Castle; and staff at Napier University in Edinburgh and Kresen Kernow Archive Centre in Redruth, Cornwall.

And, of course, Graham.

Anne Louise Booth

LIST OF ILLUSTRATIONS

1. Processions, Central London, 10 June 2018. (1418Now.org.uk)
2. *First Class: The Meeting ... and at First Meeting Loved* by Abraham Solomon. (National Gallery of Canada)
3. Reworked version of the painting by Abraham Solomon. (National Gallery of Canada)
4. Harriet, Duchess of Sutherland, by George Henry Phillips, 1841. (National Portrait Gallery)
5. Scissors by William Whiteley & Sons (Sheffield) Ltd, made for Queen Victoria. (William Whiteley & Sons (Sheffield) Ltd)
6. Mona Caird, 1894. (*The Review of Reviews*, Volume 10, July – December 1894)
7. Caroline Norton by Daniel Maclise, published by James Fraser, lithograph, published 1831. (National Portrait Gallery, London)
8. Dame school in Twelveheads, Cornwall. (courtesy of Kresen Kernow)
9. *The Governess* by Rebecca Solomon, 1854. (Purchased from Magnolia Box 2020)
10. Staff of the Victoria Press, *Illustrated London News/Mary Evans Picture Library*. (Courtesy of the British Library)
11. Female telegraph clerks from *Rab Bethune's Double* by Edward Garrett, 1894.
12. Mary Lowndes by Arthur James Langton. An example of Lowndes' poster art *Is This Right?* to support female suffrage and her stained glass window *The Finding of the Saviour in the Temple*. (Courtesy of the Arts and Humanities Research Council)
13. Fashion plate featuring day and evening dresses, hand-coloured etching, line and stipple engraving, 1869. (National Portrait Gallery, London)

INDEX